INTERIOR DESIGN MASTER CLASS
100 ROOMS

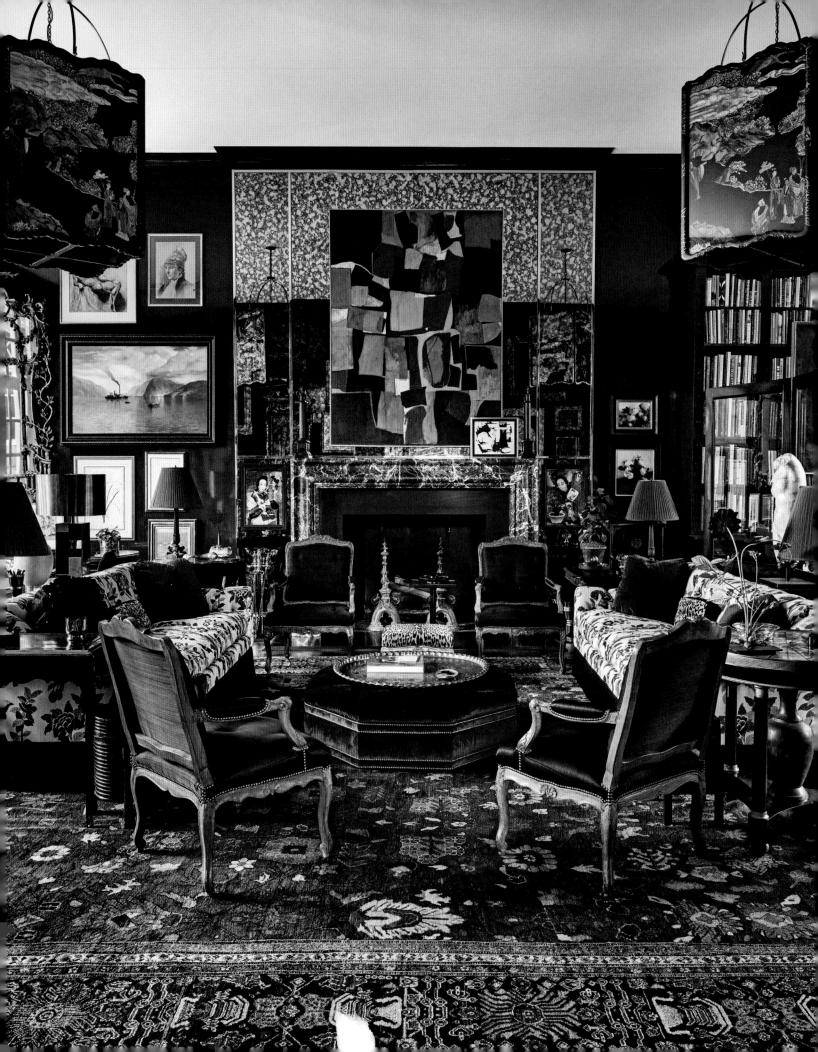

INTERIOR DESIGN MASTER CLASS
100 ROOMS

LESSONS FROM THE FINEST DESIGNERS ON THE ART OF HOME

Edited by

CARL DELLATORE

RIZZOLI
NEW YORK

New York · Paris · London · Milan

CONTENTS

INTRODUCTION

When my book *Interior Design Master Class: 100 Lessons from America's Finest Designers on the Art of Decoration* was published in 2016, the positive response to it revealed something surprising and affirming: In our frenzied age of instant visual inspiration and algorithmic design suggestions, people still hunger for more profound wisdom about creating a home.

Thinking back, I see that producing that book was a truly remarkable journey. Over two years, I had the privilege of learning directly from 100 of America's finest designers in their offices, conference rooms, and homes. I went to design school in an unorthodox and yet gratifying way. The designers' collective knowledge provided an extraordinary design education—one that I continue to be fortunate to share with readers far and wide through the book's publication.

Since then, in many lively conversations about interior design, I've repeatedly been asked one fundamental question: How do I design a home like the ones I see in your books? This practical mission inspired me once again to gather 100 designers and ask them to share specific, actionable advice. I asked them to tackle the questions that challenge everyone who has endeavored to design and decorate a home: How do you successfully combine patterns? What are the key considerations when thinking about curtains? When should you choose high-gloss over matte paint? From these essential questions and many more, *Interior Design Master Class: 100 Rooms* was born.

Many of the respected voices from my first volume appear in these pages, their practical wisdom more vital than ever in our rapidly changing world. But they are now joined by members of the new guard of designers who have risen to prominence in the past decade. These younger voices bring fresh perspectives shaped by contemporary lifestyles, giving them unique insight into how people discover and interact with design. What's striking is how often their advice aligns with and builds upon the wisdom of their predecessors—proof that certain principles of good design transcend generations. Inclusion of this new cohort makes this volume a tangible guide and a living dialogue between established masters and emerging talents, collectively redefining the decorative arts for a new era.

As you read through the pages of this book, it's essential to remember that no two rooms are identical, just as no two people share the exact needs or vision for how they want to live. And yet, throughout the diversity of spaces our contributors have created certain truths emerge repeatedly. The essays in this book reveal those truths, not through rigid rules but through principles that can be adapted to any space and style. The designers have spent decades solving decorating dilemmas, large and small. Now, they're sharing their solutions with you.

Whether you're a new homeowner tackling your first decorating project, a design student seeking to understand the real-life application of your studies, or a design professional looking to refine your process, you'll find guidance here that will transform the way you approach the art of decorating.

Page 2: In this Gatsby-esque room by Redd Kaihoi, lustrous chocolate-brown walls are the perfect backdrop for a riotous collection of furnishings that includes French chairs, chintz-covered sofas, and a cherry-red ottoman.
Opposite: In this Upper East Side parlor, Lucy Doswell employed Bali II wallpaper from China Seas as a sophisticated foundation. Its brown and cream pattern creates an invigorating context for conversation.

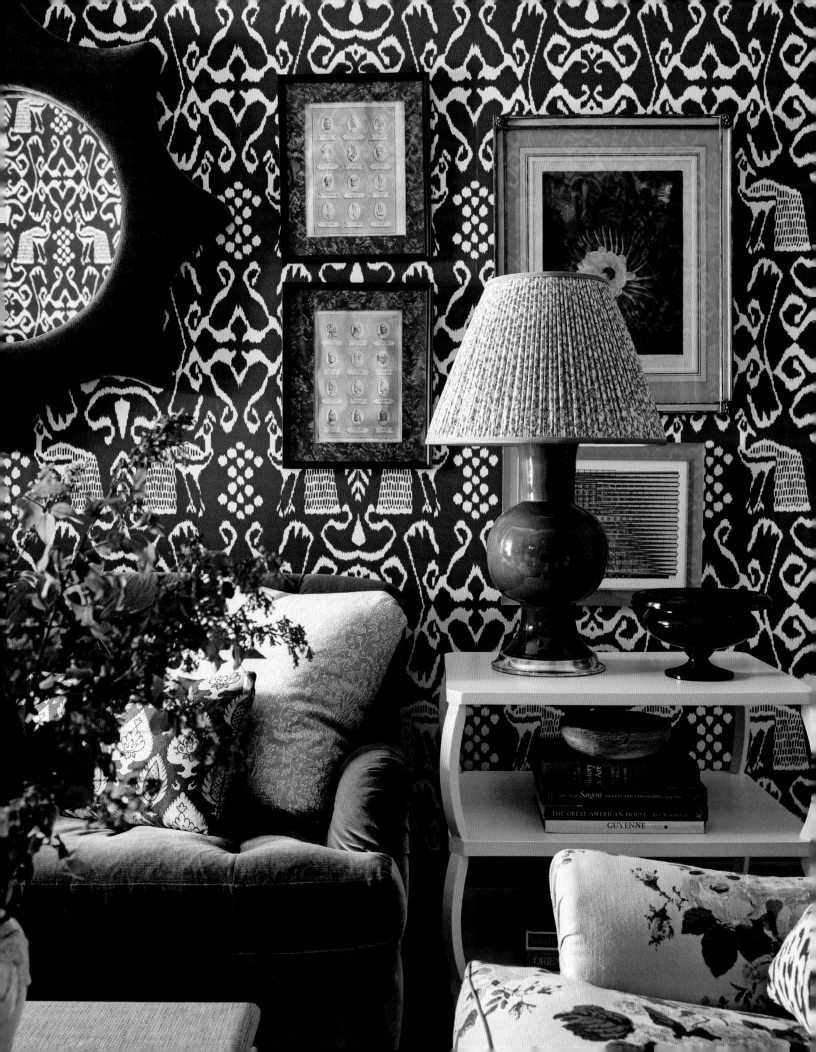

The character of a well-designed home is defined by the communal spaces where we gather. These are the rooms where familial relationships are bolstered, rooms that are the backdrops for daily activities. Therefore, they serve a higher purpose than merely providing aesthetic pleasure. We live in them. As the designers in this chapter demonstrate, the most successful gathering spaces share certain elements: generous, comfortable seating arranged in intimate groupings, soft lighting at multiple heights to create ambiance, and side tables located within easy reach—all orchestrated in materials and finishes that invite relaxation without provoking worry about disturbing a precious scene. These thoughtful choices—and others described in these essays—set the stage for taking the chill off a winter's day around a crackling hearth, curling up for family movie night, or lingering over post-dinner conversations that stretch long into the evening

GATHERING

1

CURTAINS

BUNNY WILLIAMS + ELIZABETH LAWRENCE

[Williams Lawrence]

With myriad styles and variables to consider, curtains can be bewildering, but when done right they transform a room. Curtains should complement the architecture, so the first step is to study the windows. Maybe you want to give the illusion that they are taller, or perhaps there's a view that needs framing. Good curtains are like a well-tailored suit: they disguise bad proportions and create a flattering silhouette.

Craftsmanship and choice of fabric are paramount. We often gravitate toward materials like linen, silk, and cotton. Some fabrics drape better than others, and a lining helps curtains hang in a relaxed way. Decorative trims or custom embroidery can add a bespoke touch, tying them into a room's overall color scheme.

Solid fabrics, especially those that match the wall color, help disguise oddly placed windows while allowing other elements to shine. Patterned textiles, used sparingly, introduce visual interest and depth to a room. Curtains should always reach the floor, and a little extra length can make them look softer. Full curtains create a sumptuous feel, while streamlined panels offer a modern look. Perhaps most importantly, curtains should fit the style of the furnishings. Elaborate curtains will feel out of place in a simple room—so save the swags and fringe for more formal environments. And hardware should not be overlooked and should harmonize with other fixtures in the space. We often employ curtain rods that curve toward the wall, as they add dimension.

On a practical note, curtains provide privacy and control the natural light that filters in. Bedrooms usually require them for these reasons. Other times, a view is just too breathtaking to obstruct, so you might opt for a shade that tucks itself out of sight. Always consider how curtains look from the exterior of a house, too. The lining should be consistent if you are looking at a house from the front and can see windows in various rooms.

In the hands of a skilled designer, curtains are a defining feature that elevates an entire space, blending beauty and utility in perfect harmony.

Bunny Williams and Elizabeth Lawrence placed metal rods high above tall windows with arched tops and hung straight curtains on either side so as not to obscure the windows' rounded shapes. This sitting room balances pale blues against shades of burnished gold and brown. The desk lamp is from the Bunny Williams Home collection.

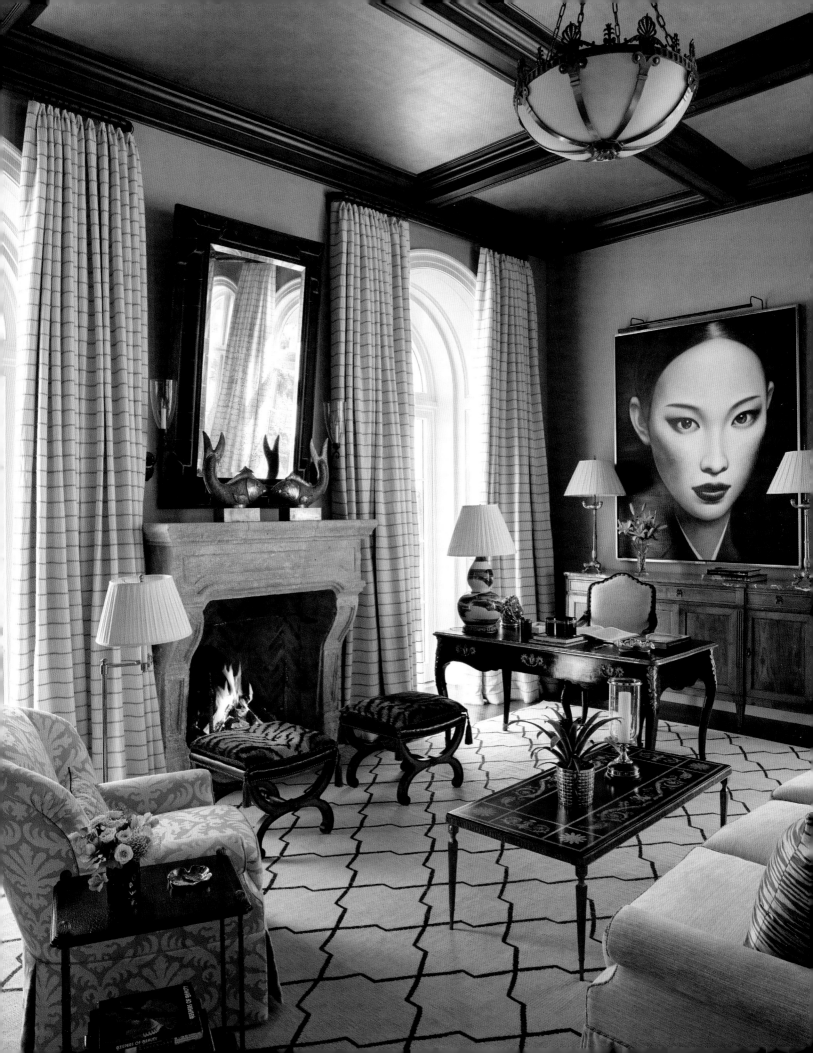

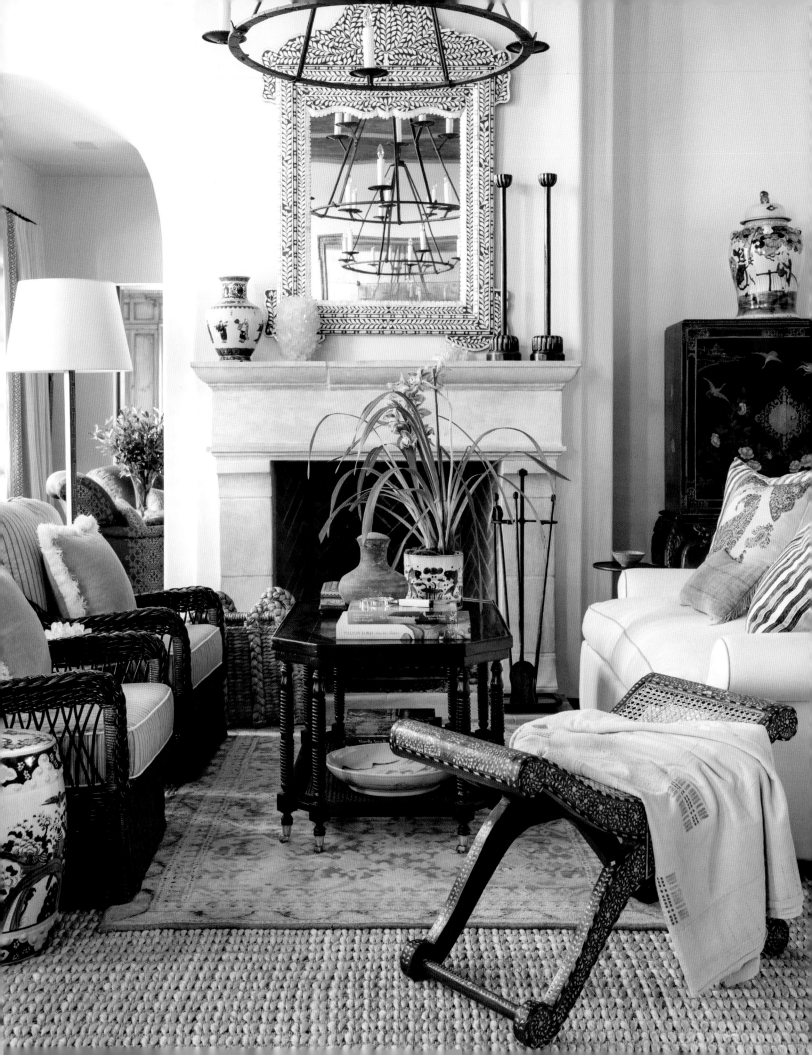

2

TABLES

MARK D. SIKES

Tables are stages where parts and scenes from our lives play out, from the books we're reading to the plants we're tending. Each is a small world of its own.

Still, the practical aspects of tables usually come first. Think about the way people are going to use a room and where they'll need a spot to rest something. Once that concept is clear, begin to incorporate various tables. If a room is large, I like to break it up with a center table to create two seating spaces: a cozier one, perhaps beside the fireplace, and another that's more expansive against a wall, usually on the opposite side of the room, each with a little table or tables of its own.

I also like to use tables in a range of sizes. Small tables—like ceramic garden stools and Anglo-Indian drinks tables—are easily portable, so there's always a place to set a glass. You don't want all the tables to be rectangular or round, or all the same size and height. Mixing materials, shapes, and scales is vital to prevent them from all reading the same. Good design is often about the mix: combining various silhouettes, materials, and scales to strike the right note. The range is what prevents a room from feeling static or too thought-out. (You never want to set a glass vase on a glass coffee table, for example.)

In putting together tablescapes, there are a few beautiful elements that I employ so often that you could call them my signatures: books, pretty boxes, bowls, and plants. Keep in mind that when you're arranging decorative things on a table, you don't want everything to be at the same level; it's much more interesting to look at a tablescape when its elements have a varied skyline. Typically, the flowers or plants are the tallest thing, and books and objets are nestled beneath. I often incorporate something a little bit unexpected, whether it's a magnifying glass, a found shell, or a nostalgic keepsake. Anything that brings into play that final touch—a moment of beauty.

Opposite: This intimate arrangement features an espresso-hued rattan chair with down cushions and a linen loveseat. Blue-and-white porcelain adds a touch of the designer's signature chinoiserie charm.
Following pages: This refined sanctuary is artfully bisected by an Indian teak center table, sourced through John Rosselli, that features intricate natural and ebonized bone inlay; it elegantly delineates two conversation areas.

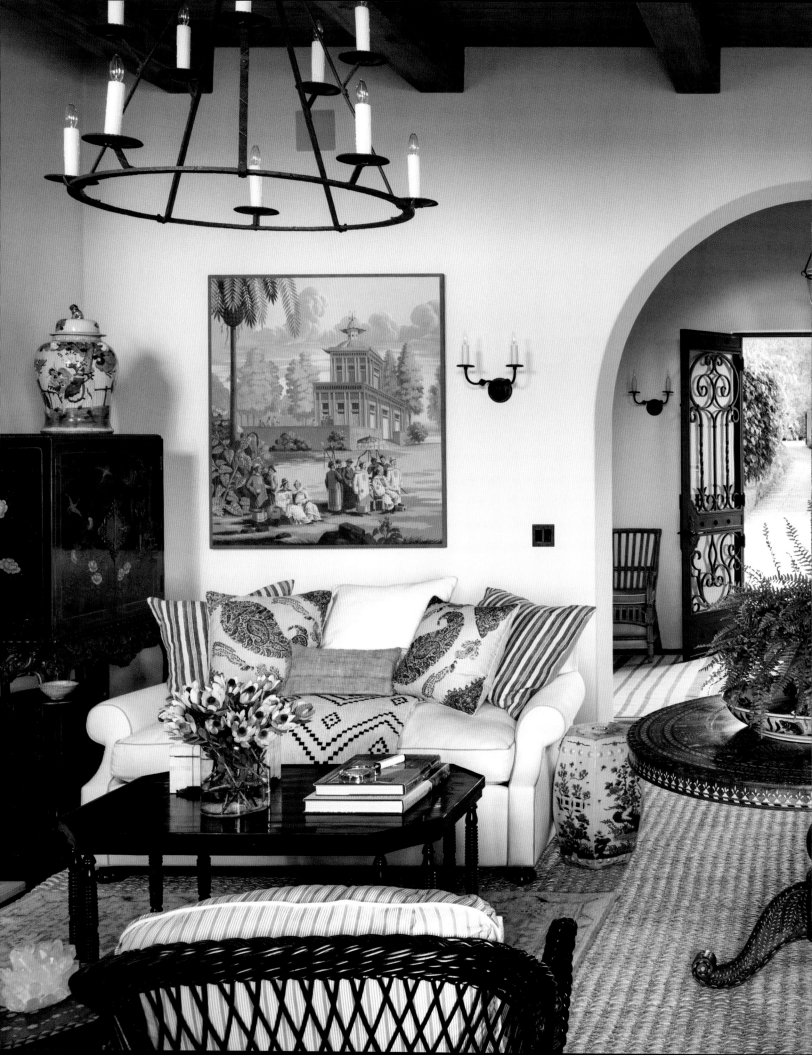

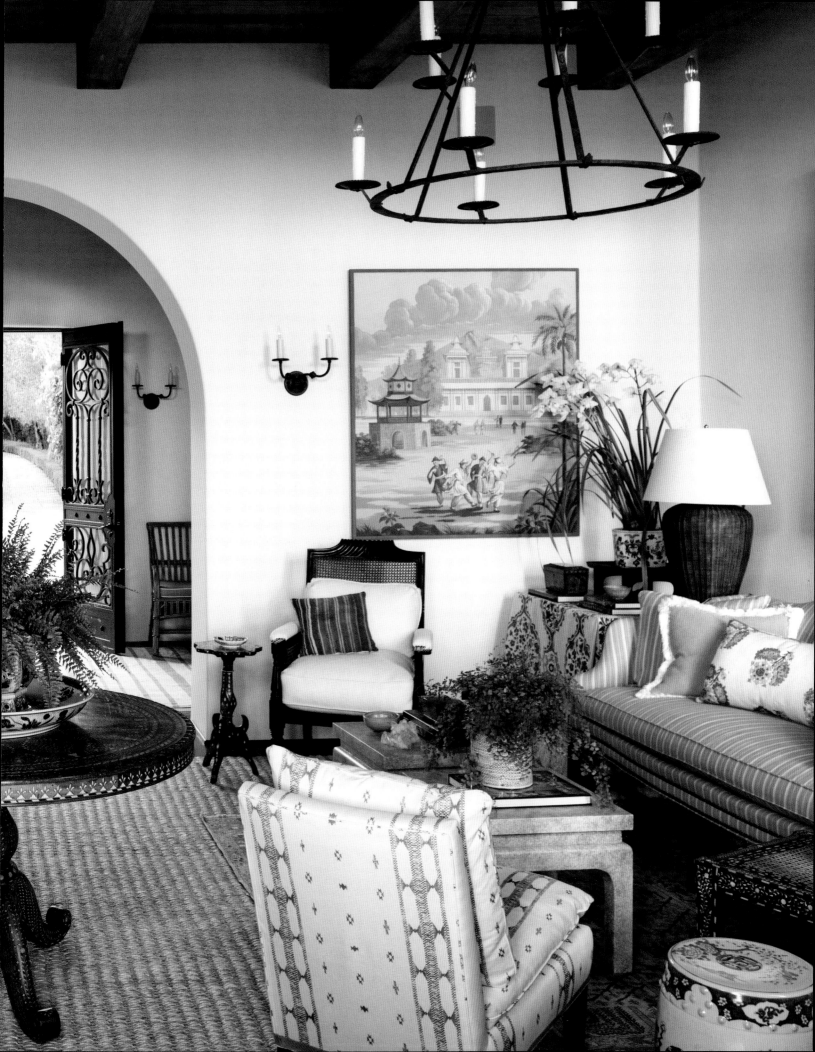

3

CARPETS

AAMIR KHANDWALA

Antique carpets introduce a sense of refinement and sophistication to a space. These unique pieces, often decorated with richly detailed patterns and vibrant colors, are more than mere floorcoverings—they are beautiful works of art. They possess a transformative ability to elevate a room into a meticulously curated and culturally enriched environment.

The 1905 Persian Kirman rug in my own bedroom, with its beautiful floral design, offers solid proof of this theory. I feel as if I'm walking in a beautiful garden every time I step on it!

One of the primary advantages of integrating antique carpets into interior design is that each is unique, with its own story and provenance. Unlike mass-produced contemporary rugs, antique carpets bear the indelible marks of skilled craftspeople and tradition, reflecting the cultural nuances and artistic conventions prevalent at their origins.

Using antique carpets is sustainable and eco-conscious. By opting for these vintage and antique pieces, designers and homeowners reduce demand for new materials while preserving cultural heritage.

Furthermore, from a practical standpoint, antique carpets offer durability and longevity. Crafted using traditional weaving techniques and high-quality materials, these rugs have withstood the test of time and can endure further with appropriate care. Their inherent resilience renders them a pragmatic choice for high-traffic areas, where they not only enhance visual appeal but also fulfill a utilitarian purpose.

Because antique carpets feature a diverse array of designs and motifs, they seamlessly blend into many design styles. The intricate floral patterns in a Persian rug, geometric shapes in a tribal kilim, and symbolic motifs and muted colors in an Oushak rug harmonize with a broad spectrum of aesthetics. One can place an antique carpet in a modern interior, a mountain chalet, or a beach home. These timeless pieces serve as a valuable addition to any discerning design scheme.

The furnishings and art in this New York City home reference the homeowner's favorite places:
New York, Paris, Morocco, and California. Underfoot, a circa mid-twentieth-century Oushak rug features blush,
gold, salmon, and green tones, creating a soft foundation for the room's invigorating palette.

4

MIXING TEXTURES

ALEXANDRA PAPPAS + TATYANA MIRON AHLERS

[Pappas Miron]

A successfully designed room delights and excites all the senses. The eye moves around the space, taking in different details—the shape of a sofa, the way the light glimmers on a glass table, or the soft folds of drapery rippling in the breeze through an open window. Texture is an especially important component in our interiors, a key element in creating the magic of a beautifully designed room. There are a few ways to achieve a texturally interesting interior: combining various hard materials, such as wood, glass, and stone; using different fabric types, including velvet (cotton, mohair, silk), wool, silk, and linen; and mixing the lighting, from lamps that cast soft light to focused art lights, overhead chandeliers, and more practical task lighting. All these elements create an artful and interesting design.

When approaching the design of any room, consider the envelope first. Look at the architectural elements: flooring, walls, doors and door hardware, cabinetry, windows, and ceilings. Of course, also consider the location of the home and the needs of the residents. These all contribute to the direction of the design and the material and furniture selections. A typical room has stone or wood flooring, sheetrock walls, windows, and a sheetrock ceiling. If we're lucky there are vaults, beams, moldings, huge windows, or other exciting details to play off, but most of the time we are given a box. It's easy to enhance basic elements by layering area rugs on floors and installing wallcoverings, hand-troweled plaster, or glossy lacquer to the walls. Windows are dressed with drapery (or shades) and floors warmed up with area rugs, velvety carpets, or natural seagrass or sisal. The key to a thoughtfully designed room is the mix of all of these elements, the balance of hard and soft, rough and smooth.

To build a texturally interesting room, make an initial selection, like the floor covering, wall treatment, or drapery, and build from there. For example, start with the rug. Is it old, worn, and wool like an antique carpet, or is it a quiet backdrop of seagrass or jute? Perhaps the floors are stone or concrete and you need to add some warmth and a dose of something cozy—then a delicious mohair or high-pile Beni carpet is just the thing. The idea is to create balance and to establish a conversation between all the elements.

Furniture also should vary in scale and style; some pieces should be fully upholstered, while other pieces should have wooden or metal elements (think of an upholstered mid-century Italian chair with wooden legs). Fabrics should vary. Some should be smooth, some rough. Others—a cashmere or a mohair velvet, for example—should invite you to touch them. Drapery can contribute color, but also movement, light filtration, and sound attenuation.

Much like building a stylish outfit, mixing textures in an interior is the key to creating an artful and exciting space.

Opposite: In this Brooklyn living room, mottled lime-washed walls in a deep mallard are a moody canvas for a sculptural settee and marble-topped oak occasional table. Following pages: A substantial mohair velvet sofa harmonizes with the wall tone. The eclectic textural palette conjures visual intrigue—a matte-lacquered vintage coffee table dialogues with cork-and-wood side tables, pottery lamps, and a plush shearling pouf.

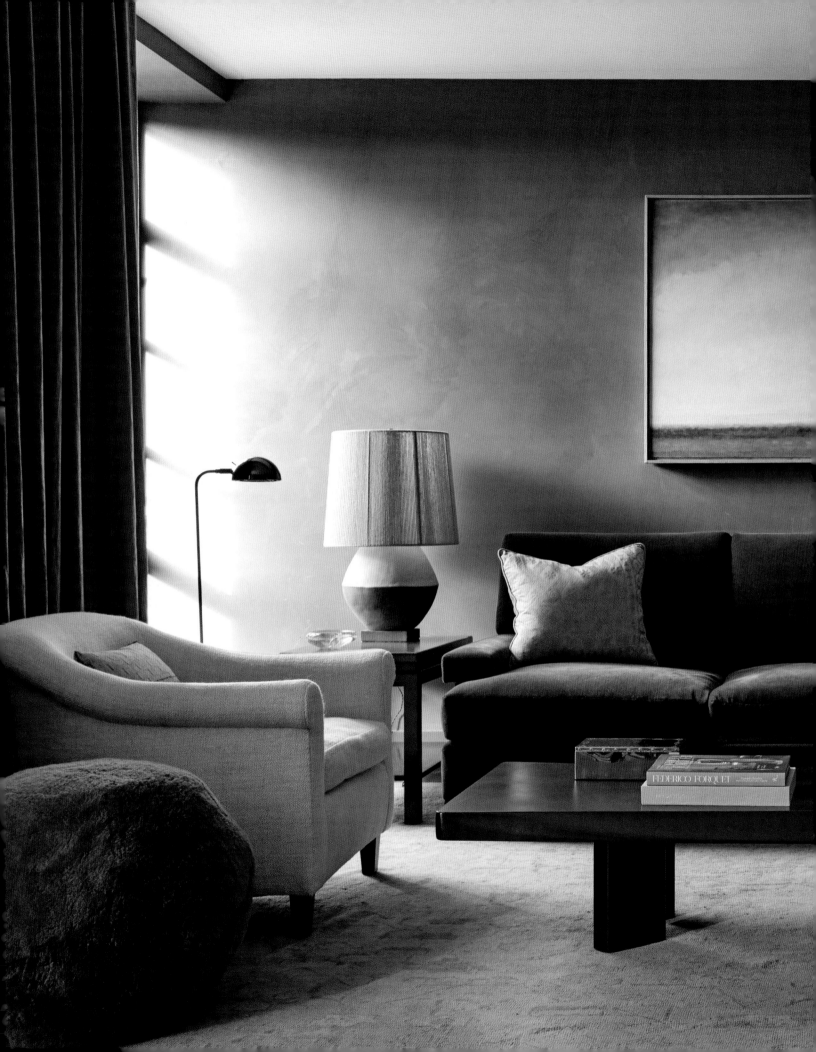

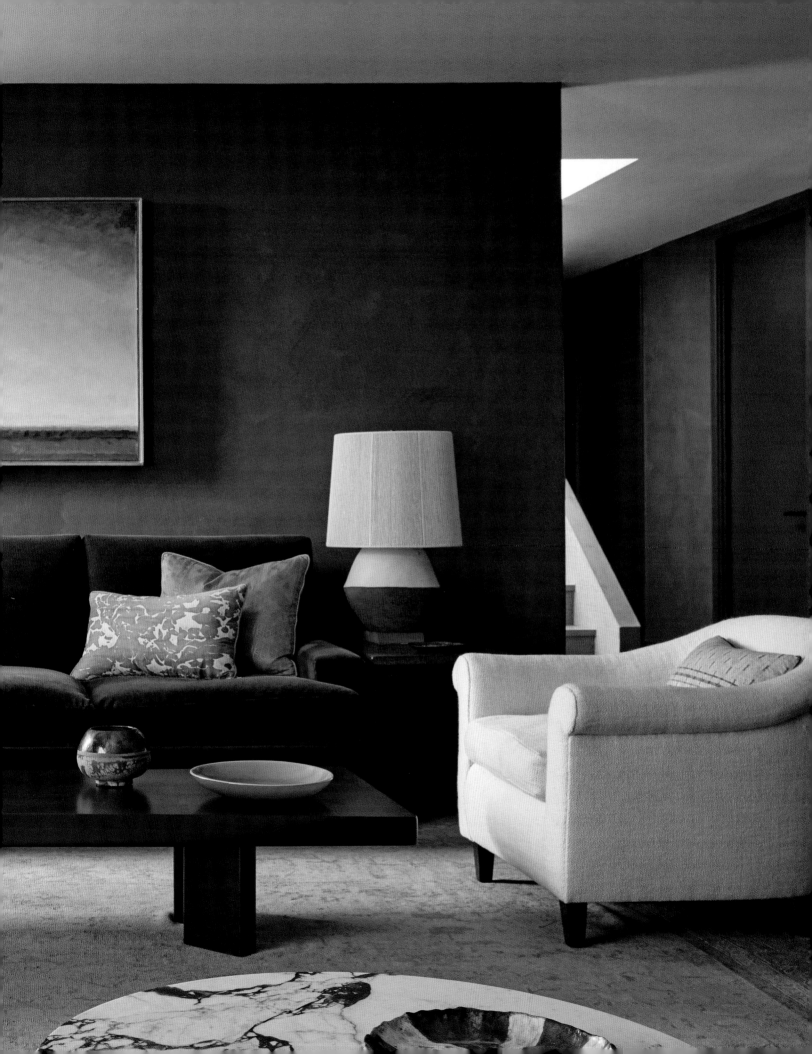

5

SUSTAINABILITY

VICKY CHARLES

[Charles & Co]

Sustainable design relies on practices that do as little damage as possible to the environment, but it also focuses on spaces and pieces that are timeless and well-made and can last for years. Designing sustainably means eschewing fleeting trends and working toward the greater good. These two sides of the sustainability coin complement each other, like hues on opposite sides of the color wheel.

Reduce, reuse, recycle. Incorporate antiques and reclaimed elements, such as wood and stone, and even recycled fabric. This tactic can be applied to everything from furniture to flooring. The results are stunning, and they need not read as rustic—there are beautiful durable materials available in all styles. There was a time when furnishing a space meant shopping for new items. Now we often reimagine a client's existing pieces through reupholstery or refinishing. Shaping what the client already owns makes a space feel personal and customized in a way that starting from scratch rarely does. Antique and vintage pieces lend warmth and depth, and each tells a story. Their patinated surface speaks of lasting quality, and traditional joinery techniques such as dovetail joints and intricate inlays on antique items have already proven to stand the test of time. Layering antiques into a contemporary design is as interesting as it is environmentally responsible.

Think globally and act locally. Artisans also play a key role in sustainable design for bespoke spaces, and that's nothing new. High-end designers have always collaborated with skilled craftspeople. These days, we look around for local artisans and businesses. That way we contribute to the community and reduce the carbon footprint stemming from long-distance transportation. Eco-friendly materials such as low-VOC paints and energy-efficient windows and other items tamp down environmental impact and position clients to respect their communities and the planet.

Opposite: This Los Angeles sanctuary's sumptuous teal velvet sectional invites fireside relaxation. Reclaimed oak floorboards and a timeworn rug ground the space. Following pages: In this modernist interpretation of farmhouse style, architect Howard Backen employed board-poured concrete walls that echo wooden planks but have a smaller environmental footprint. Vast windows illuminate a clean-lined table and campaign chairs in the airy dining space.

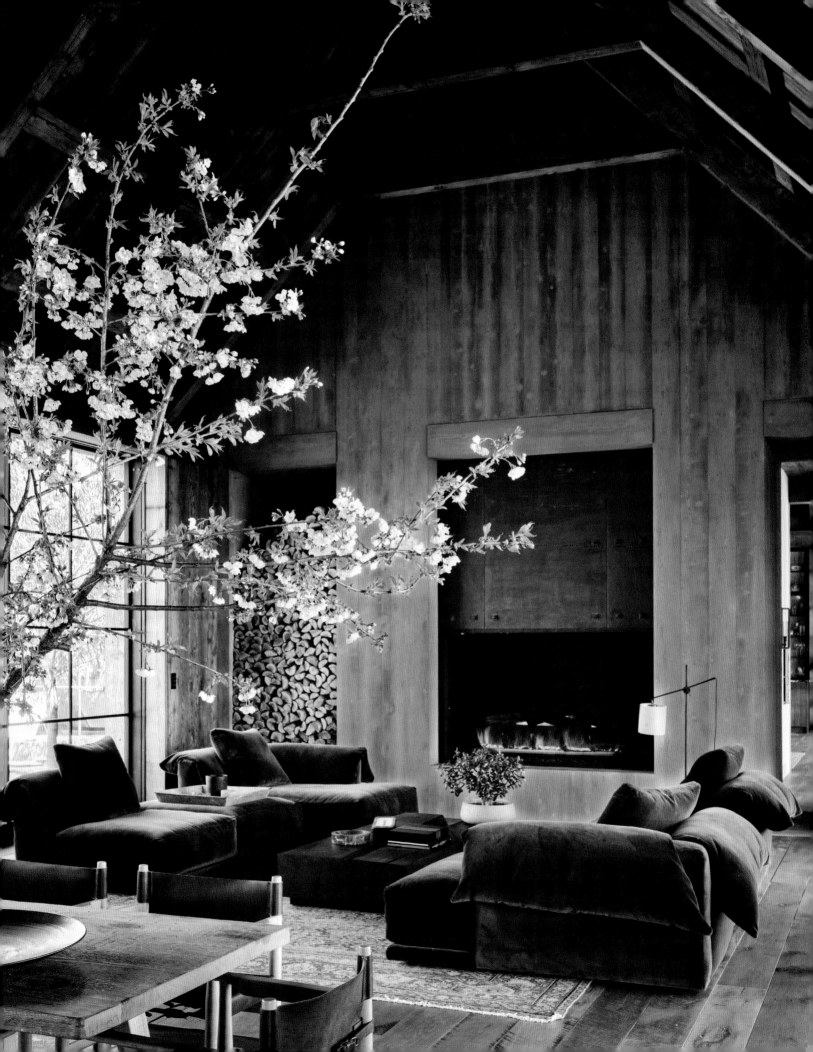

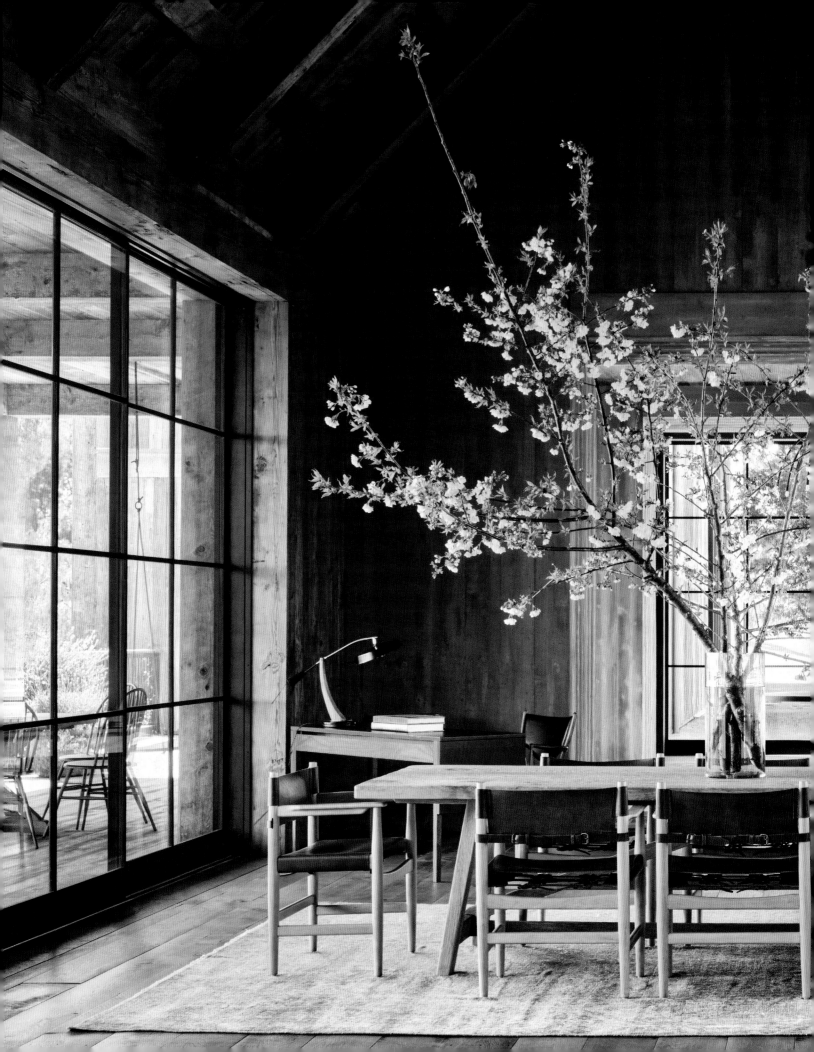

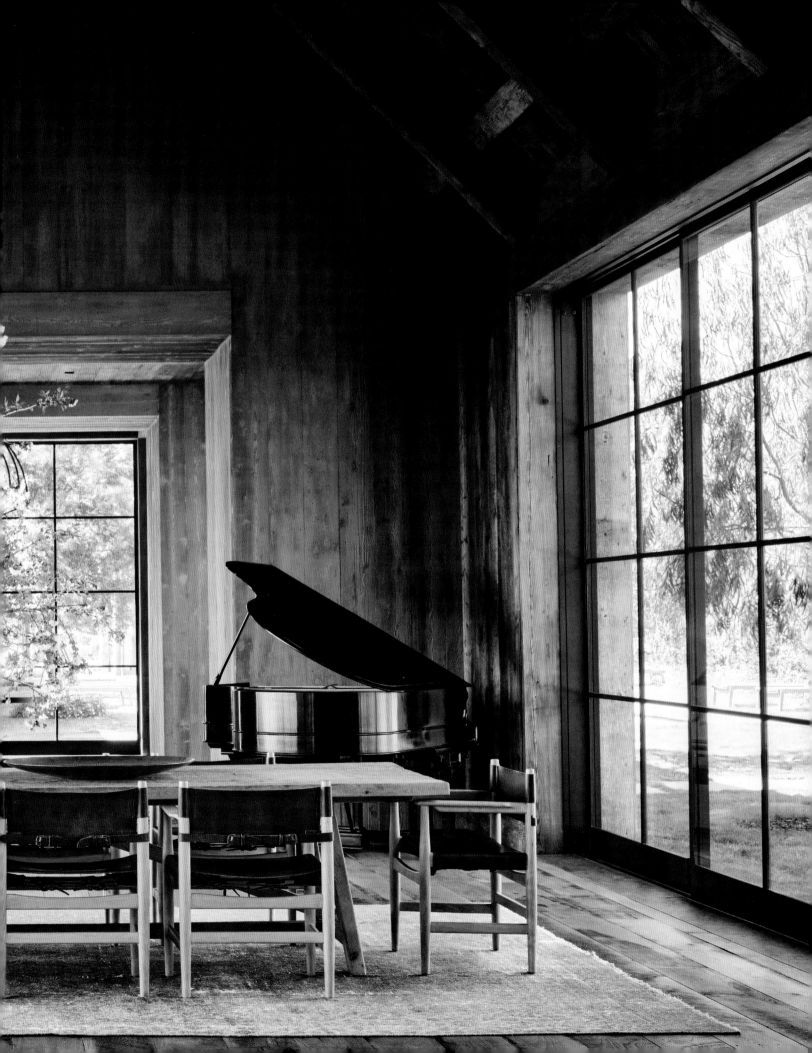

6

PATINA

SHAWN HENDERSON

With their aged and weathered appearance, patinated surfaces—oxidized oak, tarnished brass, and care-worn marble—add warmth and depth to an interior by lending a sense of history. These finishes evoke a lived-in, cozy atmosphere, making spaces feel inviting and comfortable. The subtle variations in color and texture that develop over time enhance the richness of materials, giving rooms a timeless quality. This natural wear aligns with my design philosophy, which values authenticity, comfort, and the beauty of imperfection.

Patinated surfaces reveal human interaction, as each mark, softened edge, and change in texture reflects use and care. These signs of life imbue a space with warmth, telling stories of the past while adding a comforting quality that enhances the overall ambiance of a room.

However, there are some rules to follow when introducing patinated pieces. First, don't be afraid to mix antiques, vintage pieces, and contemporary furnishings; together, they make a room feel curated, with a layered look that reads as personal and collected rather than overly staged. That said, be careful of the number of time-worn pieces you choose for your home. Too many distressed finishes can leave you feeling like you're living in a ruin, or worse, in a museum.

Mixing patinated metals like zinc, copper, and brass in a well-designed home adds to a rich, layered aesthetic. Some might find that counterintuitive, but each metal brings its unique tone and texture; the blend of cool and warm hues fosters a balance that reveals itself slowly over time as you live in a space.

When considering your home's architecture, remember that older houses benefit from weathered pieces because the architecture and furnishings share a historical context, creating cohesion. Antiques complement the craftsmanship and character of older homes, enhancing their charm and preserving the integrity of the design. This harmony between structure and decor makes the space feel more naturally integrated. Conversely, adding antique or vintage pieces to a modern house can soften contemporary spaces—especially when pieces are mixed throughout the rooms.

One final thought: avoid synthetically patinated furniture, as it lacks the genuine character and depth of naturally aged pieces. These artificially aged items can appear contrived and inauthentic, undermining the integrity of a room's design. Opting for genuinely worn or naturally patinated pieces ensures a sense of timelessness.

Opposite: The parlor in this antebellum Mississippi mansion swirls with patinated furnishings, including a nineteenth-century chandelier and gilt mirror. In an homage to the original craftsmen, the mantel's trompe-l'oeil marble finish was restored. Following pages: A campaign bed, René Gabriel chairs, and a leather wingback form a vintage tableau. Printed linen curtains in a Rose Cumming pattern honor the home's period heritage.

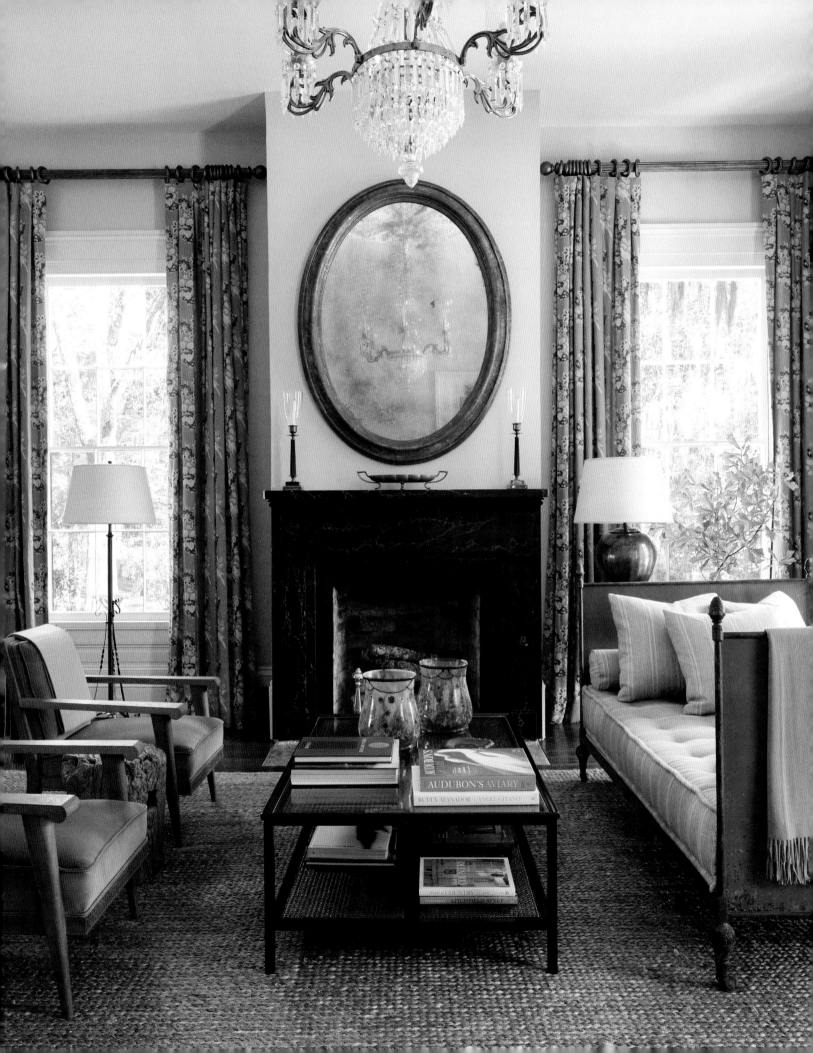

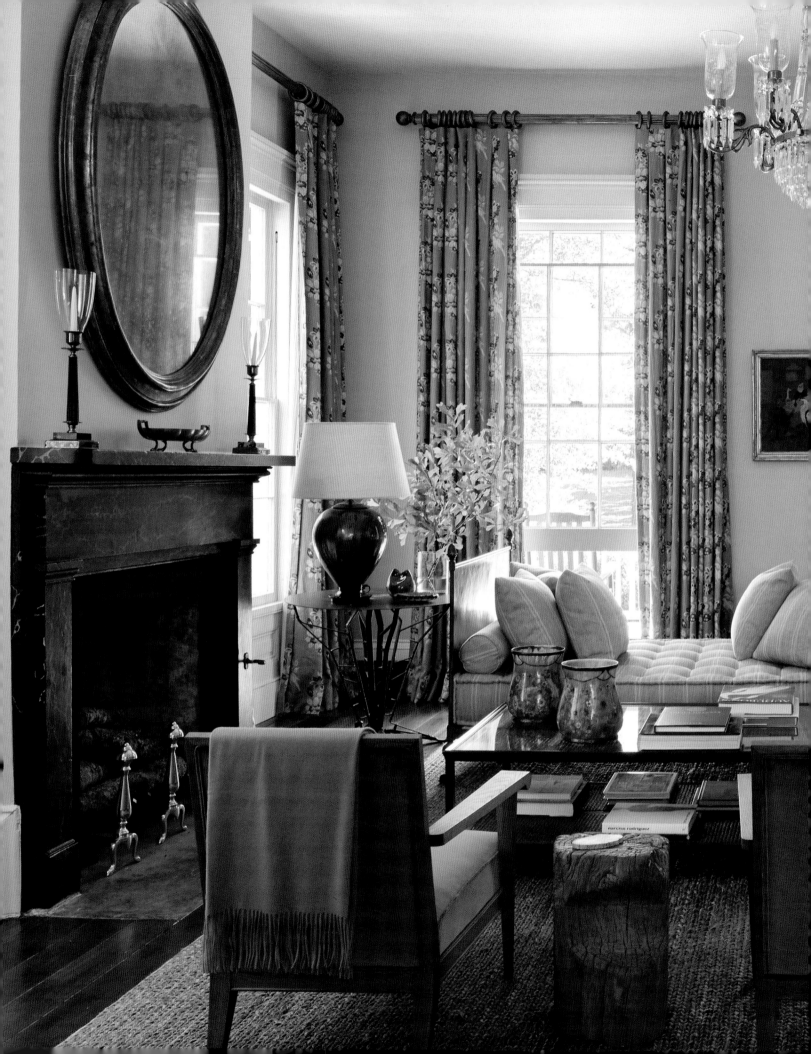

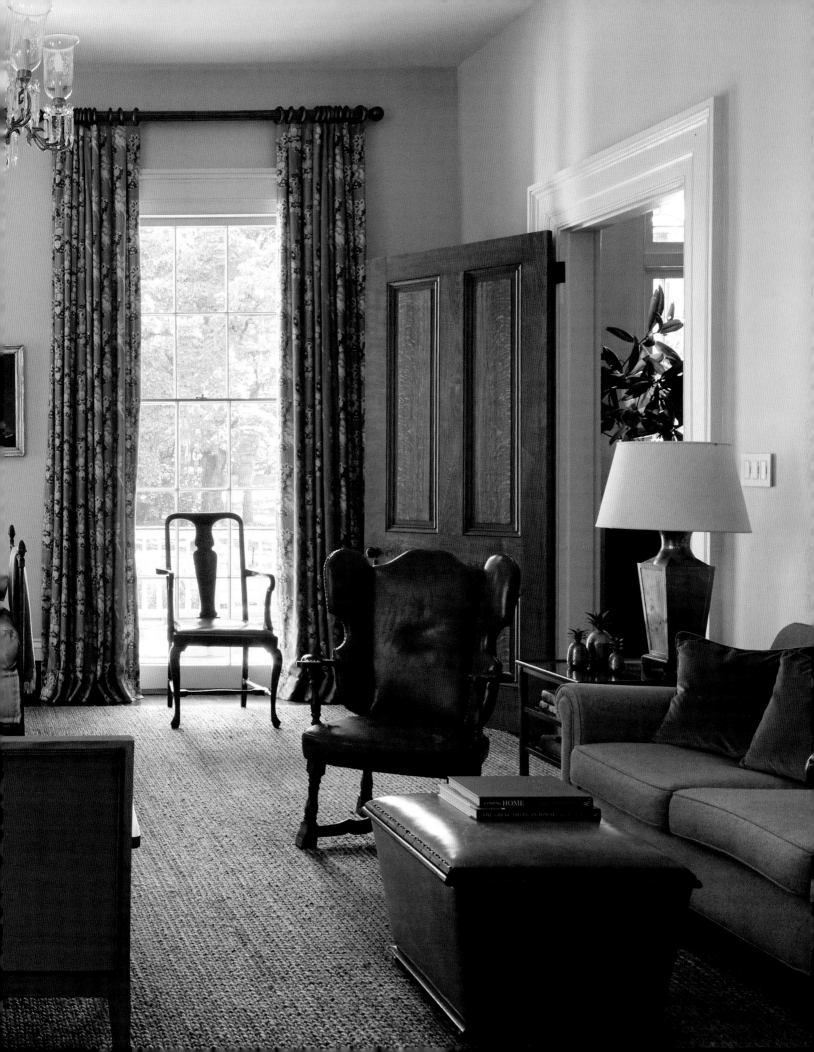

7.

SEATING

KEVIN DUMAIS

I love chairs. My husband, friends, and family have a running joke that I can't stop buying them in pairs. I might be the only designer who doesn't follow the rules about featuring odd numbers of items. I tend to gravitate toward pairs of everything I love to collect, so I source pairs of chairs at every opportunity around the city and during my travels. It's a welcome pleasure to write about a topic I hold dear.

When I start fresh with a new room, my team and I first look at the floor plan and function of the space—be it a family room or formal sitting room—which informs the scale of pieces we select or design ourselves. Much of the time we customize sofas to fit perfectly. Then we anchor them to focal points within the room, like artwork, fireplaces, or entertainment centers. This creates intrinsic cohesion, movement, and flow tailored to the room's function. For instance, a family room that revolves around a television requires low, deep seating for lounging, while a formal sitting room designed for conversation calls for more upright seating.

Comfort, of course, is a top priority. Comfort is all about the depth, fill, and materiality of a sofa or chair—paired with the singular harmony that comes from having ideal proportions of all elements within a space. Ease is achieved when things are perfectly in their place. Everything else comes down to personal preference and anatomy, with variables including everything from seat firmness to armrests to back support.

Address comfort and proportion in a holistic manner through the lens of style: palettes, materials, and references guide visual design. My personal style is influenced by mid-century modernism paired with a contemporary approach and deft use of color that feels livable. All of this is then adapted to the client's way of life and existing architectural details. Of course, no home exists in a vacuum; location also feeds into design. A SoHo loft required rich hues and deep, low-profile seating. A beach home in the Hamptons called for lightness and a conversational spatial plan. A Tribeca apartment needed minimalist daybeds and vintage tubular mid-century chairs.

For me personally? I like to end the day in a 1950s Bauhaus-style lounge chair found one weekend in Hudson, NY. There's warmth to the patina of the chrome frame and Bakelite armrests, the seat is low and pitched, and it has a generously high back, upholstered in leather and shearling. It feels like home.

Drawing inspiration from mid-century Italian design's innovative approach to comfort, this media room showcases a thoughtfully conceived sectional that embraces the square space by spanning the perimeter. Varied throw pillows make it even more inviting. More seating comes in the form of plush floor cushions that pick up the hues of the artwork and light fixture.

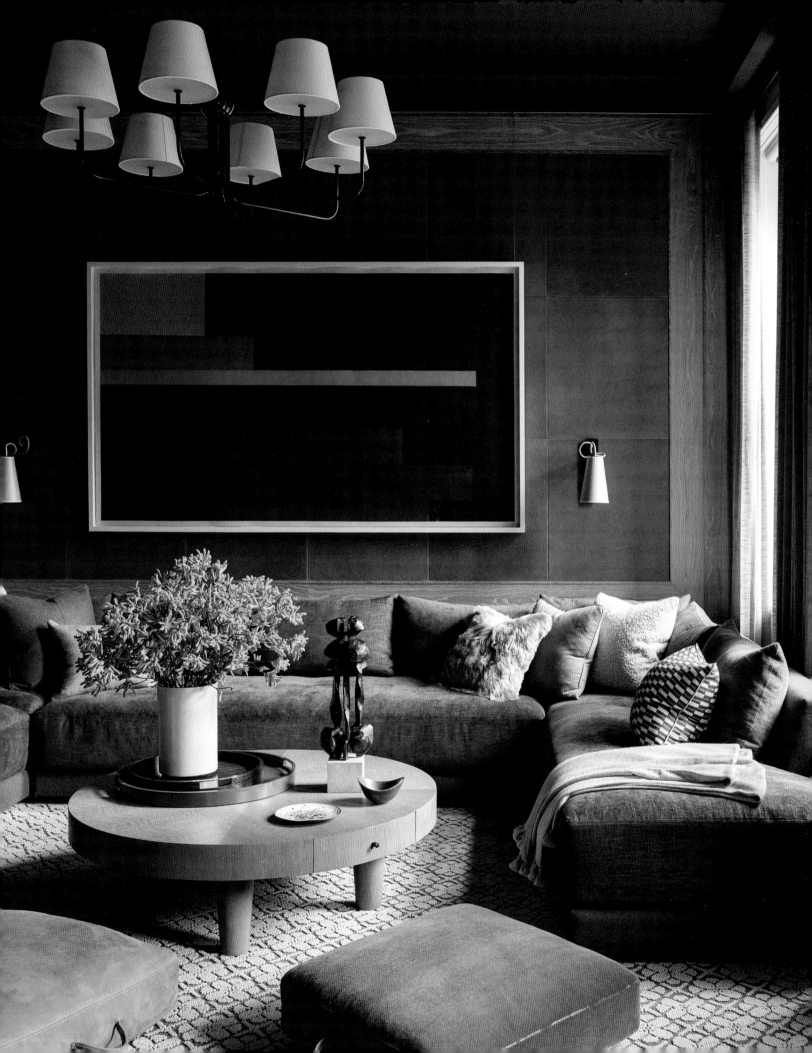

8

ACCESSORIES

ALAN TANKSLEY

Accessorizing takes many forms encompassing everything from arranging a single tabletop to styling an entire home. However, there are certain principles that always apply.

A minimalist approach means using fewer items of visual and/or personal importance, each having the presence and stature to anchor its surroundings. Keeping the surrounding area clear—without the distraction of items nearby—and raising the esteemed object on a stand projects a strong pride of place allowing it to draw the attention it deserves. In cases where no single item has a commanding presence, try arranging a tight cluster of like-minded objects. Collectively, they will have more presence than any individual piece—the grouping being greater than the sum of its parts.

Choose items of varying heights to create visual interest. Try raising similarly scaled items on individual stands of differing heights. It's often helpful to select the single most prominent piece to serve as a focal point. The classic approach is to center this piece and work outward and downward from it. Alternatively, the focal point can be moved off center with objects spilling asymmetrically outward along the surrounding surface.

Arrange open sightlines, giving the human eye a place to rest. Accomplish this by staggering items, placing pieces of differing heights and materials close to each other while leaving empty space here and there.

In any case, whether displaying a collection, such as a family of Murano glass vases; a gathering of disparate elements varying in scale, themes, and materials; or calling attention to a special keepsake, keep in mind that there's a fine line between thoughtful composition and clutter. Accessories need breathing room in order to shine.

Opposite: Tucked into an alcove, a dining ensemble basks
in natural light softened by semi-sheer textile shades.
Following pages: Curated treasures engage in dynamic dialogue.
Knowing when to let a star shine on its own is key.

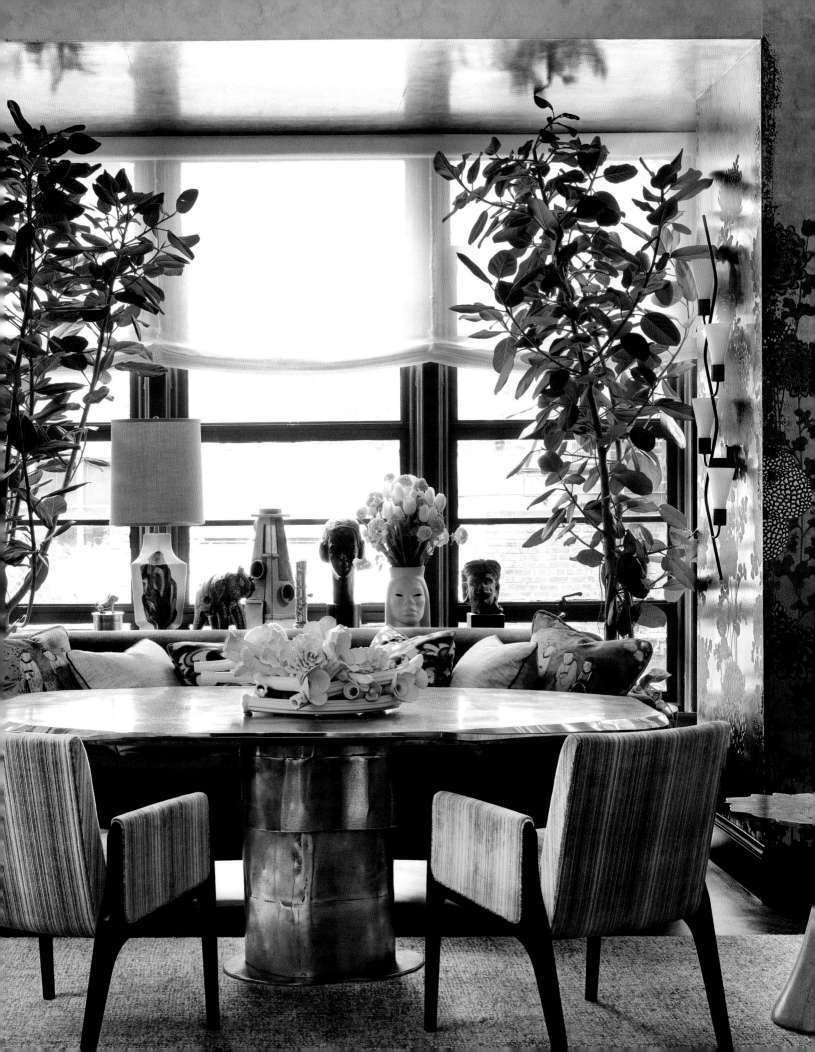

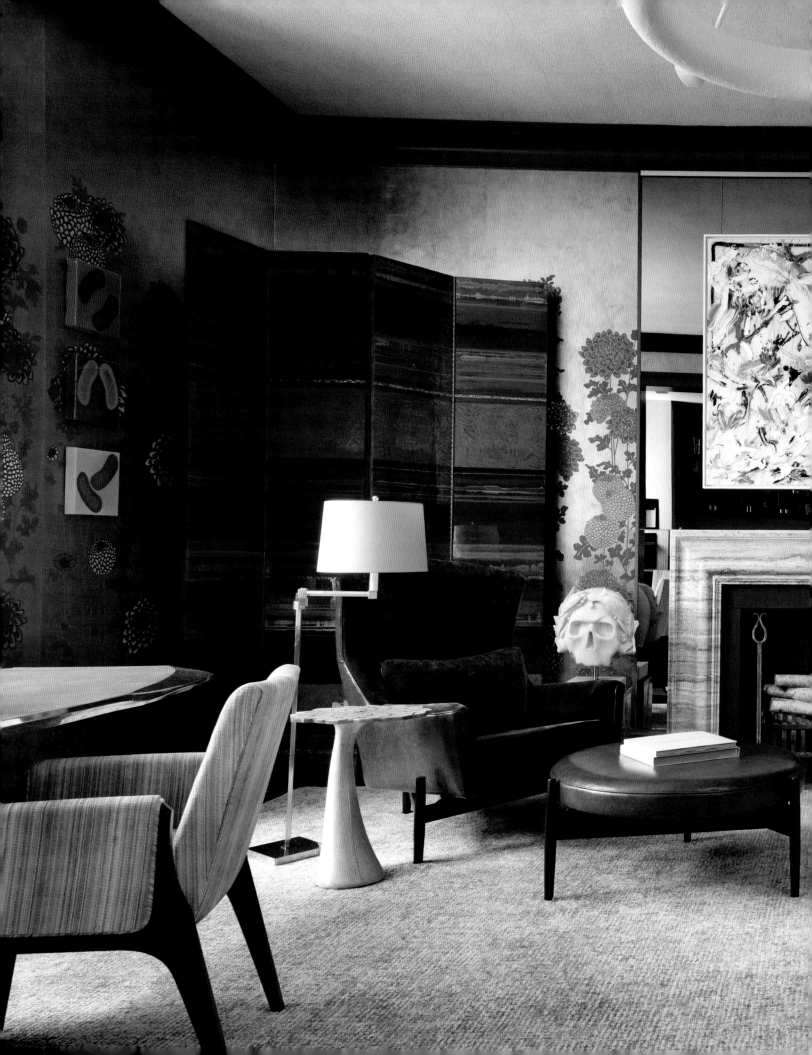

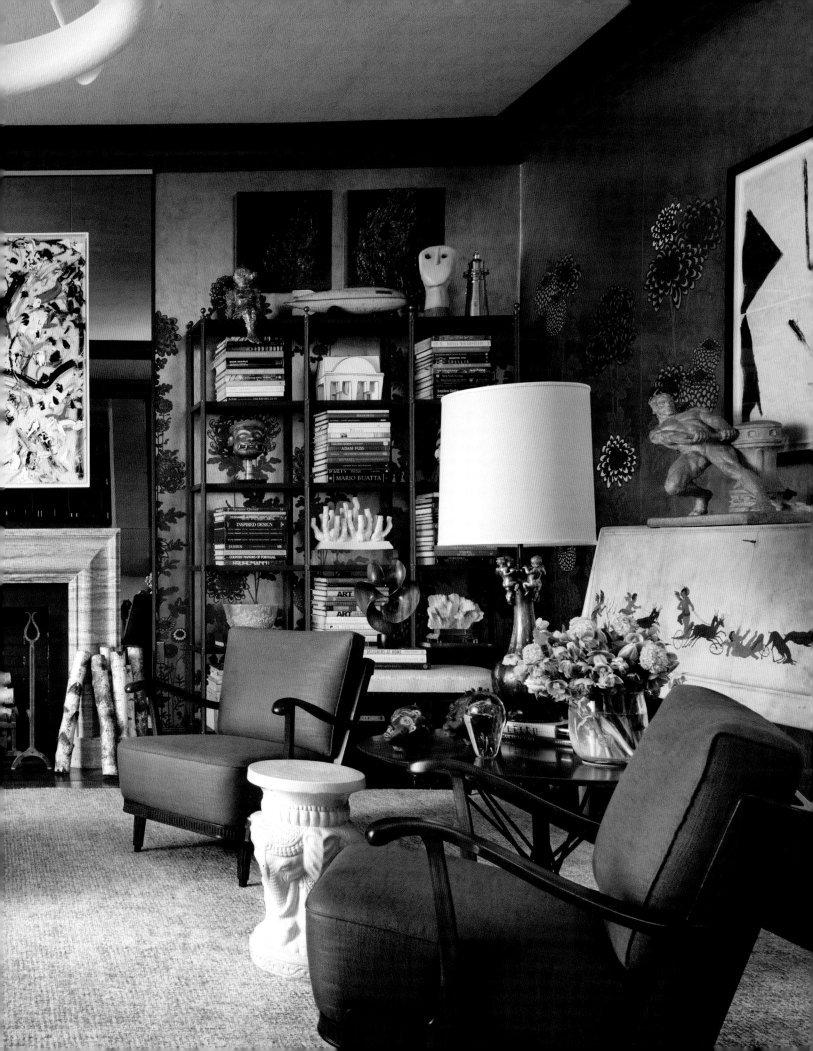

9

GEOMETRY

DAVID RIES

[Ries Hayes Interiors]

Designing interior spaces that convey peace in an urban setting is quite challenging. With increasing frequency, clients request homes that serve as escapes from the chaos just outside their doors. By harnessing the inherent properties of geometric forms, my colleagues and I are able to craft spaces—from individual rooms to entire homes—with a sense of order to give clients the stability they crave.

Textile design can tap into the power of geometry. Forms such as circles, squares, rectangles, and triangles, printed or woven into fabrics, have strong impact on design. Geometric patterns can also be incorporated into architectural elements, such as wood and stone. Along with being beautiful, these shapes, and their relationships to each other, infuse a room with balance and harmony.

Repeating a shape once or twice in the same room hammers home this concept. An example would be designing pillows with rectangular embroidery and then selecting a fabric for draperies that also features rectangles. Repetition of geometry strengthens the form and the energy it provides.

A single design element or feature is equally adept at grounding a space. For instance, if the design direction calls for a tranquil gathering space, I often employ an oversized, solid light fixture with a circular shape. Circles represent unity, integration, and wholeness. The weight and impact of the fixture hanging overhead sets the mood for everything below it.

Geometry is also expressed through furniture layouts and shapes. Symmetry can impart equilibrium, but finding order and completeness in asymmetry can also be rewarding.

I often rely on the golden triangle, a mathematical proportion found in nature and art, to create visually pleasing and harmonious compositions. This compositional technique involves arranging design elements along imaginary triangles, creating a pleasing flow for the eye while maintaining open and unobstructed surrounding space. I often use this method when arranging objects on a coffee table. Adherence to this principle grounds a space and provides a feeling of cohesion to those within it.

Although not always understood consciously by the naked eye, geometry creates a visual symphony. Plainly speaking, it establishes a rhythm that makes people feel good. Geometry lives at the heart of successful design.

An Alice Neel masterwork against plush Ultrasuede walls commands attention in this Park Avenue sanctuary. The space achieves harmony through circular motifs—from the overhead fixture to the ottoman and end tables. Even the carpet bears a subtle curve. A bespoke sectional in Cowtan & Tout fabric completes the sophisticated composition.

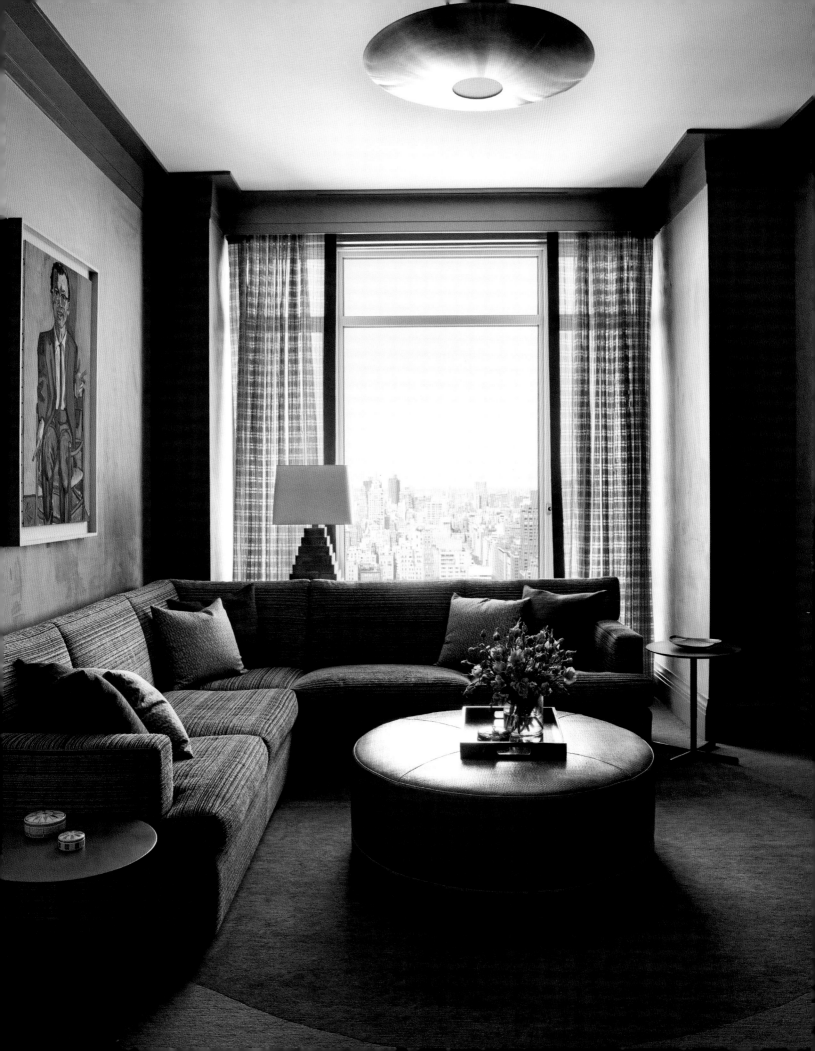

10

COLOR BLOCKING

ASHLEY LAVONNE WALKER

Opposites attract. The adage is certainly true when it comes to color blocking, although color blocking is more than just pairing contrasting colors—it demands skill and discernment akin to that required for composing music. Like notes in a symphony, colors must be understood individually and in relation to others to create harmonious compositions.

Central to discussing color is the color wheel, a tool that organizes colors based on their relationships. It starts with primary colors—red, yellow, and blue—and expands into secondary and tertiary colors, offering a spectrum of saturation and intensity. This foundational framework illustrates the relationships and boundaries of the most common hues.

When colors are isolated and combined, their potential to influence perceptions and emotions becomes evident. Artists like Piet Mondrian and Le Corbusier used color blocking to create balance or tension in their works. Color theorists such as Johannes Itten further developed these concepts by analyzing how different color combinations impact our visual and psychological responses—how one color can be made to appear more blue or red by just switching its surroundings.

Ultimately, color is not just a visual spectacle but a fundamental aspect of sensory experience that enriches our connection with our surroundings. By experimenting with different palettes, designers can craft unique atmospheres, whether it's a tranquil, serene environment or a vibrant, energetic one. In essence, color blocking is not just about the selection of hues but about arranging the interplay of colors to create spaces that are both visually captivating and emotionally resonant.

A curated color palette in discrete sections unfolds in this inviting family room, where a tailored sofa in contrasting fabrics is tucked into a windowed alcove. A sculptural ochre pendant illuminates the thoughtful composition, revealing layers of visual interest; the similarly hued area rug defines the space.

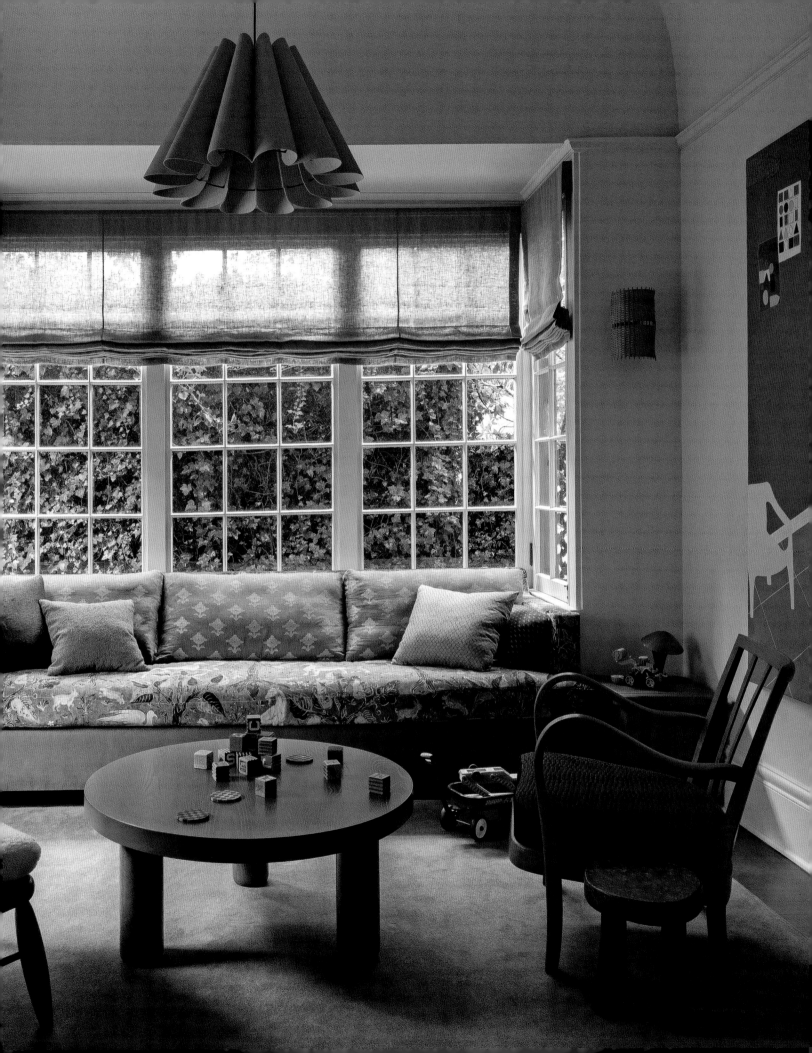

11

LARGE-SCALE PATTERNS

LUCY DOSWELL

Large-scale patterns give a room energy and command attention. They can create a moment of whimsy, or add drama to make a space feel dynamic and extraordinary. Take Sister Parish and Albert Hadley's classic design for Brooke Astor's library. On the sofa and chairs the designers used a vividly striped Brunschwig & Fils La Portugaise fabric that popped against red lacquered bookcases, making the room memorable and striking. The genius of Parish and Hadley is evident in the way they infused a bold pattern into a room with proper restraint, so that it didn't feel loud or jarring.

A brave choice gives space for character and life. Don't get me wrong; there is always a place for layered and thoughtful neutral rooms. However, adding elements of pattern and color can expand your space and transport you (and your guests) to a place of comfort and warmth. Using bold wallpaper can make a room look much bigger in size than

it is, almost like shooting it with a wide-angle lens. That's because large patterns and striking colors draw the eye, giving the illusion of a grander space. Try an oversized pattern in a small room to make the most of the ceiling height and create a jewel box effect. To maximize this, choose a design with depth or perspective, which will also trick the mind into seeing beyond the room's physical limits. There are many ways to incorporate large-scale motifs, whether through wallpaper, fabrics, carpets, or artwork. The key is to ensure that they add dimension and personality to the home in a way that complements other elements instead of overwhelming them.

My advice for those considering taking the bold route is this: why not go big? Find a pattern you love and build around it. Take time to source things that make you happy and bring you joy. Don't be afraid to make the daring choice.

Stylized peacocks, articulated in brown and white, meander across the walls of this
New York sitting room within an oversized graphic pattern of juxtaposed shapes. The floral chintz injects
another large-scale pattern into the space. Shades of lavender, garnet, celadon,
and pale blue add to the dynamic flair. The neutral low-pile carpet grounds the room.

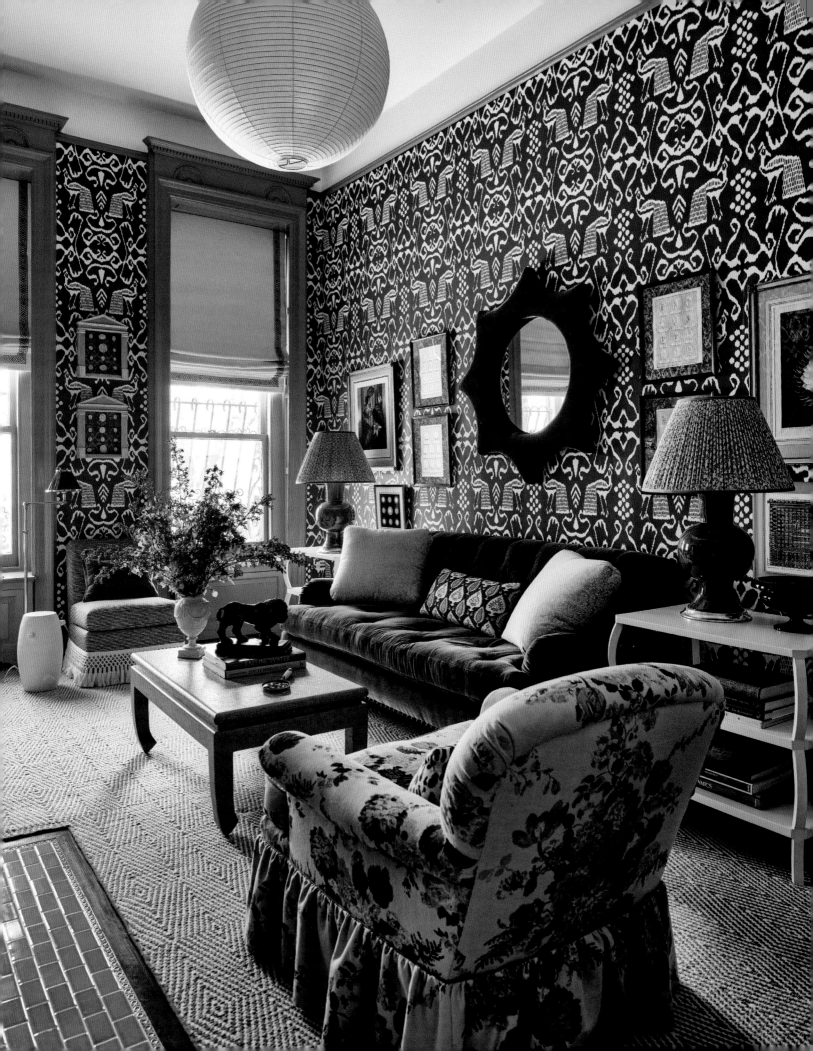

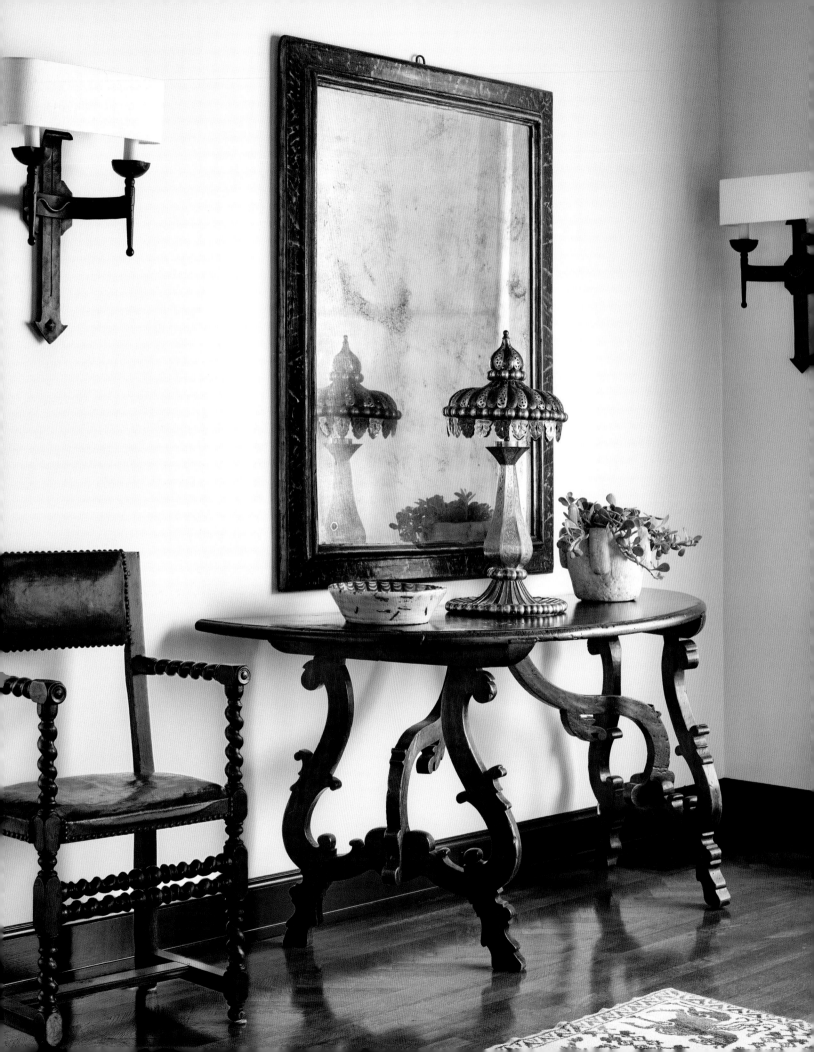

12

CALIFORNIA

MADELINE STUART

California. The word evokes a vision of beaches, mountains, deserts, and sunshine. There's the California Girl and the Hollywood sign, the redwood forests, and the Golden Gate Bridge, the endless line at Pink's Hot Dog stand, and the missions that dot the coastline. The defining nineteenth-century directive that counseled "go west, young man" still prevails.

There's also the light—grey-tinged on a hazy day in Los Angeles, ferociously bright and bleaching in Mojave, sparkling and effervescent by the ocean. The light changes after a rain—it's richer and more vibrant. The foggy mist of San Francisco subdues the light, and the intensity of the sun in Malibu washes out the vibrancy of certain colors.

Then there's the scale: the Spanish-influenced haciendas and grand mansions built by those who made their fortunes elsewhere and emigrated here. California offered the luxury of space. New Yorkers had their fabled apartments, but in the Golden State, you could reinvent yourself and build accordingly. The neoclassical Casa Encantada by James Dolena and T. H. Robsjohn-Gibbings in Bel Air, San Simeon, or furniture that takes on the epic proportions of a Michael Taylor–designed sofa.

To those who live in the Golden State, the notion of "indoor-outdoor" inspires a specific approach to architecture, interiors, and furniture. The seamless transition from interior to exterior has influenced generations of designers and helped establish the California look.

Elaborate window treatments look incongruous here. Velvet draperies may keep out the cold back east, where sheers and linen panels diffuse the brightness of the western sun.

There's a sense of place in California, where the mountains frame the sky, and the sun sets into the ocean. The light is the thing. It's poetic even on the gloomiest of foggy afternoons. Up and down the state, the light embraces and refracts, seduces and reveals, warms and cools. If you live here, you know it instinctively and design accordingly.

Opposite: An Italian console, chair, and mirror reflect the West Coast's deep European roots.
Following pages: Channeling California's heritage, Stuart crafted this home with meticulous attention to detail, from the refined ceiling to the thoughtful doorways. A nineteenth-century fireplace is this room's centerpiece, while a 1950s Spanish Prado carpet adds a historical motif. Linen-slipcovered sofas introduce casual Californian ease to the classical composition.

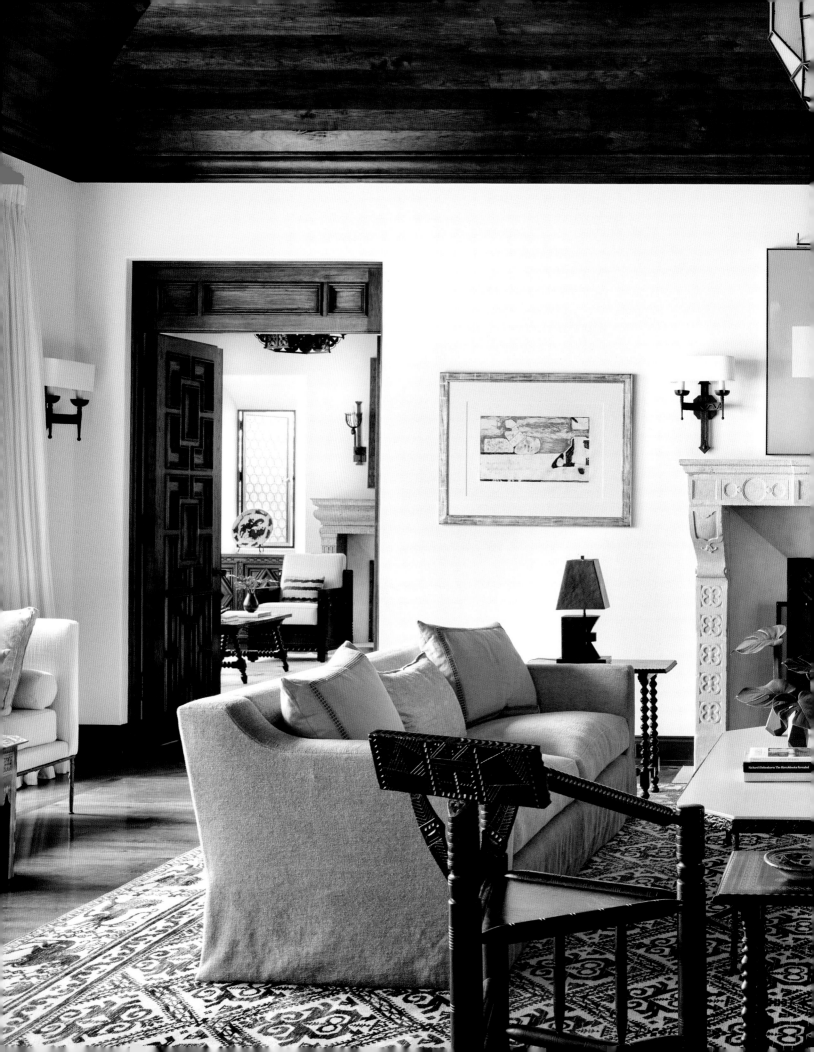

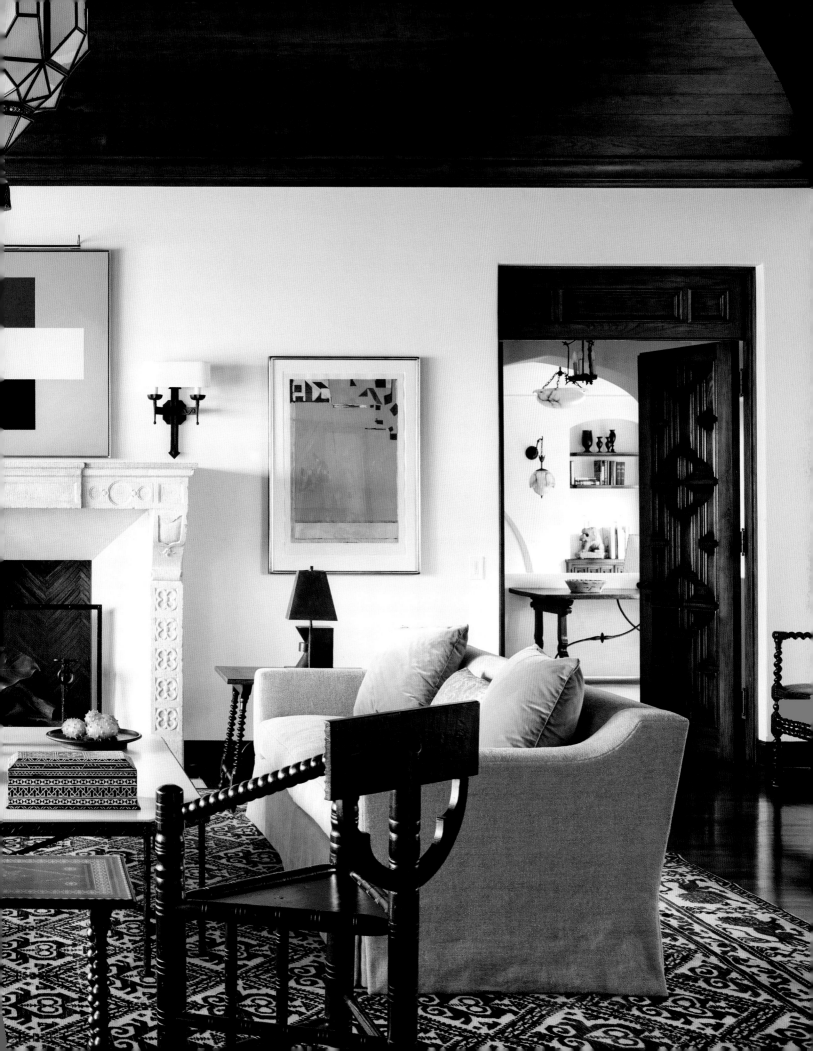

13

LAYERING

HEIDE HENDRICKS + RAFE CHURCHILL

[Hendricks Churchill]

A successfully layered room has a few essential ingredients. It abides by a hierarchy that helps inform the room's function and mood. This hierarchy includes a variety of furnishings, textures, colors, and natural and artificial light—both ambient and task. A concern for balance of scale and size is paramount when considering the delicate relationship among these layers. Yet a room is most successful when it appears as if none of this was deliberately considered.

First, it is essential to understand the use of space. What kinds of activities will be taking place in the room? What time of day or night will the room be occupied? How many people will occupy the space? Is the room multifunctional?

Once the program is established, approach the room from the outer layer and move inward. This encompasses making choices that impact the texture and color of the walls, windows, doors, millwork and trim, paint, wallpaper, and curtains. While these layers can be bold, the relationship between them must always remain delicate and balanced. The walls will become the backdrop that will inform layers of artwork, current and future. For example, the finely etched rhythmic lines of a wallpaper can handle a more graphically contrasting paint color on the trim to bracket the wallpaper's pattern and, eventually, a painting, photograph, or sculpture.

This ultimately creates a livelier backdrop that brings vitality to the room and will successfully anchor subsequent layers.

Then, establish the key foundational pieces that will center the room, whether that be an antique rug that may be layered with a more neutral natural fiber rug or other key foundational pieces—a sofa, armchair, or dining table. When choosing these pieces, it is important to consider which wall to feature. Orienting these key pieces to frame this wall will pull your eye across the room and seduce you into the space.

Once these pieces, site lines, and focal points are established, introducing soft furnishings—pillows, window shades, blankets, and throws—brings in pattern and texture. These layers are less static and can be adjusted to evolve with the room's program throughout the day or as seasons change.

The final layer is lighting. This is the secret ingredient that makes a room sing. Unsuccessful lighting will wash out a room. Successful lighting will not only aid in the activities the room was designed for, but will create a mood conducive to comfort, calm, and serenity. Warm lighting will highlight the richness of the deeply contrasting layers previously constructed through pattern, texture, and color.

When layering, adhering to this hierarchy will help strike a balance between functionality, scale, texture, and mood.

In their Litchfield County, Connecticut, home, designers Heide Hendricks and Rafe Churchill painted all the millwork in the living room a lush moss green. The rich color, repeated in the wallpaper, grounds the expertly curated space. Multiple carpets rest on the original floorboards, and books, blankets, throw cushions, and objet d'art harmonize with proportional balance and scale—the key to successful layering.

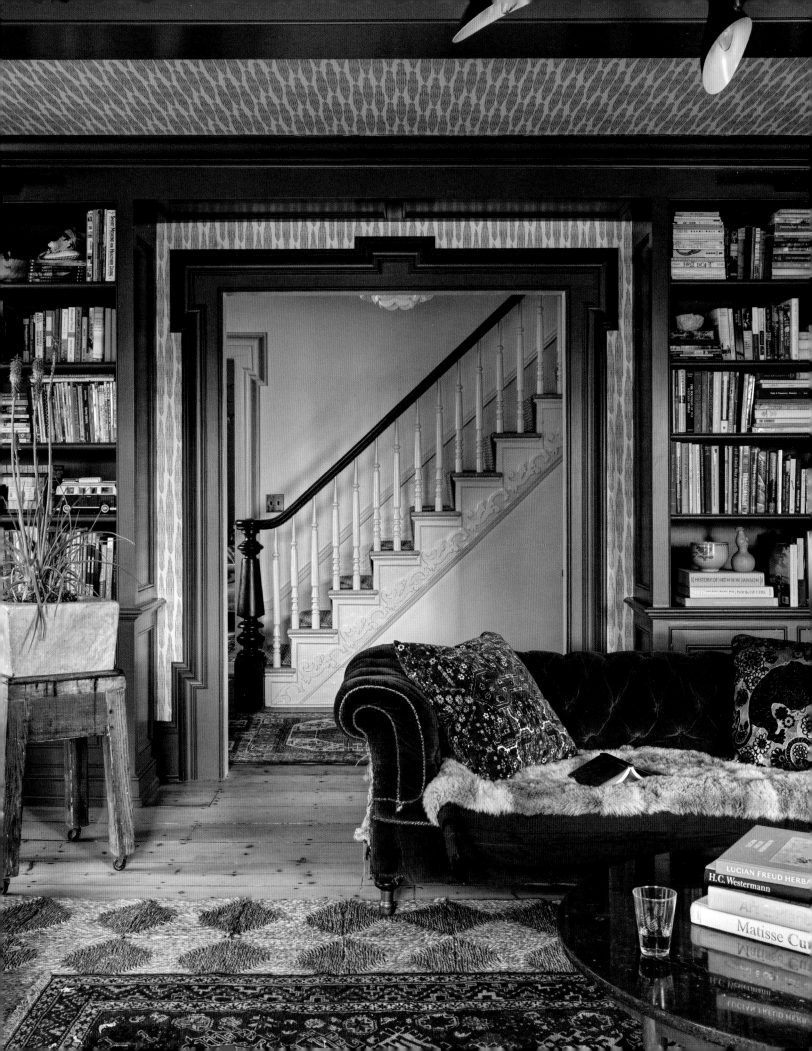

14

PURPLE

OLIVER M. FURTH

There is nothing neutral about nature, and yet there's a common misconception that natural palettes are those with desaturation of pigment. I beg to differ. A walk outdoors reveals nature's humbling rainbow of fauna and flora in abundance, and in combinations that I could never imagine. There is nothing more natural than color.

I have a special affinity for purple. Violet, lavender, periwinkle, eggplant, and puce have worked their way into many of the projects I've designed, and for good reason. Purple (and its familial hues) is an intermediate between red and blue, and it's the only shade that's both warm and cool. Purple plays well with others; it can be layered and enveloping when syncopated with related tones, and it pops beautifully when accenting an otherwise neutral room.

Our fascination with the color purple goes back thousands of years, as noted in Homer's *Iliad* as well as in the Old Testament. Tyrian purple, a pigment made from the mucus of murex snails, was used as fabric dye by the Phoenicians as early as 1200 BCE. The color was used in ancient Rome exclusively for the clothing of magistrates and noblemen. This pigment was expensive and time-consuming to produce; thus, items colored with it became associated with power and wealth.

Today, even though current technology has caught up with demand, purple is still the color most associated with royalty, luxury, and ambition—not to mention the artist formerly known as Prince. While luxurious materials and techniques can sometimes still exude elitism, color today is democratized and free for everyone to enjoy. Purple costs the same as beige, and the dividends it pays out are tenfold.

In this West Coast sanctuary for East Coast transplants, Furth enveloped the media room in royal purple, from textured grasscloth walls to luminous wool window treatments and plush wraparound seating. One of the few tonal disruptions, a vintage Peter Hvidt coffee table in warm teak and brass, centers the space with segmented geometry.

15

MURALS

COREY DAMEN JENKINS

I find Saturday mornings the ideal time to pore over clients' projects in our New York City atelier. In those hours, when the typically bustling office empties, I use the following ingredients to get into my creative groove: hot English breakfast tea with honey, lit candles, and music streaming overhead. Music is a wonderful complement to my design process, as it envelops space in a holistic and spiritual way.

And in my opinion, murals are music for the eyes. They envelop a space so thoroughly that you may not need any artwork to adorn the walls. Whether hand-painted by a commissioned artist or acquired as a series of antique panels, murals elevate rooms to a level that cannot be achieved with other wall finishes. Murals are quite versatile, too: they vibe equally well with traditional or modern interiors. Murals also bring harmony to disparate decorating elements and camouflage architectural inadequacies.

However, decorating with murals requires serious forethought. Like a conductor's choices in directing a musical performance, a mural's palette can drive a room's entire look, so it must be considered carefully. I often tie a project's furnishings and paint color choices directly to the hues in a scenic mural.

Lighting is also a factor. Does the room get northern or southern exposure? The answer may dictate how and where certain panel sequences are hung. When decorating, I think it's important to work with—not against—the elements that govern a room's visual energy. For example, a dark and moody scenic mural will be gorgeously seductive in a space that gets less natural light, whereas a bright and chipper mural may look like it's trying too hard to overcompensate in that same environment. I tend to use murals in spaces where people will bask in their ambiance for an extended period, i.e., around a dining table or in a cozy bedroom retreat. Murals can also make a dramatic statement in a front hall with a sweeping staircase.

Finally, there are matters of deployment to consider. For example, how will the mural's scenes scale with furniture and door openings? Where will it start and end? Will window treatments enhance or detract from it? Without careful planning, the outcome may resemble an orchestra's musical warm-up sequence: noisy and clashing. So, mull it over, measure everything three times, and—most of all—have fun with it! When used judiciously, a mural can truly make a room sing.

Opposite and following pages: In this historic 1890s Massachusetts home, Jenkins retained the living room's original wall moldings. To add visual drama, he covered the walls with a verdant mural inspired by the works of artist Nicolas Poussin, providing fresh juxtaposition for the antique and modern furnishings sourced for the project. The family has affectionately nicknamed the space "the garden room."

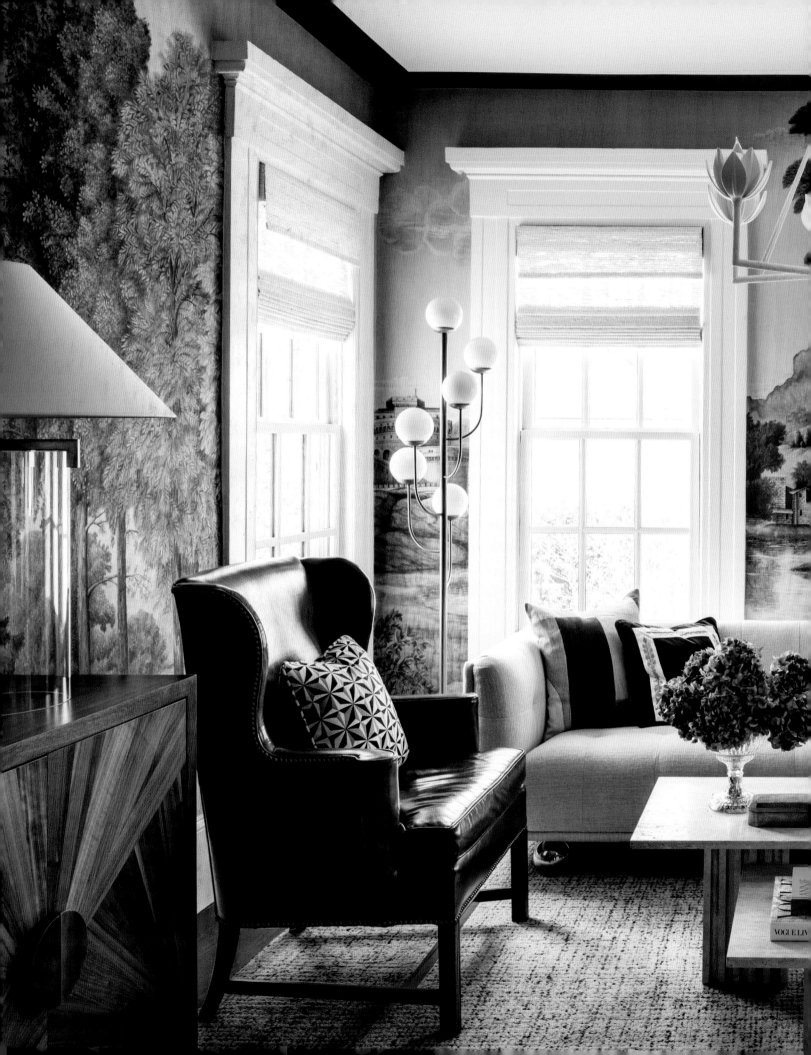

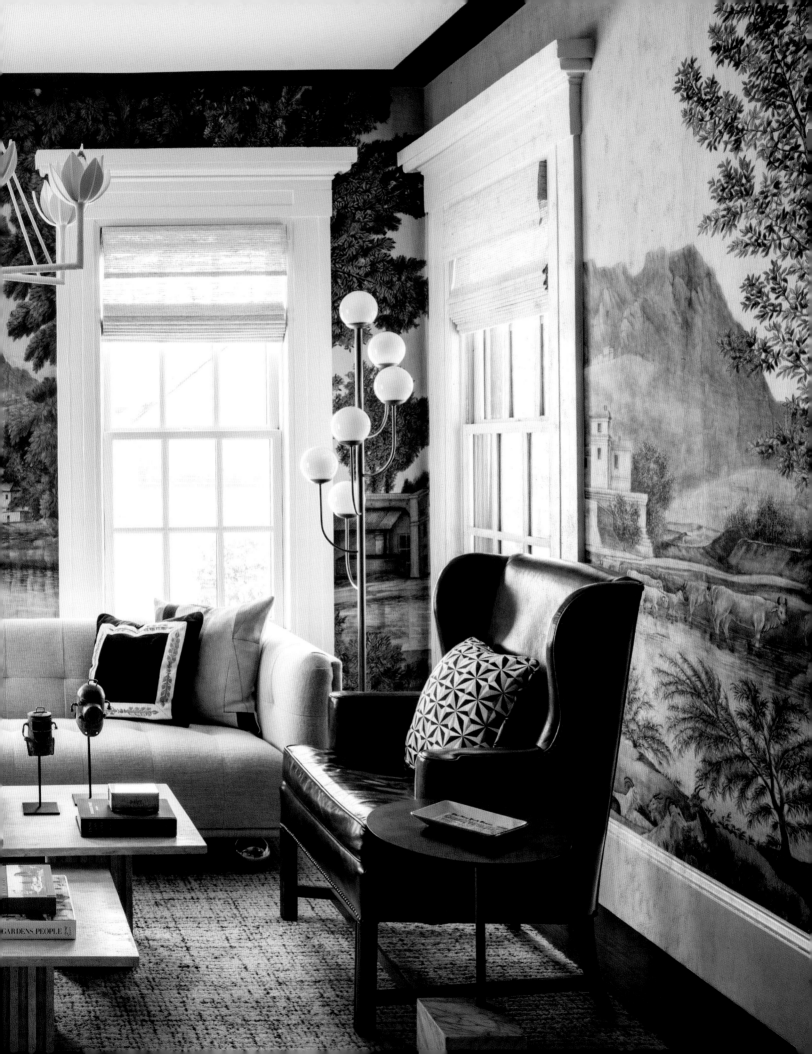

16

MELDING STYLES

DAN FINK

Who doesn't love a great conversation? A spirited exchange (preferably by a fire, and better yet with a glass of wine) where your ideas flow freely and what you hear in return opens your mind.

Or that delightful moment standing over a simmering pot when the last pinch of salt transforms what once were a bunch of disparate ingredients into something delicious.

Or think of that jittery second when you've taken your seat at the philharmonic. The concertmaster delivers her guiding tone, and a tinkering group of instruments unify into a perfectly aligned whole. The hall rings.

All of these moments share the feeling I'm looking for when I'm making rooms. A room is an assembly of many things. The designer's challenge is to make them come together in a way that's, well, in tune.

From where we stand in time, we can see a great landscape of design histories—from the ancient classical, orderly Georgian, and romantic Belle Époque to the glamorous Art Deco, utilitarian mid-century, and eclectic postmodern. Each era, and all those between, played with different forms and details—a push and pull between the ordered and the organic, the exuberant and the restrained.

And further, we're lucky to have access today to the diverse design cultures established geographically over centuries (not unlike language) even in places that are far from us. In a globalized, globe-trotting world, what's available to our everyday design vernacular has expanded greatly.

Design work offers the opportunity to know about all of it, and through that knowledge rooms of all different personalities can be made—rooms that are authentic to where they are and who lives in them.

To me, a great room, like any great conversation, has a cross-section of points of view.

The old and the new.
The detailed and the spare.
The sumptuous and the plain.
The rough and the fine.

And when all those voices assemble in a room, in just the right balance, they make music.

Opposite: Detailed boiserie paneling wraps this city salon, where a work by German artist Miriam Böhm hangs above a contemporary American console table. Following pages: The other side of the stately space features an Art Deco chandelier from 1930 and a Maison Leleu settee from the 1950s, in concert with a sofa by Italian architect Guglielmo Ulrich and a Moroccan stool. Additional works by Böhm flank the fireplace.

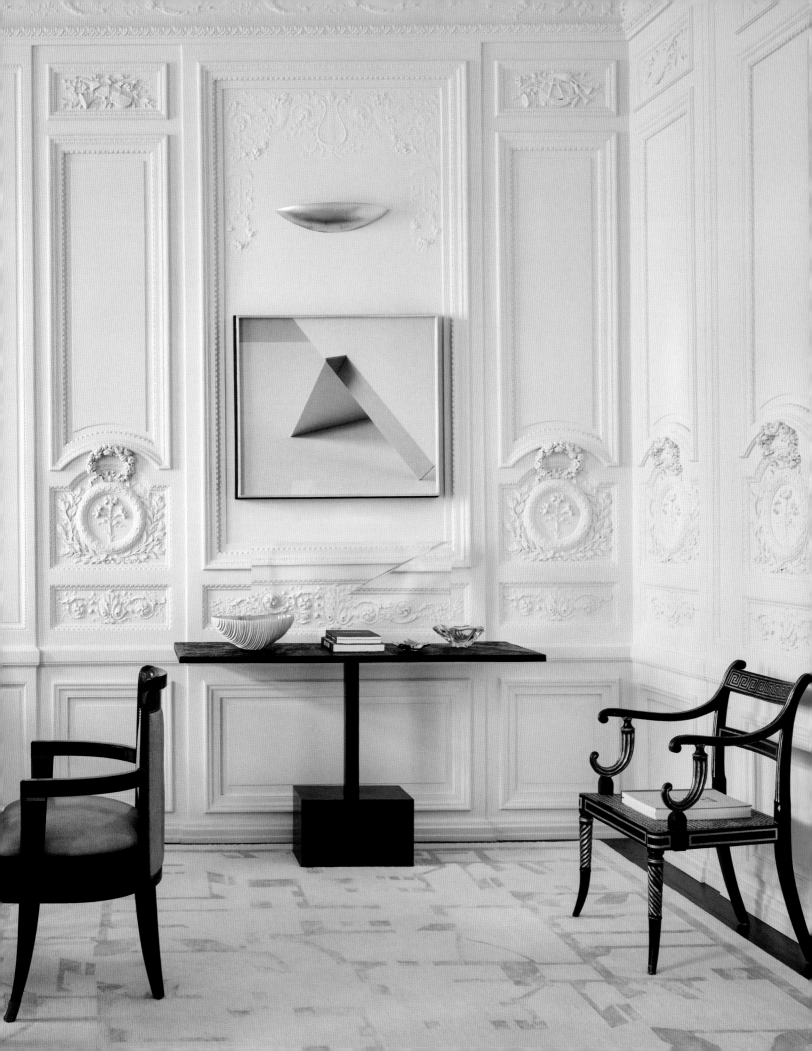

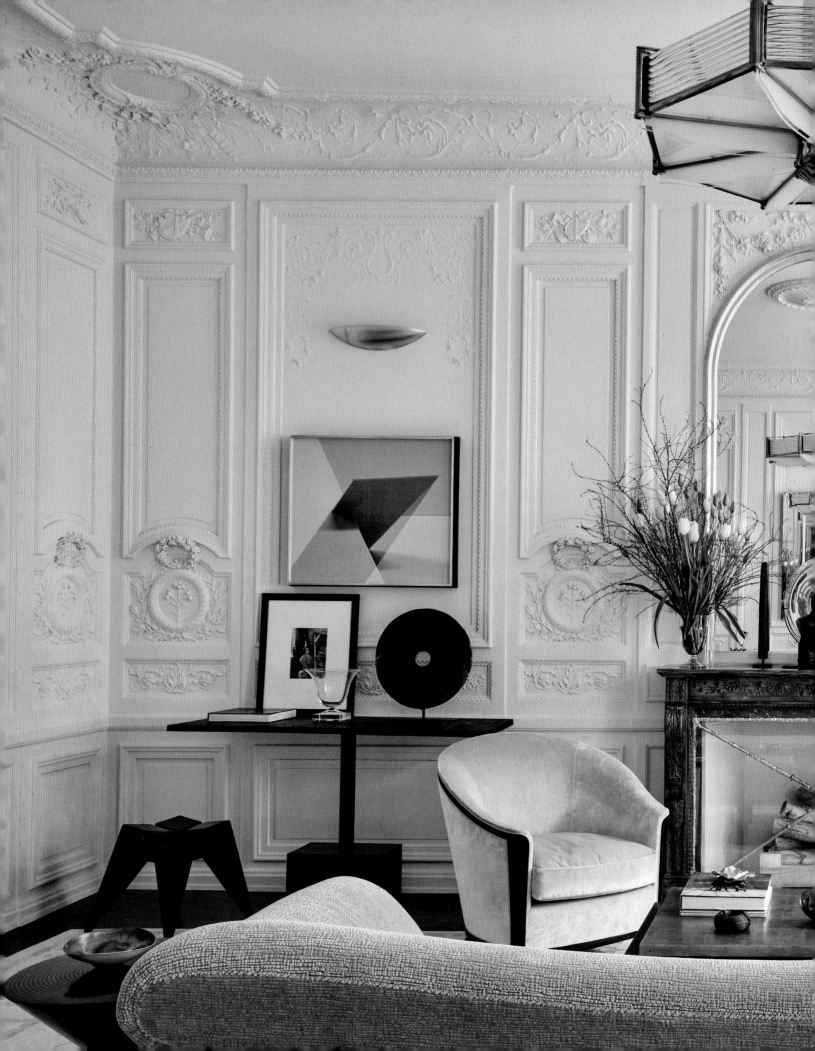

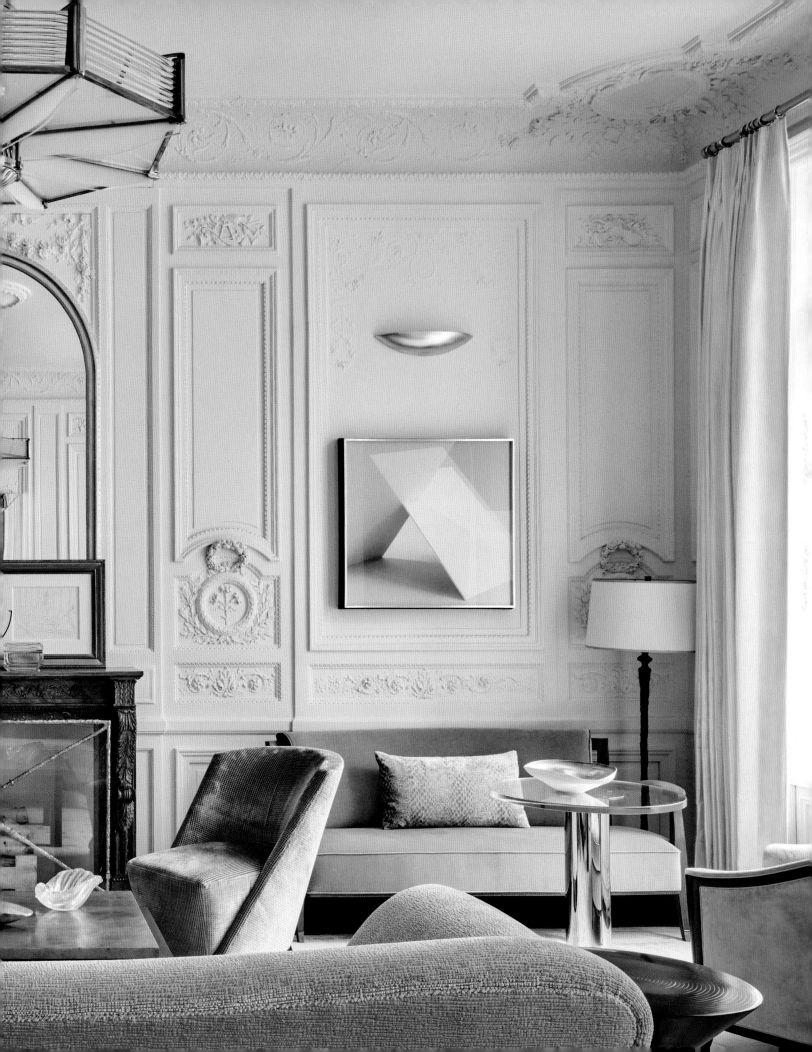

17.

ARRANGING ART

PHILIP GORRIVAN

There are as many ways to hang art as there are people who collect it, but there is one universally accepted rule: the optimum height to hang art is 60 inches from the floor to the artwork's center. This standard, often called gallery height, aligns the artwork with the average human eye level, creating a more engaging and accessible viewing experience. This placement consistency also helps create a harmonious and balanced feeling in a room.

Hanging singular works of art on a wall requires careful consideration to showcase the piece effectively. I start by selecting the optimal location, ensuring that I avoid exposure to sunlight; excellent options are available for illuminating artwork without possible UV damage. Use a level and measuring tape to mark the placement, and choose the appropriate hanging hardware based on the artwork's weight and frame type. Secure the piece with wall anchors or use a picture hanging system for added stability if the piece is heavy. Once hung, step back to assess the placement, making minor adjustments to ensure the artwork is straight and well-positioned. This meticulous approach ensures the singular piece becomes a focal point, enhancing the room's aesthetic appeal.

To organize hanging art in the French salon style—often called gallery walls—select a diverse collection of artworks in various sizes, mediums, and frames to create a rich and eclectic visual experience.

Here's a trick I use: Start by measuring the wall space and marking out the dimensions on the floor using painter's tape, then arrange the works on the floor to preview the arrangement before hanging, adjusting for cohesion. Place the most significant pieces at the center and build outward, filling in gaps with more minor works to achieve a balanced composition. As you transfer the art to the wall, endeavor to maintain visual flow—but avoid being too exact about the arrangement and spacing! Gallery walls should be casual, embracing the abundance and variety that reflects personal taste and history through a curated yet seemingly effortless display.

The exception to this spontaneous approach to grouping works is when you have a collection of works—say, eight botanical drawings in matching frames. You want exact spacing between the works to underscore that they are a collection.

Opposite: A generously proportioned club chair beckons visitors to this intimate corner, where a single painting in a gilded frame commands attention. Following pages: In this Washington, Connecticut, living room, artworks are curated gallery-style in a casual but studied arrangement over a Bridgewater sofa and accent pillows covered in dueling Josef Frank botanicals. A zebra-clad Thebes stool and kudu antlers introduce an African note.

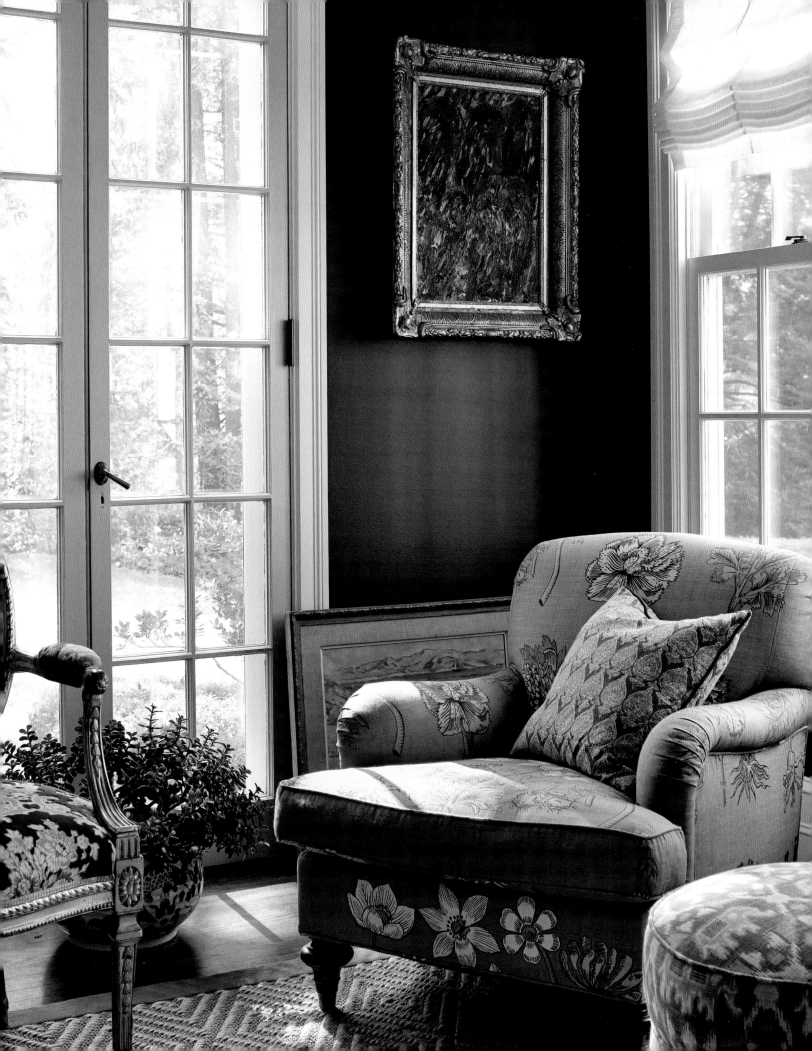

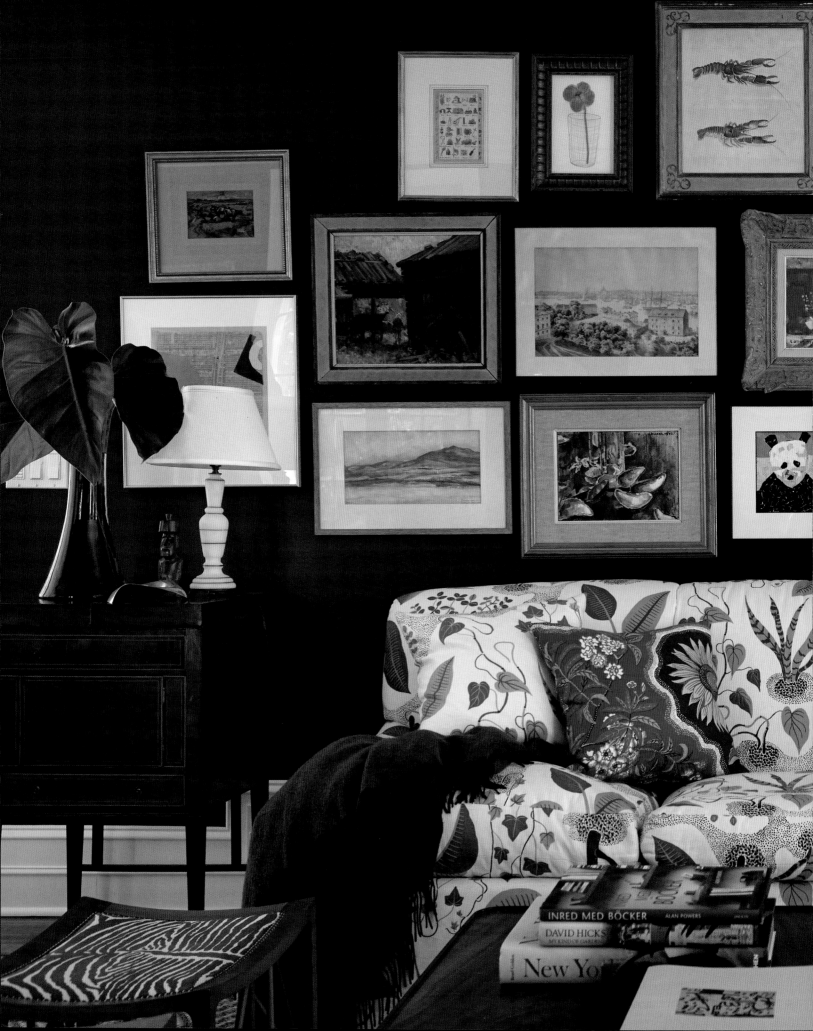

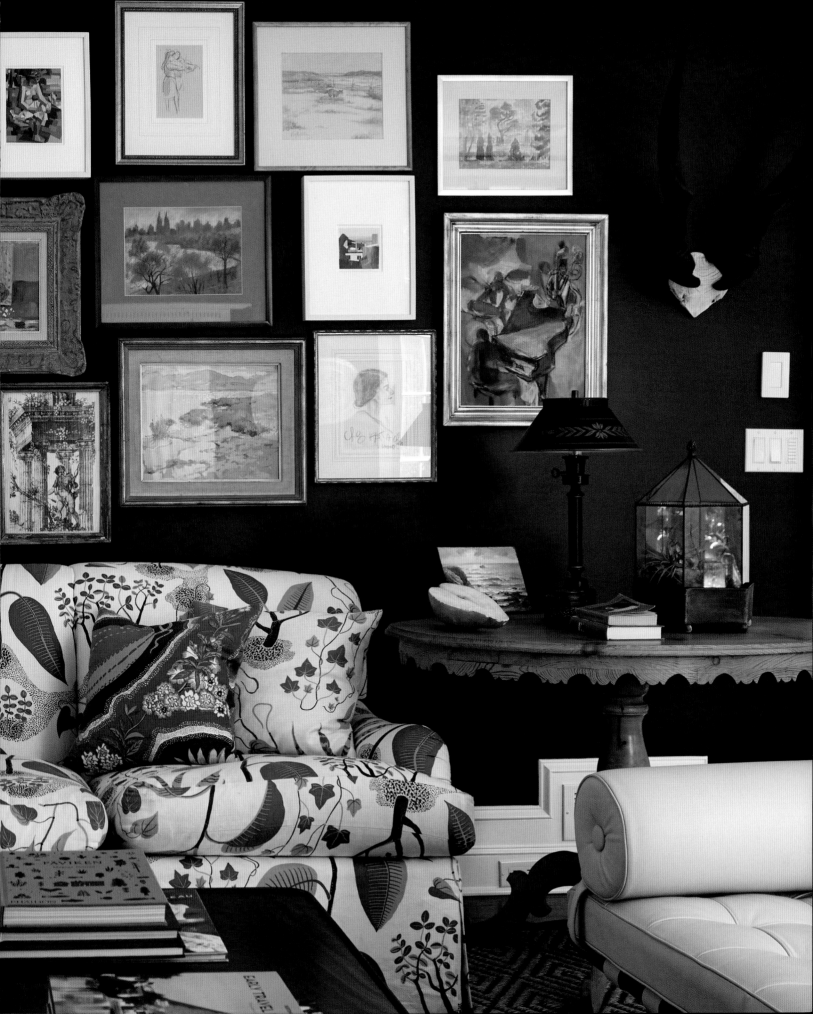

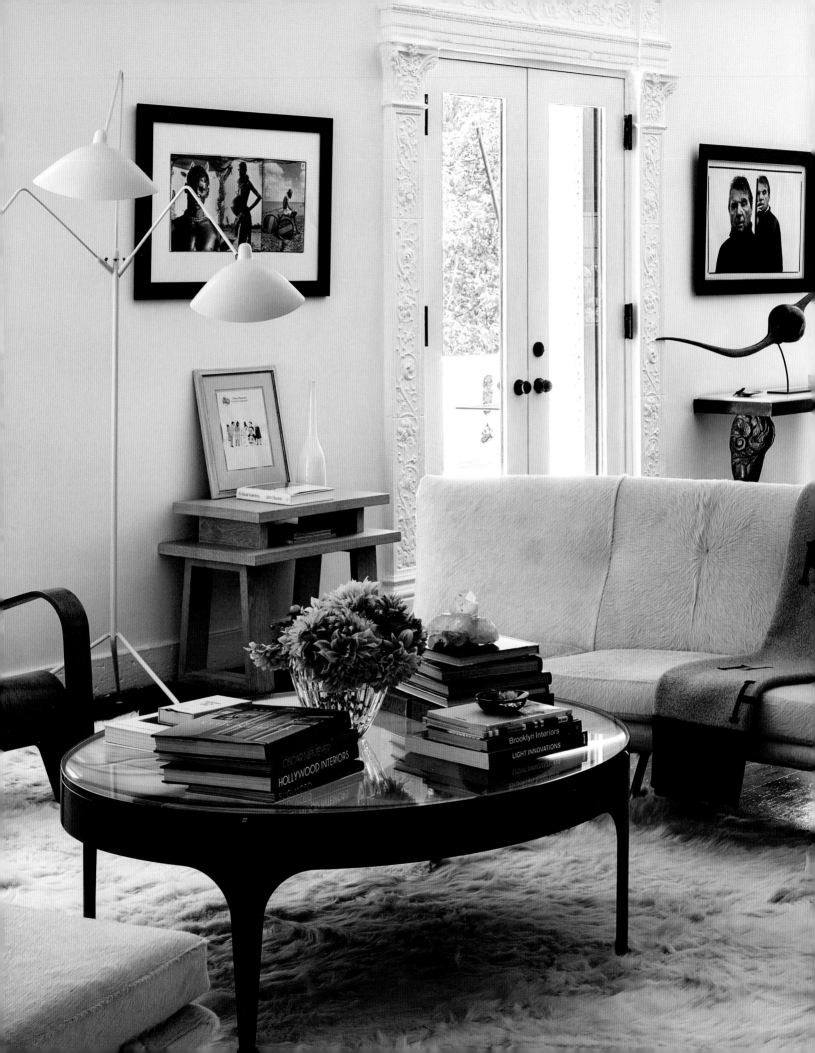

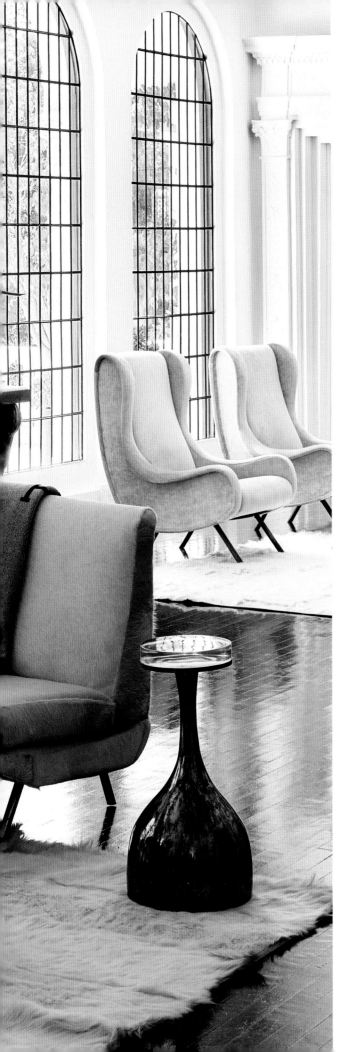

18

TRANQUILITY

BRIGETTE ROMANEK

[Romanek Design Studio]

A thoughtfully designed space can offer balance in a world that often feels overwhelming. Our homes should be a reprieve—an escape from the noise, a place to reset. Tranquility in design is about creating an environment that nurtures peace, warmth, and calm.

When I work with clients, I always consider how to cultivate tranquility in their homes. One of the first things we explore is color. Soft tones—earthy neutrals, warm beiges, dusty blues, and gentle greens—have a naturally soothing effect. Monochromatic palettes can also create harmony, allowing the eye to rest rather than darting from one high-contrast element to another.

The right lighting—warm, layered, and dimmable—can completely shift the mood of a space. Natural light should be maximized whenever possible, with window treatments that soften it but don't block it out. In the evenings, soft-glow table lamps, sconces, and candles create a welcoming ambiance.

Tranquility often comes through in the details. Personalized touches—a favorite piece of art, a beautifully worn chair, a stack of books that inspire—make a space feel meaningful. Incorporating natural materials like stone, linen, and wood adds warmth and texture and makes a room feel inviting and lived in rather than overly polished.

A home that feels serene can shift our energy, helping us move through the world with more ease and clarity. Tranquility is something we all deserve to come home to.

Opposite: In the light-filled living room of Romanek's own Laurel Canyon estate, she created a tranquil, California vibe. Dark stained floors and black and white photography lend gravitas juxtaposed against the pristine white walls. Following pages: In this view, the room's classic architectural elements are counterbalanced by modernist silhouettes arranged on a goat-skin carpet. The pair of lounge chairs are vintage Marco Zanuso, while the low-slung table is populated with a collection of blue-and-white porcelains, which Romanek says are akin to an art installation.

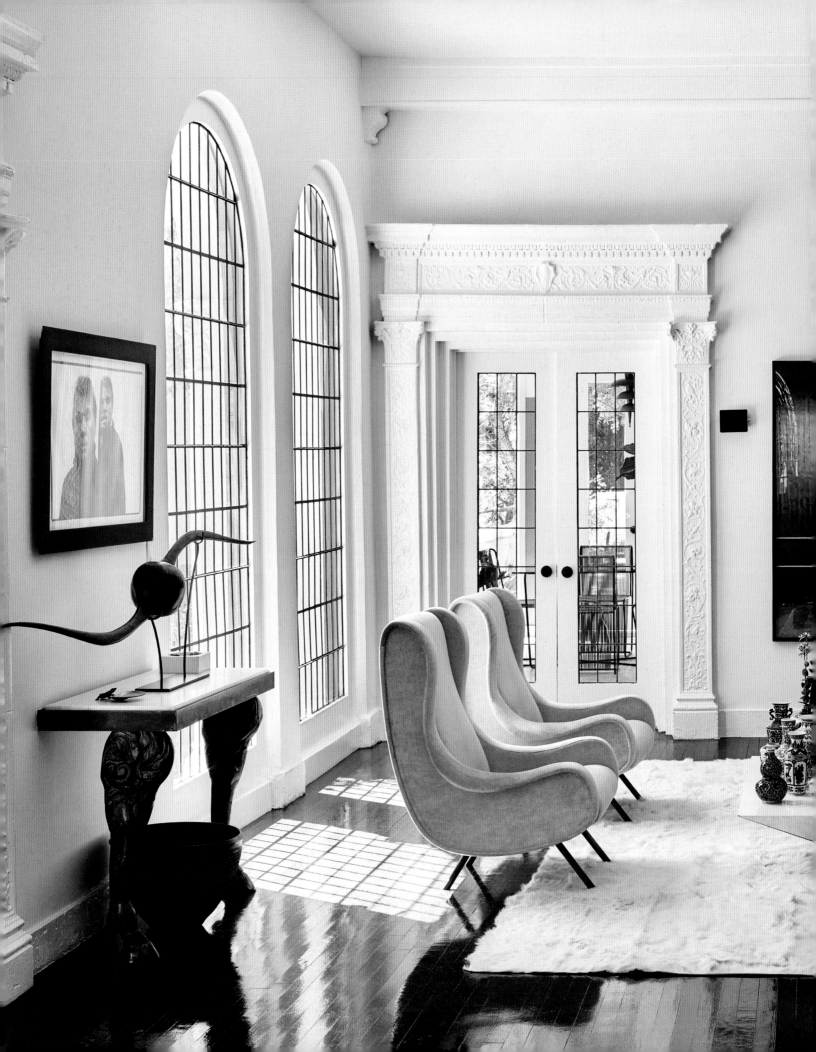

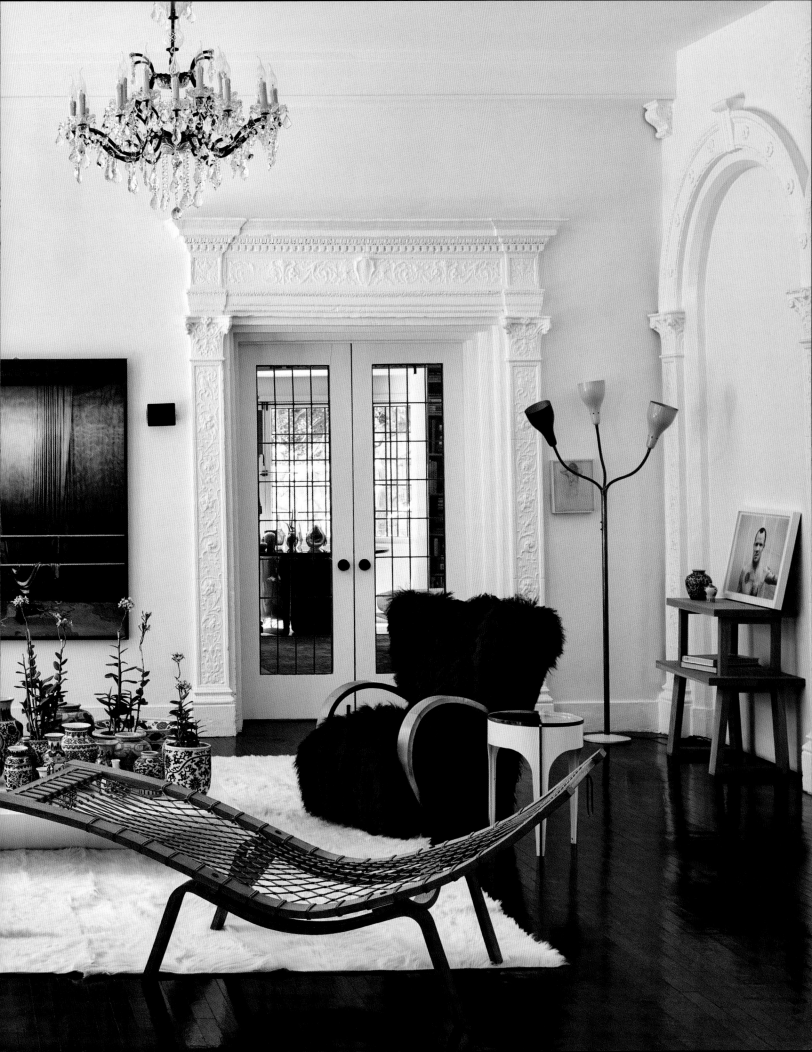

19

PANELED ROOMS

JESSE CARRIER + MARA MILLER

[Carrier and Company]

Paneled rooms evoke tradition, formality, and wealth. When designing within a paneled room, we always consider the intended atmosphere of the space relative to that association. Will the paneling serve as a foil to what is otherwise an informal room? Does it have a rich patina that should be preserved?

Even applied moldings, used to create the illusion of a paneled wall, can be highly successful in establishing a sense of permanence and quality in a home. They offer a clever way to elevate a room that would otherwise be painted.

Paneling itself can be painted. White-painted paneling is a popular choice, as it lessens formality and brightens cozy spaces. White magically enhances all colors and textures, intensifying their best qualities. A lacquered paneled room exudes luxury. The gloss amplifies the color of the paint, capturing sheen and shadow in its architectural details. In fact, any colored paint is a bold choice for paneling—paint often elevates paneling from mere decor to interior architecture. Thus, even a soft, muted tint of a color grows inherently more exciting when painted on paneling.

Paneling readily enhances the layered quality of a room. When designing a wood-paneled room, we prefer to use a variety of textiles in the upholstery, rugs, and window treatments to balance color and pattern. Wooden walls tend to absorb light, which then allows for especially bold and vibrant textile choices.

Artwork is always a decorative element, but in a paneled room the way artwork is hung becomes exponentially expressive. Do we place a piece inside a large panel, perfectly scaled, or hang an over-scaled work from a vertical rail, covering panels? Are we assembling a collection of pieces that are composed salon-style on top of an even grid of paneling? Are we embracing the formality of the walls— or rebelling?

The same calculations need to be made regarding furniture plans and styles: conventional symmetry versus relaxed asymmetry, traditional versus contemporary forms. Are we embracing tradition or accommodating a more contemporary lifestyle? Or perhaps we are achieving both by utilizing modern forms in a traditional layout.

Ultimately, every room evolves through a series of intentional choices until it achieves the perfect balance for the client's point of view and aesthetic. This is no different for rooms with paneling, which sets a baseline that can then be used as a launchpad to further creativity.

Opposite and following pages: In this family-friendly room in a stately 1920s Tudor in Bronxville, New York, heritage oak paneling and ceiling beams create a timeless backdrop. Traditional silhouettes—a Bridgewater sofa and wingback chair—dressed in vibrant fabrics engage in a contemporary dialogue. Floral-print curtains and shades lighten the scene, and red trim on the coffee table adds punch.

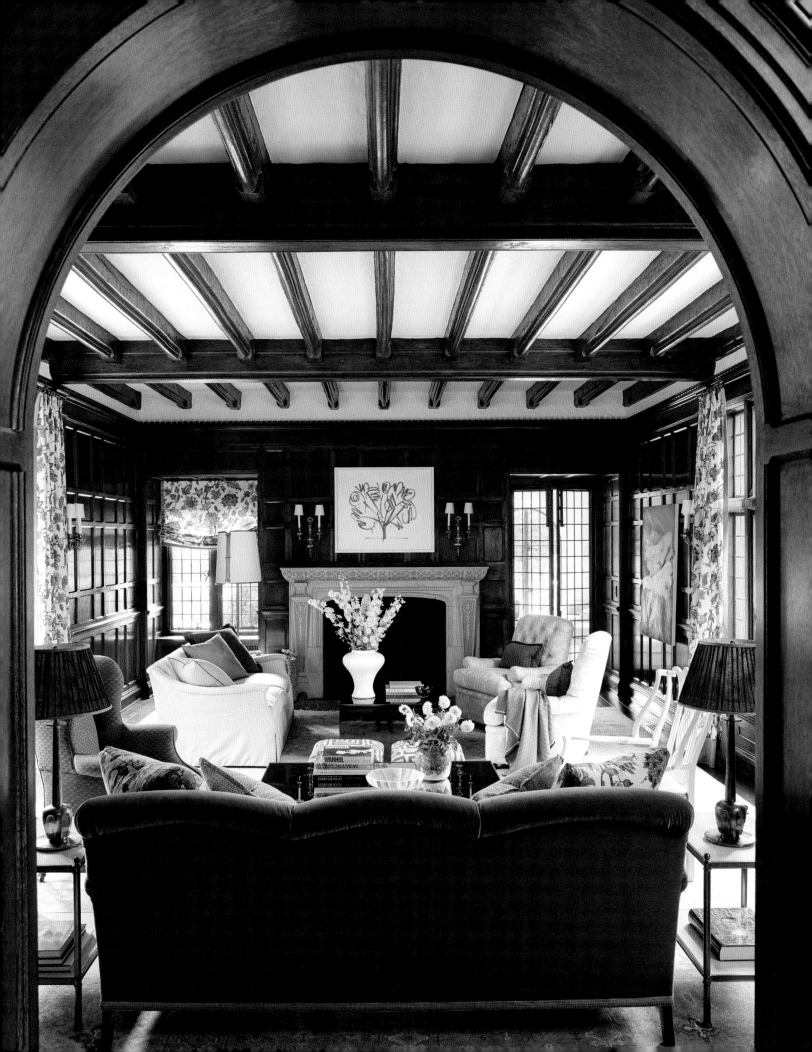

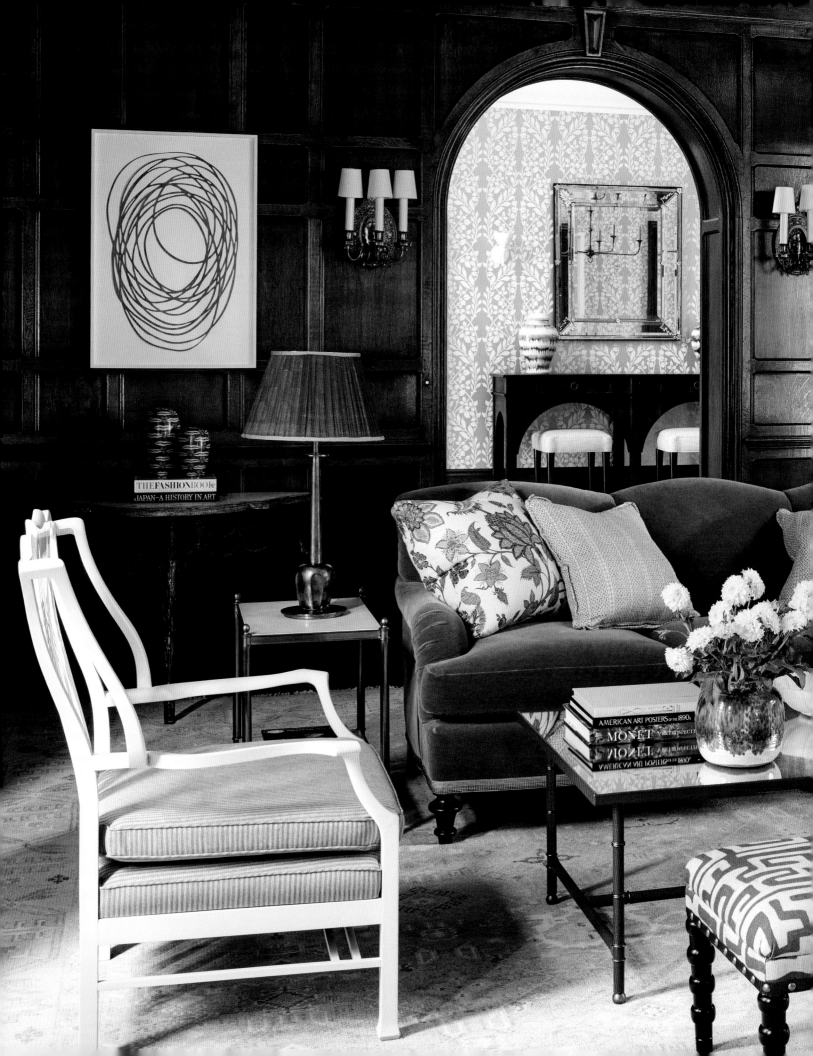

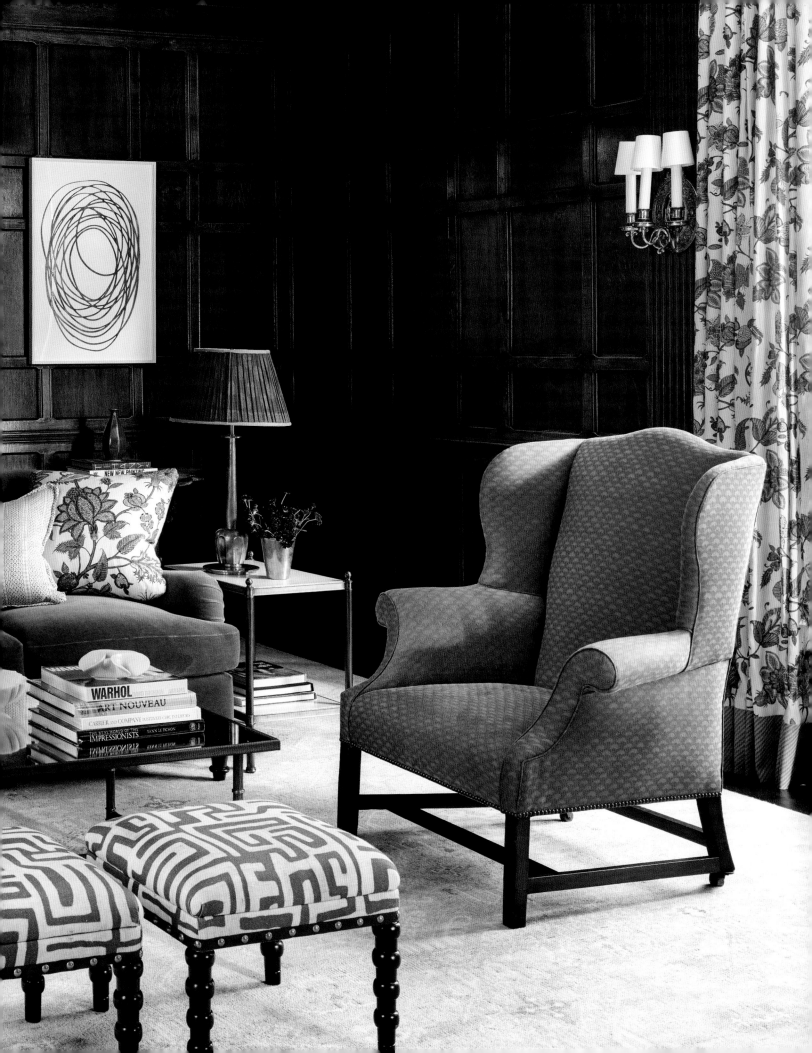

20

FIREPLACES

ROMAN ALONSO + STEVEN JOHANKNECHT

[Commune]

Once essential for heating homes and cooking meals, fireplaces are now primarily a charming anachronism in modern life, replaced by central heating and high-tech kitchen appliances. Yet on a subliminal level, fireplaces are universally appealing. They add a touch of nostalgia and history; they invite intimacy and conversation.

Regardless of the lack of functional necessity for a fireplace, it is often the focal point of a room; at other times, it takes a supporting role in a vital view or outdoor area. It depends on the room and the fireplace's scale.

A fireplace must integrate well with the home's architectural style. It might be part of the original architecture and simply restored, or a new design focused on beautiful materials for the mantel and surround: tile, stone, brick, copper, and plaster can all be considered, as well as the potential of carved motifs or details that make the fireplace unique. Furthermore, fireplaces offer an excellent opportunity to feature an artisan commission, perhaps a bronze or ceramic frieze, a priceless piece of stone, or a particularly unique piece of timber. Sometimes, the mantel plays a role in supporting the artwork above it; sometimes, it becomes the artwork itself. It's all about achieving the right combination of materials, scale, design details, and proportions.

A room's furniture arrangement is usually established in response to its size, shape, doorways, and pathways. A fireplace adds another layer to consider. Sofas and chairs might directly face the fireplace or sit perpendicular to it, allowing a direct path and view of the crackling embers. On the periphery of the room, it is always important to create a way to enjoy the fireplace via inglenooks, fireside seating, or an adjacent window-seat reading alcove.

On a practical level, it's essential that the firebox, flue, and damper follow requirements. Although wood-burning fireplaces are a nostalgic favorite, new fire codes, particularly in California, have made them almost extinct. When choosing a gas alternative, ensure that the vendor offers attractive ceramic fire logs. Luckily, there are lovely options available today.

The focal point of the living room of this Marin County retreat, initially built by designer Alex Riley,
is a shimmering glass mosaic fireplace studded with a white floral motif and framed in a bronze surround.
The interiors of Scandinavian summer houses inspired the color palette.

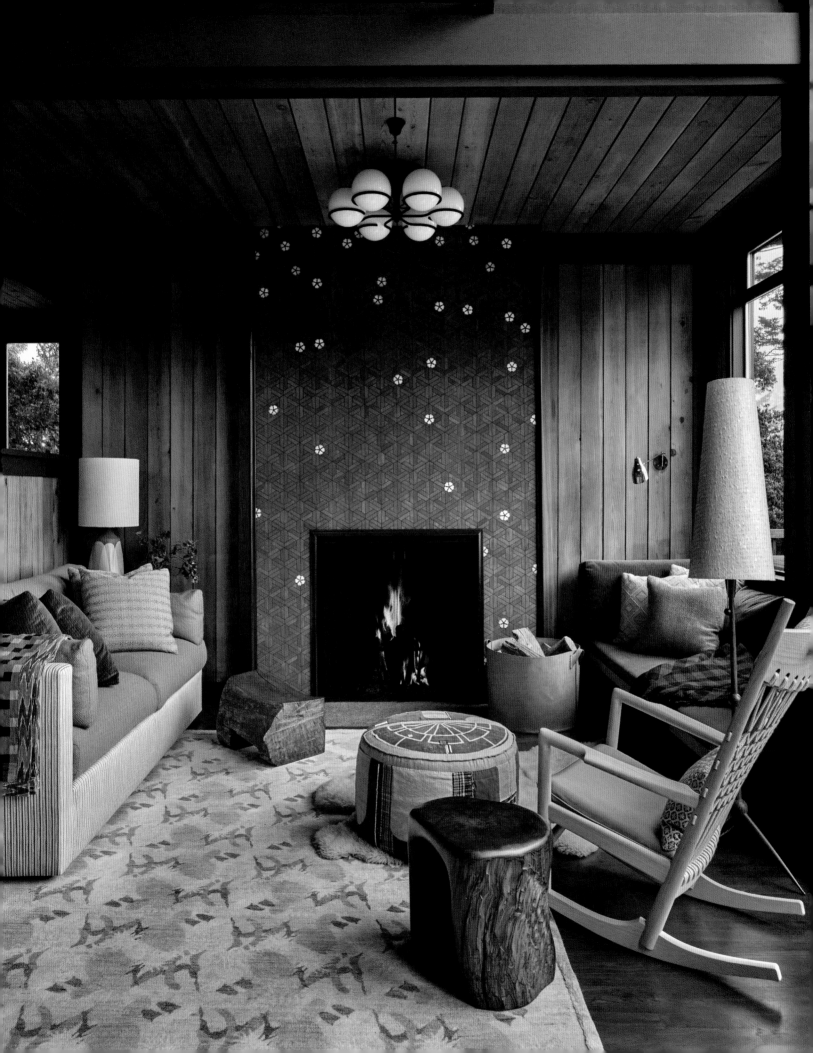

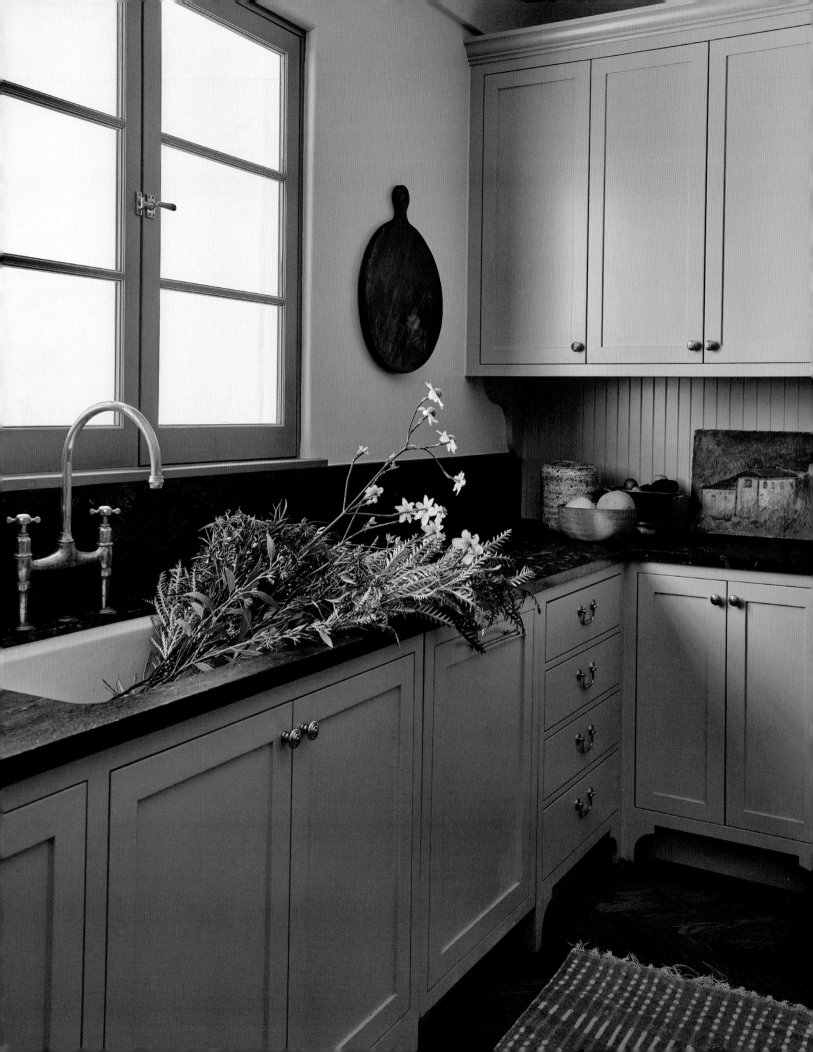

21

EMOTIONS

JAMIE HALLER

Approaching design through the lens of emotion means leading with the heart. Choose color palettes and material stories that elicit an emotional response. I always suggest that my clients base their selections on an emotional, rather than practical, perspective. What that means is choosing the textile or wallpaper that they love, rather than the one they think they should choose. I encourage them to choose colors that they feel drawn to and that stir something in them rather than colors that simply feel safe. Create a space to explore all the options and then proceed intuitively so that it feels purposeful but also free.

When someone enters a home or room that was designed from the perspective of emotion, their brain, heart, and body will register all the small moments that were created and chosen. The space will be inhabited in a more alive way. It will be an emotional home.

The simple act of naming a feeling provides direction and context for emotionally led design. I start by asking clients to give me a word that signifies what they want to feel when they enter their home or a space within their home. This helps tremendously with paint color or palette selection. Sometimes I give them options. For exterior paint, I might ask what they want to feel when they see their home. Examples might be proud, rich, cheerful, grounded, calm, protected, or magnetic. Color should be selected to foster that feeling, so that they will be happy to come home to it every day.

I also use emotion as a guidepost for my designs. When I work on a home, I make choices every day that bring me joy. Every material matters to me. As the designer, I find it very important to stay at the center of the energy. I must be able to design from a place of authenticity. The only way to truly create something fantastically rich and true to the client is to allow feeling and intuitive creativity to lead the project, from start to finish.

Opposite: Deep-charcoal soapstone countertops afford a durable work surface in this Spanish colonial kitchen. The unlacquered brass knobs and fittings are from Paxton Hardware.
Following pages: Original architectural features guided this renovation. The floor plan was reimagined to improve flow between the spacious eat-in kitchen, a butler's pantry, and a laundry room. Intricately carved wooden doors and restored plaster cove moldings establish the home's refined character.

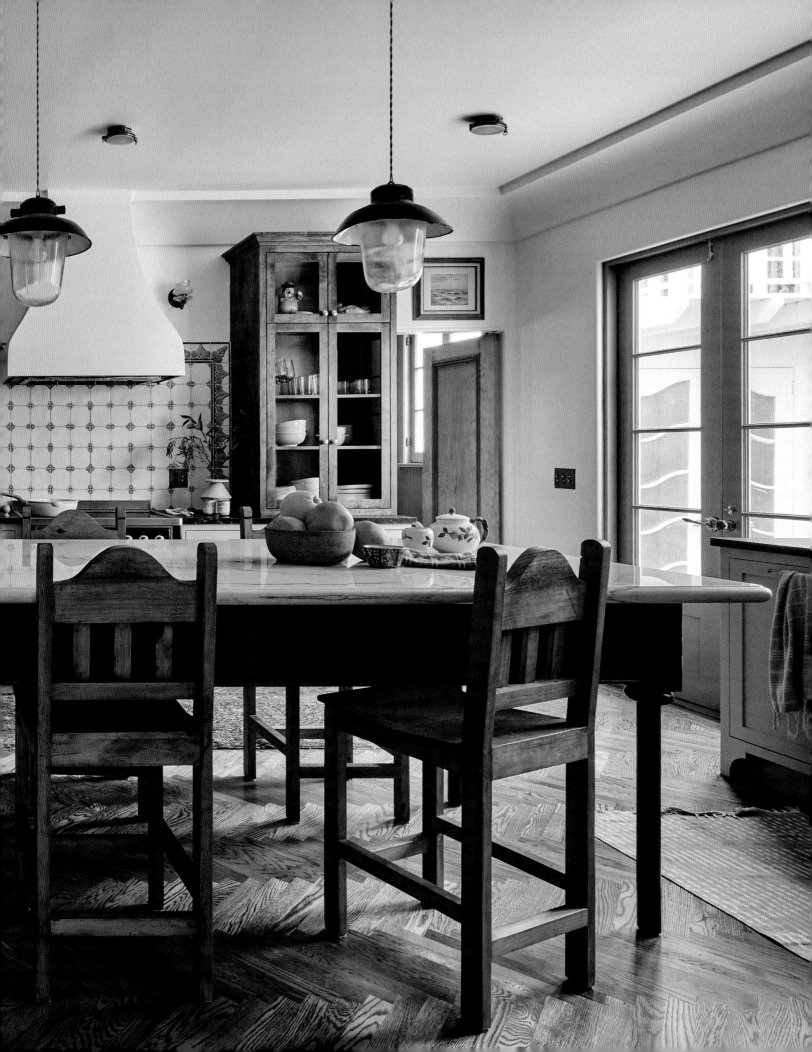

22

MIXING PATTERNS

ROBERT COUTURIER

The French have a healthy disregard for matching patterns. That may be because almost all of us have inherited furniture that we are loath to reupholster. After all, pieces that bear the signs of history bring back cherished memories.

Whether you're French or not, it's best to rely on your eyes and instincts when scheming a mix of patterns. There are no concrete rules. Conventional wisdom is the enemy of creativity.

But there are a few ideas to consider.

Color palettes are crucial when mixing patterns, as they create harmony and cohesion. A unified palette ensures different patterns complement each other rather than clash, balancing visual interest with aesthetic appeal. Coordinated colors tie disparate designs together, enhancing the overall look and feel of the space.

Mixing patterns of different scales adds depth and visual interest to a space, creating a dynamic and engaging environment. Combining large and small patterns prevents monotony. Interspersing solid colors and textures is essential, too; they create negative space, so your eye moves from pattern to pattern while maintaining balance.

The element of surprise comes into play when unexpected patterns harmonize, delighting the eye and adding personality. This interplay of varied scales and surprising combinations can transform a room, making it uniquely captivating and thoughtfully designed. It's the bold approach that pays off. Before you overthink a design decision, just take a stand. The last thing you want is a dull room!

Inspired by Eugène Viollet-le-Duc's nineteenth-century architectural studies for Notre Dame's restoration, Coupe de Pierre wallpaper, sourced through Baron Paris, transforms the designer's study with its trompe l'oeil stonework detailing. The chevroned window shade and floral-striped armless sofa extend the invigorating red palette. Maurice Utrillo's *La Cathédrale de Rheims* presides over all.

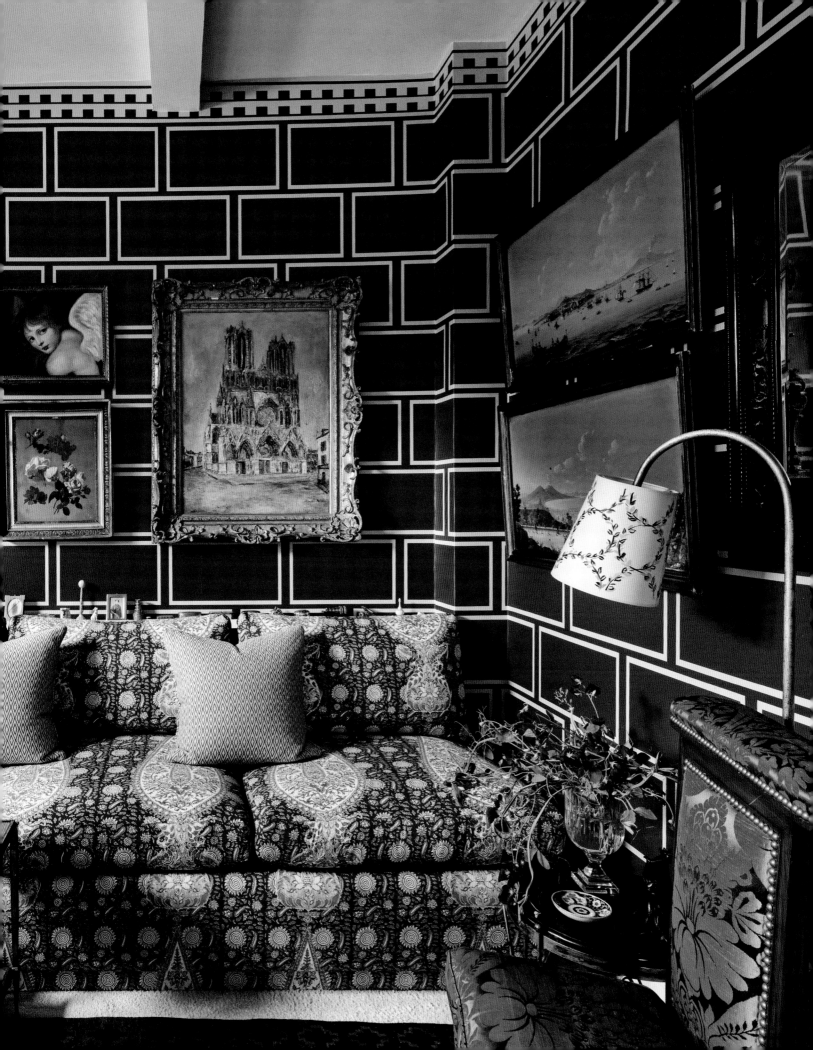

23

UPHOLSTERED PIECES

DAVID SCOTT

There are many criteria for judging the appropriateness of upholstered furniture, but comfort is the most important to me. Over the years, I have found that commissioning custom upholstery from a trusted and skilled local workroom allows me to tailor the "sit" precisely to a client's needs and ergonomics. I generally schedule a client visit to the upholsterer at the time the furniture is being made so that we may see it in muslin before fabric application. We can then judge whether any adjustments need to be made. Some clients want super comfortable down-filled cushions that require fluffing, and others want a firmer sit and, therefore, cushions that require less maintenance to keep them looking orderly.

Quality, style, proportion, and scale are vital criteria as well. I often choose contemporary upholstered furniture from to-the-trade showrooms because of its uniqueness and careful engineering. I am especially drawn to finely crafted furniture with subtle curves and beautiful base materials such as bronze legs and fine wooden platforms. I generally favor durable natural-fiber textiles that are railroaded. Railroaded fabric is arranged on the roll horizontally, which reduces the need for seaming. Not all fabrics are railroaded; for instance, velvet has a directional nap and usually cannot be railroaded. Natural fibers like wool are generally easier to clean, are sturdy, and stand the test of time. A lot of care goes into selecting the correct fabric. I ask questions such as, are there children or pets in the home? Will this be used every day, or is it for occasional use? If it's a summer or resort home, will there be family members and guests wearing wet bathing suits and skincare products? In the case of the latter and for outdoor furniture, we use synthetic textiles made for indoor-outdoor use. Many of these fabrics are quite beautiful and soft to the touch, and the number of options in this category continues to grow.

Finally, adding details like corded or fringed trim on seat and back cushions and varying the way fabrics and materials are applied creates interest. Upholstered furniture that is comfortable and well-made can last many years—and provide an almost infinite amount of pleasure.

Opposite and following pages: A Dupré-Lafon-inspired sofa by Anthony Lawrence-Belfair upholstered in a Dedar textile and a pair of 1920s Swedish Art Deco club chairs covered in a Pierre Frey fabric anchor Scott's 2023 Kips Bay Decorator Show House room. Their plush neutrality allows the 1985 Larry Poons canvas *Log Train*—characterized by thick impasto swirls—and the diminutive red *Phantom Touch* by Jules Olitski to shine.

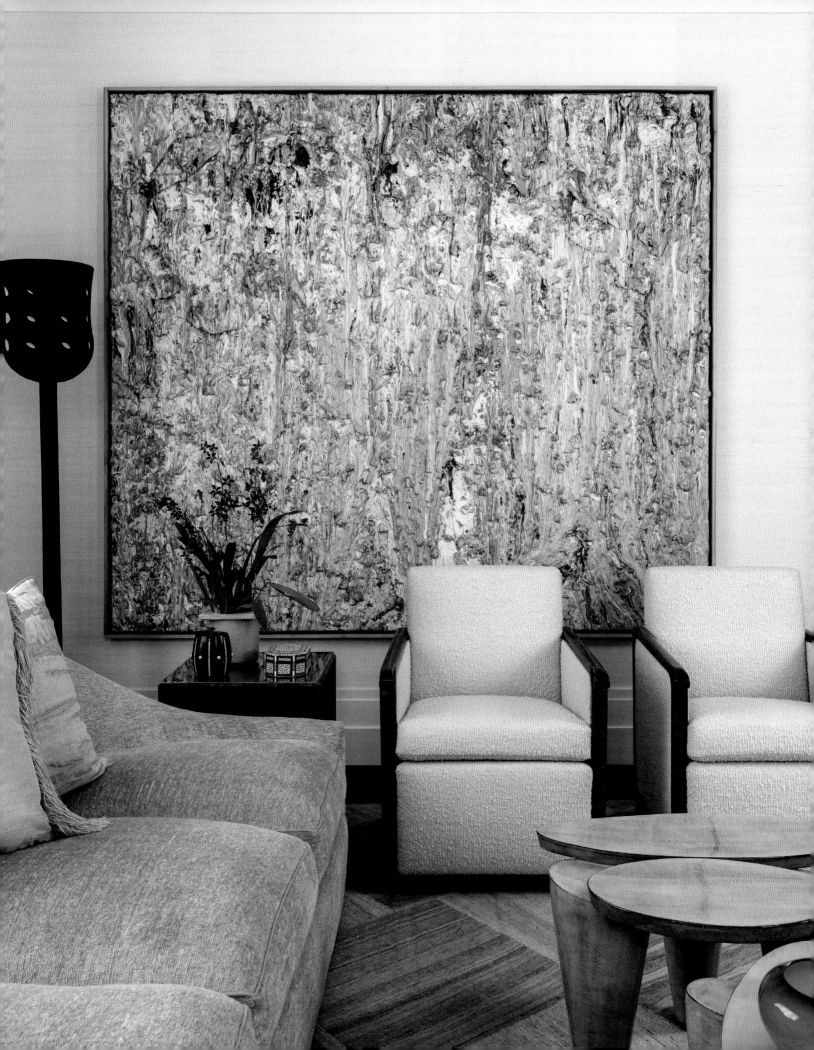

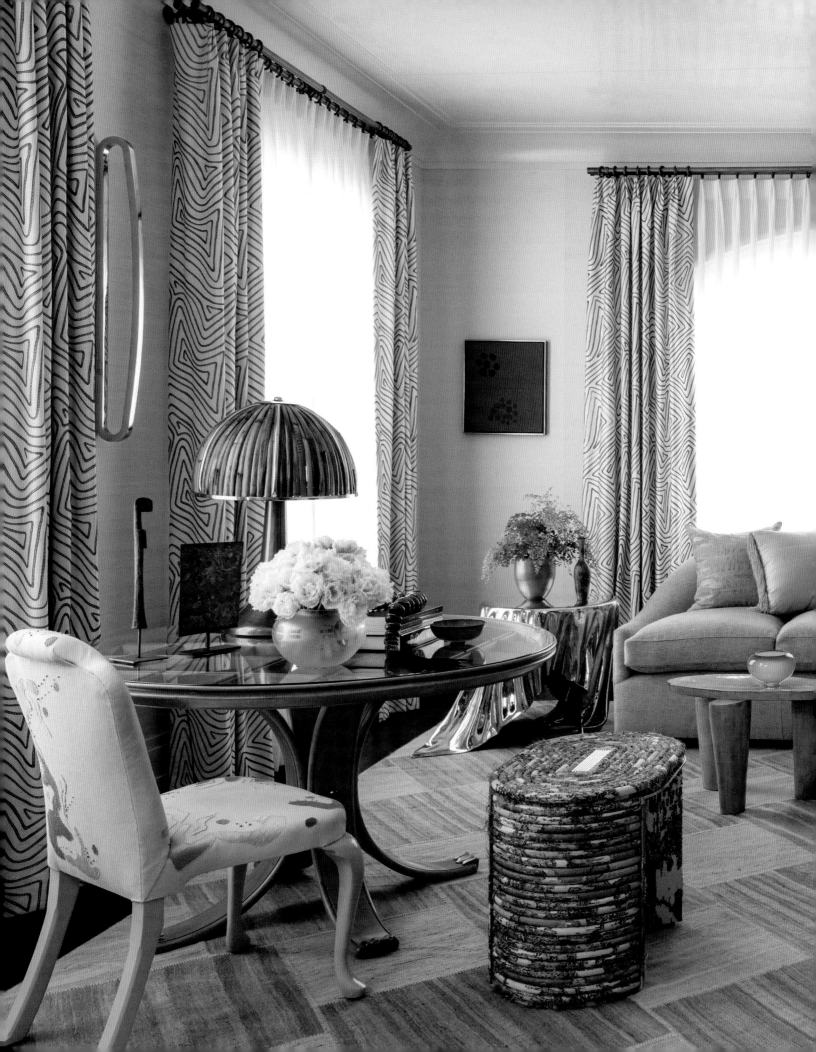

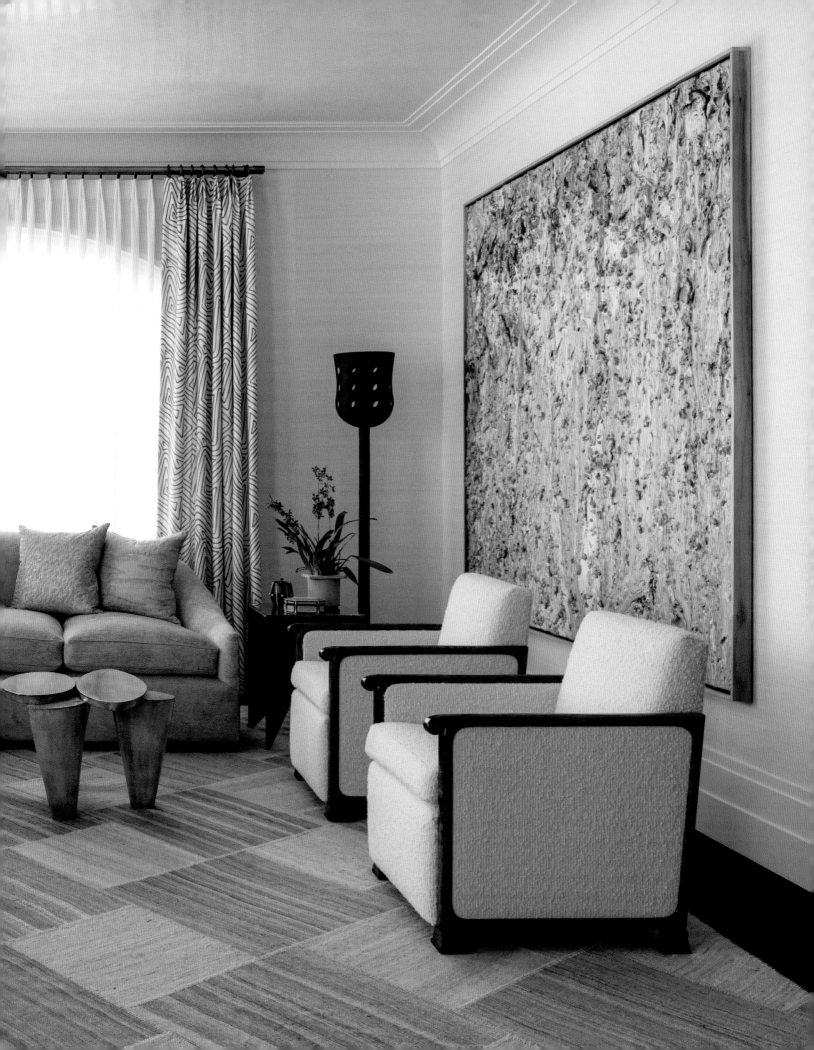

24

SILHOUETTES

GHISLAINE VIÑAS

Selecting furniture for a room can be a challenging task, as you must consider more than just aesthetics and color. For a room to be successful, all of its elements must work together, so consider how the shapes and forms will interact with each other. Silhouettes have the power to make or break a space, and there are endless ways to play with composition to create a captivating environment.

One of my favorite ways to promote excitement and energy in a space is to pair extremely rectilinear shapes with rounder, plumper forms. I'm always mindful of height, often incorporating tall sculptural pieces to create a surprising and interesting overall profile. Varying the heights of elements within a room contributes to a more engaging composition. Think of your space as the skyline of a city and the way your eye travels across the buildings as you take it in. Conversely, for a serene feel, keep all furniture aligned at a lower height with simple, cohesive shapes.

Just as important as height are the ergonomics of the space. Maintaining similar seat heights is a must, but play with varying back heights on the chairs. The contrast between high-backed chairs and a low-backed sofa, for instance, can create a dramatic yet balanced effect. However, be cautious with scale. It may simply be impossible to achieve harmony when placing a large upholstered chair next to a smaller wooden chair.

Layering is another essential aspect of designing with silhouettes. Rounded pillows and organic patterns can soften the look and feel of angular furniture, infusing the room with warmth and personality.

The architecture of the space also plays a crucial role in design choices. If the architectural details are busy, simplifying the furniture shapes brings balance. Round forms and soft curves or minimalist rectilinear pieces can set the mood. Conversely, in an unadorned space with little architectural detail, experiment with more dynamic and varied pieces to bring the room to life.

By thoughtfully combining shapes, heights, and layers, you can create a space that is exaggerated or harmonious, or both—reflecting your vision.

Opposite and following pages: This Los Angeles living room exudes exuberance through a masterful composition of forms. Iconic Gerrit Rietveld chairs, an undulating De Sede Snake sofa, and a curvy vintage polished brass coffee table by Karl Springer enter into a sophisticated dialogue between angular and fluid shapes.

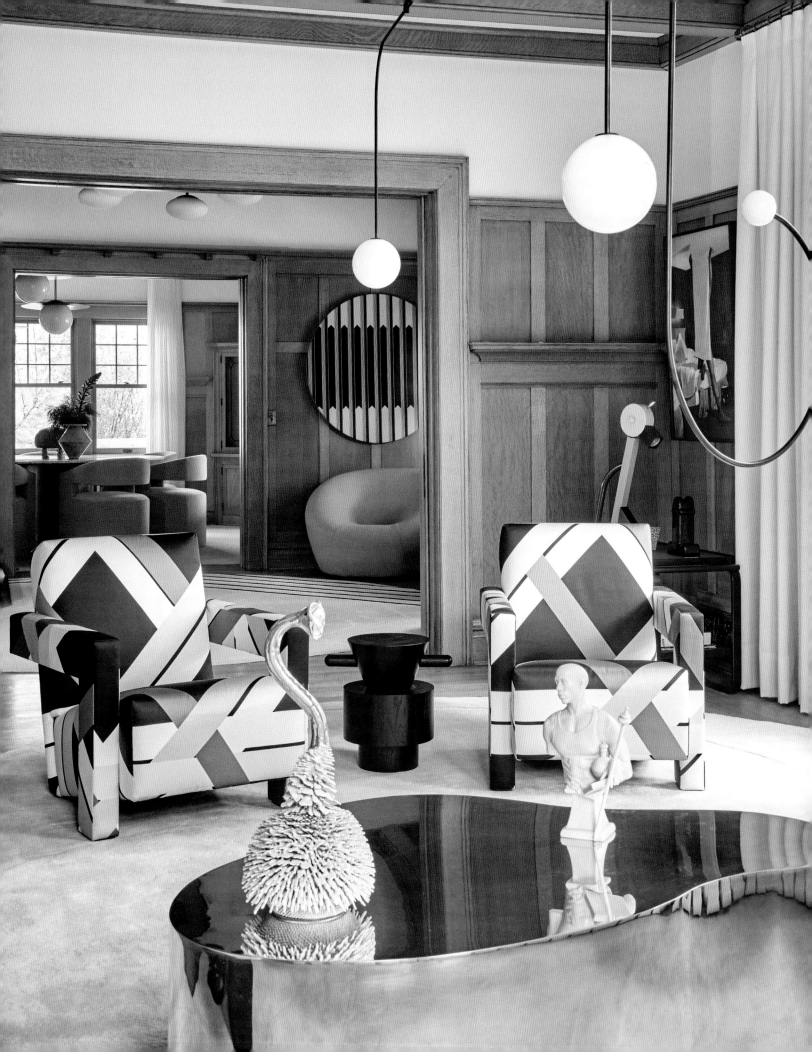

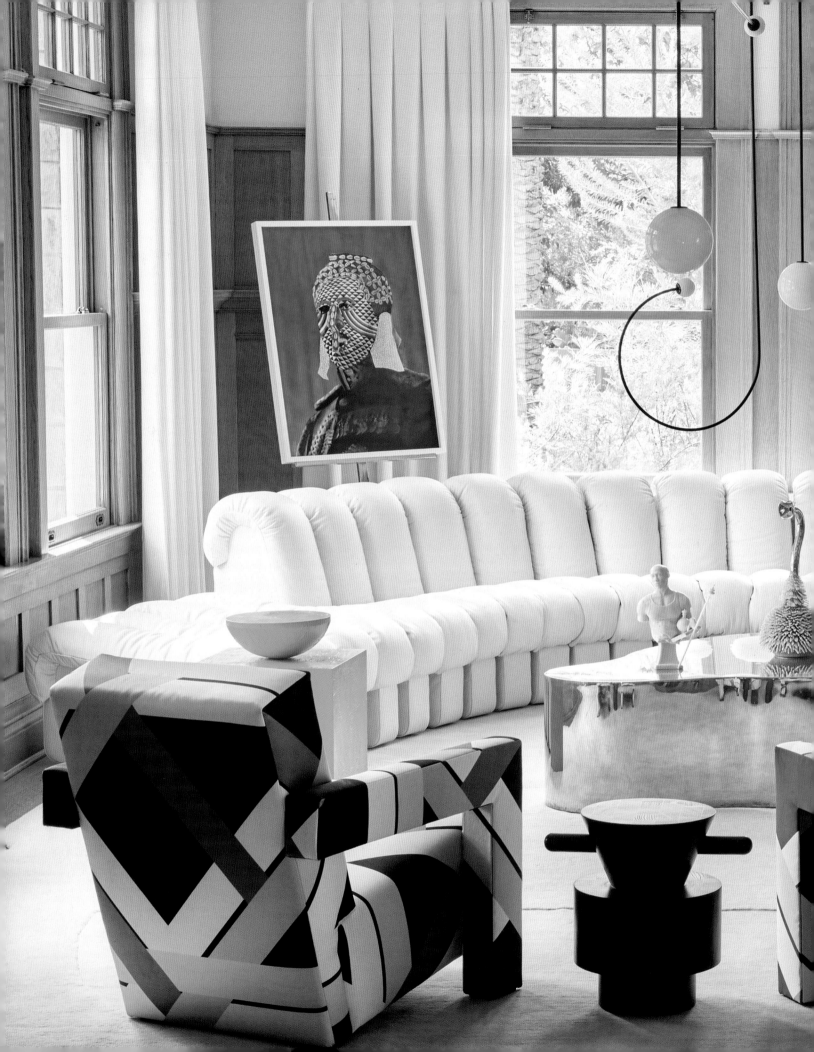

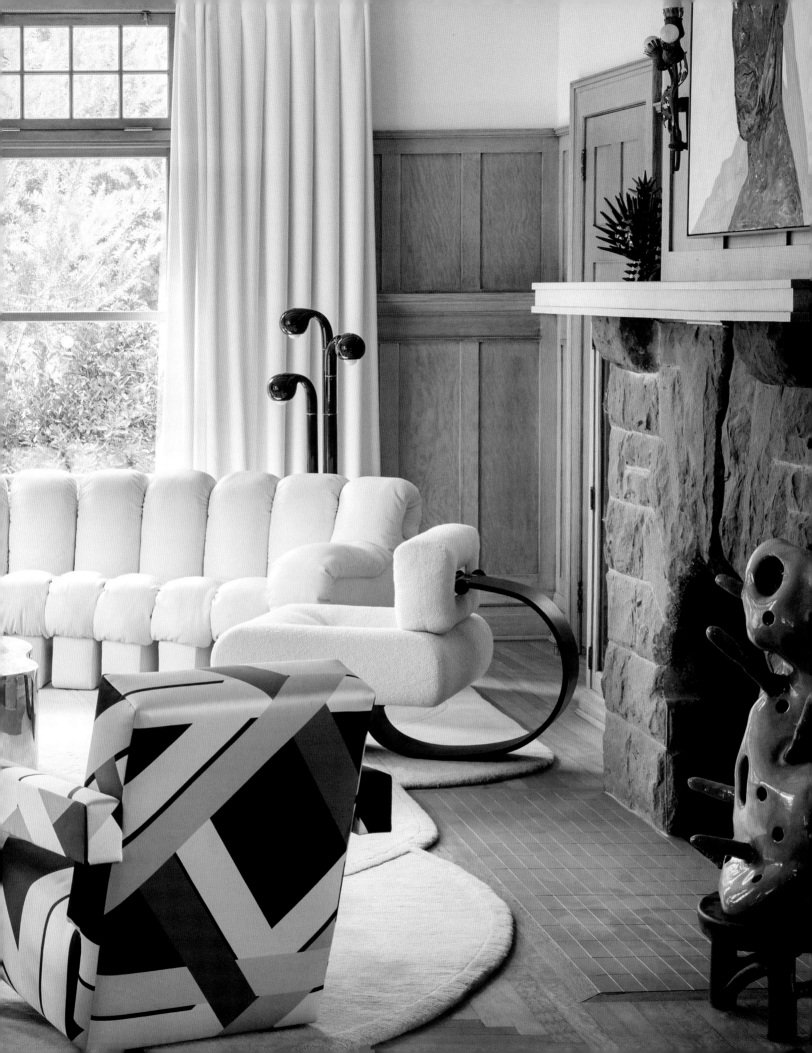

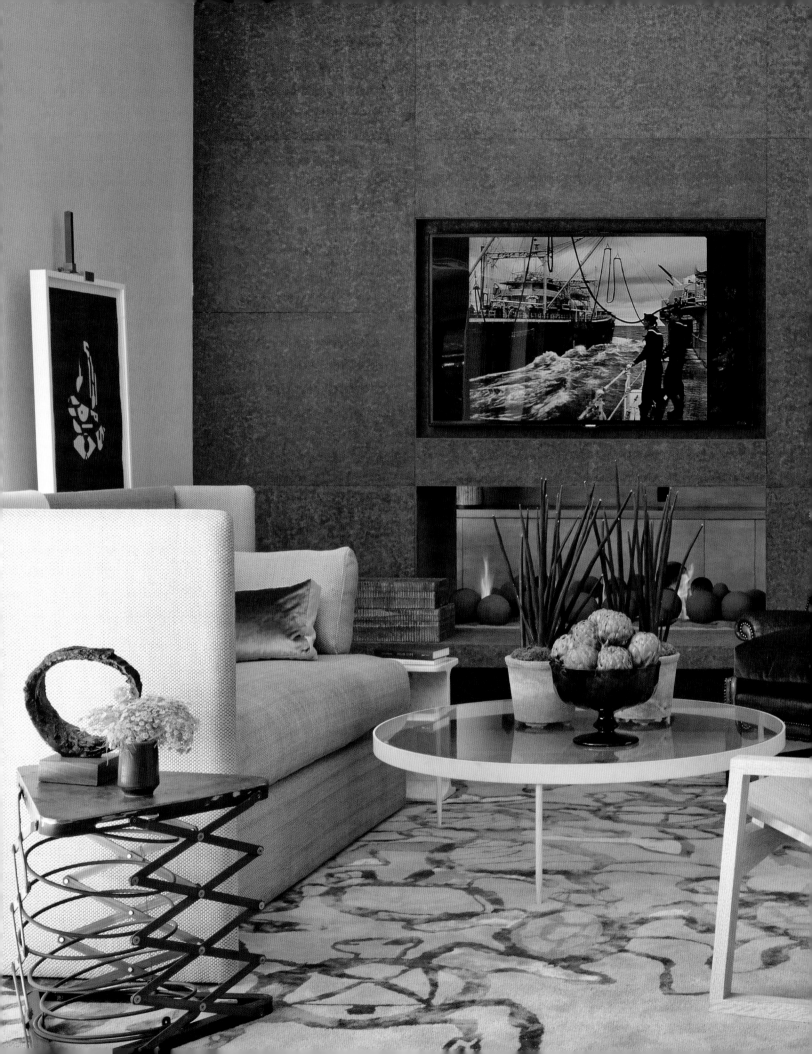

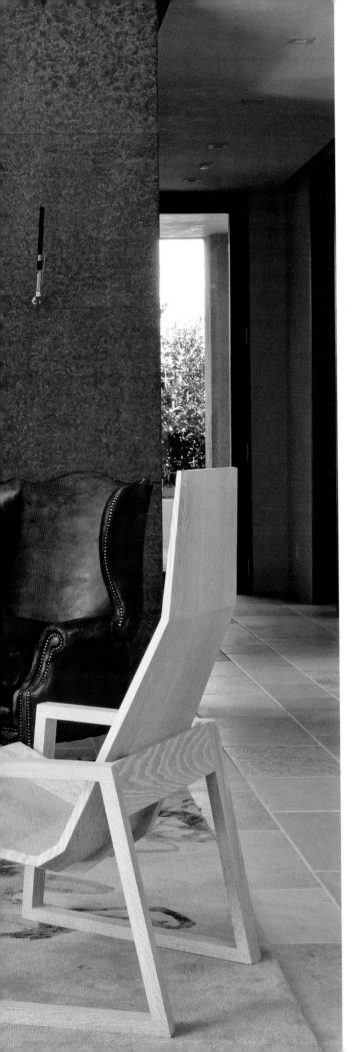

MEDIA ROOMS

JEFFREY ALAN MARKS

I tend to design nontraditional media rooms, as I prefer to create multipurpose spaces that function both for entertaining and for entertainment.

Regardless of aesthetics, the most important thing for a room centered around a TV is for it to be comfortable. I start by choosing a deep, low sofa, which I cover in throw pillows and blankets to enhance comfort. It's important to include additional seating options that can be moved to accommodate extra bodies accordingly. For families with kids, those might include bean bags or floor pillows. Rather than a single large coffee table, I find that multiple, easily reachable small tables for drinks and snacks work best in intimate spaces.

Even in a media room, I prefer to disguise the TV. I often treat the screen or monitor as I would a high-end art piece, carving a nook into the wall where it is placed so it feels more intentional and sinks into the room. Another option is to frame the TV, so technology literally becomes art. And sometimes I actually hide the TV completely behind wall panels so that it is not always on display but can still be easily accessed when everyone gathers to watch a flick.

In terms of the overall aesthetic, it is imperative for a room with a device as the focal point to be timeless. Too contemporary and it risks feeling like an office, and too classic and the screen reads as anachronistic. To achieve this, I juxtapose modern pieces with antiques, such as resting an English wingback chair beside a sculptural white oak piece. A mix of lighting is also essential. I create ambient mood lighting with table lamps and dimmable overhead lighting. The end result is a room that is both functional and sophisticated.

In this media room, three distinct seating pieces forge an unexpected harmony: an English wingback wrapped in supple leather, a carved oak statement piece, and a high-backed upholstered sofa. Their arrangement balances formality with comfort, creating a relaxed atmosphere perfect for viewing.

26

BREAKFAST BARS

BRIA HAMMEL

When embarking on the journey of designing a kitchen with a breakfast bar, one must ask: What do I want this space to evoke? Beyond practicality, a breakfast bar is the heartbeat of the home—a space where mornings begin, conversations flow, and life's moments are celebrated. It is a space where aesthetics, functionality, and a sense of community converge.

The breakfast bar should be a seamless extension of the kitchen, balancing charm and practicality. Consider its purpose: Will it host quick breakfasts, serve as a workspace, or accommodate weekend brunches? Its role shapes its design. It must integrate with the kitchen's flow, enhancing the space without disrupting traffic or the kitchen triangle. Additionally, think about how the bar's size and placement can accommodate gatherings so that it becomes a true focal point of the kitchen.

For a family-friendly breakfast bar, thoughtful spatial planning is key. Position it to foster interaction between the cook and family while maintaining accessibility. Rounded edges and adjustable heights can make it safer and more inclusive for young children. Include a designated space nearby for items like napkins, utensils, and even a fruit bowl, keeping everything within easy reach for busy mornings.

When designing the perfect breakfast bar, comfort and accessibility should always come first. Welcoming spaces invite use and encourage engagement. Functionality should balance with beauty, with durable materials that also reflect elegance. Seating, lighting, and storage transform the breakfast bar. Stools should be both comfortable and durable, with a height suited to the counter. Upholstered options or those with backs add an extra touch of comfort. Pendant lights above the bar provide both practicality and ambiance, creating a focal point. Layered lighting ensures functionality throughout the day. Beneath the bar, incorporate storage to house essentials while maintaining a clean look, or even create a small nook for personal touches like cookbooks or family photos. Thoughtful details, like power outlets and footrests, can enhance usability and elevate the experience.

It is equally important to avoid overcrowding the space. Too much seating or decor can diminish functionality and make the area feel cramped. Balance is key, ensuring the bar complements the kitchen's design. A breakfast bar that is too large can dominate the room, while one that is too small may go underutilized.

In a fast-paced world, the breakfast bar anchors the home. It is where parents sip coffee as children share stories, where friends laugh and linger, and where solitary moments of reflection find their place. By design, it fosters connection and slows life's rush. A well-designed breakfast bar enriches daily life, offering a space for connection and creating memories that last a lifetime.

Opposite: A pair of soft brass-finished pendant lamps from Visual Comfort illuminate the farmhouse sink in the bar in this serene kitchen. In contrast, slate-blue sisal wallpaper lines the insides of the custom cabinetry.
Following pages: Four wicker and cushioned stools tucked under the breakfast bar invite conversation. The walls and cabinetry are bathed in Benjamin Moore's Swiss Coffee.

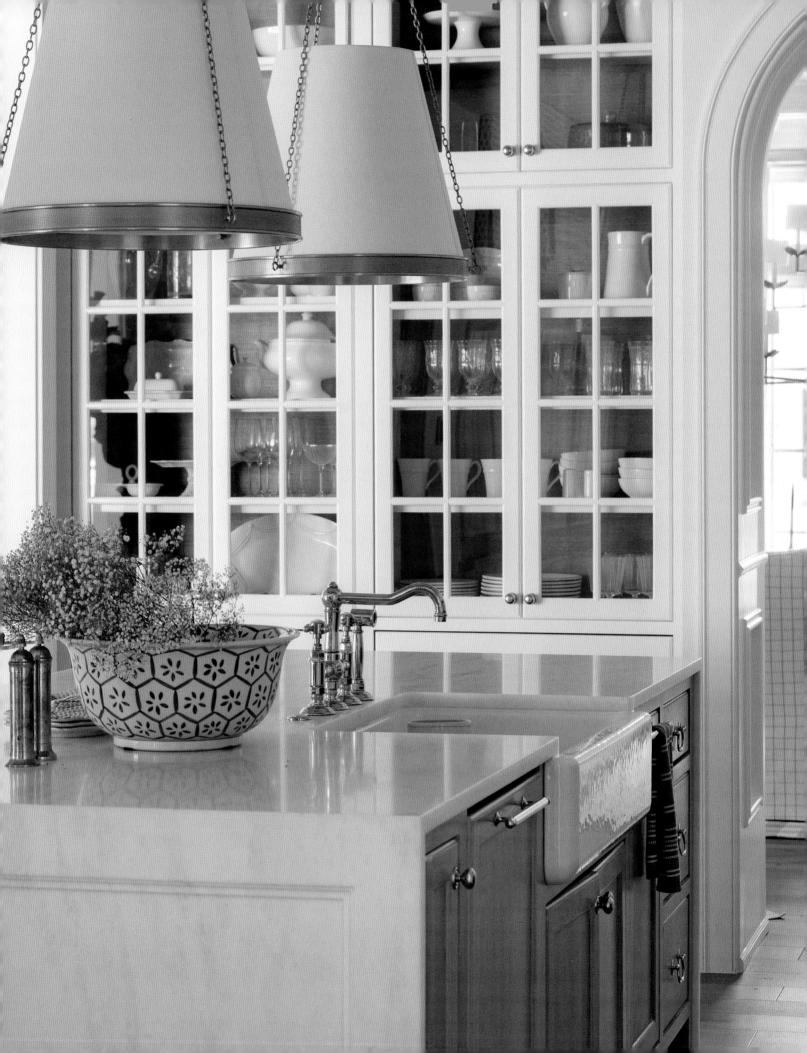

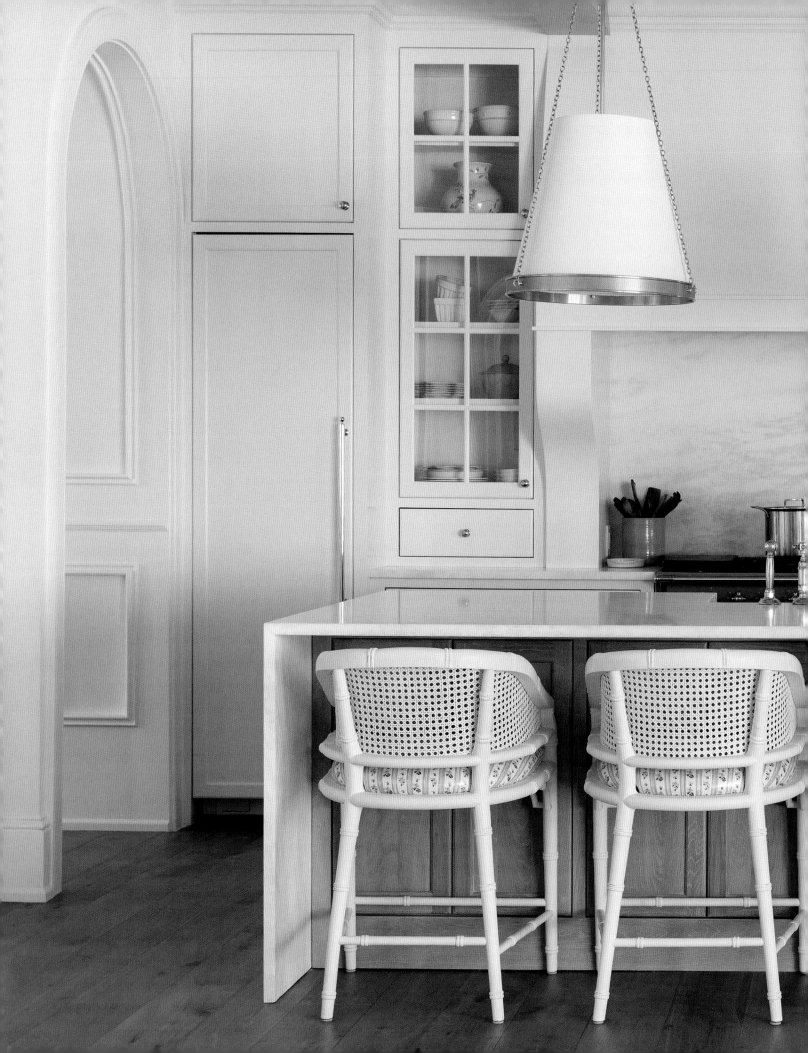

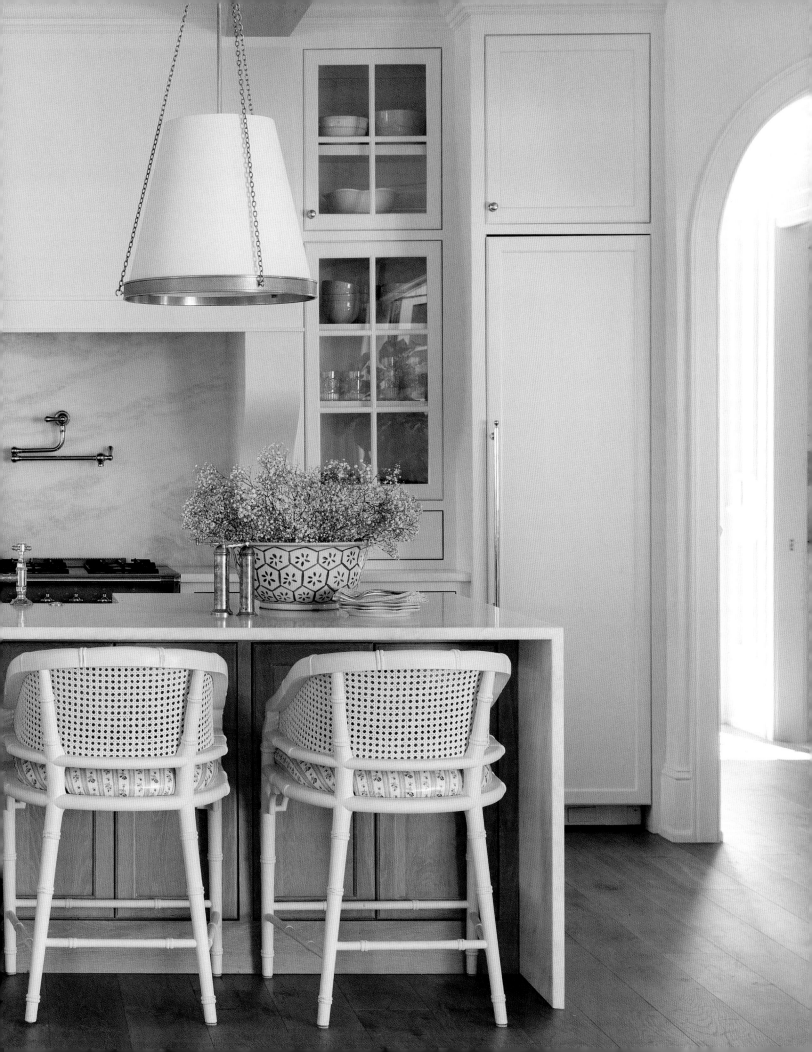

The act of extending an invitation sends out ripples of impact. When we welcome others into our homes, we open our doors to shared laughter, spontaneous conversation, and lasting friendships. These moments weave together to create a framework that establishes and strengthens our sense of community. For entertaining, chairs are often arranged around dining tables, game tables, and coffee tables. Beyond that basic floor plan, the designers represented in this chapter offer myriad suggestions for entertaining successfully. A warm welcome is key, and that should be expressed through the environment. A well-stocked bar, a quirky powder room, flattering lighting, and a cozy guest bedroom or bunkroom all signal to those arriving for a few hours or a longer stay that they can settle in and relax. Knowing that our entertaining spaces are equipped to handle the occasion lays the groundwork for any event.

ENTERTAINING

27

CHANDELIERS

ELIZABETH BOLOGNINO

In interior design, a chandelier serves as more than just a source of light; it embodies the essence of a space. Whether a chandelier exudes opulent glamour or emits a subtle warmth that is felt rather than seen, it plays a pivotal role in defining the ambiance of any setting. As an interior designer, I understand the profound significance of selecting the perfect chandelier for a client's space. The importance of choosing the right chandelier transcends mere functionality; it lies in its ability to elevate the ambiance of a space, convey a narrative, and evoke emotions.

At the onset of any project, I initiate a dialogue with my clients, probing them with a fundamental question: How do you want your space to feel? Their responses serve as the blueprint for crafting or selecting a centerpiece that encapsulates their persona and aspirations. I seek out chandeliers that transcend mere functionality to serve as sculptures— true works of art—and elevate the atmosphere of the rooms they grace.

Beyond mere illumination, a chandelier can shape perceptions and spark conversation. For example, by juxtaposing antique fixtures with modern environments, I imbue spaces with a sense of academic prominence or gravitas. Each chandelier tells a unique story—whether about the space itself or the individuals who inhabit it—leaving an indelible impression on all who encounter it.

I meticulously study how each fixture appears when illuminated and when not illuminated, considering factors such as the type of light emitted—sparkling and twinkling or diffused through materials like milk glass, paper, or crystal. I observe how light refracts and dances upon the walls and ceiling, transforming the room into a captivating spectacle. A chandelier takes on even more significance in a room that benefits from ample natural light. In such a space, a chandelier serves as a focal point even during daylight hours.

In the quest for the perfect chandelier, every detail matters. To ensure harmony, each element is carefully considered, from design and material composition to its ability to evoke emotions and captivate the senses. Ultimately, the chandelier serves as a beacon of personality and style, illuminating the true essence of interior design.

Gabriel Scott's faceted Myriad chandelier casts delicate reflections across the blush lacquered ceiling, finished in Benjamin Moore's Touch of Pink. Clean-lined furnishings enhance the dining room's hushed atmosphere, while the chevron floorboards add a note of tension.

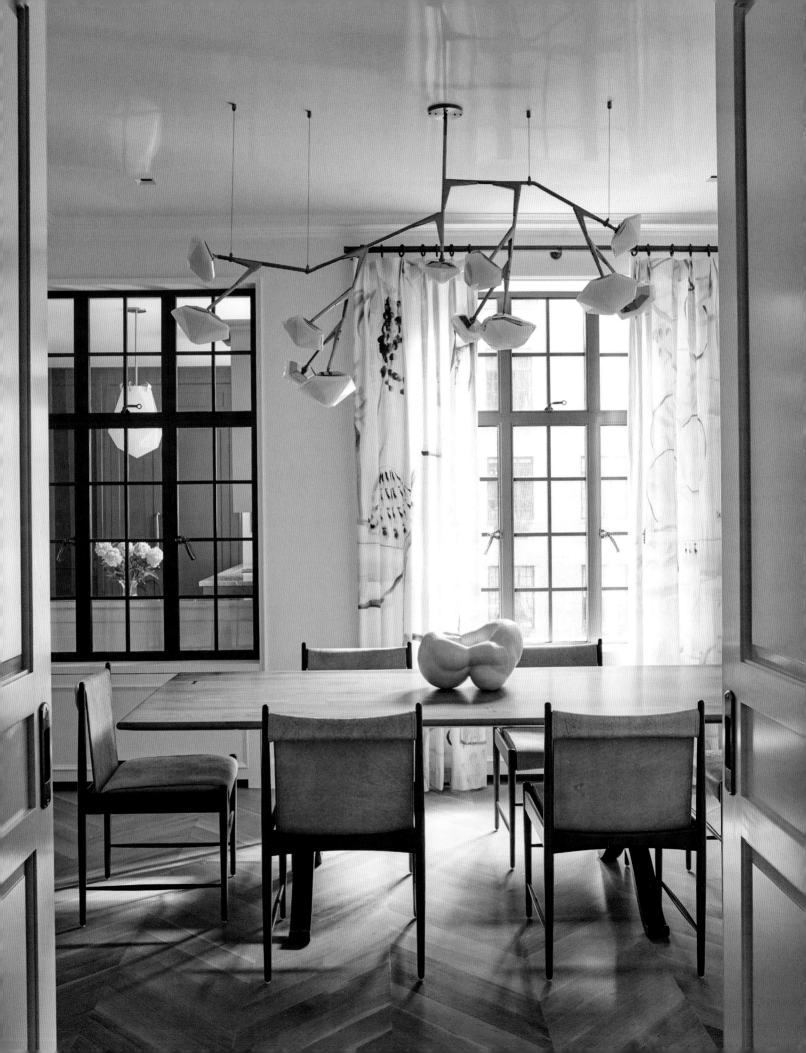

28

CULTURAL INFLUENCE

CAROLINE RAFFERTY

Designing spaces with cross-cultural influences isn't about creating a perfect match; it's about finding unexpected harmonies. A vibrant ancient silk robe, its floral patterns mirroring the textiles on the sofas and chairs, combine to create a sense of unity despite their differing origins. The pairing is a testament to the universality of beauty and the enduring allure of good design.

Interior design, often seen as a reflection of personal taste, can become a powerful storytelling tool by embracing global influences. By weaving together design elements from diverse cultures, a space transcends mere function and becomes a narrative tapestry—the sort of space that celebrates diversity, fosters curiosity about different cultures, and, ultimately, allows us to share a piece of ourselves with the world.

I see every home as a unique and universally relatable story. And each room is a chapter in this narrative that contributes to telling the story: the people who live in the spaces, the objects, and the players who come and go. If done right and well, no two homes are identical, as they comprise a mélange of the elements that distinguish us from each other.

Imagine a living room that tells the story of a world traveler. A contemporary light sits atop an antique writing desk with intricate inlay patterns inherited from an aunt whose travels were captured in the novels she wrote. A vintage patterned rug lies beneath a French modernist coffee table. The walls are adorned with classic chinoiserie paper offset by contemporary art. This fusion creates a dynamic space.

Ultimately, the most compelling stories are personal. A treasured family heirloom from a different culture displayed prominently can spark conversation and reveal the homeowner's passions and heritage. These personal touches tie together diverse elements and create a space that is not only beautiful but also deeply meaningful.

Opposite: Honoring the homeowner's Chinese heritage, this Palm Beach living room in a 1920 Addison Mizner estate is sheathed in hand-painted wallpaper and accented with Chinese porcelains. A mohair sofa mingles with a pair of nineteenth-century bergère chairs.
Following pages: European and Asian antiques include Ming-style mahogany pieces, Scalamandré-covered upholstery, and Chinese Qing dynasty garden stools. The ceiling beams and fireplace are original.

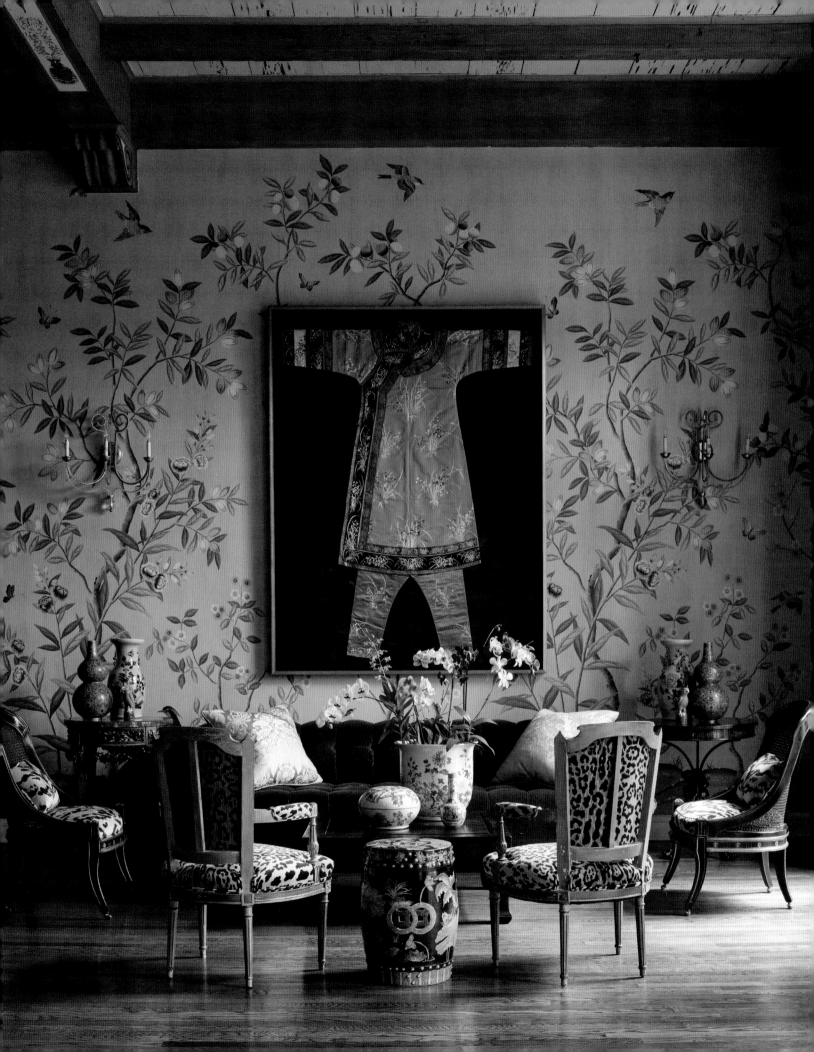

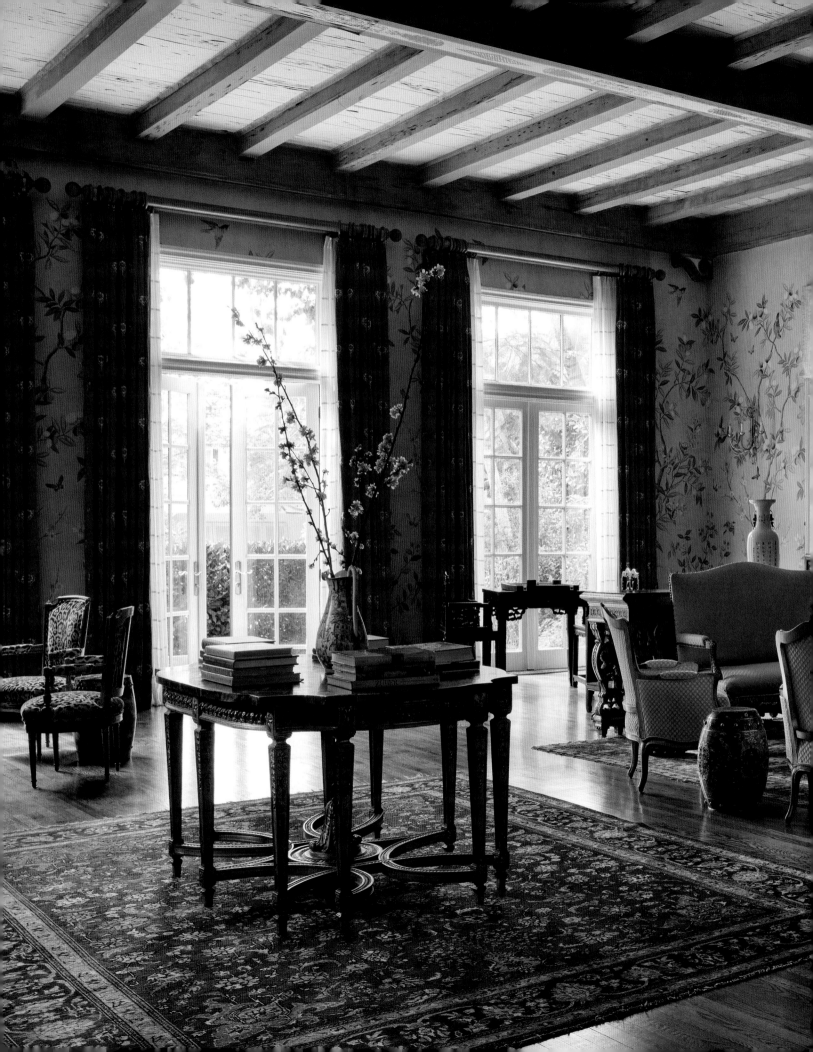

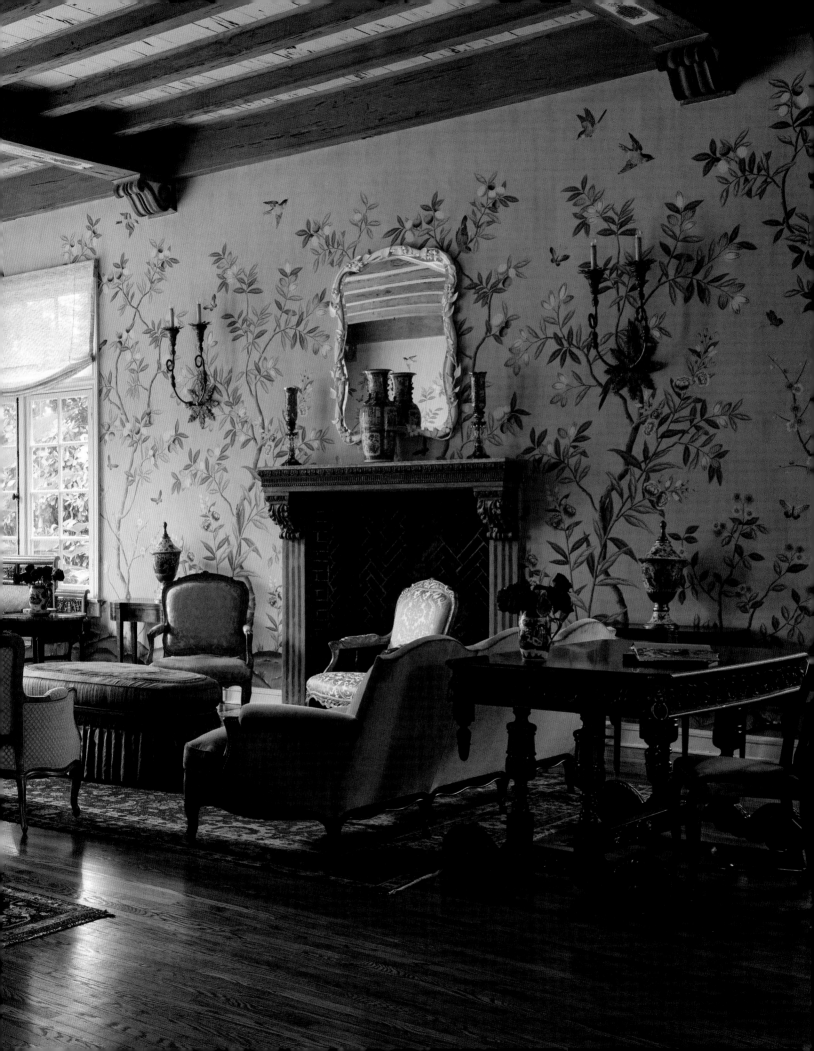

29

BARS

THOMAS JAYNE + WILLIAM CULLUM
[Jayne Design Studio]

Having a bar at home offers a chance to create an escape—a fantasy. A bar can be a daring space, with its own character and personality completely different from the rest of the home. It is a place to entertain guests, but more importantly it is a place where you can vacation in your own home.

Bars come in many different sizes, from an entire room to a small table dressed with bottles and glassware. Hunt around for a space—even a small one—that can serve as an optimal location for a bar, especially if a home doesn't have a dedicated space for it. You can install a petite counter in a closet looking for a new life. A room so small that it would feel awkward with furniture is often a good choice for a bar. Even an underutilized study or den or transitional space can be injected with new life by adding a freestanding bar or simply a bar cart.

Most important is the element of surprise. Wherever the bar is located, visitors should feel like they have arrived somewhere special when they get there.

A bar is versatile and can be as complicated or as simple as you like—plumbing not necessarily required. In terms of functionality, a surface that is durable and easy to cut on—while also being beautiful—is imperative. Inlaying a piece of stone into a fragile counter can enhance function and offers a chance to collage different materials. Even a beautiful cutting board represents an opportunity to add personality.

A bar at home has a different kind of intimacy than a commercial space, and you should adorn it with that in mind. Decorating a bar is like decorating any great room, but you can let your imagination run free—remember that this is an isolated place to have fun. The bar should convey the style of its occupants and contain personal effects like paintings and photographs to make it more convivial and familial. Of course, a bar needs comfortable places for guests to sit, relax, and rest their drinks.

And the great news is that even after everyone has left and you shut the door, your favorite bar is just a room away.

An English rattan bar purchased at auction in Texas anchors this converted library, now an intimate entertaining space. Shelves lined with paper-backed Etro linen store various liquors. The lantern was found at a favorite shop in London.

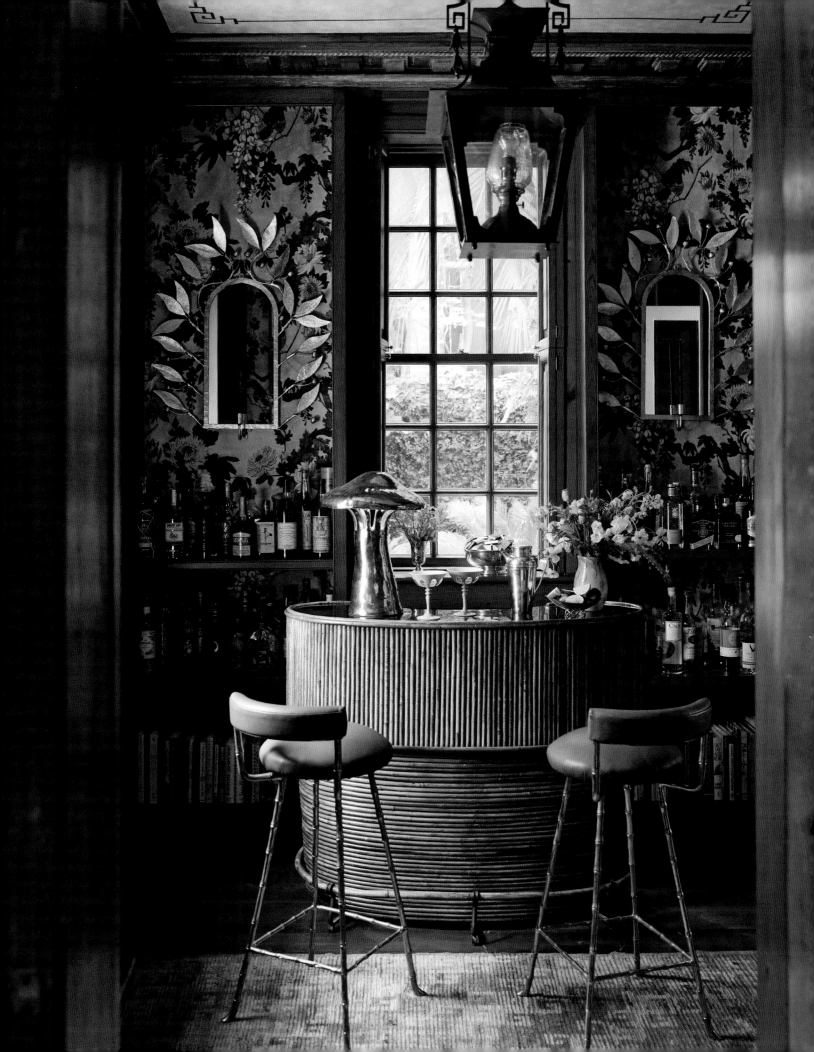

30

CONTEMPORARY ART

DAVID KLEINBERG

I have been fortunate in my career in many ways—the people who have mentored me, the colleagues I have collaborated with, and the clients who have employed me. Perhaps the way I never anticipated being so fortunate was working with exceptional art. Over the years, I have had the pleasure of placing many outstanding contemporary pieces in my projects.

Obviously, interior design is a visual medium, and therefore not drastically unlike the world of fine art. In both the main concern is looking and considering what is being seen. The process of selecting art may sound simple, yet it is open to endless interpretations and variables.

When working with art, paintings, and sculpture, I adhere to the same principles I follow in design: proportion, texture, suitability. I love the contrasts to be nurtured by placing contemporary paintings in a classic environment, much as I like a modern woven fabric on a beautiful gilded eighteenth-century chair. These contrasts draw us in and push us to look more carefully at each object.

Needless to say, art selection is a very mutable process, and I have come at it from many different angles. I have worked with clients who already have extensive collections when we meet and with clients who are just beginning to delve into the somewhat intimidating world of art acquisition. I have worked with art consultants, and I have also been the one to suggest artwork. I've visited galleries and auctions with clients, and I've had a client surprise me with a piece that needs to be placed in the home.

Taste in art is the most subjective thing in the world. Personally I am drawn to minimalist modern paintings. I would sacrifice a great deal to own a work by Agnes Martin or Robert Ryman, but that is my taste, and my goal as a designer is to create a home and environment for my clients, not to impose my own preferences on them. When placing each work, lighting, perspective, and the other pieces sharing the space must be considered.

Methods for displaying art are as varied as artwork itself. In some instances, we have planned the location of every piece as if curating a museum show. In others, I have picked up a priceless painting and wandered around until I found the perfect spot for it. Some artworks beg to be part of a group, while others work best on their own. Needless to say, it is a very mutable process and each variation leads to a hopefully successful result. Don't get hung up on the right way to do things: a Van Gogh can fit perfectly at the top of the stairs leading to the basement, or a Léger may suit a powder room. Art is precious, but we need not be precious about it. It enriches interiors—and indeed, everyday life—and is meant to be enjoyed.

Opposite: In this modernized 1914 Upper East Side residence, the kinetic black-and-white Franz Kline painting *Crosstown* from 1955 holds court, and a Kleinberg-designed custom sofa and lacquer-top table create an intimate conversation area. Following pages: A vibrant Joan Mitchell canvas is hung between Art Deco lacquer doors. Custom upholstered pieces in shades from off-white to barely-there gray create a sophisticated setting for contemplating the seminal artwork.

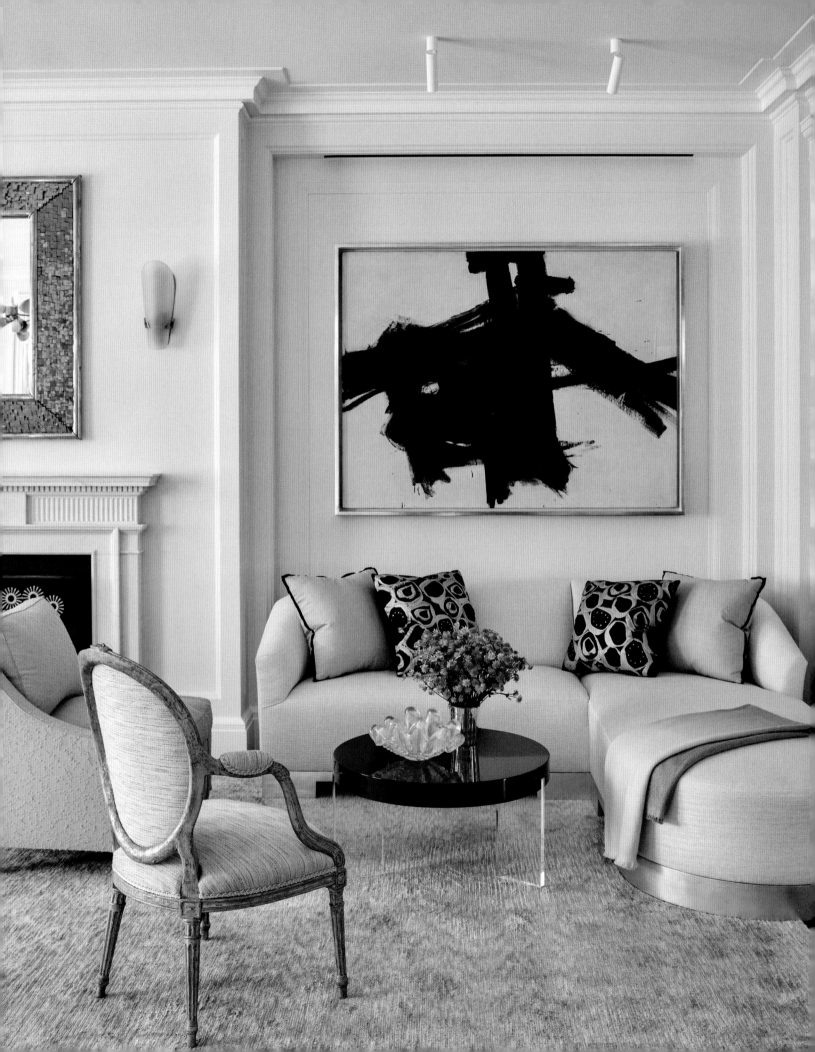

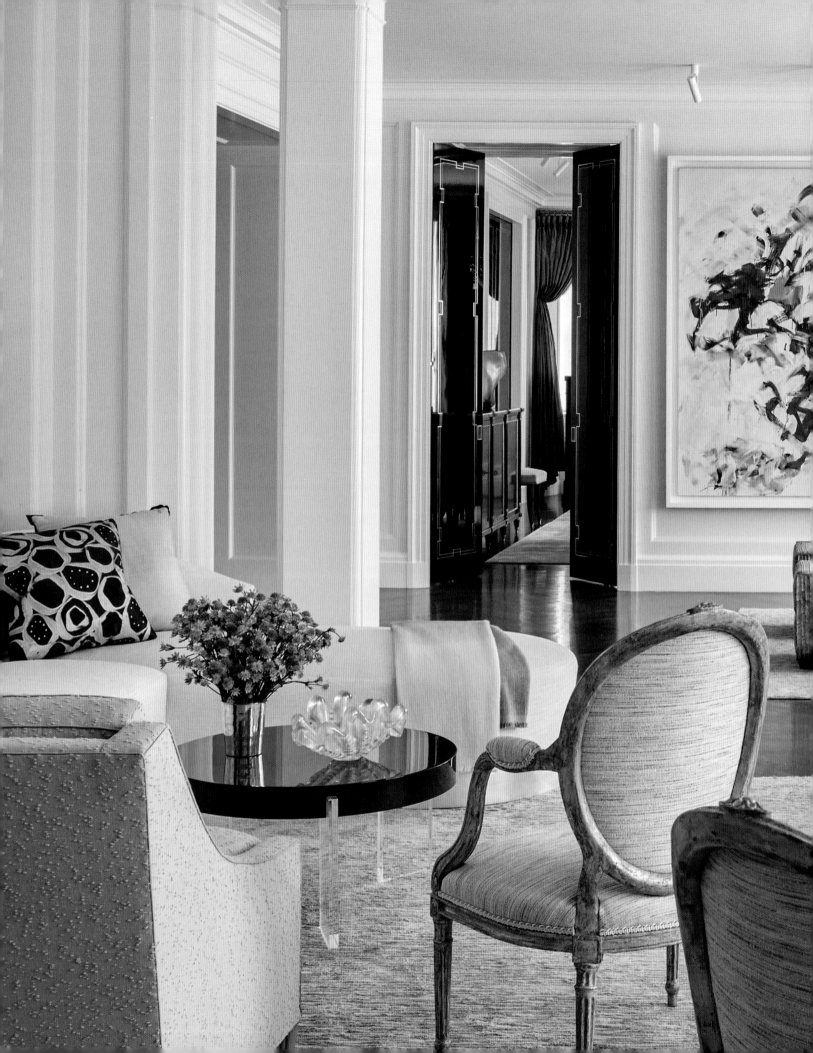

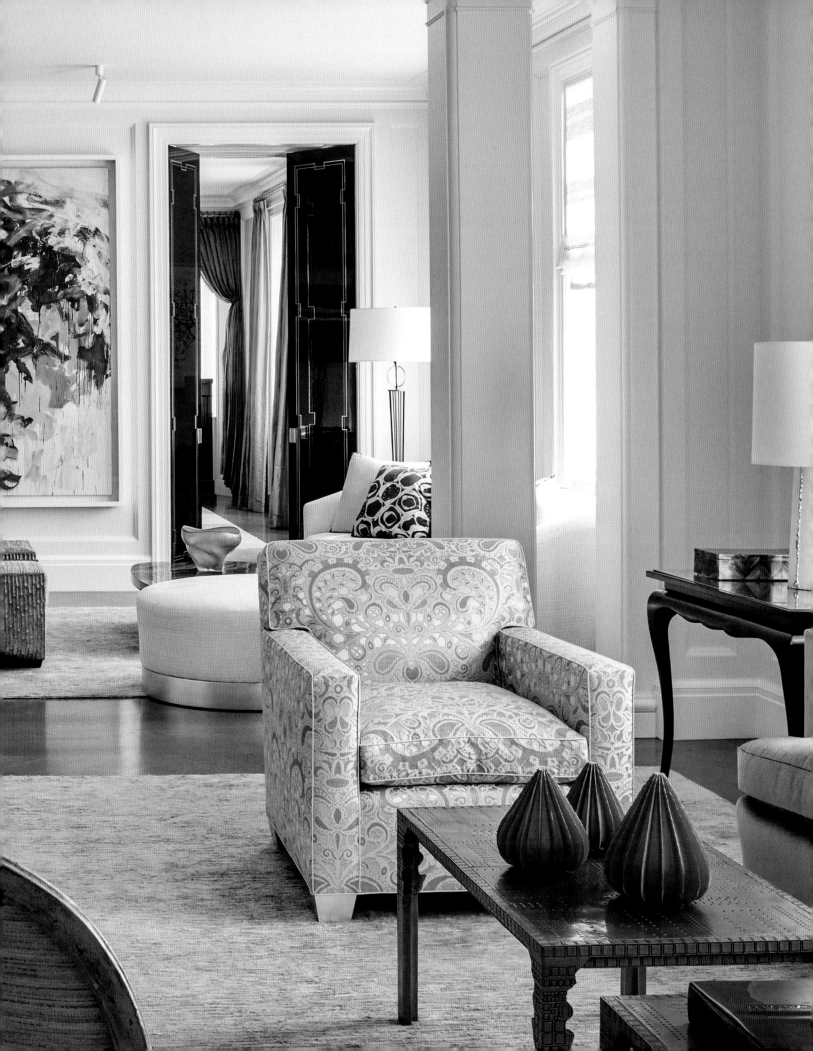

31

WHIMSY

CHARLOTTE LUCAS

Introducing whimsical elements into a home's design adds a playful touch to even the most unassuming spaces. Vibrant colors, mix-and-match patterns, and eclectic pieces infuse rooms with personality and charm. From unconventional furniture shapes to fun artwork and imaginative lighting fixtures, these elements create a lively atmosphere that reflects a homeowner's unique style. This approach to decorating encourages creativity, making every room feel distinct and engaging.

Before the fun of selecting furnishings and finishes begins, it's essential to understand how residents want to feel in the home and, by extension, how they want guests to experience it. If they're interested in sparking joy, choosing the unexpected is a great way to achieve it.

Sometimes, obvious and bold design decisions are the key ingredients to a whimsical room—like painting the entryway in a cheery shade of a favorite color or wallpapering a dining room in a riotous floral print atop a navy ground. Alternatively, lighthearted details provide subtle charm, like a group of plates collected from travels that mix effortlessly with inherited china or a lampshade hand-painted with elements that tell a personal story. The key is to create threads and connect patterns, colors, and design elements that appear in different spots throughout the home, like a jigsaw puzzle that reveals its final image gradually with the addition of each piece.

It's important to be judicious about whimsical elements, though, because taking things too far can feel cartoonish. Balance vibrant choices with more subtle ones, and above all, remember that comfort is key. When family and friends feel welcomed and embraced, post-dinner conversation flows more easily. Creating joyful rooms is essential to balancing the demands of busy twenty-first-century lives. As schedules become increasingly hectic, spaces that radiate positivity and cheer provide much-needed relief and rejuvenation. These spaces serve as sanctuaries to unwind, recharge, and feel grounded. By prioritizing joy and comfort in our interiors, we create environments that enhance our well-being and foster a sense of harmony and balance.

Opposite: Whimsy is all about surprise and playfulness, as exemplified by large-scale cranes that parade across de Gournay's Sarus Cranes hand-painted silk wallcovering in a Georgian home in Raleigh, North Carolina. A chinoiserie-patterned, cut-velvet settee provides seating. Following pages: The sofa and armchair are vintage pieces, refreshed in rich blue textiles that echo the wallcovering.

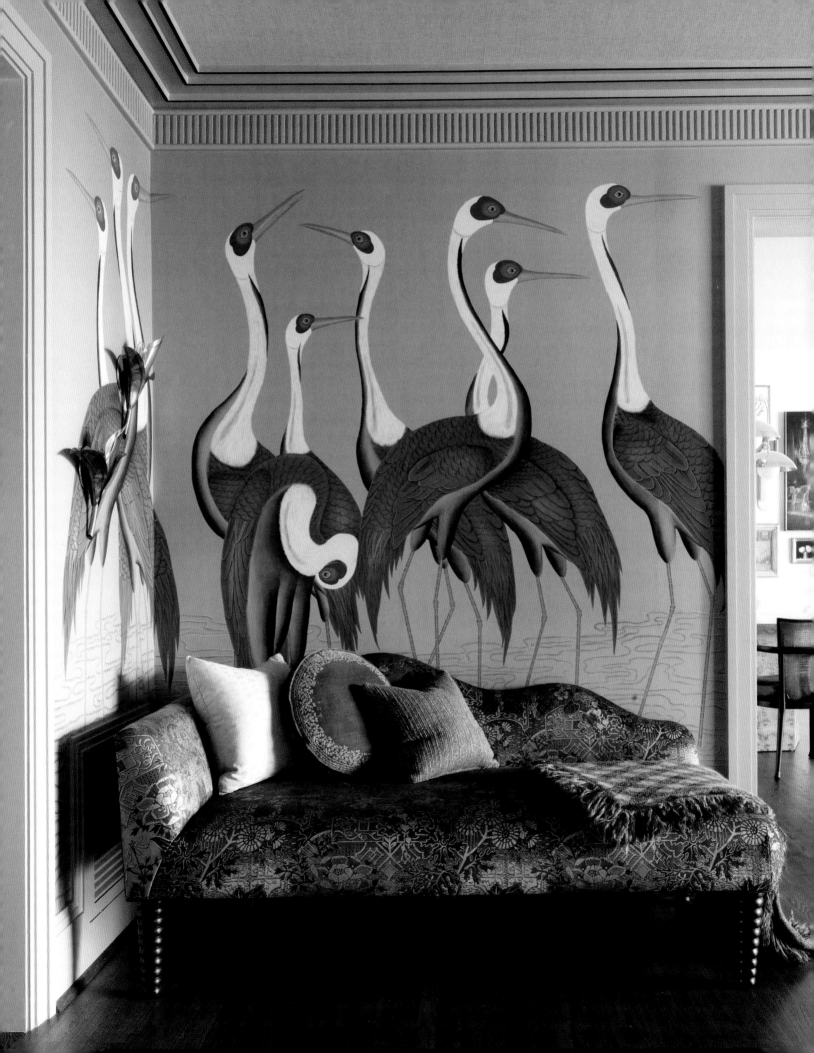

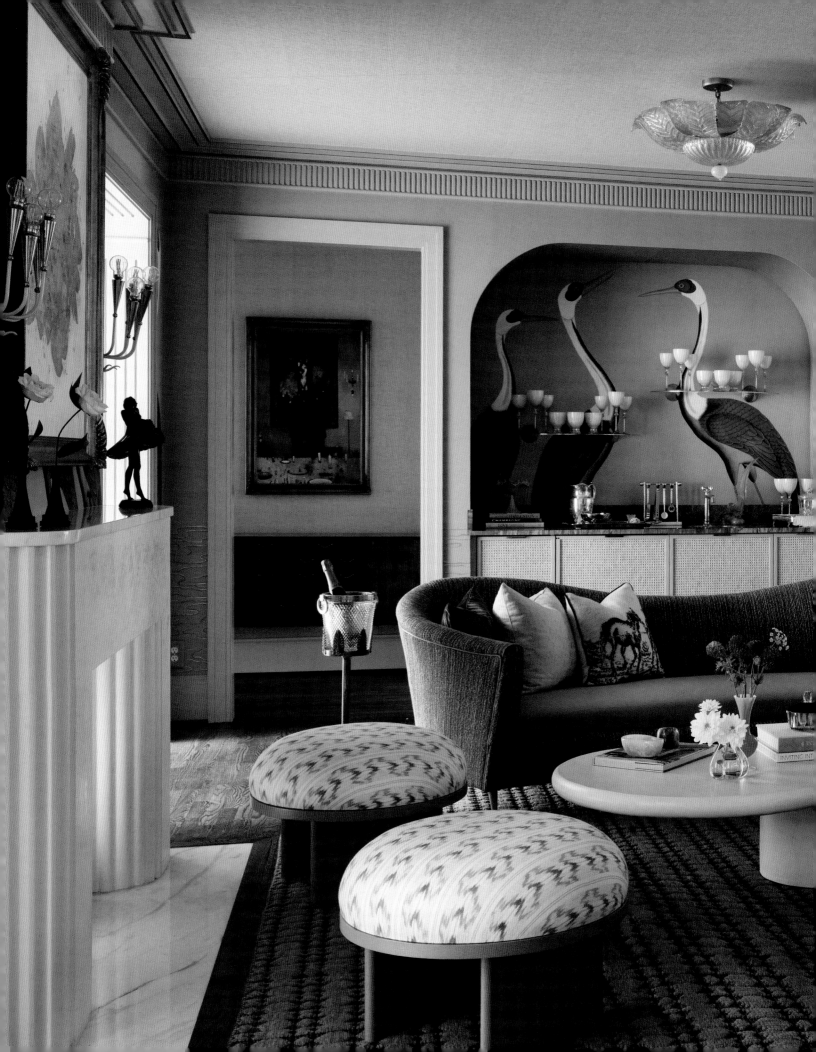

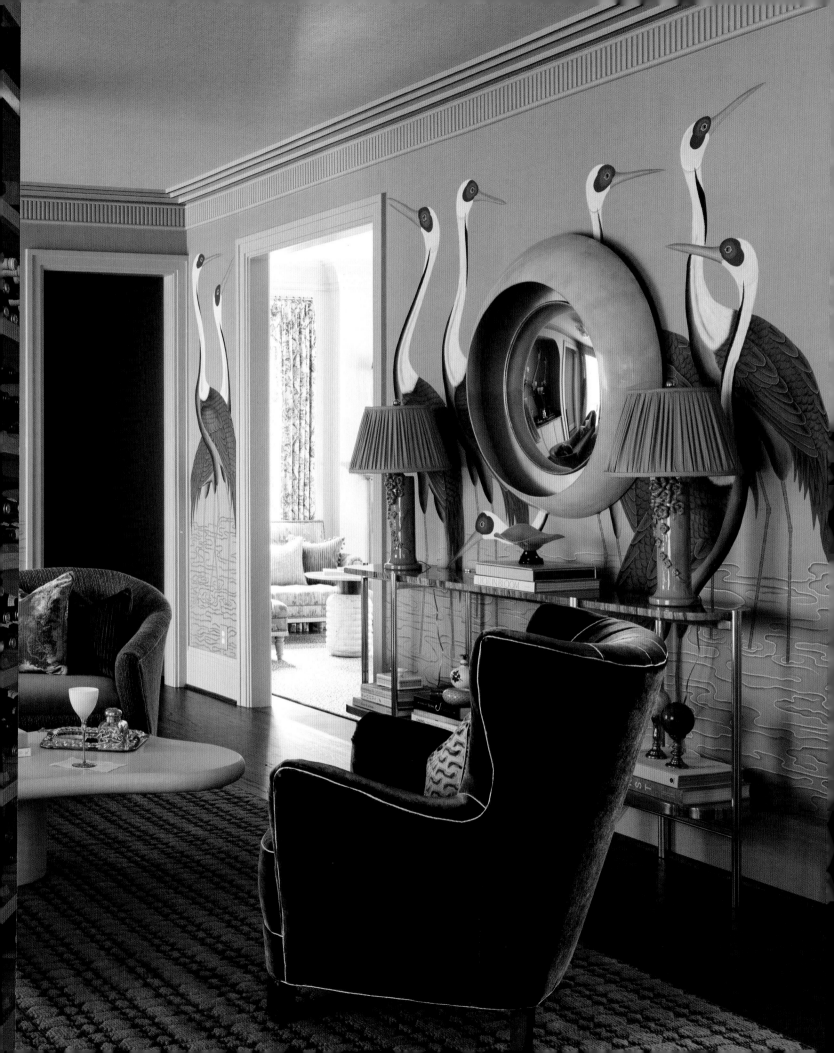

33

HISTORY

CHELSEA HANDEGAN

In my hometown of Charleston, we have a motto: Gut fish, not houses. This prompt is intended as a reminder of the potential negative impact of removing the decorative elements adorning the city's historic dwellings. Such loss diminishes any city's sense of place. In 1931, Charleston was the first city in the country to enact a zoning ordinance to restrict and comment on any development, redevelopment, or addition within its historic district. Other cities followed suit, giving rise to the historic preservation movement.

When designing the interiors of old homes, consideration of their historical elements and rooms is paramount for preserving the integrity of the space. Historic homes, whether modest or grand, often reflect specific architectural styles and cultural contexts, necessitating thoughtful design choices that respect their histories and save them for posterity. To strip a home of its historic characteristics is to strip it of its identity.

Using antique pieces in an older home can significantly contribute to the overall aesthetic and historical narrative. Such furniture not only provides a tangible connection to the past but also adds unique character and craftsmanship that contemporary productions often lack. A successful mix of antique and modern furnishings can celebrate the past while accommodating the present, creating a dynamic and personal living space that resonates with both history and contemporary life. The key is to ensure that the selected pieces have harmonious scales and complement each other, whether through color, texture, or form. The incorporation of antiques not only supports a circular economy by encouraging the reuse and repurposing of furniture, but also helps sustain family legacies through heirlooms, deepening the emotional connection between owners and their spaces.

Right: An antique French iron table anchors the dining room of Handegan's 1854 Italianate Charleston rowhouse. Following pages: The dining room, part of a classic double-parlor floor plan, has 13-foot ceilings, original plaster moldings, and wide-plank pine floors. A pair of eighteenth-century Italian still-life paintings hang between the windows.

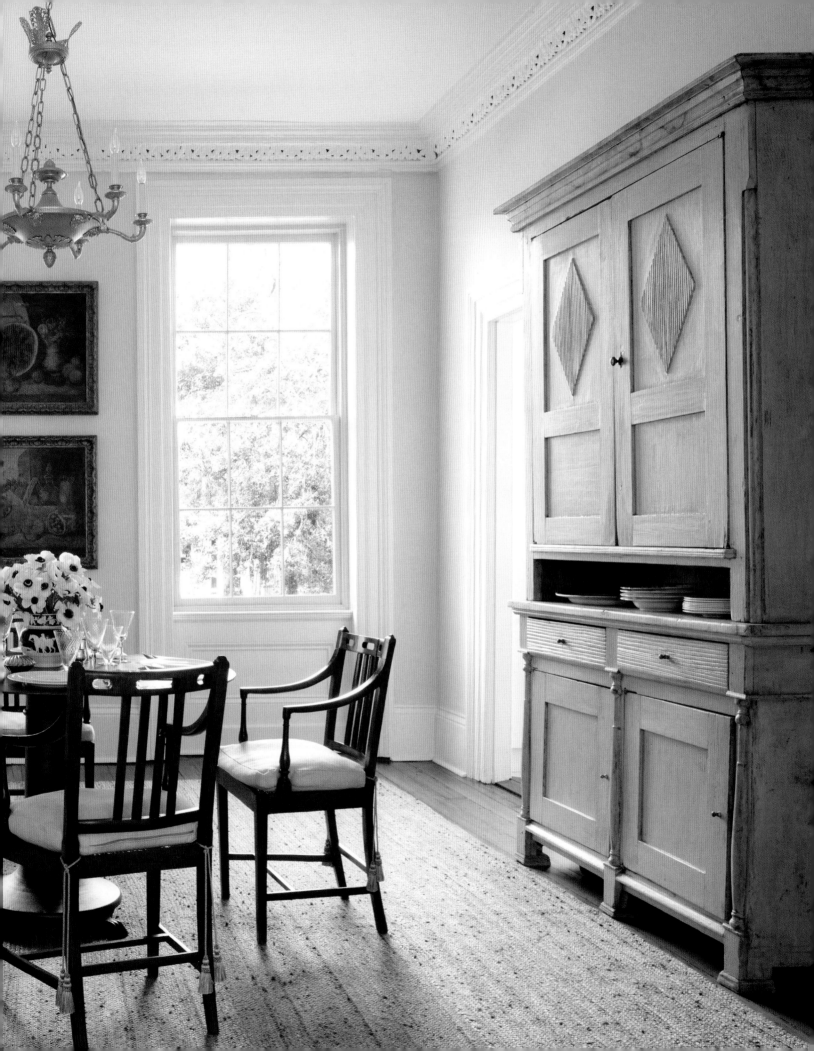

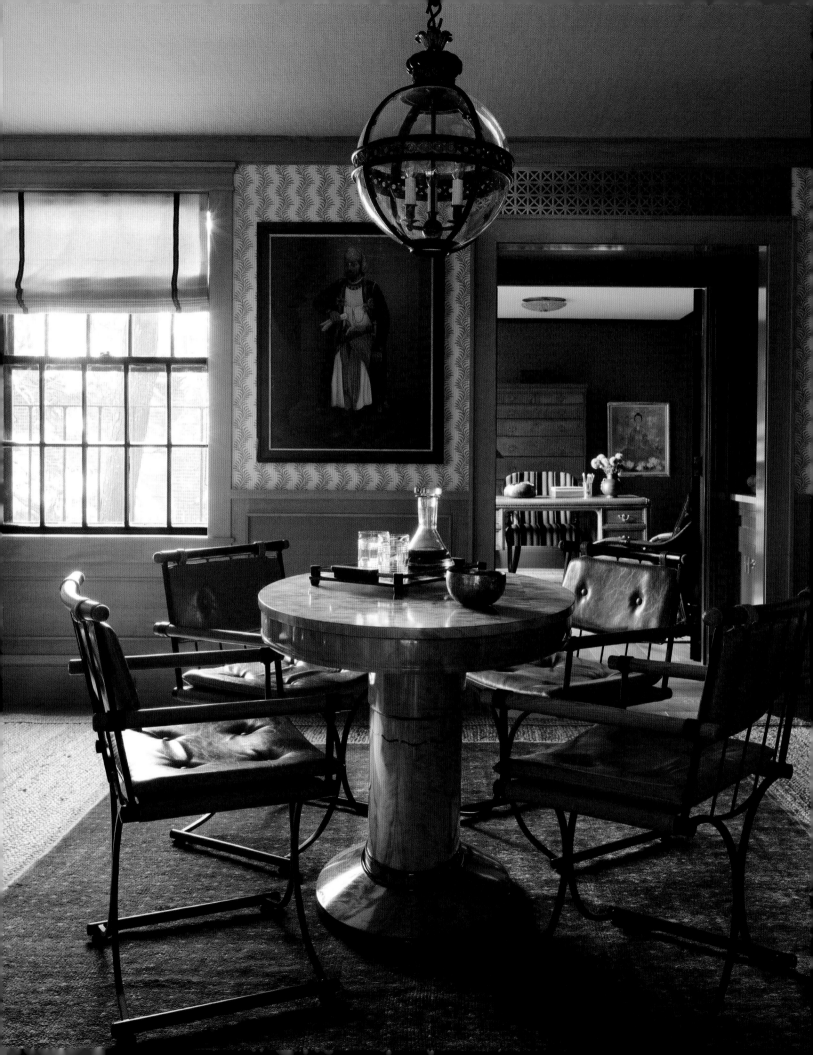

34

ENGLISH INFLUENCE

NINA FARMER

As a designer, I pull inspiration from my travels and from images I pore over of far-flung locales. But whether I'm borrowing ideas from ancient Egypt, imperial India, or mid-century Scandinavia, my job—and my great joy—is to distill the motifs, materials, and overall atmosphere of a place into decor that will work for my clients.

When looking to incorporate aesthetics inspired by the best British interiors, I rely on several strategies. First and foremost, I emphasize layering. I place texture on top of texture, rug on top of rug, and pattern on top of pattern on top of pattern—always mindfully varying the scale of the prints from one to the next so they don't compete.

As for color, I channel the English proclivity for finding subtlety in mixes of even the most saturated hues. Rarely do I combine contrasting or complementary colors. Instead, I work with a smaller arc of the color wheel: greens, yellows, and cognacs, say. The United Kingdom's strong sense of history offers opportunities for references. That translates to interiors dotted with antiques and architecture with neoclassical notes. And I seek out pieces from British designers, artisans, and brands to add authentic, locally sourced ingredients to the mix.

Amidst all these strategies, I focus on a room's purpose, and often its name. The British have and use so many more room types than we do: the snug, the parlor, the games room. Defining your space with a title that conveys its specific purpose, its real reason for being, helps you distill all these elements into a cohesive whole, one that's so much greater—and so much more British—than the sum of its parts.

A Soane wallpaper establishes the decidedly British atmosphere in this parlor in Boston's Beacon Hill neighborhood. Campaign-inspired metal chairs in burnt-orange leather sit easily around an Art Deco table, balanced by a tufted olive velvet sofa. The room's sophisticated layering reflects classic English decorating traditions and the homeowners' Anglophile sensibilities.

35

CONVERSATION

ROBERT STILIN

The late Oscar Wilde wrote, "Ultimately, the bond of all companionship, whether in marriage or friendship, is conversation." And I wholeheartedly agree.

In my work, I create interior spaces conducive to conversation through thoughtful planning and attention to layout and ambiance. The goal is to foster a welcoming environment where people feel comfortable and engaged, encouraging natural and meaningful interactions.

A home's layout is crucial when designing a conversational space. Arrange furniture in a way that facilitates face-to-face interactions. For example, instead of positioning all seating toward a focal point like a television, consider placing chairs and sofas in a circular or semicircular configuration. This arrangement makes it easy to maintain eye contact and hear each other, which means everyone can be included in the conversation. Avoid significant gaps between seats that can make communication feel strained or forced, and ensure pathways remain clear to avoid awkward movements that might disrupt the flow of dialogue.

Comfort is another critical factor. Comfortable seating encourages people to linger, which is vital for extended conversations. Choose stylish furniture that supports good posture and offers cushioning for long-term comfort. Consider a mix of seating options, such as armchairs, loveseats, and ottomans, to cater to different preferences and ensure

everyone has an inviting spot. Adding plush throws and soft cushions can enhance ease and create a warm, inviting atmosphere.

Lighting plays a significant role in setting the tone for a conversational space. Soft, warm lighting creates a cozy, intimate environment that encourages openness. Use a combination of overhead lighting, floor lamps, and table lamps to create layers of light that can be adjusted to suit different moods and times of day. Dimmer switches are a great addition, as they allow easy adjustments of lighting intensity based on the moment's needs.

Acoustics should not be overlooked. A room that is too echoey or noisy can hinder conversation. Soft materials like rugs, curtains, and upholstered furniture absorb sound and reduce noise levels, making it easier to hear and be heard. Don't forget plants, which can also soften a space's acoustics while introducing natural elements that enhance the overall aesthetic.

One final thought: Fostering conversation in the home is essential to counterbalance our screen-focused, contemporary lives. Face-to-face dialogue nurtures deeper connections, strengthens relationships, and creates a sense of belonging. It offers a refreshing break from digital distractions, enriching our lives with meaningful interactions that rarely occur in the realm of technology.

Opposite: In the library of this 1920s Tudor-style home in Lexington, Kentucky, custom bookshelves and textured plaster walls create an inviting backdrop for gatherings. Following pages: In a seating area primed for lively conversation, jewel-toned Giovanni Offredi and Harvey Probber chairs surround a Maria Pergay table. A teal tufted sofa and sculptural stool complete the tableau. Custom Roman blinds soften the interior architecture while filtering the afternoon light.

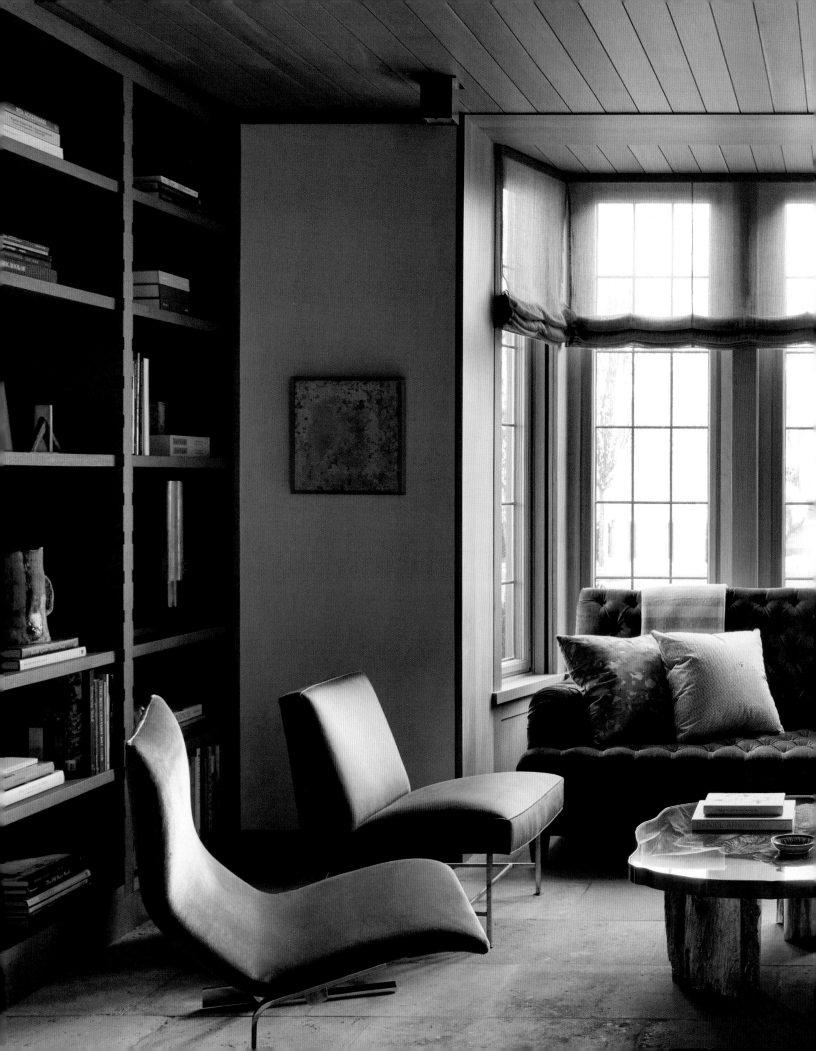

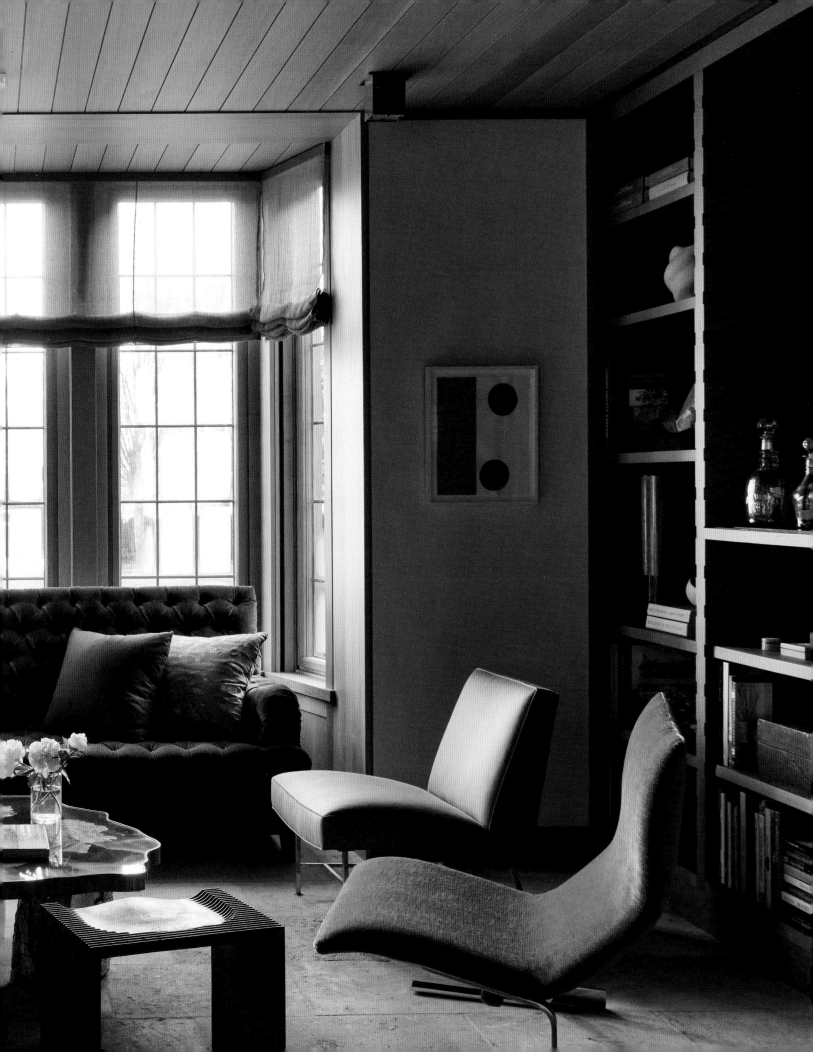

36

RESTRAINT

MARKHAM ROBERTS

Decorating is much like a play or movie: a cast of characters act out the story, and everyone in the story can't be the star. There are major and minor roles, and it is as crucial to know how to use the minor characters to develop the narrative as it is to push the stars into the spotlight for maximum effect.

Restraint is not often discussed in shelter magazines, but it is as important as a harmonious scheme, killer art, proper lighting, or a functioning floor plan. And while print and social media tend to embrace visually grabby rooms that attract attention and likes, the reality is that a room that is subtly nuanced can be just as impactful and even more beautiful than its flashier counterparts.

Knowing where and when to hold back when choosing a finish or a piece of furniture is crucial to giving certain elements importance or visual prominence. For example, if you have a bold and vibrant painting, you don't want to hang it on an equally visually stimulating wall treatment, as that would draw the focus away from the artwork—unless, of course, the painting is hideous and you're actively trying to detract from it.

Always make sure the eye has relief and can pass over the room and focus on certain things without lingering too long on others, at least at first glance. The point is not to give everything away at once. Details and layers can reveal themselves upon further inspection, and it is lovely to uncover new things as one settles in and experiences a room or space.

The concept of restraint can seem simple, or worse, boring, but that's a misinterpretation. A space can still be layered and nuanced and have all sorts of exciting things going on. Restraint makes the whole more effective. After all, you don't want everything in a room jumping out at you, screaming at equal volume for attention. One loud individual in a group—one star of the show, so to speak—is usually enough.

Opposite: Artisan Robert Christian transformed this Nantucket dining room floor with an open trellis design, interweaving stylized petals in blush pink and soft green. A colossal Minton nautilus shell, one of a pair, rests atop a directoire column. Following pages: Red-and-white-striped fabric was meticulously pieced into panels, then upholstered onto the walls. Custom slipcovers in floral linen with tape trim complement the soft white curtains framing the windows.

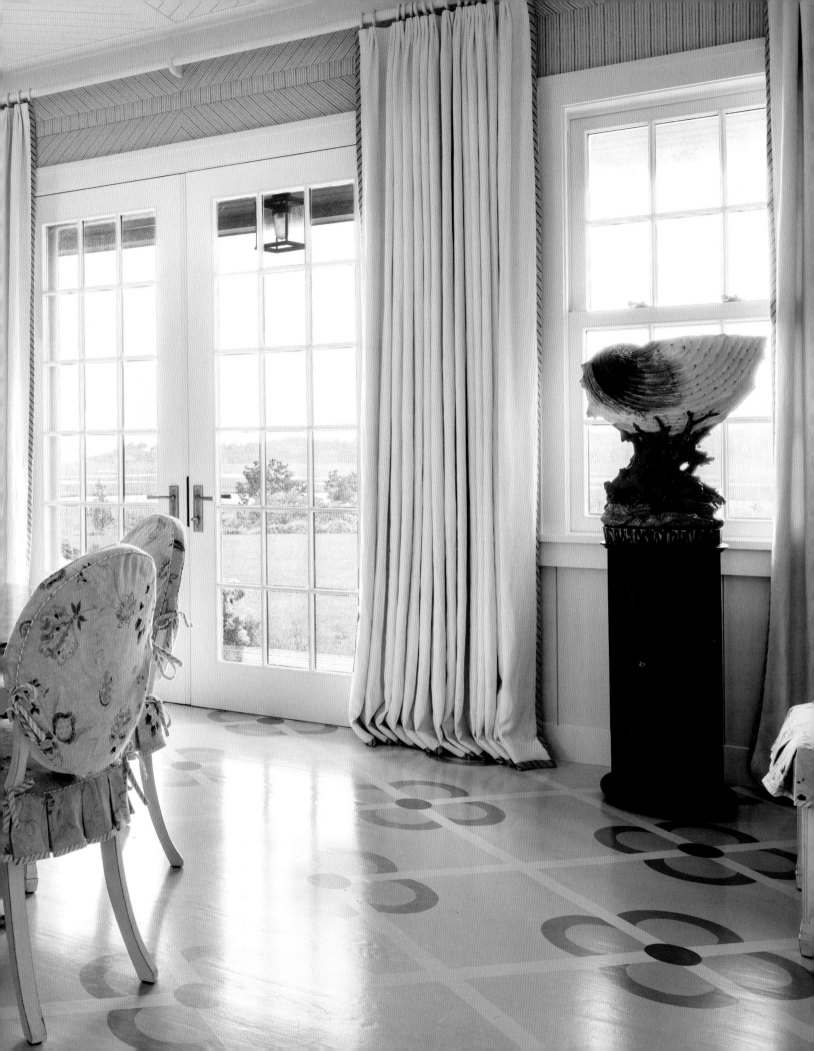

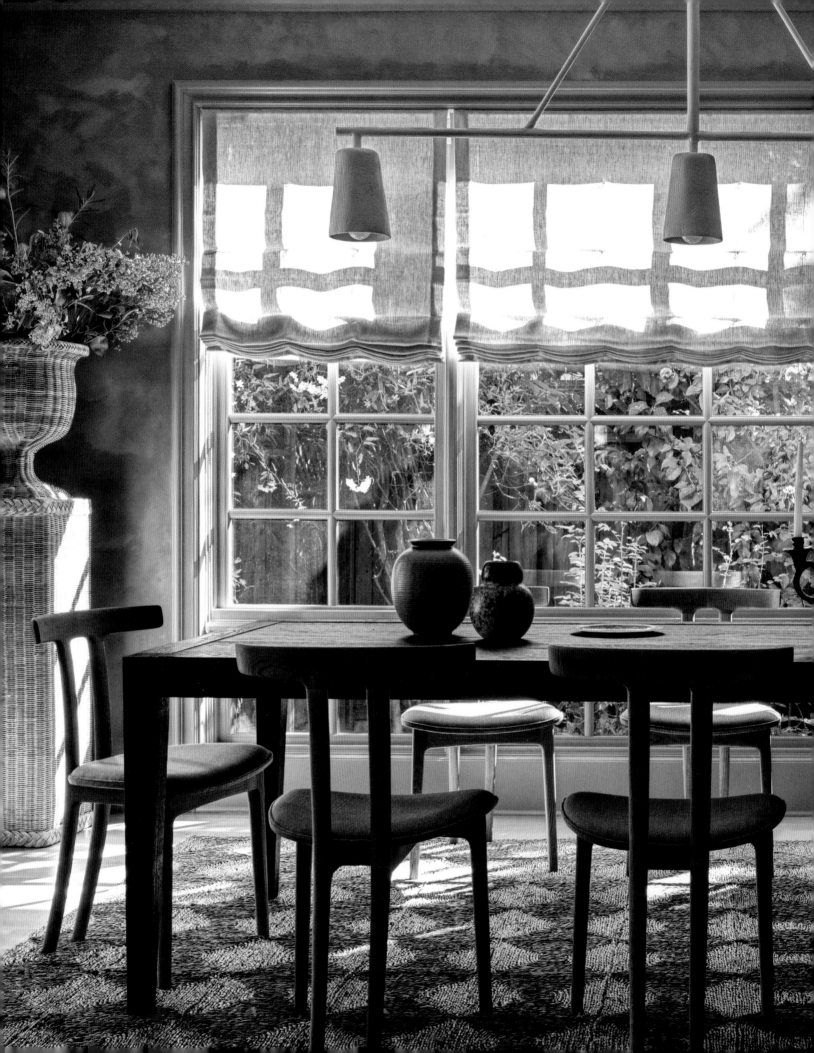

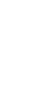

37.

DINING ROOMS

LAUREN WEISS

Throughout history, the formal dining room has been an emblem of sophistication and elegance, a space reserved for lavish dinners and grand gatherings. Adorned with ornate furniture, fine china, and delicate crystal, it epitomizes refined taste and societal status. Yet, as the sands of time shift, so too does our perception of space and its utility. In the twenty-first century, the formal dining room has undergone a metamorphosis. It has evolved into a versatile hub that caters to the multifaceted needs of modern living.

Gone are the days when the dining room was a shrine to formality, reserved only for special occasions and holiday meals. It has emerged as a dynamic space that can seamlessly integrate functionality with style, reflecting contemporary society's changing lifestyles and priorities. The once-isolated dining room now wears many hats: homework space, library, hangout. With the rise of remote work and flexible schedules, it has become commonplace for individuals to transform their dining tables into makeshift offices, where laptops and paperwork share space with breakfast plates and coffee cups.

While formal dining has given way to more casual and intimate gatherings, echoes of tradition still linger in the modern dining room as people seek to preserve the rituals and customs that imbue food with meaning and significance. Whether celebrating holidays, observing cultural traditions, or simply gathering around the table for a home-cooked meal, sharing food remains a timeless expression of love, community, and connection. In this sense, the formal dining room of yesterday may have morphed into a more versatile space in the twenty-first century. Still, its essence—as a place of nourishment, communion, and togetherness—endures, bridging the past with the present and the future.

Mottled moss-green walls conduct a seamless visual dialogue with the garden vista in this San Francisco dining room. Layered natural textures—the woven rattan pedestal and urn, seagrass matting, and light-filtering Roman shades—reinforce the connection between interior and landscape.

38

COLOR PALETTES

KATIE RIDDER

I think of creating a compelling color palette like a chef might think of combining ingredients to create a delicious dish. I gather the colors together and study them—subtracting when one is not exactly correct and adding a new shade if I think it will enrich the scheme. When you get it right—when the risotto is perfectly seasoned or the colors for the living room are glorious—a marvelous sensory experience results.

Where do I look for color inspiration? Travel comes to mind first. On holiday, color inspiration is everywhere.

Italy is a place of rich history and vibrant hues. The terracotta and ochre facades of ancient ruins and the lush greens of its verdant landscapes cannot help but inspire.

India's textiles proffer another vivid palette—this one with brilliant reds, pinks, and oranges, or the deep blues and greens of elegant silk saris adorned with peacock embroidery.

The color palette across Scandinavia, with cool, serene blues and grays reflecting Nordic waters and skies, is complemented by crisp whites and soft pastels that echo the region's minimalist design and natural light.

Gardens are another revelatory place to observe color.

The breathtaking shades of bearded irises range from deep purple and royal blue to vibrant yellow and pure white,

creating a stunning display. Bend down and quietly observe their sophisticated textures.

The same could be said for the myriad shades of peonies that burst forth in the spring—and the geometric symmetry of dinner plate dahlias in a cutting garden in fall.

I call on all these memories when devising the color palette for a home, and I rely on a few simple yet essential rules.

No two rooms in a house should be the same color unless it's a creamy white that serves as a backdrop for all the other colors.

With adjacent rooms in different colors, it is imperative to understand the underlying tones that allow for visual flow as you traverse the space. For example, Prussian blue paint in a dining room will have just a tinge of violet; beyond an archway, the library next door could be lacquered aubergine with a hint of violet, too.

Finally, listen to your intuition. If you've always wanted an apple-green bedroom, why not sheathe it in the perfect shade? Be daring; have fun. The most memorable rooms I have seen are spaces where bold palettes spark emotions: excitement, joy, contentment, and serenity. And revisiting my chef analogy, aren't those feelings the spice of life?

Opposite: A generously scaled sofa, upholstered in color-drenched velvet, nestles alongside a down-filled club chair dressed in Pierre Frey fabric—a favored spot for the designer's dachshund. Following pages: A vintage Oushak, purchased from the Dodie Rosekrans auction at Sotheby's, graces the floor in the designer's Millbrook, New York, living room. The walls are covered in a rose-hued de Gournay paper, while complementary olive-green curtains frame the windows and doorway. The matching arch-topped valance was custom embroidered by Penn & Fletcher.

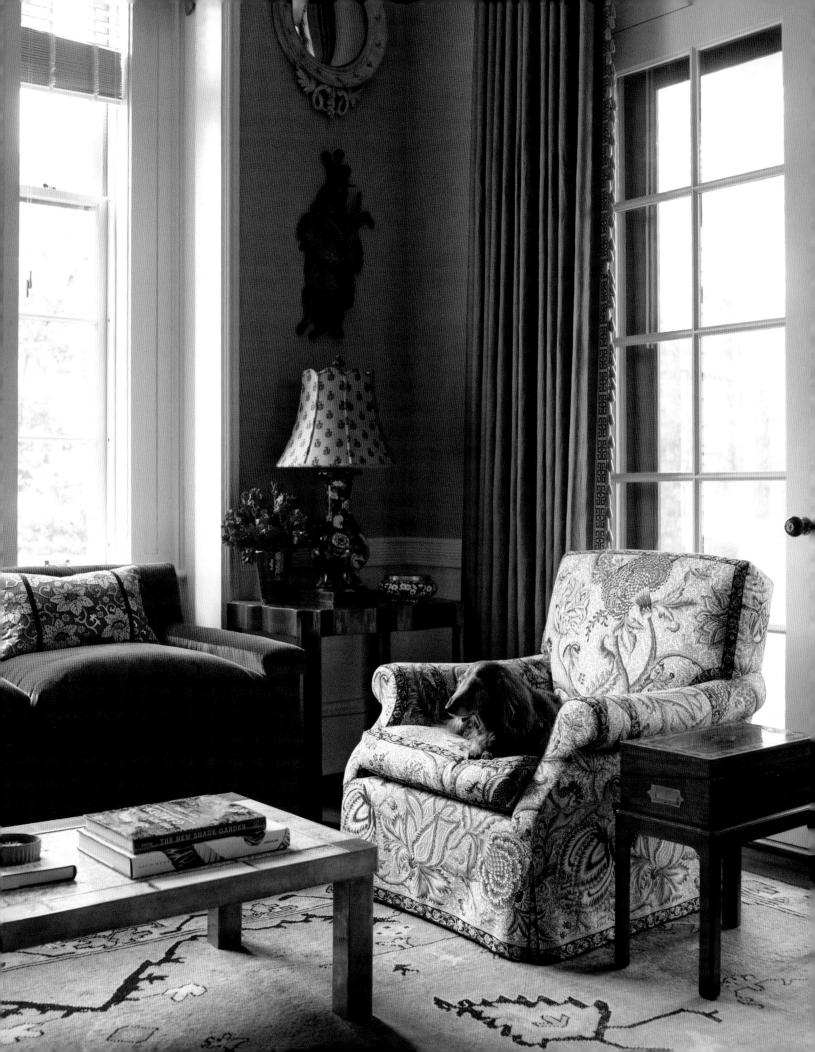

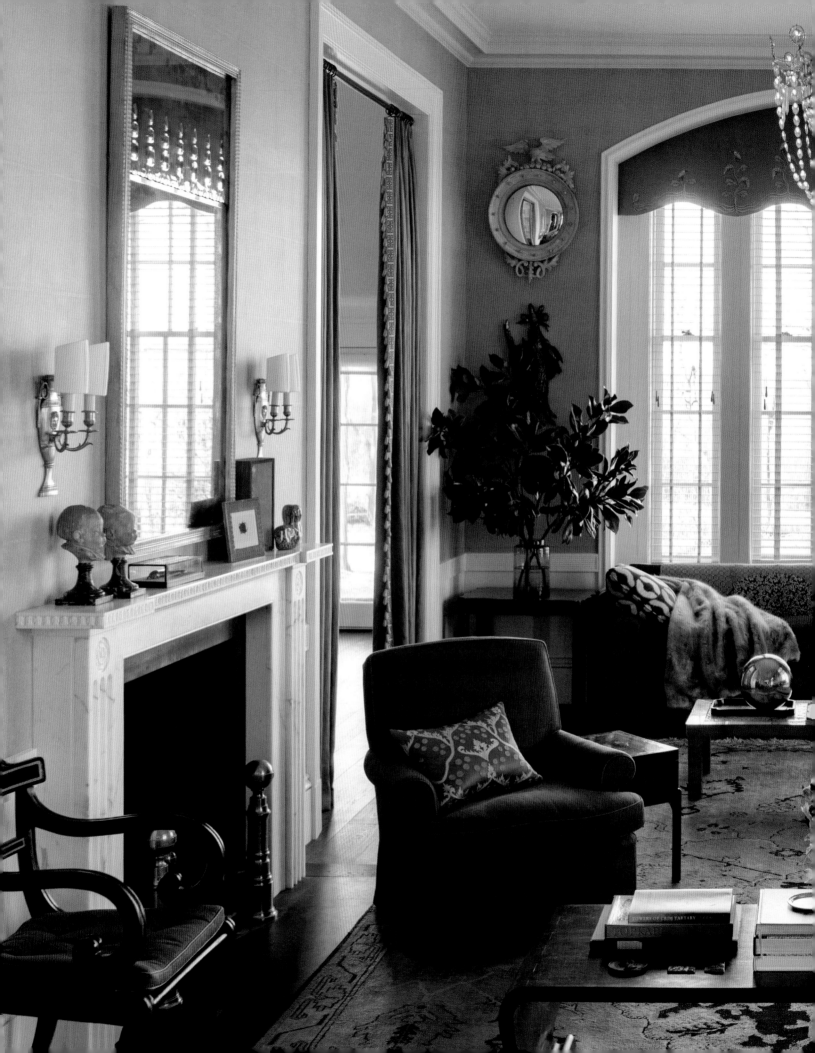

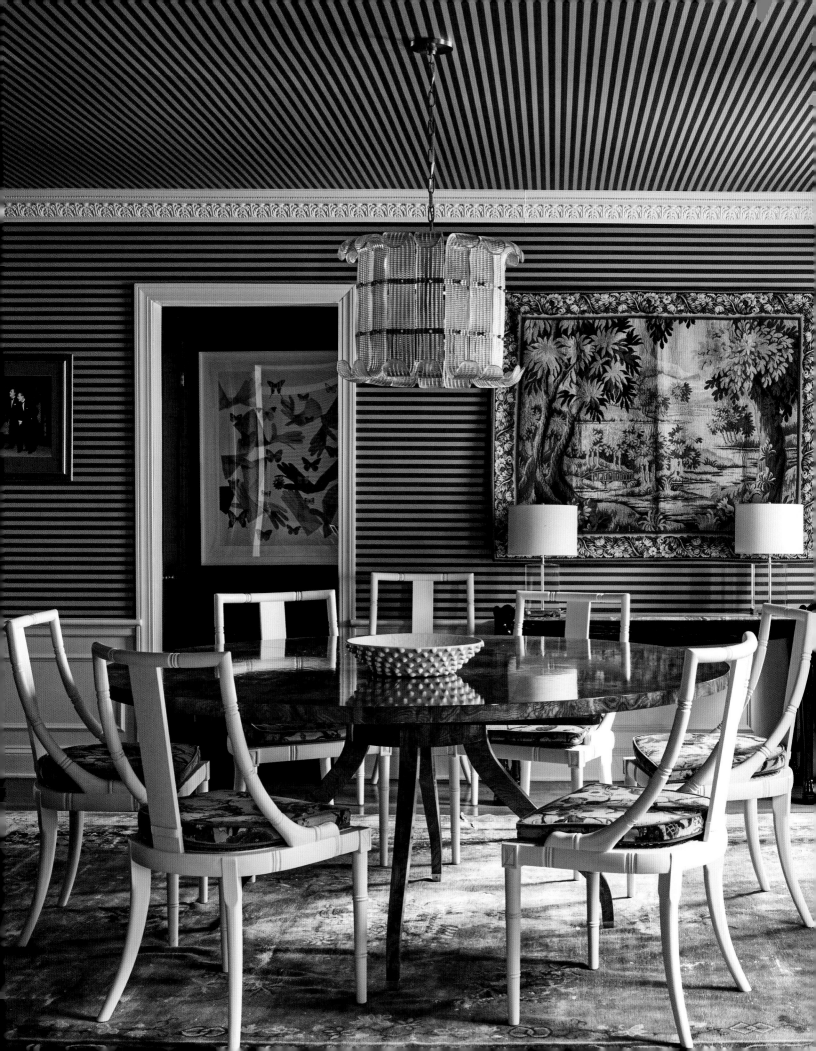

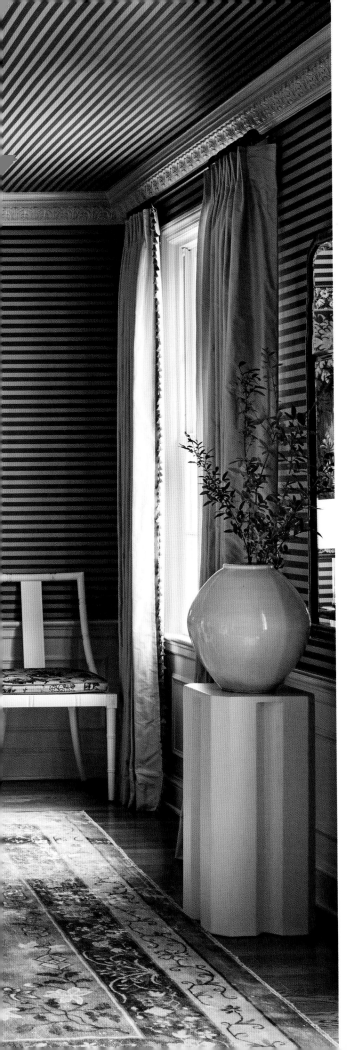

39

WALLPAPER

ZOË FELDMAN

If paint is the ultimate bandage for architectural imperfections, wallpaper comes in a close second. It can imbue interest, softness, and texture and even dampen unwanted ambient noise. When selecting wallpaper, I use a few guiding principles.

Start with light. How does it interact with the space throughout the day? Am I using wallpaper to brighten the space or embrace its moodiness? In open rooms, soft colors and subtle textures prevent a cavernous feel. Consider wool, grasscloth, and small prints like ticking stripes. I embrace rooms with little natural light as an opportunity to engage saturated tones. Rather than fight a dark space, I lean into it—fully cloaking the walls and ceilings and choosing a floor covering in a similar tone for an enveloped feel.

Use also influences my decision. High-traffic areas, such as hallways and playrooms, benefit from textures or patterns that camouflage wear and tear, or non-woven materials that can be cleaned easily. Conversely, formal and less-used spaces like dining and powder rooms can showcase more delicate materials, such as silk and hand-painted papers. Get creative with daring colors and patterns—wallpaper can stand as art in its own right.

I also create tension with scale and motif. A delicate room can be balanced with a strong stripe on the walls; a modern space softened by a botanical print. In historic homes, I am often up against architectural idiosyncrasies (and in new builds, lack of architectural interest). Patterned or textured wallpaper disguises imperfections and creates presence. A white box turns bespoke when wrapped in a funky toile. Disguise unsightly soffits with an all-over ditsy pattern.

I frequently note that those who know the rules may break them. Now that you know my wallpaper fundamentals, abandon them strategically to create a space just wrong enough to feel right.

Graphic Farrow & Ball striped wallpaper is arranged to run in oppositional directions. Above, the Murano chandelier harmonizes with the room's linear elements; it adds a subtle dimension to the scheme.

40

GAME ROOMS

SUMMER THORNTON

Traditionally, game rooms have been pretty staid due to sad and dark color palettes, too much plaid, and a lack of sophistication. I love designing game rooms because it allows me to turn all that on its head. A game room should not only reflect the rest of the home but take it to the next level. Why not go bolder and more avant-garde in the game room? It's a place for entertaining and should be a wow! Game rooms, after all, are about having fun and letting loose—allow the design scheme to take the lead in setting that tone.

In game rooms, there is typically a lot going on, whether it houses a bar, a pool table, TVs, golf simulators, or all of the above. That busy feel can stand up to an intense tonal palette. Start with fantasy. What is a truly exciting color? Intense indigo? Yves Klein blue? Hermès orange? This is the place to go wild. The game room is the new powder room.

From there, fulfill all the practical needs but make the solutions feel elevated. A sleek bar with plenty of storage and a busy stone surface to conceal spills. Lots of seating sprinkled throughout the room to give a bar-lounge feel but with better fabrics. And don't forget the art. Use this space to show off a prized piece and leave the dogs playing poker in the attic.

Consider a prime location for the game room. Gone are the days of relegating these spaces to the basement. A game room can be located off of a living room, near a pool, or on a top floor with a great view! Giving this space pride of place in a public area of the home allows entertaining to follow a natural progression.

When decorating game rooms, avoid clichés. It's fine to include a pool or ping-pong table if clients play, but they're not requirements. There is no rule book that says a game room needs to look like a regression to college days. Let the room speak to where clients are now and put their best and boldest foot forward!

Opposite: In this game room, Jean-Michel Basquiat's *Catharsis* hangs above two chic banquettes made from mahogany, brass, mohair, and leather. Following pages: Walls are lined in custom-dyed Yves Klein–blue silk, which adds beautiful sheen and depth. Varying shades of blue repeat throughout the space, from the upholstery, curtains, and rug to the felt on the pool table.

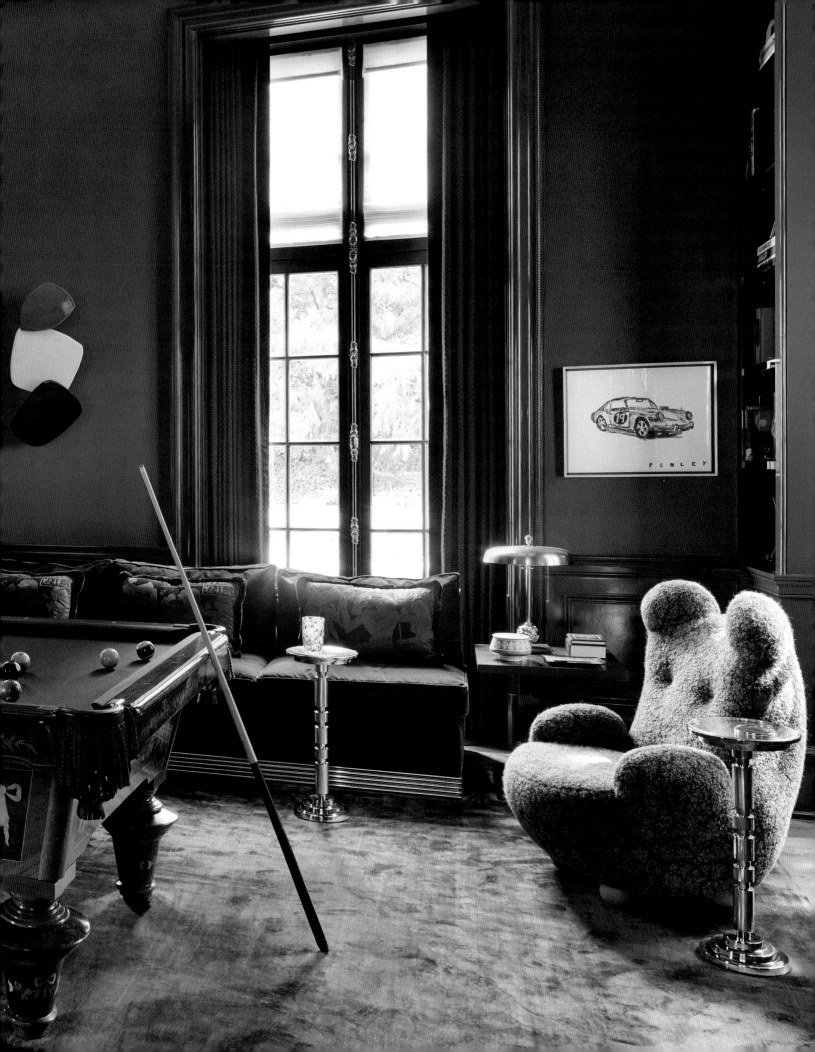

41

GUEST BEDROOMS

RYAN LAWSON

Today's guest bedrooms usually do double or even triple duty as rooms for hosting visitors as well as for studying, exercising, or television watching. The utility of dual function overtakes the luxury of having a bedroom sit empty, awaiting the next overnighter.

But at their best, guest bedrooms are not merely utilitarian. They are unique in the context of your home—both a place of refuge for guests for a night or two (or even longer) and a reflection of your personality and sensibilities.

To establish a welcoming atmosphere for guests, a few basic elements are critical: a comfortable bed, cotton or linen sheets, two good pillows per guest, a bedside lamp with warm and dimmable light, window shades, and a phone charger on the bedside table. Additionally, if the room is used for fitness pursuits or studying when it is not occupied, be sure that there is sufficient storage to tuck away dumbbells and textbooks when friends and relatives come to town.

Beyond those essentials, more meaningful choices await.

Crafting a space and an experience that departs from a guest's everyday life is the goal. The room should invite them to indulge in your vision of beauty and hospitality. Aim for a blend of familiarity and novelty to transform a short stay into something specific—they are, after all, staying with you and not with someone else.

Give the room a distinct point of view—unique to you and the space itself. Consider the color story. Choose artwork and objects that are personal. Leave a few favorite books and a little note on a table. Give the room a scent that will remind guests of their visit. Send them home with a favorite tea or bottle of wine shared during their stay.

Create a space that feels like a natural extension of the home while, at the same time, offers an enriching and memorable experience for guests. The room does more than provide them with a place to sleep—it offers a glimpse into your private world and leaves a lasting impression long after their stay has ended.

Opposite: This guest suite glows in deep yellow from Ressource Paints and is crowned by a headboard wrapped in an antique suzani textile. A vermillion rug grounds the bed, while Holland & Sherry linen portiere curtains soften the doorway. Following pages: A triptych by Frank Porcu presides over the sitting area, where deep club chairs and a velvet-clad Bridgewater sofa cradle visitors in creature comfort.

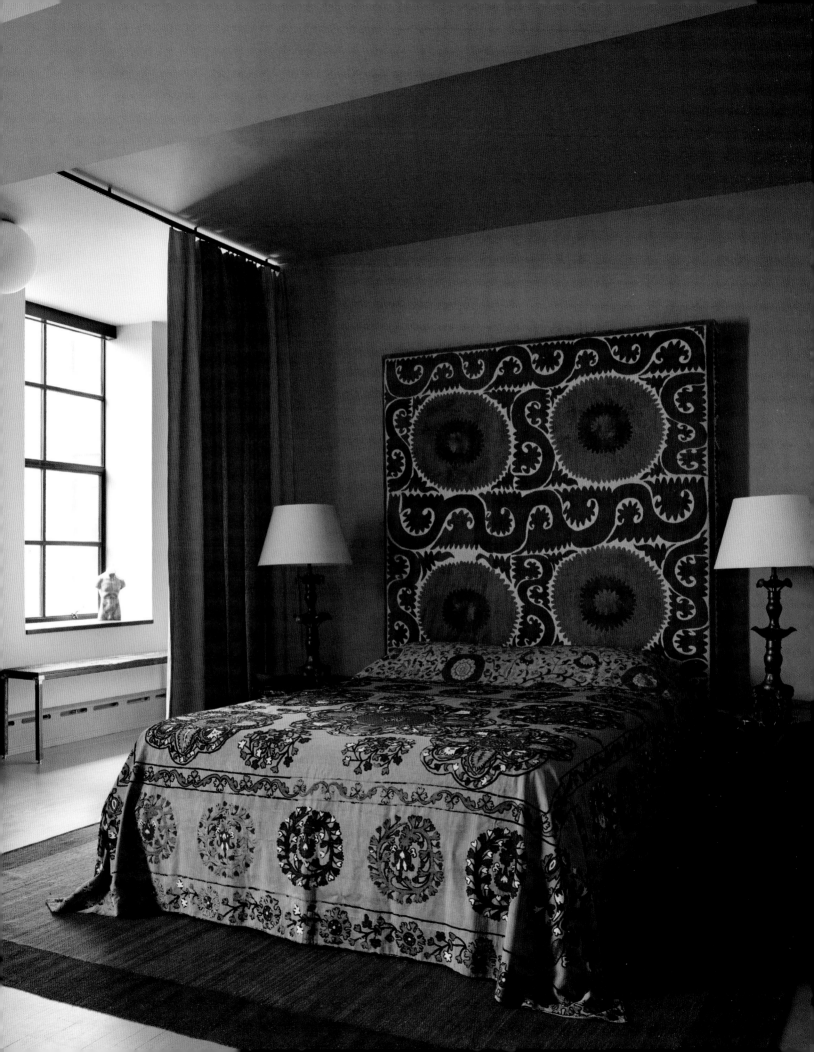

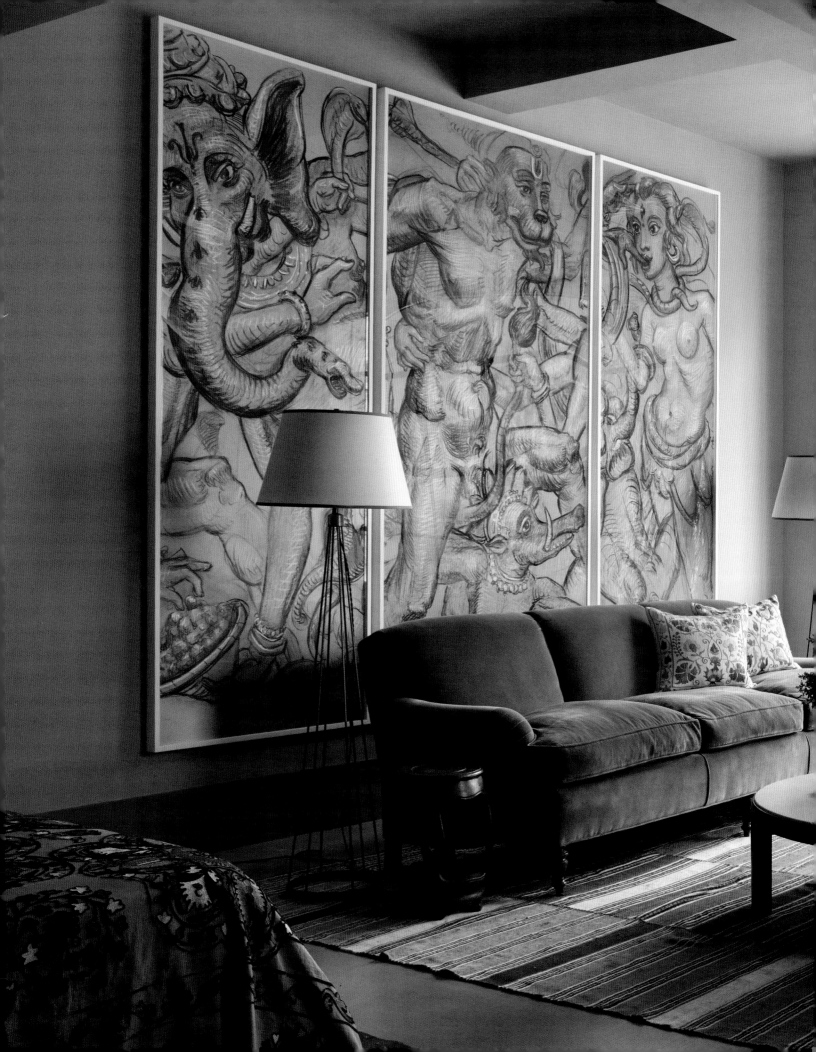

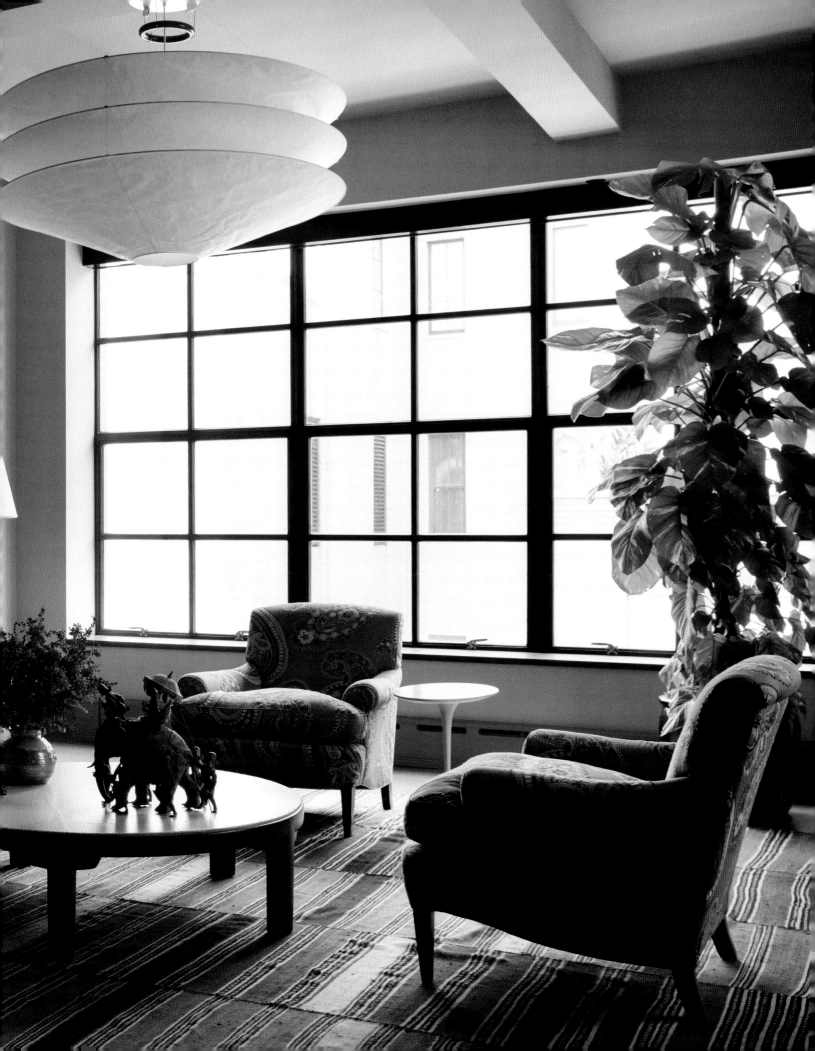

42

POWDER ROOMS

AMANDA NISBET

Designing and decorating a powder room presents a unique opportunity to blend functionality with fantasy. Often relatively small, these tiny rooms are the optimal places to bend the rules and have fun. Practicality coupled with aesthetics ensures a visually striking yet comfortable room.

The first step in designing a powder room is optimizing the layout. Given the typically limited square footage, careful consideration must be given to the placement of fixtures. A compact sink, wall-mounted toilet, or a corner vanity can maximize space without compromising function. Recessed niches, pretty containers, and well-designed shelving can store essentials, keeping surfaces uncluttered.

Choosing the right materials is crucial, especially in a small space where every detail is magnified. High-quality materials such as marble, granite, or porcelain can elevate the room's luxury. The flooring should be durable and moisture-resistant; options like tile or stone are stylish workhorses. Walls provide an excellent opportunity to introduce depth through bold wallpaper, textured paint, or wainscoting, which adds architectural interest.

Lighting plays a critical role in the ambiance of a powder room. Of course, windows let in natural light, which is always best. But artificial lighting also plays a part, and it becomes even more vital in powder rooms without windows. Layered lighting, with wall sconces flanking the mirror and an overhead fixture, creates a well-lit space that's flattering. Dimmers can be added for adjustable mood lighting, allowing the room to transition from bright and airy to soft and intimate.

Regarding color and decor, powder rooms offer a license to be daring. While lighter hues can make the space feel larger, deep, rich tones or vibrant colors can add drama and sophistication. A statement piece such as a unique mirror, an eye-catching faucet, or decorative art can be a focal point. Don't be afraid to experiment with patterns, texture, and scale, as this is a room where you can let creativity shine. Whatever the look, this is the place to have fun!

A butterscotch onyx vanity—echoing the adjacent library's wood tones—centers this jewel box powder room. Bronze-and-teal-toned damask wallpaper provides an old-world backdrop for an oversized brass pagoda fixture, transforming the intimate space into a sanctuary of decadent whimsy.

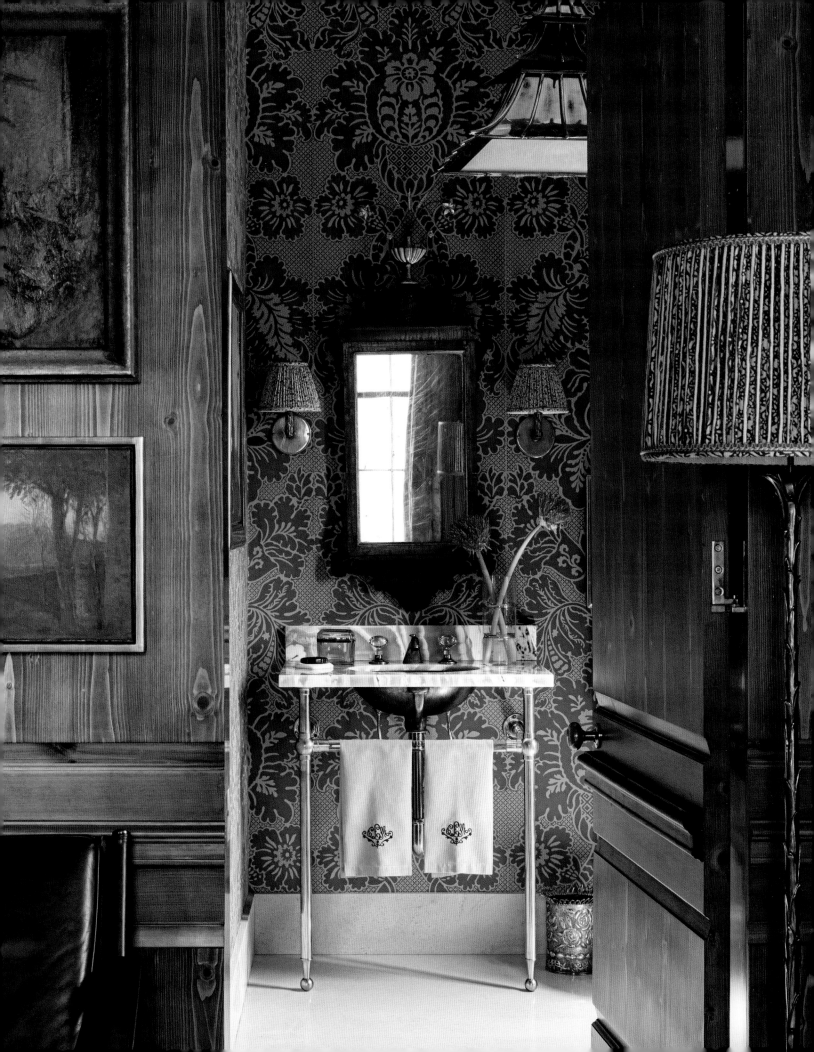

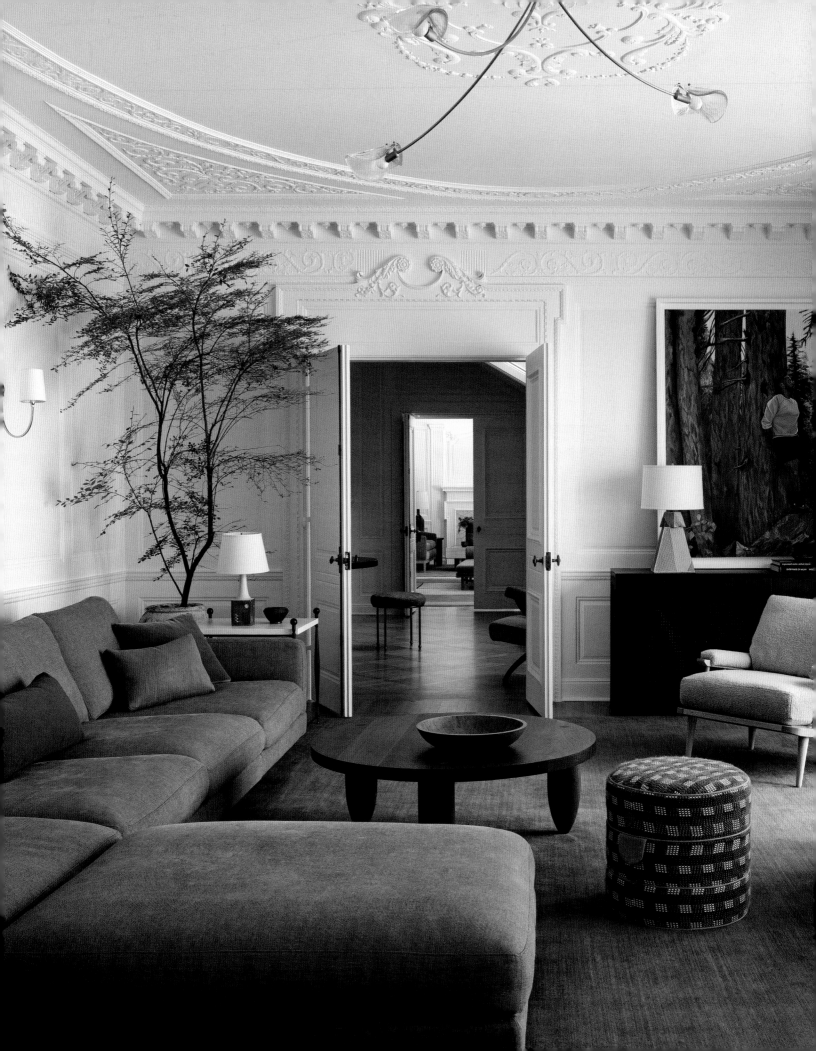

MOLDINGS

ANDY BEERS

[Ore Studios]

Often relegated to the realm of ostentation or nostalgia in contemporary building idioms, architectural millwork is, in fact, one of the most powerful tools at a designer's disposal. Few elements have as much flexibility and impact as moldings and trims. They are essential for covering seams and creating clean transitions between materials. Molding also allows for the kind of tolerance in planning that makes beautiful, hospitable interiors come together. And despite the fact that transitioning between floors, walls, and ceilings is possible without trim, rooms that lack trim are harder to furnish and don't feel as finished.

Rooms come in all shapes and sizes, and incorporating moldings is one of the simplest ways to create hierarchy that brings them to human scale. Vast spaces can be made understandable to the human eye by creating subdivisions and repeating patterns out of trim. Small spaces can be made more refined with moldings: ceilings visually raised and walls stretched to the horizon. Important details, like windows and doors, can be highlighted and enhanced with ornament applied to their trim pieces. Rooms with molding translate into spaces where people want to gather; they are rooms that invite lingering. People may not understand why they are attracted to certain spaces, but strong interior architecture and careful detailing of molding creates rooms that feel good.

Indeed, the detailing of molding is equally as important as its presence. Using traditional or contemporary profiles and components changes a room completely. You can lean into the style of the interior architecture and select decoration that feels kindred, or make a decisive departure, creating wonderful tension. As with all elements, making purposeful decisions is key to assembling beautiful rooms.

Carefully preserved 1920s plasterwork and moldings provide an elegant counterpoint to this Seattle family room's comfortable, versatile seating arrangements, balancing historic grandeur with intimate warmth.

44

TABLESCAPES

MEG BRAFF

Entertaining and decorating go hand in hand, each with limitless possibilities. My first decision, after setting the date for a party, is determining the size and location. Will it be a seated dinner, a buffet for a crowd, a cocktail party, or an expansive meal on the terrace? I also love mixing up dining spaces and might host a small luncheon in the breakfast room, or place a table in a hidden corner of the garden.

Growing up in the South, I watched my mother and grandmothers entertain with aplomb. They passed on a love of dishes, flatware, napkins, and table decor—and gave me a head start on my own collection. It's fun to have options and mix and match depending on the mood and palette. Vases, containers, candlesticks, and votives, too. I like options! As a decorator with my own line of fabrics, I often start with a tablecloth to set the tone.

Flowers add so much to an occasion, I like to use what is in season and play off the palette on the table. Depending on the size of the table, I add small house plants or romantic greenery that trails onto the table, and I sprinkle about gilt and silver figures, shells, and bonbon dishes. Decorating with items taken off shelves throughout the house makes the table personal, and it's as enjoyable for me to see my treasured items in a new setting as it is for my guests.

The care you take in planning a tablescape has real impact. I treasure my friends, and I hope they sense that warmth from me all the time, but especially when they are with me in my home.

The true reward of thoughtful decorating reveals itself in this Locust Valley, New York, dining room, where carefully selected elements serve a purpose greater than aesthetics: creating an inviting backdrop for friendship, conversation, and the timeless ritual of gathering around a dinner table. Fresh flowers elevate the tablescape.

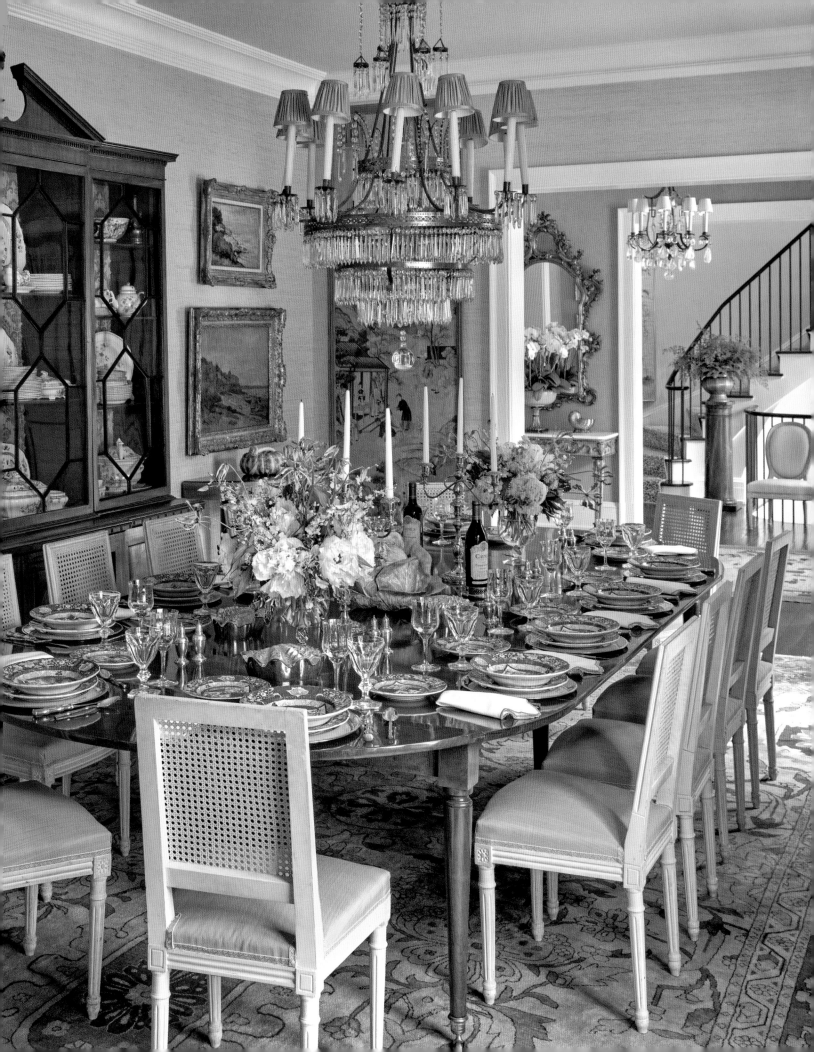

45

BUNKROOMS

ELLEN KAVANAUGH

Designing bunkrooms presents an exciting opportunity to combine functionality, creativity, and a touch of whimsy. These rooms aren't just places for sleeping—they're spaces where kids, and even adults, can come together to share experiences, create lasting memories, and let their imaginations run wild. When I approach a bunkroom project, I aim to balance the practical elements with a sense of playfulness, ensuring the space feels welcoming and comfortable, and a little bit magical.

When I was a child myself, a bunkroom offered dreams of endless adventures. The bunks were never just beds—they became boats drifting through uncharted seas, islands to escape to, or forts where I'd stage make-believe battles with friends. In the bunkroom, imagination reigned, and each corner offered the possibility of a new game or story.

When designing a bunkroom, three guiding principles come to mind: maximize space creatively, incorporate storage wherever possible, and create cozy, inviting spaces that encourage both rest and play. Durability is also essential, as these rooms are often high-activity areas. The materials and furnishings should withstand plenty of use.

The floor plan is key in setting the tone for the room and maximizing space without sacrificing comfort. Avoid bulky furniture that can overcrowd. Keeping the arrangement traditional by stacking beds is always a great option. If space allows, a play area is a wonderful addition. This might be a reading nook, a spot for playing board games, or a craft table designed to inspire creativity and fun. The key is that this area feel integrated and purposeful, not like an afterthought.

Each bed should have its own private space while still being part of a larger, shared environment. In terms of bed count, four typically strike the right balance, if space permits. A quartet of sleeping spaces creates a collective feel and still allows for individual comfort.

And for color palettes, I lean toward the whimsical, such as light blue, teal, and pink. However, choices of colors and materials are often driven by the room's intended use. Whether the space is built specifically for girls or boys or as a flexible room for guests, grandchildren, or family visitors, a balanced design ensures it can adapt over time. This allows it to evolve with the family's needs and style, making it a long-lasting investment.

In this children's retreat, a rugged leather channel sofa serves as the perfect gaming perch,
while custom pine bunk beds command attention against the walls and ceiling wrapped in spirited blue plaid.
The playful yet polished space carefully balances childhood fun with enduring style.

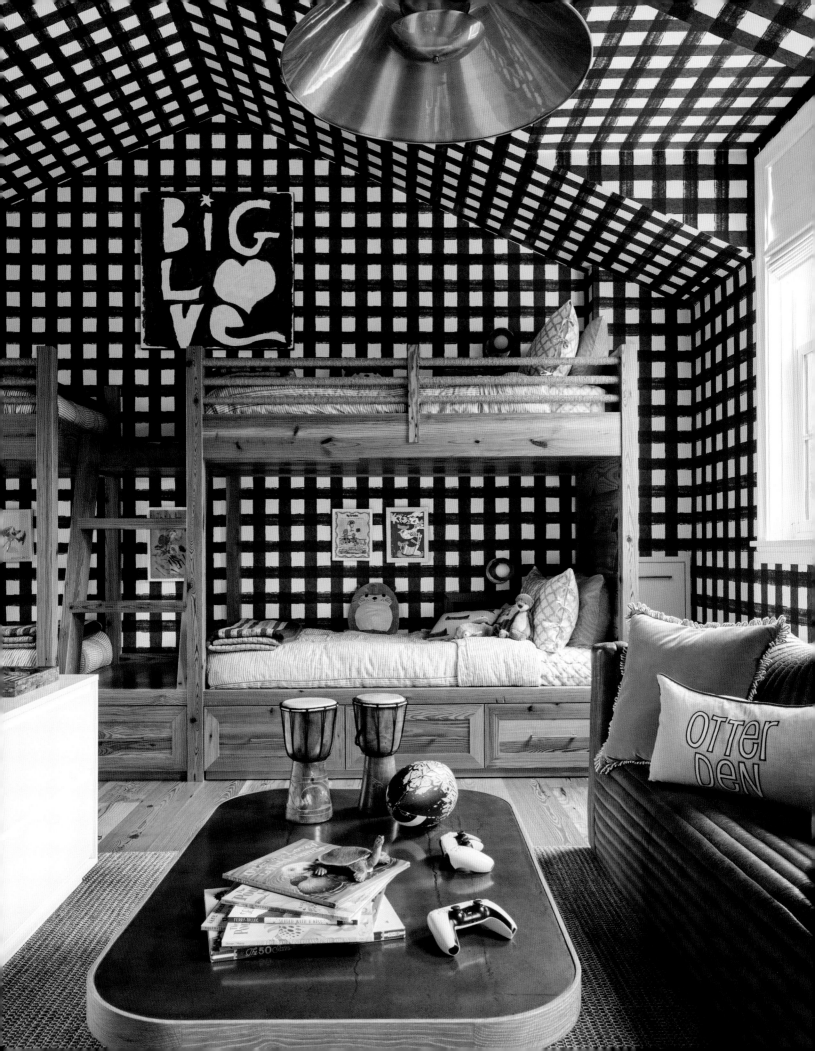

Creating sanctuaries within our homes is essential for mental and emotional well-being. These respite spaces—primarily bedrooms, bathrooms, and media rooms or libraries—are vital refuges from modern life's constant digital noise and demands. A well-designed bedroom is much more than a place to sleep. It fosters tranquility and helps minds transition from the daytime whirlwind of activity to nighttime peace. These days, bathrooms are personal retreats for mindful daily rituals, while dressing rooms offer private areas to pause and prepare. Design elements like soothing and saturated palettes, plays of light, and comfortable seating nooks create environments that help us rest and recharge—whether that means reading in a quiet corner or soaking in a deep tub.

RESPITE

46

PRIMARY BEDROOMS

SUZANNE KASLER

The main bedroom is typically the most personal room in a house. My own is my favorite room. I relax there, draw, read, plan my schedule, and watch my favorite shows. I recently redecorated my bedroom in an ethereal, serene palette. It's light-filled, all in platinum, so the subtle shimmer adds interest in the day and brings a touch of romance at night.

I have always loved white—for myself and my clients—and I often work with its many different shades, tones, and values. Quiet hues of white, bone, taupe, beige, platinum, and champagne are especially effective in bedrooms, where they form a subtle backdrop. Within this envelope, the restrained use of color not only feels more strategic, but the color itself has stronger impact.

Luxurious silks and sumptuous fabrics with a nice hand are perfect for the bedroom. Beautiful drapery is essential. Sometimes I'll upholster the walls with the drapery fabric to bring the whole room together. Using one fabric to dress an entire room may feel traditional, but with the right fabric, the approach can be both inviting and modern. Or I'll use a paint color that matches the drapery, choosing the background tone to suit the individual and adding accents of their favorite color.

Then there are the details: the artwork and special antique, vintage, or contemporary pieces that give each bedroom—and really any room—its unique personality. In a bedroom, furnishings can make a statement but, above all, must be comfortable. Lighting is also key. A light fixture can serve as a sculptural element that anchors the space, but it should also cast gentle light ideal for winding down.

Lighting isn't the only source of illumination in primary bedrooms. Many main bedrooms today are constructed with tall windows that offer a direct connection to the outside and act as architectural elements that determine layout. Nature's colors and textures become part of the design; another reason I prefer tone-on-tone palettes—they let this organic beauty shine.

With the focus on all the distinctive, thoughtful choices that reflect the design, what could make this most personal of rooms more inviting?

Opposite: In this primary bedroom, a refined upholstered divan tucked into a corner is the perfect spot for an afternoon nap. The Venetian sterling silver mirror is by Nancy Corzine. Following pages: The serene bedroom was unified by deploying a Jim Thompson silk on the walls, bed frame, and curtains. Natural light falls on a pair of club chairs and an ottoman, and a vintage Italian glass chandelier further illuminates the space.

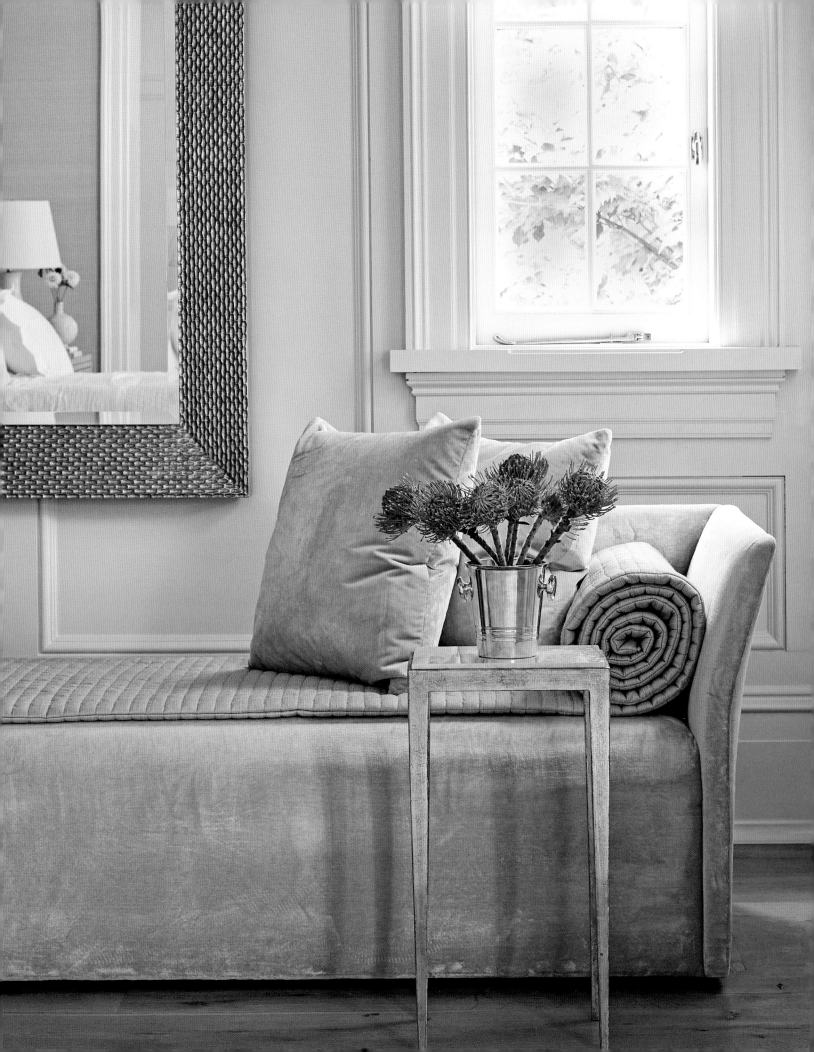

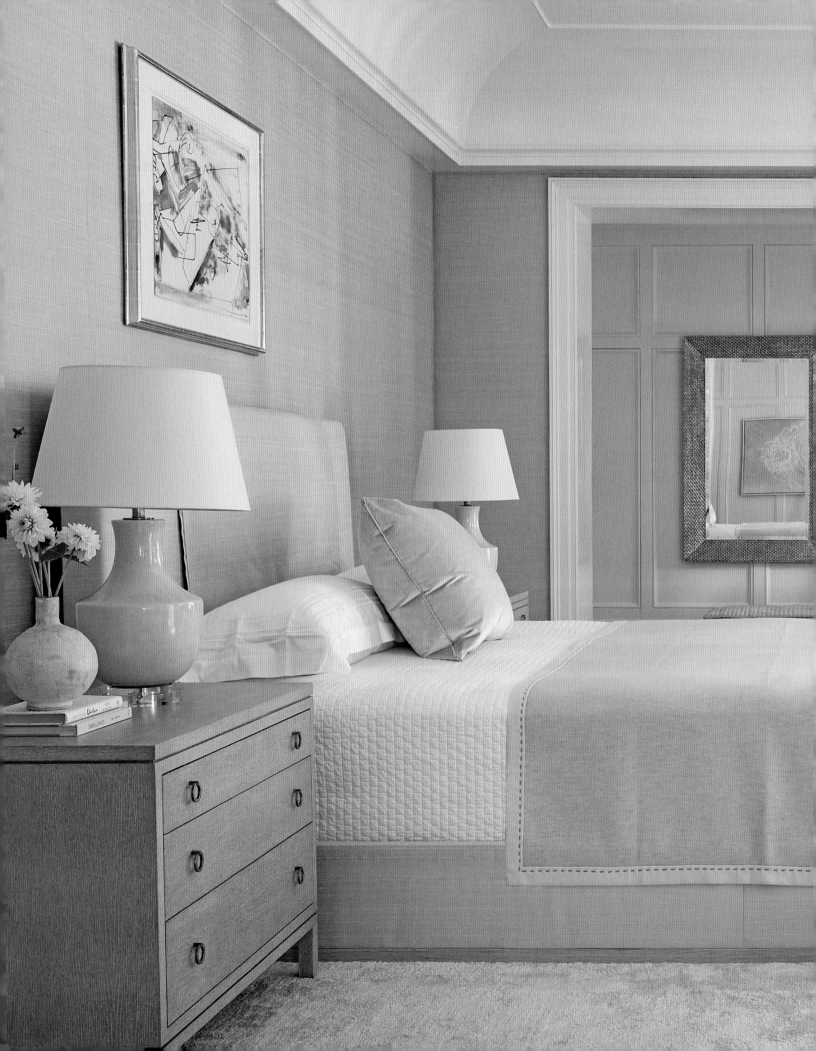

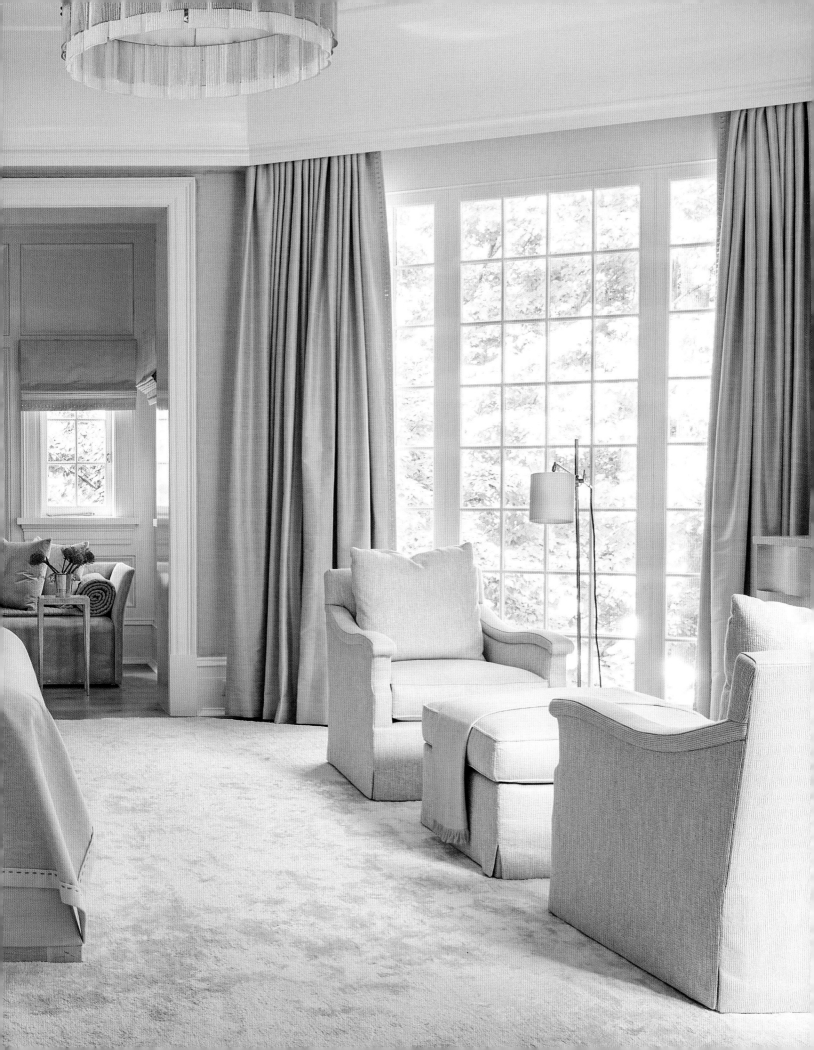

47

LIBRARIES

EVE ROBINSON

Jorge Luis Borges once wrote, "I have always imagined that paradise will be a kind of a library." Paradise. That's a tall order for a designer. In the digital age, a library may seem anachronistic, yet many of my clients want libraries in their homes. My job begins with trying to understand how they view the library's function. Some have significant book collections; many do not. Regardless, a library is a place both for exercising the mind and for emptying it of the chaos outside—a place of refuge and reflection, as well as for stirring the imagination. These days a library is not necessarily a stage set for solitude; instead, it is frequently used for gathering to play games and watch movies. It is a room decidedly unlike any other in the home, a kind of mini-paradise (so Borges was not far off).

A library has a license to exist apart from a home's general design aesthetic as a singular space. Clients often want their libraries to feel moody and prefer to use deeper, darker colors in them than in other parts of their homes. They also want their libraries to feel sophisticated, luxurious, and inviting, with plush, comfortable seating. While layering light is important in all rooms, the multipurpose nature of the modern library demands that the choice and placement of sconces, overhead pendants, floor lamps, table lamps, recessed fixtures, and cabinet lighting create richness, versatility, and functionality.

Whether one is reading Proust alone by the fireplace, sharing a game of chess, catching up on work, admiring rare artifacts, or watching *Dune* with the entire family, the library is a space that exists out of time. It is imbued with a certain magic, like paradise itself.

Opposite: This meditative home library by New York–based architect Ben Fuqua features custom cabinetry housing treasured collections. A rolling library ladder provides access to literary heights, while a sand-toned sofa layered with down-filled pillows establishes a soft counterpoint. Following pages: The soaring ceiling height inspired elegant paneled walls, and reflective finishes amplify the grand volume. Creative space planning accommodates multiple seating areas and a game table.

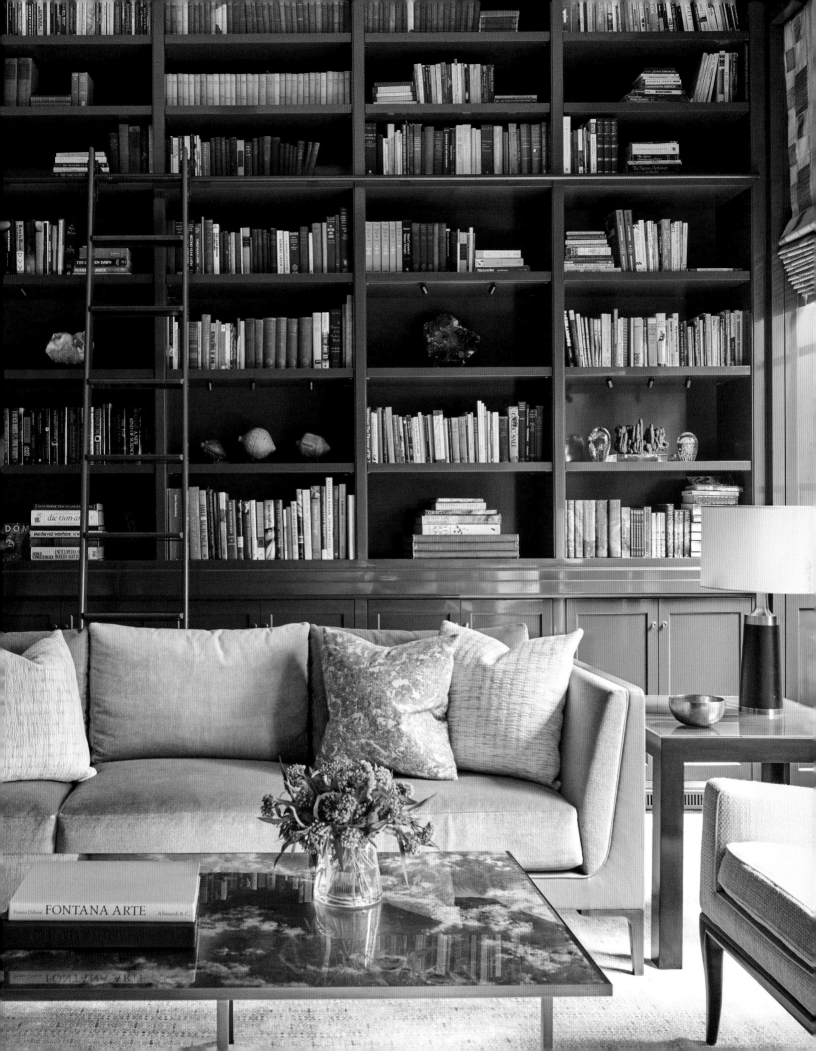

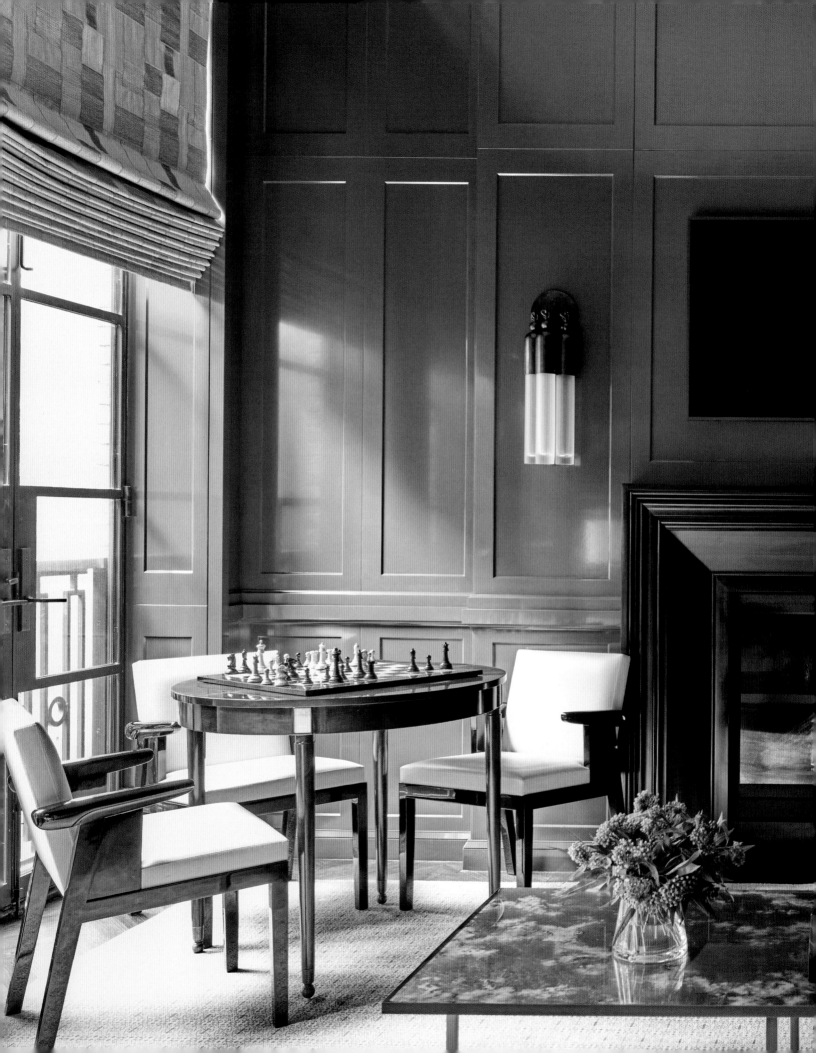

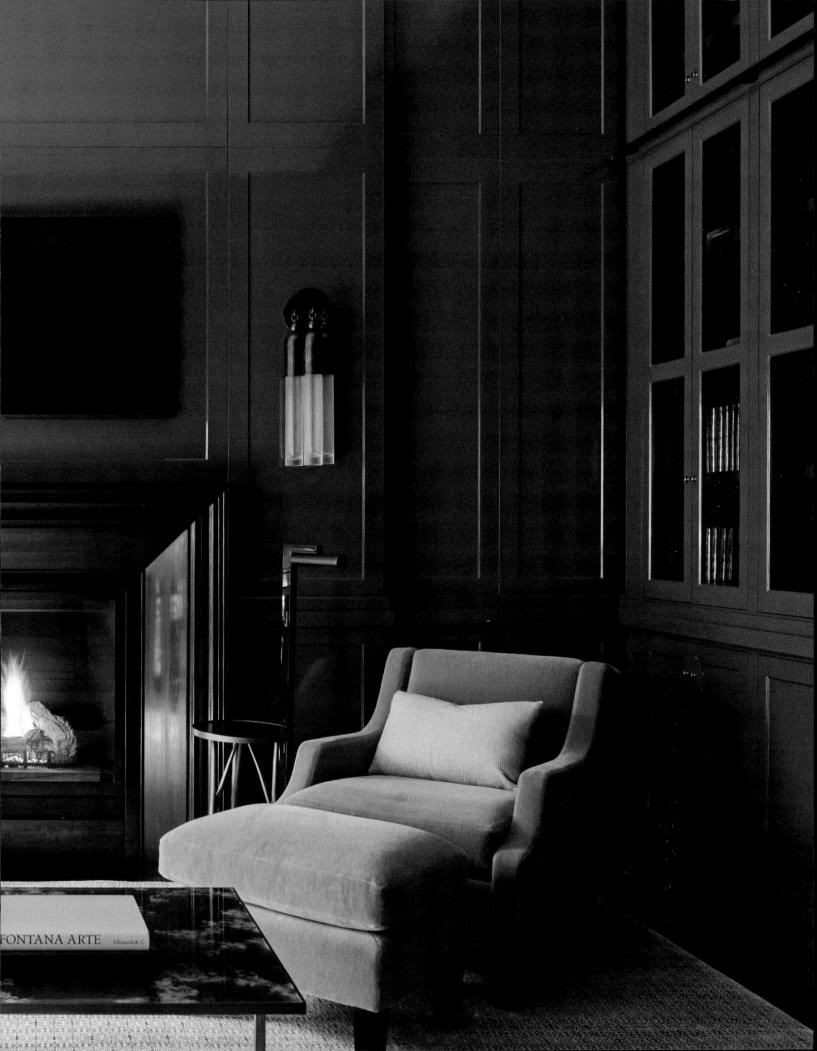

48

DRESSING ROOMS

BENJAMIN JOHNSTON

Dressing rooms are among the most personal and customized spaces within the home. For a collector of fashion, shoes, handbags—or all three—it's essential to plan the space and how items are to be organized. Tailored storage solutions like custom shelves, drawers, and hanging spaces can maximize the area and be designed to fit a collection perfectly, making it easy to keep everything organized and accessible.

It's best to begin with a thorough inventory of the current dressing room (or closet) to understand what works well and where there may be pain points. Some thoughts to keep in mind: Do you prefer open or closed storage? If closed, is a glass or a solid front preferable? I prefer closed storage alongside a few glass-front cabinets showcasing prized pieces, as I find that approach keeps things clean and organized. If you prefer to see everything at once, display items beautifully behind glass.

Consider incorporating a vanity area or glam room within or near the dressing room when space allows. This dedicated space serves as a luxurious, private area to get ready for the day, complete with perfect lighting, comfortable seating, and storage for beauty essentials. Filling islands with drawer storage is another luxurious (and practical) addition to a wardrobe. These islands can rival kitchen islands in size and provide ample, customizable storage solutions for jewelry, accessories, and travel essentials. They also offer a convenient surface for packing and organizing outfits.

In a dressing room, lighting is crucial. Natural cross-light from windows on at least two walls creates the best illumination. However, when this isn't possible, layering light becomes essential. I typically implement overhead recessed fixtures complemented by decorative lighting for added style. Retail-style track lighting can also give the space a boutique feel and can be used to highlight specific elements or items. Additionally, incorporating LED lighting inside closet bays helps display colors and details more clearly, enhancing the wardrobe's functionality.

Adding layers of comfort enhances the sophistication of a dressing room. Consider incorporating luxe area rugs or runners, beautiful textiles for seating, and soft window treatments. These elements contribute to a welcoming and stylish environment, making the dressing room feel like an extension of the home rather than just a practical space.

An eight-armed chandelier casts gentle illumination across this Houston dressing room, where crisp white cabinetry and glass door fronts afford easy visual access to the homeowner's wardrobe. A custom leather-studded table rests atop a rose-hued rug festooned with flowers and fronds.

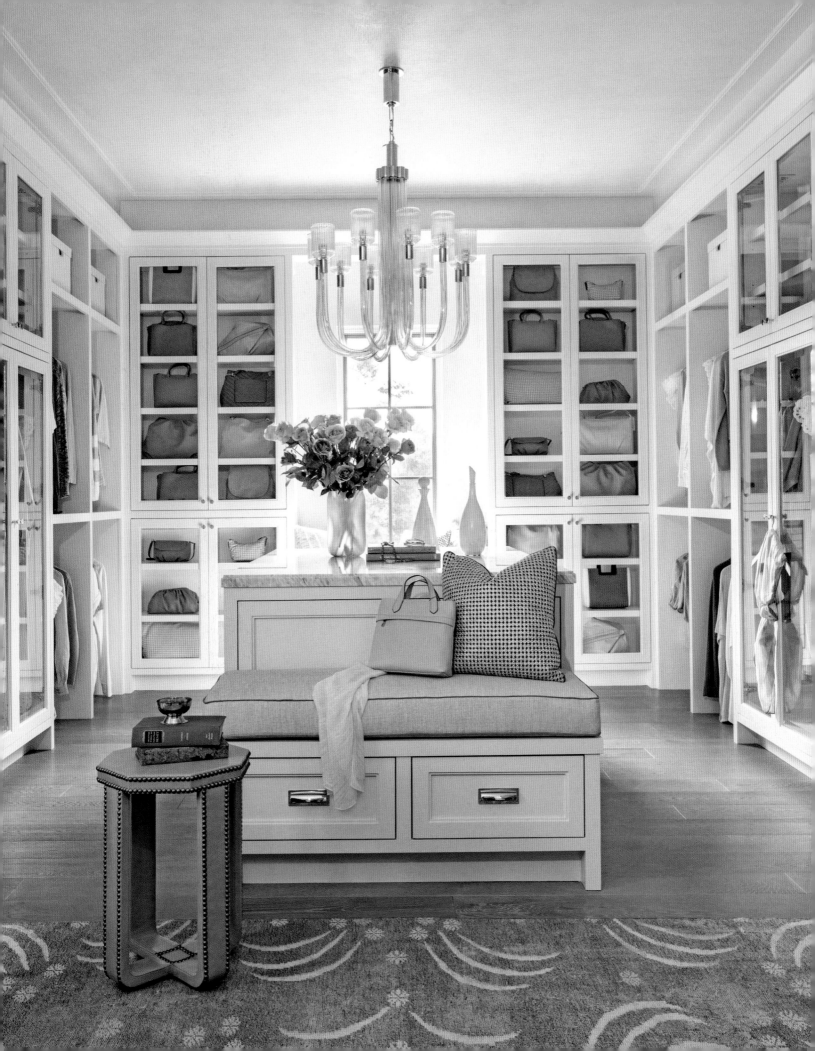

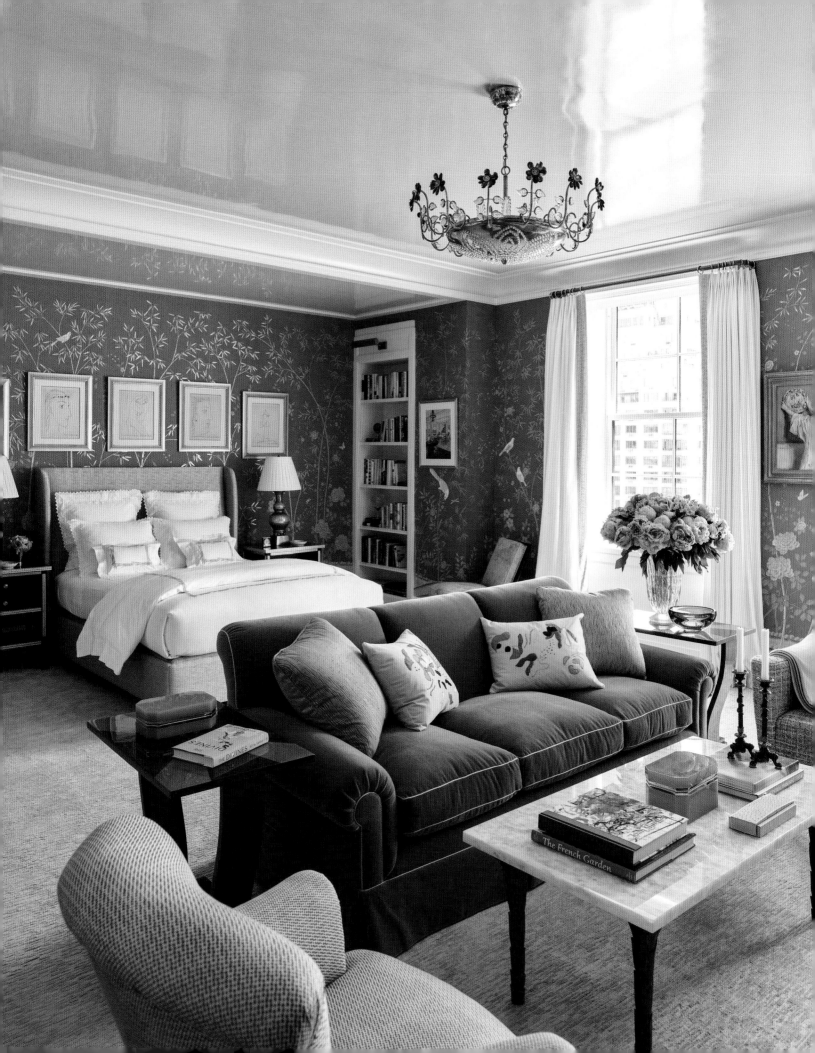

49

REFLECTIVE SURFACES

ELLIE CULLMAN

[Cullman & Kravis]

Reflective surfaces are an excellent tool to enhance a space. They can reflect natural light around a room, brightening it and making it feel more spacious. They also have an incredible ability to elevate and enliven everything around them. At Cullman & Kravis, we never shy away from adding a touch of sparkle and glamour, but these elements serve functional purposes as well.

One of our favorite ways to add reflection to a room is by using lacquer finishes. Walls painted in high gloss are superbly chic and make a space sparkle. The problem with lacquer paint is that it shows every blemish, so it is imperative that the surface be skim-coated to perfection and that the paint be applied with no streaks. We especially love doing lacquer paint on a ceiling because it is at once subtle and unexpected—and it also makes an incredibly modern and elegant statement.

In small or dimly lit spaces, using mirrors is the easiest and often most effective way to bring in more natural light and create the illusion of depth and openness. Mirrors don't have to hang on walls (although they always look great that way). A mirrored backsplash makes a small galley kitchen feel bigger and brighter. Incorporating a piece of furniture with a mirrored finish can also make a significant impact in a small space.

There are dozens of other ways to add reflective elements to a room: polished metal finishes on hardware, crystal chandeliers, glass tables—the list goes on. We love to get as creative as possible when it comes to bringing a subtle sheen into a space. For instance, we have embellished wallcoverings with silver-leaf accents, had hand-applied gold leaf sanded into plaster walls, and even had an artist paint gold streaks on a velvet settee. Touches of shimmer are essential to creating a dynamic, elevated space. After all, doesn't every outfit need jewelry?

In this bibliophile's primary bedroom retreat, a luminous lacquered ceiling amplifies natural light across 30 feet of thoughtfully planned space. Lavender tones mix with neutrals to envelop a serene sleeping area and a generous seating arrangement.

50

CHILDREN'S ROOMS

ALEXIS TOMPKINS + LEANN CONQUER

[Chroma]

When we're designing spaces for young people, we follow many of the same principles that inform our approach to designing any other room in a home, but we embrace a few specific motifs. First, keep it playful. Beware of design decisions that are overly serious, delicate, or formal. Focus on layering unique combinations of textures and patterns with a vibrant, intentional use of color. Equally, though, prioritize function. A sense of play needs to harmonize with thoughtful practicality that nurtures kids' autonomy and builds their confidence. Future-proof for comfort and ease using soft, accessible furnishings and storage solutions that can change and adapt as the children grow.

Perhaps the most essential facet of designing for young people is to validate them. Infuse the room with their personalities and interests in ways that inspire their creativity and reinforce their senses of self. Be purposeful about tapping into a young person's individuality. It's not just about incorporating their favorite color or activity. Customize pieces that encourage them to navigate their physical space and their interior world. This turns the room into an authentic form of self-expression.

Connect this room holistically with other spaces in the home through related tones or color stories. A custom mural is a meaningful design move that allows for playfulness, function, and intentionality with color. Directly engaging young people in the design process of a mural gives them aesthetic and personal agency, but it's wonderful for anyone of any age to experience and be immersed in artwork at that scale. Finally, whether their room is large or small, defy perceived limitations of size. Create sensory spaces at their proportions, like special nooks and cozy corners. Such design details embody the freedom of curiosity and instinct for exploration that define the possibilities and potential of childhood.

Opposite: A bespoke sun-bleached oak bunk bed with an integrated ladder adds a futuristic note to a children's room. A fully upholstered lounge chair is sheathed in a Rosemary Hallgarten textile.
Following pages: A lyrical forest scene, conceived in collaboration with the mural artist Rafael Arana, animates the walls. Cascading bookshelves hang above an interconnected desk.

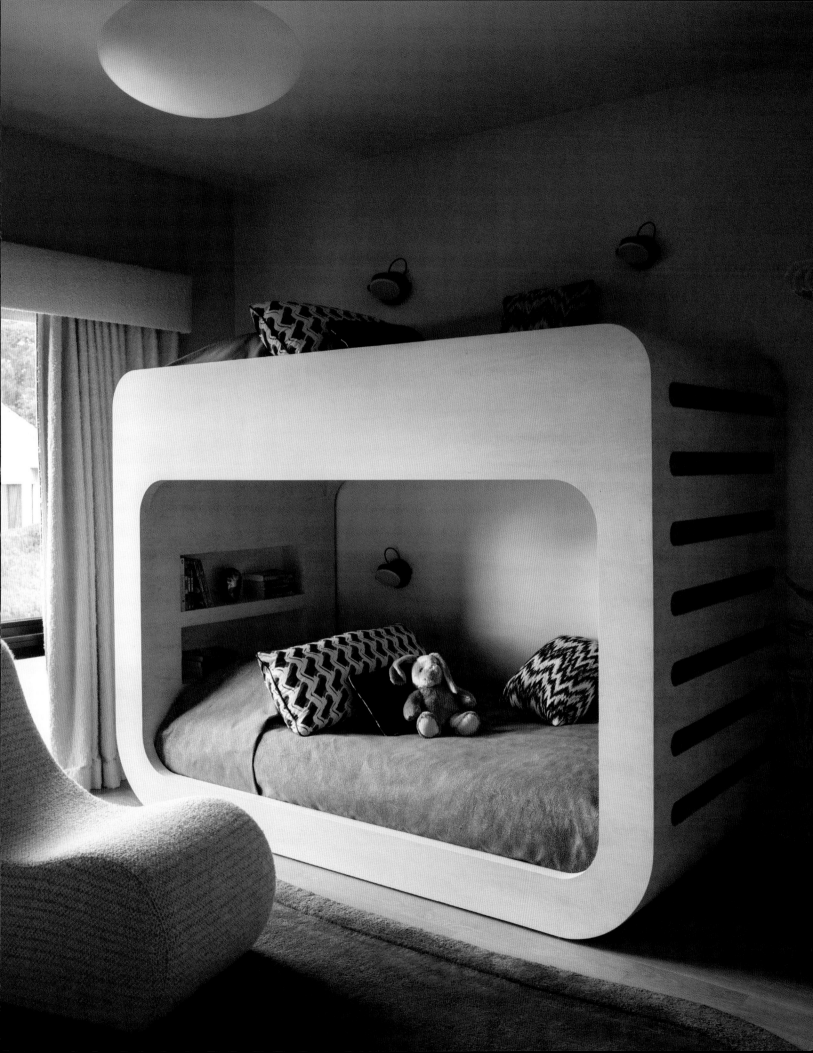

51

FEMININE SPACES

PAMELA SHAMSHIRI

Incorporating femininity into design work means celebrating the beauty and diversity of the human form and embracing softness and sensuality, while also prioritizing comfort and aesthetic harmony.

In my practice, I begin with a ground plan to ensure that each of the client's needs are accounted for. Then I dive into the next layer. The process is a holistic one. Femininity as a design idea rarely works when looked at myopically; it must be applied through a variety of elements and insights. When implemented with a deft hand, the components of feminine design are more complex than any one element, and they can be used in varying degrees in spaces of any shape or size.

Femininity—in the design sense—can be expressed through color, lush texture, diaphanous, silken drapery, or rounded shapes and corners that mirror the natural curves, tones, and touch of the female body. (Elements to avoid include materials that are cold to touch or hard, like metal and glass.) Look for furniture without sharp angles.

Seek out circles, ovals, and curves. Install soft surfaces in soothing colors.

Recently in a townhouse, I created an expansive feminine bathroom replete with a full sitting area and a working fireplace, double sinks, a separate sitting makeup vanity, and a water closet—all reminiscent of a nineteenth-century salon. A bas-relief on the ceiling depicting the celestial zodiac appears fluid and supple. Having a tub custom-carved was critical to the design process, as I could control the curves and undulations that foster a sense of feminine repose.

Feminine design does not imply sticking to pink or installing frills and fillips, and it is not achieved via stereotypes or a stock set of tropes. Instead, it is a feeling infused into a space through subtle repetition and connection. Ultimately, summoning femininity into architecture and design does not mean conforming to arbitrarily assigned color palettes or traditional gender norms, but instead should feel uniquely intimate and empowering to the user. Feminine design is a reminder of the beauty and power within every woman.

Opposite: A brass shower enclosure commands attention in this West Village, New York, townhouse bath.
Following pages, left: Celestial plaster bas-reliefs with zodiac motifs crown this ethereal retreat, equal parts conversational salon and bathroom. Following pages, right: A Maison Leleu daybed is paired with a striking Osvaldo Borsani cabinet beneath a Gio Ponti chandelier. An ivory mohair rug underlies the unabashedly decadent tableau.

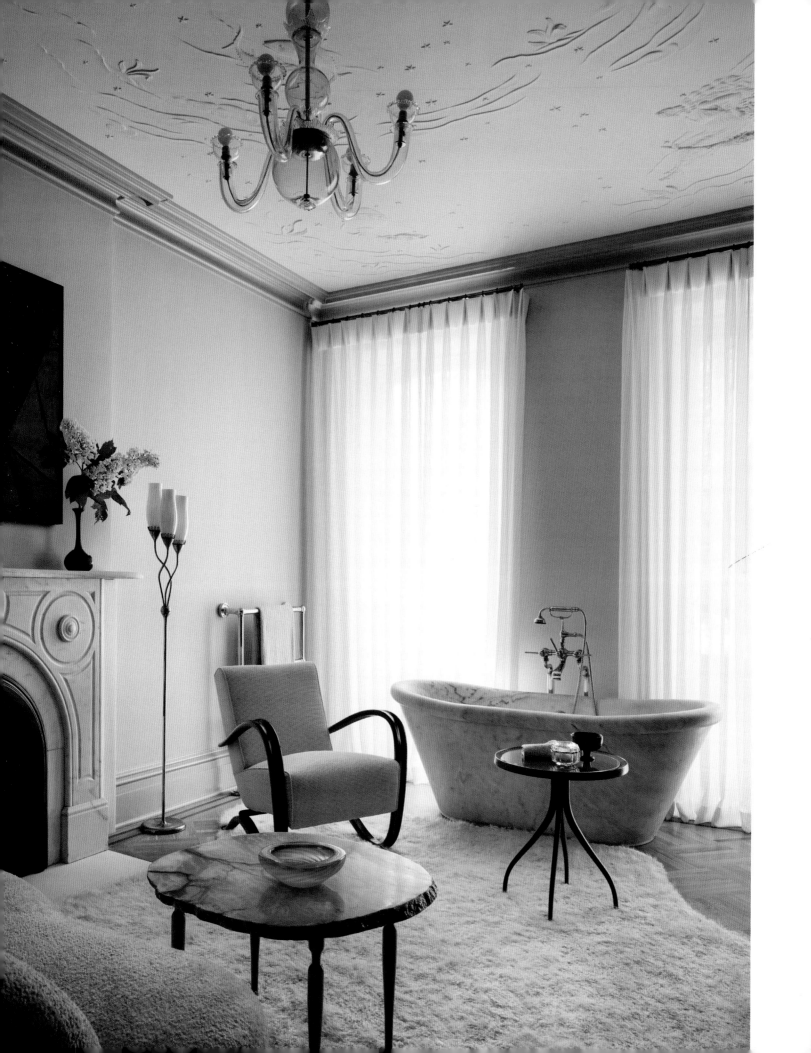

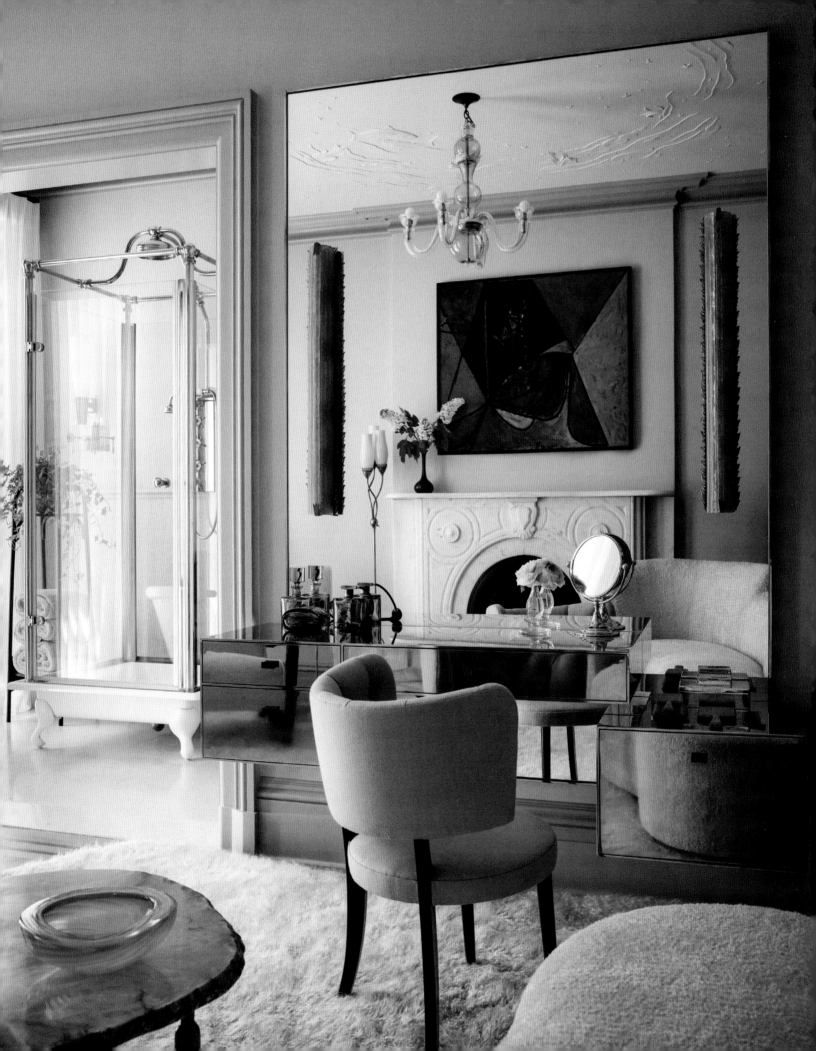

52

RICHLY HUED
BEDROOMS

BENNETT LEIFER

Bedrooms are personal retreats where we rest and dream. They should be designed in a manner that sets the tone for both the day ahead and a peaceful night of sleep. But they can provide us with so much more. This special room is the setting for our most intimate conversations and the place where we dress for all occasions. Bedrooms are sanctuaries where we pensively spend time alone and ponder the most important questions. When designing a bedroom, it's important to consider how the client wants to live and feel in this dynamic space.

I love a richly hued bedroom. Saturated tones evoke the feeling of an oil painting; they wash us in sophistication and elegance. A dark boudoir provides comfort and security, almost enveloping us with a sensory embrace. By stepping away from a light and airy palette, one can create an environment that allows its inhabitant to feel most at home in their most private of spaces.

A rich palette can still achieve an environment that is calm and soothing, but also sultry and vibrant. The effect of the deeply imbued color changes depending on the time of day and the light. A deep green–toned room with varied levels of saturation feels like a lush garden in daylight, then transforms into a jewel-toned haven at dusk.

A velvet headboard nestles into a dramatic niche where deep green paint unifies the architectural details, from ceiling beams to moldings. Matouk linens complete the cozy sanctuary.

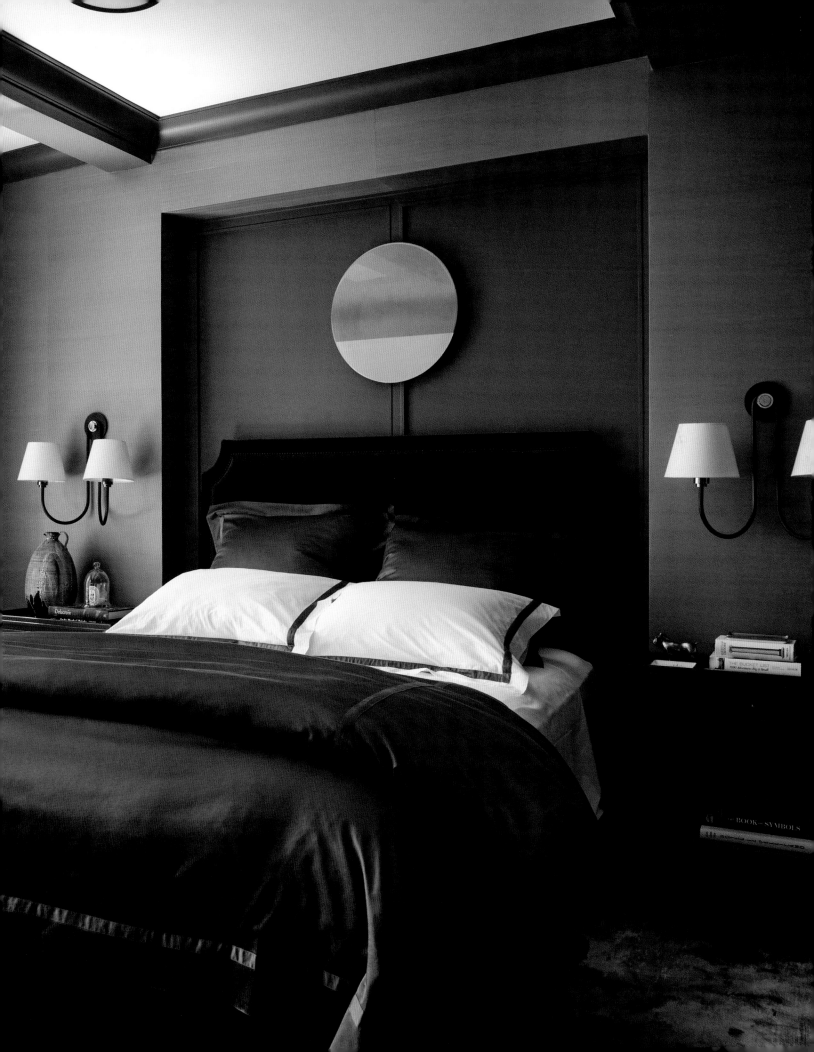

53

STORAGE

JAMES DOLENC + TOM RIKER

[James Thomas Interiors]

Incorporating practical storage solutions does not mean sacrificing a stylish aesthetic. We like to adorn hardworking spaces such as mudrooms, laundry rooms, kitchens, and closets with elements and embellishments that feel both practical and elegant. Bringing millwork, wallcoverings, and heirloom furniture into utilitarian rooms adds a sophisticated layer that can elevate spaces that might otherwise appear underwhelming or neglected.

We advise clients to take stock of what they currently own before diving into storage solutions and investing in expensive systems. Identifying items that are reached for regularly versus those that are seldomly used allows us to edit and create storage systems that are streamlined and efficient. By donating items they rarely use, clients are able to focus on storage solutions that truly match their lifestyles.

It might be tempting to skimp on storage in the more private spaces of the home, but we like to think of them as jewel boxes that should be as thoughtfully designed as the public areas. They may actually be more frequently trafficked than a living room or dining room, so incorporating durable, timeless elements is important. Future-proof storage needs by building in flexibility and versatility. Invest in stackable containers and adjustable shelving that can easily be reconfigured as needs change over time.

It is important to recognize that function doesn't dictate form but rather helps to shape it. Furniture with beautiful silhouettes, such as sculptural benches and tables, can be outfitted with hidden compartments and drawers for additional storage space, for example. In a dressing room or entry, a drop zone for accessories such as watches, cufflinks, and wallets can be beautifully crafted and personalized. Using small table lamps, pretty trays and boxes, and decorative pieces adds a personal layer to these spaces.

Above all, invest in making everyday storage beautiful. Just like making the bed each morning, having well-organized and visually appealing storage solutions sets the stage for daily success and creates a more inspiring environment. Incorporate pretty finishes, sculptural hardware, and unexpected materials to transform ordinary spaces into rooms that feel personal and unique.

Bespoke cabinetry transformed this former bedroom into a Savile Row–inspired dressing room.
An alabaster pendant casts a gentle glow across an old-world marbleized ceiling wallpaper,
and wall-to-wall sisal floorcovering unifies the color scheme.

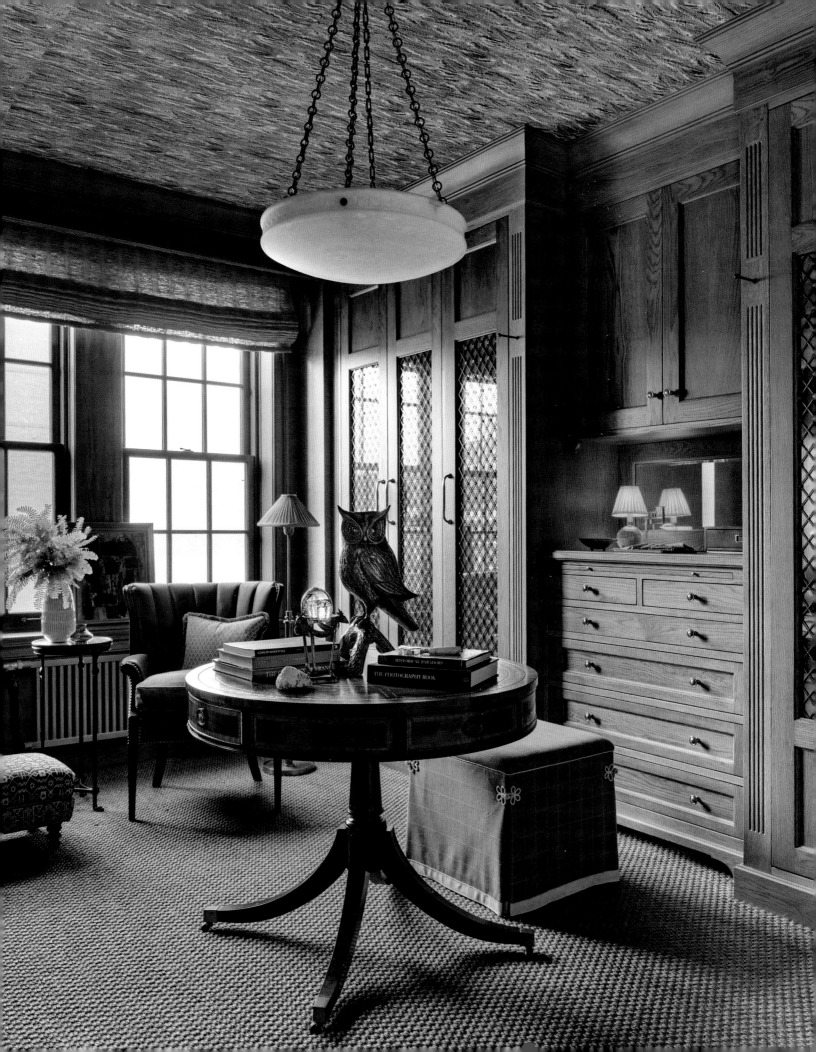

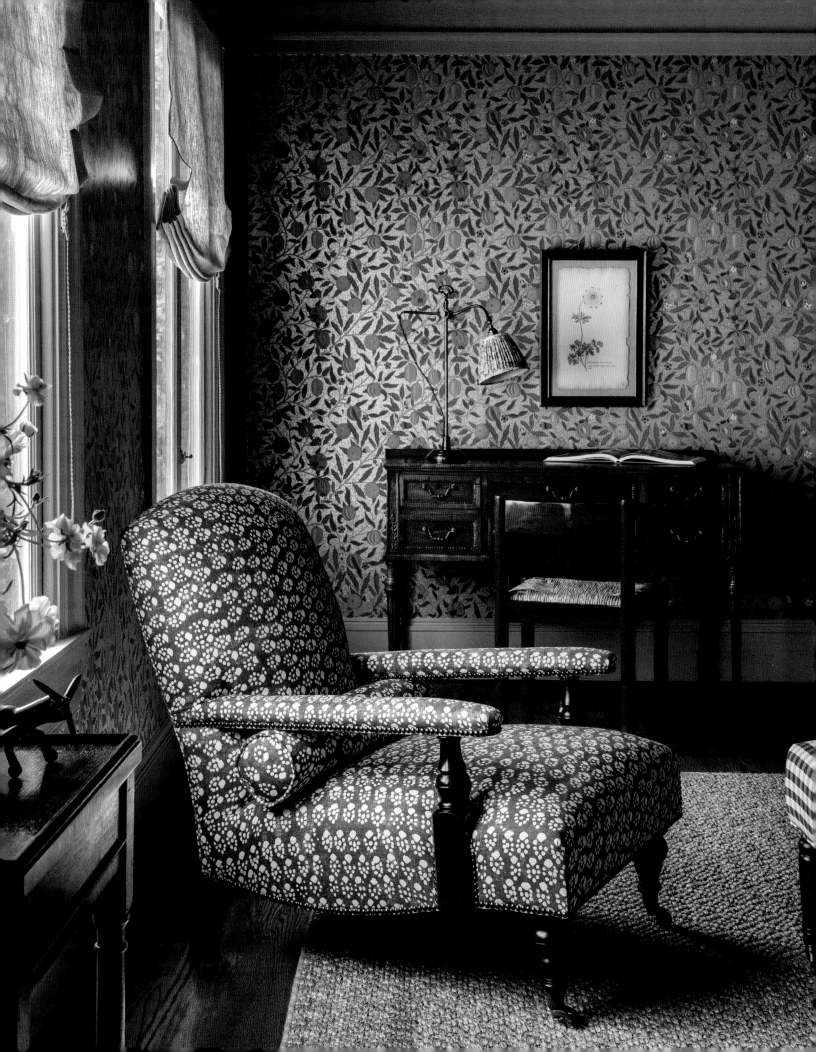

54

VINTAGE PATTERNS

HEIDI CAILLIER

The best-designed rooms appear to have evolved rather than to have been meticulously planned. They feel familiar, like a scent from your childhood home or a cozy chair you go back to again and again. You may be unable to place them, but they're comforting and delightful.

To that end, vintage and historic patterns are excellent choices for infusing a room with history and charm. Whether in wallpaper or textiles, they add a rich layer of age and character.

You can pair a sofa covered in a woven tartan with an ottoman upholstered with a colonial bed coverlet in a room with a boisterous, tea-stained floral wallpaper. But in order for this to work, you must consider styles, motifs, and scale. There aren't any hard-and-fast rules, though, and it's best not to overthink your decisions. Trust your instincts.

I prefer vintage patterns because they are often handmade, which adds an organic touch. Block-printed papers and fabrics are a great example—they come with slight imperfections that add nuance. I like to incorporate living finishes to further that idea: the oxidized oak of a well-worn chest of drawers, the subtle green tinge on an antique brass chandelier, or a gently worn marble slab in a farmhouse kitchen.

But there is an essential step to making these vintage-infused spaces feel modern: choose what I like to call a "wonky" finish or furnishing that introduces the contemporary yin to the nostalgic yang. A single discordant pattern or color in a room, like an unusual stripe on a club chair or a sophisticated shade of ochre painted on the ceiling, creates visual tension. Such a contrasting element draws the eye and serves as a dynamic focal point that encourages visitors to explore the harmony in a space.

In the end, rooms with vintage patterns mixed in an unstudied way can leave you feeling a sense of déjà vu. They encourage visitors to relax and settle in for a casual conversation, meal, or restful night's sleep. What could be more critical in our modern world?

Opposite: A modern-day reimagining of a William Morris fruit pattern shimmers with metallic accents across the walls of this charming Cow Hollow, San Francisco, sitting room. Following pages: A skirted sofa in a delicate English floral anchors a playful mix of vintage patterns, creating an intimate retreat that balances California ease with British charm. The burnished, blush-toned ceiling and millwork add the perfect dissonant note.

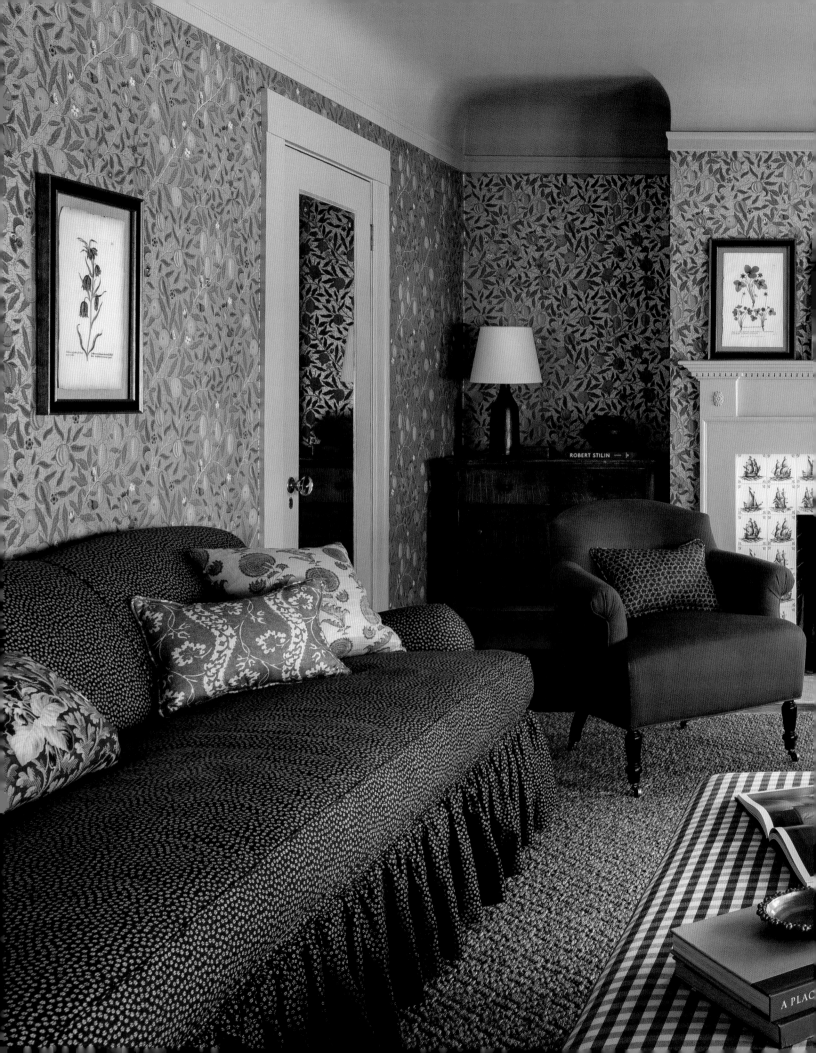

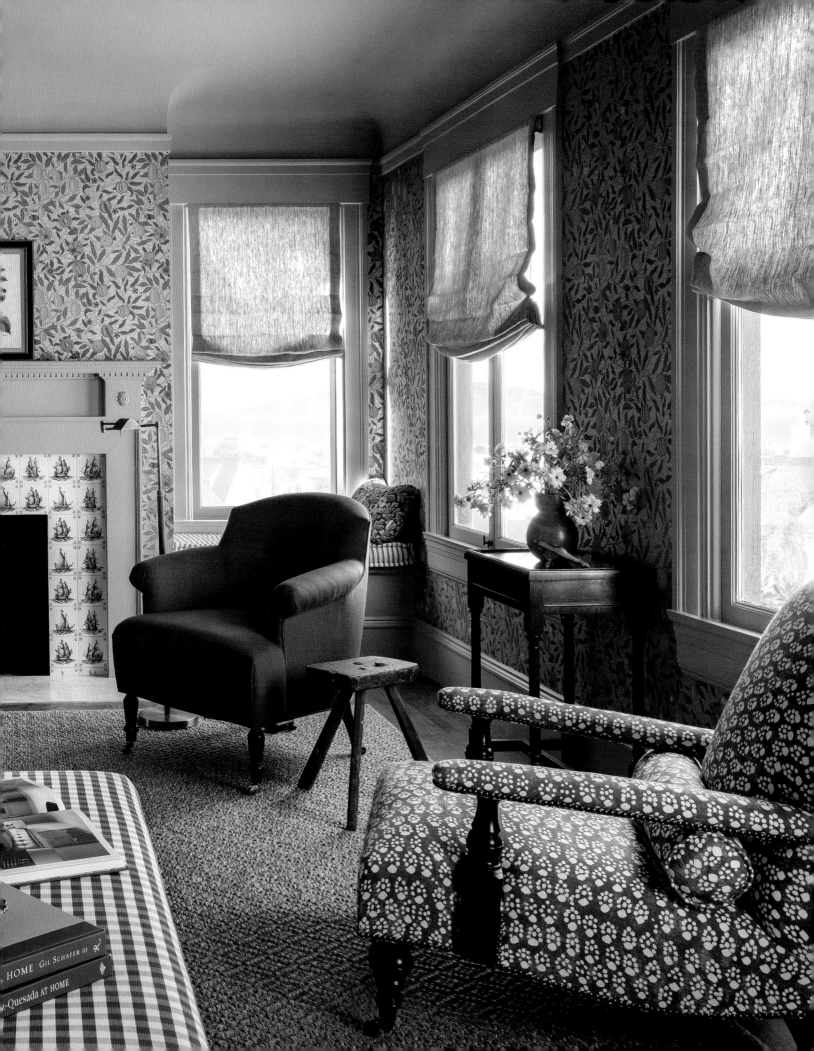

55

SCULPTURAL PIECES

DRAKE / ANDERSON

Crafting an intoxicatingly delightful room is akin to cooking a delicious stew. A skilled chef might begin by following a recipe, but they will always be open to adding a new spice to enhance the flavor. Many of our designs start with a strong, clean background, or a complex, more baroque setting, and from there we layer in upholstered seating, cabinets, tables, lamps, and chandeliers. We choose sculptural pieces to add fascination and delight, and place them with deliberate care for maximum effect.

Unique and quixotic furnishings allow us to create truly one-of-a-kind rooms. In some schemes there might be a singular showstopper, the true focal point. In other spaces there might be a few, if not many: chairs, tables, lamps, cabinets, pendants, mirrors. The artisanal makers of today constantly surprise with inventive forms, methods, and materials that breach the boundary between craft and art, functionality and sculpture. Anthropomorphic forms, like those of Chris Wolston's chairs and tables, are ready to walk around the room. The twisted seating of Sebastian Brajkovic does offer a place to rest, but it is more often deployed as a witty model for the eye to devour.

Light installations inject the unique hand of the artisan. The nimbus clouds of Ayala Serfaty add dreamlike, yet functional, illumination, while the metal spiders of Achille Salvagni conquer a room dramatically. Impactful glowing centerpieces, rich or severe, are placed above—or even off-center from—simpler upholstered forms or tables.

Unique pieces, which are often fluid or asymmetrical, add whimsy and contrast. As much as our role as designers is to meet the functional programmatic requirements of our clients, our true mission is to conjure poetic interiors that enchant and thrill.

In this refined Drake/Anderson bedroom, a luminous selenite and bronze mosaic cabinet
by Newell Design Studio creates a captivating dialogue with Lindsey Adelman's sculptural chandelier
overhead. The upholstered walls feature a painting by Darren Waterston.

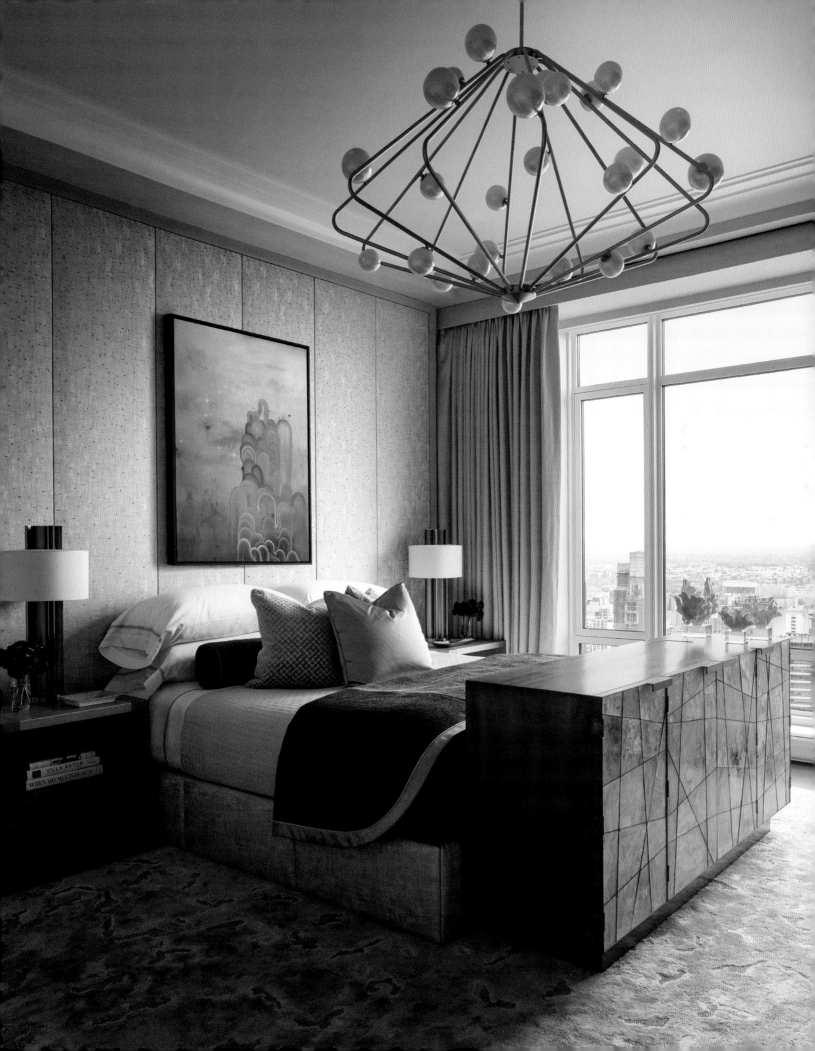

56

COMPLEMENTARY COLORS

AMY LAU

Complementary colors are those that are found opposite one another on the color wheel. It is important to understand how they work together to elevate a home when making effective design decisions. A pair of complementary colors consists of a warm hue and a cool hue; this natural opposition creates what is called simultaneous contrast, a phenomenon where two adjacent colors influence each other and change our perception of them. This contrast results in their appearance being much more vibrant, giving the illusion that these two colors cause each other to pop. This elasticity is one of the many complexities of color explored by Josef Albers in his book *Interaction of Color*. Albers's theories have forever altered how we make use of color. From him we learned that the most important aspect of color is the context that surrounds it, as it will inevitably interact with that context.

Depending on how colors are used, this contrast can have varying effects on the energy of a given space. Complementary colors create stimulating environments that are more visually engaging than palettes consisting of similar hues. This interplay between colors creates a lively space, producing an energy that is better suited to areas where you want to encourage activity and interaction. When used thoughtfully, simultaneous contrast can pull together elements of a room that are seemingly incompatible, creating harmony across contradictory components. One of my all-time favorite uses of complementary colors is in the Versailles home of Marie Antoinette. Lilac was chosen as the foundation of the home's color palette, and from there accents of citron were pulled in to produce contrast while maintaining elegance. Gold accents highlight the lilac palette and make it appear vibrant, despite its muted shade.

When I am searching for design inspiration, I frequently look to nature. From tree frogs to cardinal flowers, there is no shortage of vibrant color and contrast in the world around us. Complementary colors are a great reminder of how the natural world provides a blueprint for art and design.

The living room of a Central Park West apartment features a dramatic wall treatment that creates a gradient effect, transitioning from deep orange to sky blue. Below, a textured rug echoes these same colors reminiscent of a Pacific coast sunset. The photograph, *Surfing Nanakuli*, was taken by Anne Menke.

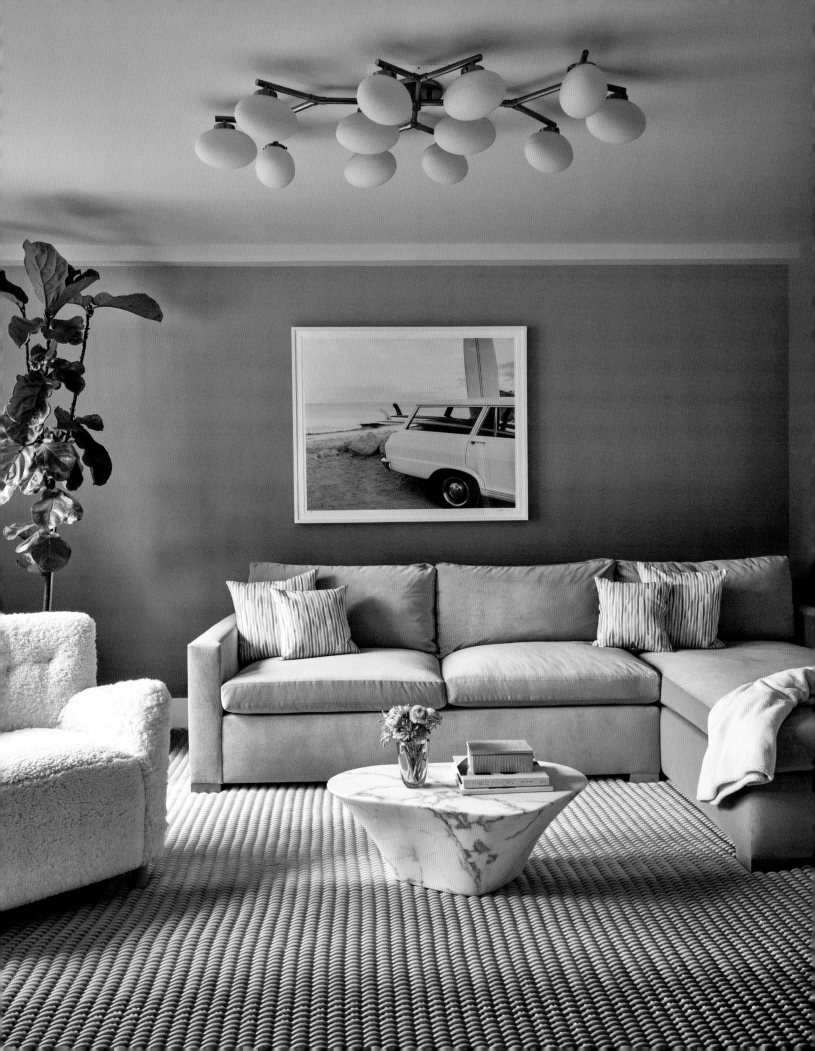

57

WHITE ROOMS

JANE HALLWORTH

The employment of white in a room can be complex—and its interpretation is complex as well. White can be used to create many different types of atmospheres, and the range is so diverse that it is by definition contradictory. White is a mystical color that has both positive and negative connotations. A white room can symbolize different things depending on the context. In literature and film, a white room is used to represent emptiness, isolation, a blank slate. Something can be made clean by being whitewashed, but to whitewash something is also a cover-up. White has little to no hue but a myriad of meaning. It can be used to dramatic effect, as we project so many emotions onto it. White can have a fierce impact on our moods, our senses, and our perceptions.

The white room is peaceful and a symbol of new beginnings. The white room is a spiritual, innocent, and pure place. The white room is bright, cheery, and open. However, the white room can also be controlling and sterile, lonely and isolating by design. A white room can even be sinister.

The contradictory meanings and feelings associated with white have their genesis in nature. The white dove means peace; the unicorn symbolizes purity, innocence, and power. Angelic creatures are depicted in white. However, the white shark and the white polar bear are synonymous with terror, the worst of their kind. Apparitions. The white buffalo is sacred in native lore—a blessing for a new beginning but also a powerful warning of change. The character of a white room lies with its creator, but by design it is very polarizing. Creepy, uneasy, cold, brash, and eerie—or peaceful, light, airy, and clean? According to Gaston Bachelard, the blank page gives us the right to dream. Does the white wall call forth the same creativity? Is white a dreamer's color, or the color of nightmares? In its purity, its severity, is it each and all? Such is the power of white.

Minimalist white surfaces become a pristine canvas for striking focal points: the 1971 Boccio dining set
by Pierluigi Spadolini anchors the space beneath a transformed bronze chandelier,
now adorned with delicate butterfly embellishments. A Fritz Hansen sofa rests near the fireplace,
while curated vintage pieces from Blackman Cruz gallery complete the vignette.

58

FLORALS

COURTNAY TARTT ELIAS

[Creative Tonic Design]

A touch of flowers makes every room blossom, and what is happier than bringing the outdoors inside when you want a splash of beauty? Nothing is more versatile for decorating than verdant florals. Just a quick look out the window will prove that Mother Nature truly is the most original decorator of all. Florals are universal motifs that imbue a home with warmth, style, and soul.

There are so many types of florals to use in a room. Working your way up from the floor, you might start with a flower-strewn needlepoint or Oushak rug or wool broadloom carpet topped by furniture upholstered in shiny chintz and embroidered silk. Walls and ceilings can be covered in paper or fabric or grasscloth ornamented with flowers in an allover decoration or made into geometric patterns. Hand-painted walls and ceilings offer another beautiful way to include flowery magic in a room. Whether the flowers are colorful or subdued, the choices are endless!

Go dramatic by enveloping an entire room in florals. It is especially effective (and fun) to choose a floral fabric that has a matching wallpaper. This treatment creates an intimate space: a dramatic, all-encompassing, one-print room. Large-scale blooms or petite prints all mix well with plaids, stripes, checks, animal prints, and, of course, solids. It is lovely to use a contrasting welt to highlight and outline a busy pattern on sofa cushions or a pillow; it makes the floral pop. Apply the same treatment to wallpapered walls with a solid gimp, creating a picture-frame effect to highlight one of the colors in a busy flower pattern. Another interesting and unexpected way to use florals is to work with the kinds of tone-on-tone, high-contrast neutrals found in muted block-prints and floral cut velvets.

Decorating with florals is not limited to the obvious (fabrics, rugs, and wallpapers). Try finding vintage and antique naturalistically carved furniture or bas-relief plaster or Murano glass chandeliers and lamps with floral themes. Many accessories are a source of flowery inspiration: Victorian sterling silver vanity sets, Murano glass millefiori paperweights, oil paintings and pastels, and porcelain plates and soup tureens. These can be displayed on tables or hung on walls.

Using florals in home decoration—from wildflowers to tropical patterns to traditional English garden prints—is not only aesthetically pleasing but also brings the outside indoors and connects the interior with nature. With florals, I truly believe anything goes: go wild or go subtle, but every room needs a kiss of flowers!

Opposite: In this corner, a window seat cushion and coordinating toss pillows provide stylish seating.
The swagging wallpaper is illuminated by a Stray Dog Designs sconce. Following pages: Stylized floral wallpaper from
MAB Studio in Dallas wraps the perimeter of this decidedly upbeat bedroom, where a coordinating printed
fabric was used to tailor the curtains, headboard, and dust skirt. The custom striped bench adds a counterpoint.

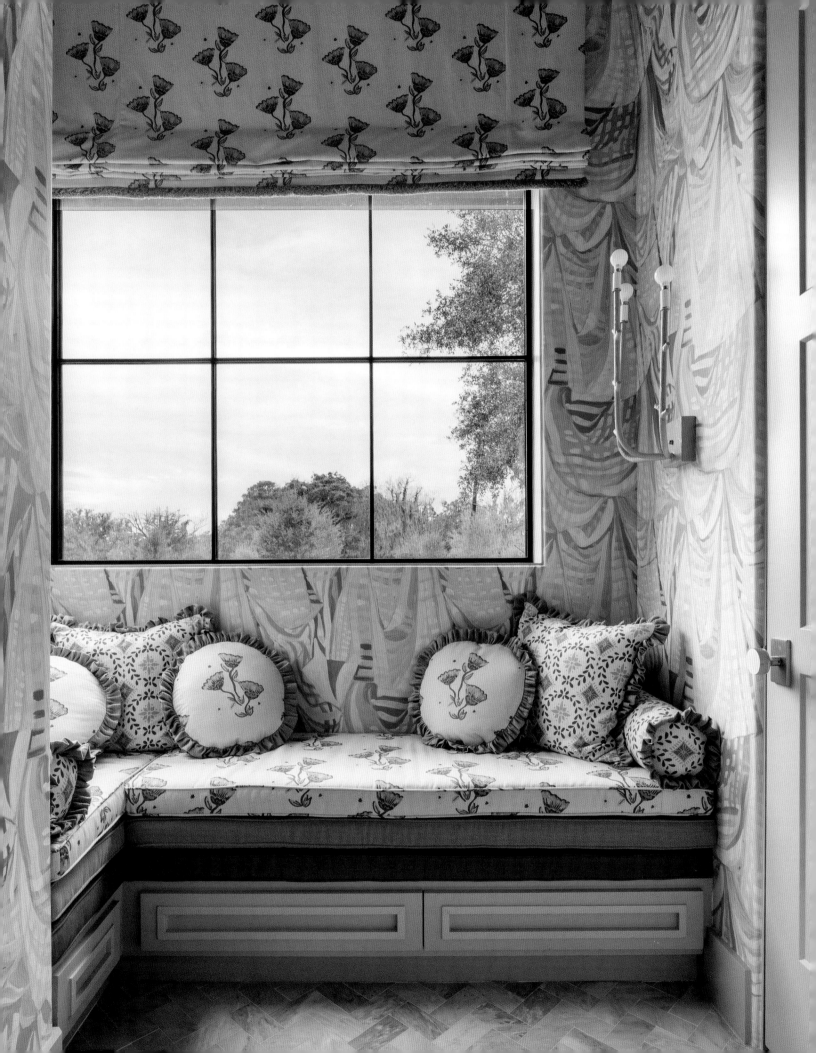

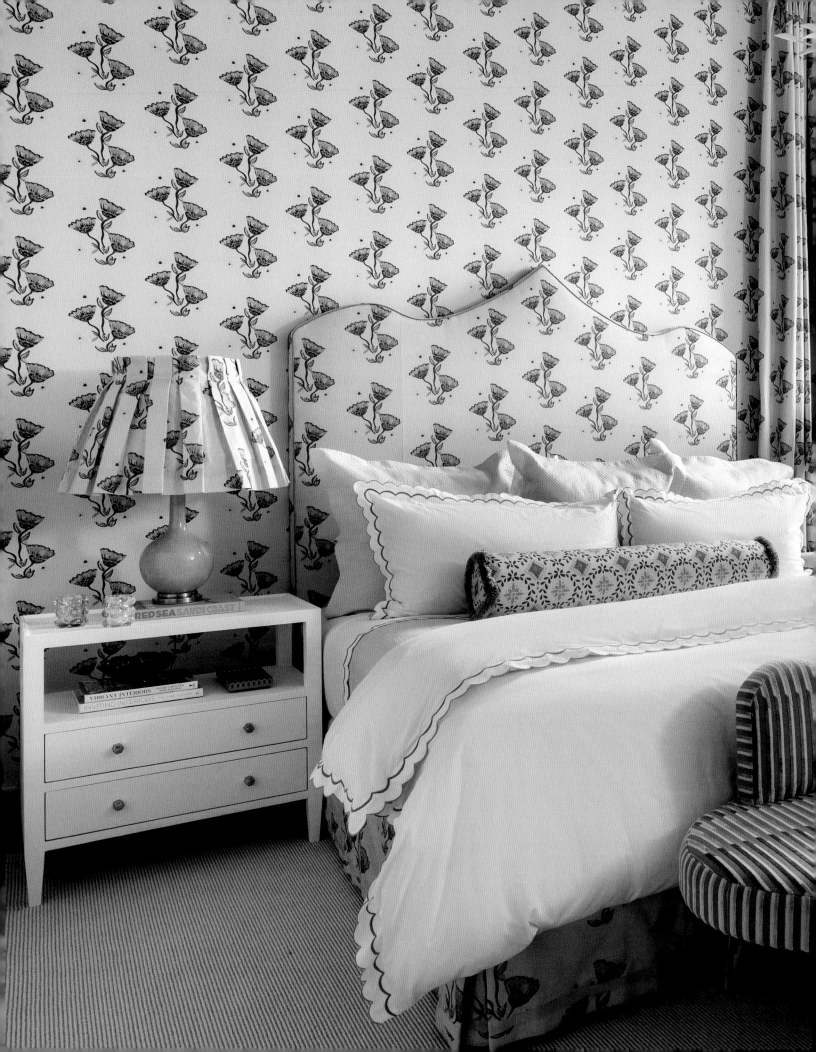

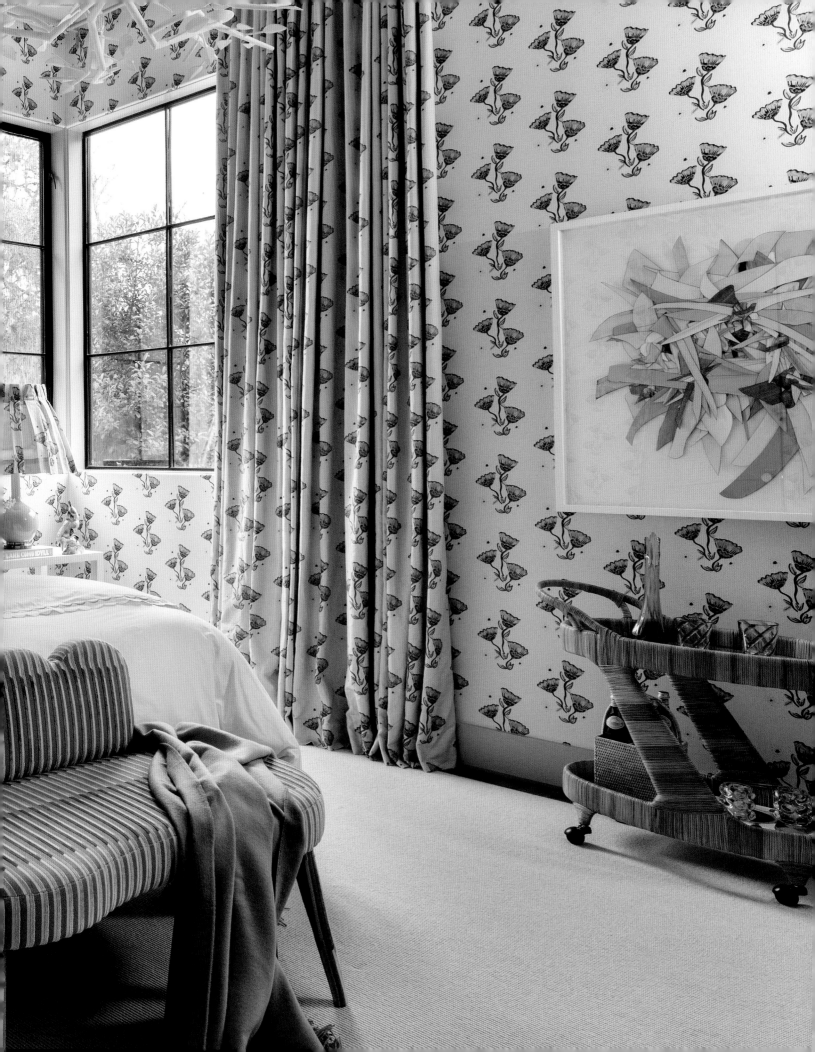

59

DRAMA

DONNA MONDI

Creating a dramatic room requires identifying opportunities within the space to evoke the wow factor. Study the room for natural focal points, perhaps a fireplace wall begging for attention or a ceiling detail that could elevate the design. Determine the star of the room—a unique architectural feature or a standout piece of furniture—and ensure that it takes center stage while the other design elements serve as supporting players, enhancing the star without overshadowing it. Remember, dramatic doesn't mean excessive. Edit your selections carefully to ensure they support the star rather than compete with it. An art wall can be a stunning maximalist feature, but if the rest of the room is equally busy, it may dilute the overall impact. Even in the most decadent spaces, intentional restraint is key to maintaining drama and sophistication. Sometimes less is more.

You don't need patterns to create drama, and as I'm not much of a pattern person myself, I often let texture do the talking. Materials like cashmere, velvet, and woven leather bring depth and interest and make even a neutral palette memorable. Thoughtfully mixing these textures can make any room feel layered and sophisticated.

When it comes to color, high contrast is a great tool for creating drama. Pairing shades like black and white, cream and brown, or taupe and burgundy introduces dynamic tension. Choose complementary colors in varying saturations: dark walls with lighter upholstery or light walls with rich, darker fabrics. And if you do choose patterns, a bold stripe or geometric design adds just the right amount of intrigue.

Lighting is another vital element in creating a dramatic space. Evaluate the existing setup to identify any gaps. Overhead lighting provides essential illumination, but adding decorative—sometimes oversized—fixtures extends the reach of light and enhances drama. Layering light sources is key. Wall sconces bring lighting to eye level, while floor and table lamps introduce unique shapes and focal points. Simple uplights, strategically placed, can spotlight a sculpture or artwork. A statement chandelier, an elegant sconce, or a sculptural lamp can shift the entire mood. When selecting fixtures, consider lumens (brightness/intensity), shape, and scale. Contrast works well here, too—pairing a modern dining table with an ornate chandelier adds a layer of tension that feels intentional and refined.

Opposite: This glass-enclosed shower features contrasting Nero and Azul marble sourced through Bespoke Stone + Tile that flows seamlessly from floor to wall. Following pages: The vanity in the foreground and the console table at the far end were carved from Azul marble, also used on the floor for a cohesive effect. Polished nickel fittings add to the bath's dramatic impact.

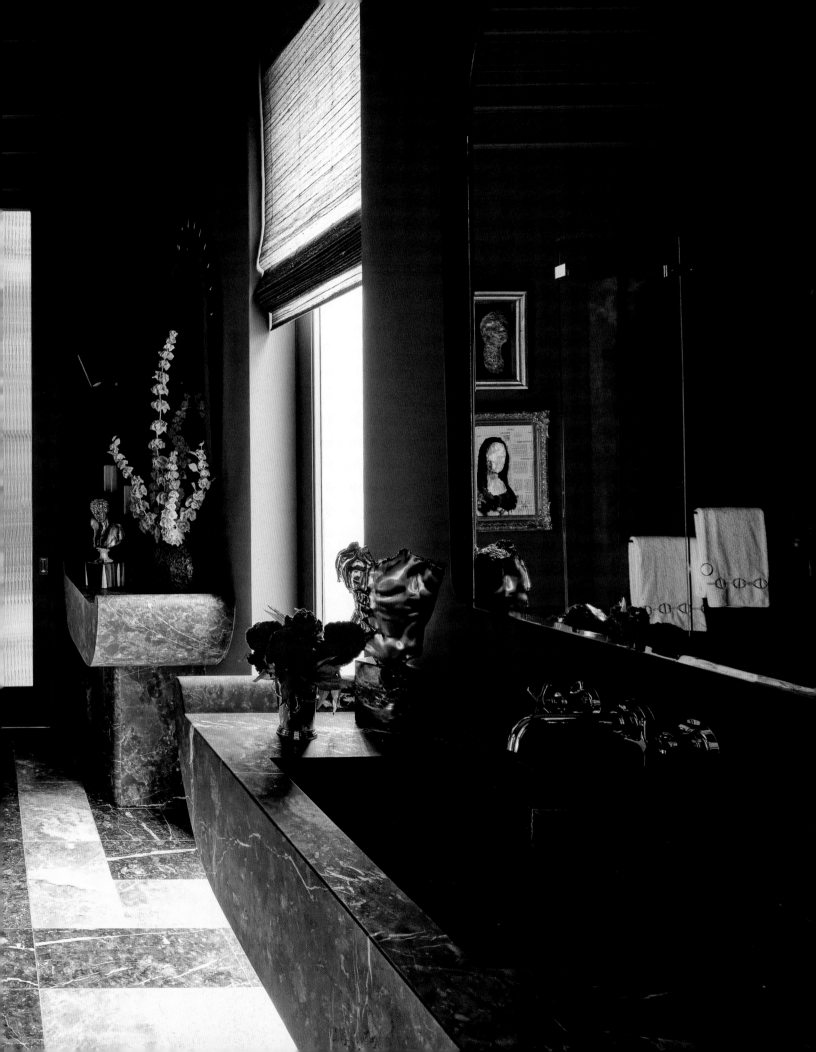

60

MONOCHROMATIC ROOMS

MICHAEL ELLISON

People often fear monochromatic rooms will be boring, but the opposite is true: a room organized around a single color is the height of sophistication. The trick is to incorporate different textures, finishes, and materials. This technique is vital to crafting a monochromatic interior.

Combining various materials, such as velvet, linen, wood, stone, and metal, adds depth and interest to a single-color palette. Complementing these textures by employing a range of tones—from light to dark—within the same color family prevents the space from feeling flat or monotonous. For instance, pairing a soft gray wool sofa with charcoal mohair cushions and a sleek, dark gray metal coffee table creates a rich, cohesive look.

Another important consideration is how light affects the color of a room over a day. To understand that idea, here's a suggestion: the next time you go for a morning walk in the park, take a moment to observe all the shades of green: on the leaves, on the trees, on a mossy stone wall—all against the backdrop of the eastern-lit sky. Then, take that same walk late as the sun sets, and you'll find that those greens have changed and morphed into entirely different hues. The same is true for the materials and finishes in monochromatic rooms. You may want to experiment with paint or fabric swatches before committing to an overall scheme.

The simplicity that people fear will read as boring is actually a strength of the monochromatic room. A monochromatic room counteracts the frenetic pace of twenty-first-century life by providing a serene, cohesive environment that reduces visual clutter and promotes relaxation.

In this Nantucket family room, calming greige walls complement furniture in varied tones of the same shade, creating an intimate, tech-free haven away from modern life. Rich textures throughout the room reveal subtle details that create depth while enhancing the atmosphere.

61

LOCATION

CHARLIE FERRER

The rooms in a home draw collectively and individually from the surrounding world. Designing a home that suits its environment is an organic endeavor—a nuanced feedback loop where the location informs the project and the project shapes the location. There's never a firm endpoint. The residents can always remix and layer as life evolves.

Context is critical. A designer has to distill the feeling of place for a home to be truly successful. Design must be based on understanding the greater environment. How do the owners interact with each other and their guests? What are the cultural themes of the community? How does geography factor in?

And then there's the personal. For clients who have an equal penchant for entertaining and relaxing, it's important to carve out both moments conducive to hosting and moments for repose, and to consider these moments against the wider social backdrop. A beach community, for example, can also be cosmopolitan; one might go barefoot during the day and wear heels at night. Acknowledging these inputs ensures a home is designed and equipped for a desired lifestyle.

Most important to the process is a deep understanding of a home's physical elements. Inside materials should reflect the textures of the outside world. You need to spend time on-site to feel it, to grasp the movements and quality of the natural light; the seasonal shifts in atmosphere; the interaction between water, sky, and sand. You need to experience a home's natural surroundings before determining the degree to which the inside will express the outside.

Seek subtlety. Translating the external to the internal shouldn't be literal: a beach house doesn't need seashell lamps. But if a home is in a beach location, make it feel that way: choose colors that complement the sun's patterns, honor the sea through shiplap paneling, and opt for durable materials, like bronze and oak, that will stand the test of time, salt, and sand. If it is in a location where climate is variable, build in provisions for the changing seasons.

To tether an interior to a place requires a mix of process and instinct. It's just as important to note a home's cultural and physical context as it is to follow your gut.

Opposite: Dramatic floor-to-ceiling curtains tailored from a Rogers & Goffigon wool accentuate the ceiling height in this Southampton, New York, home while echoing the oceanic horizon just beyond the glass. Following pages: In a meticulously balanced room, matching sofas, floor lamps, and pendant lights create symmetry. Ross Bleckner's striking *Cheer Up Brother* anchors the space above the fireplace, complemented by Julian Lethbridge's artwork to the right.

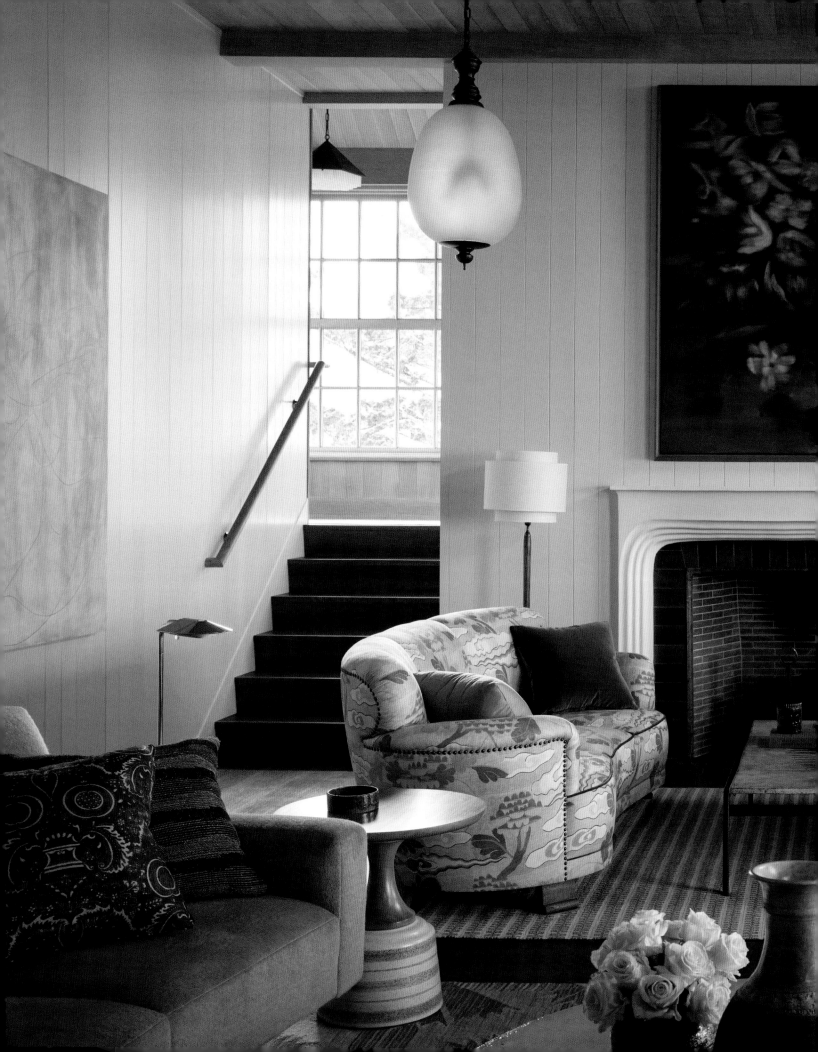

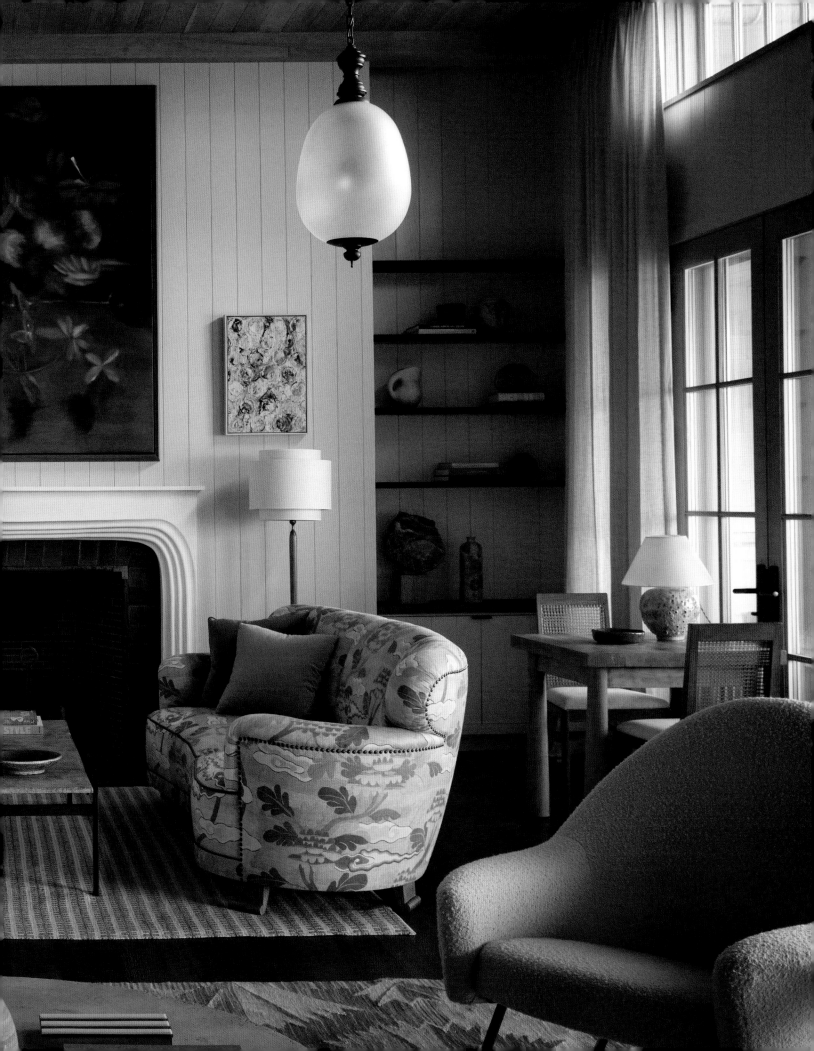

62

BEDS

ROBERT PASSAL

As a designer, I've utilized numerous bed styles, each chosen thoughtfully to elevate the ambiance of the bedroom.

Wooden beds exude timeless elegance and warmth. They come in various finishes, from rustic to modern. Sleigh beds catch the eye with their distinctively curved headboards and footboards and add a hint of history to a space.

Alternatively, upholstered beds telegraph luxury. Their padded headboards offer comfort. An upholstered bed creates a cozy spot for activities like reading or watching TV. The fabric choice can completely change the bed's aesthetic: think gingham for a country home, breezy linen for a seaside retreat, or textured gros point for an urban loft. Aligning the fabric style with the home's location and overall style is crucial.

For those craving defined geometry and a dash of drama, a canopy bed with four posts and a draped canopy makes a striking statement. The draping can consist of anything from sheer panels for an ethereal effect to lined and interlined curtains for a more substantial presence. The low profile and minimalist design of a platform bed provide a contemporary feel.

When it comes to the practical side of beds and sleep, investing time and energy into finding the right mattress is essential. Exploring options in person is key, as there are so many available, from traditional horsehair mattresses to innerspring mattresses to cutting-edge foam and hybrid. Considering you'll spend one-third of your life in bed, ensuring that the bed is comfortable is paramount. In addition, selecting the perfect bed linens ensures that every detail of your bedroom exudes elegance, combining both exceptional quality and timeless style for a restful, sophisticated retreat.

Quality sleep is vital for both physical and mental well-being. Physically, sleep allows the body to repair and rejuvenate. It also supports immune function and aids muscle recovery. Mentally, sleep is crucial for cognitive function, memory consolidation, and emotional regulation. Adequate sleep promotes mental clarity, lowers the risk of depression and anxiety, and fosters creativity, problem-solving abilities, and overall productivity. Without quality sleep, increased stress, irritability, and decreased ability to cope with daily challenges can compromise health and wellness.

Having the perfect bed, mattress, and linens in place ensures you'll always look forward to bedtime after a busy day or to lingering in bed on a leisurely Sunday morning.

The graciously flared silhouette of the upholstered sleigh bed adds a decidedly feminine note to this blush-toned bedroom in New York City's Flatiron District. An equally gestural figure painting by Cynthia Packard and an antique Swedish crystal chandelier further the effect.

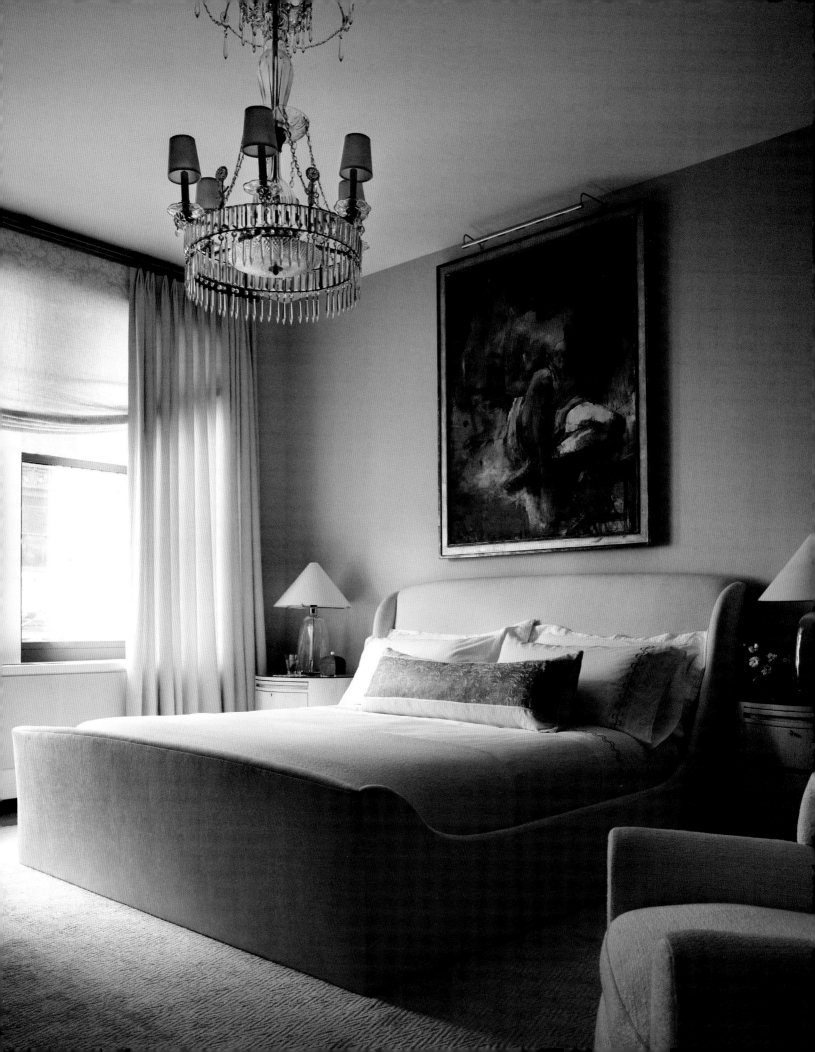

63

BLUE

STEVEN GAMBREL

Blue has universal appeal. We revere the deep blues of the ocean, reflective and ever-changing, and the pale blues of the sky, warm, inspiring and enveloping. The complexity of this color in all its tonal versions is its greatest asset. There is great pleasure to be found in mixing navy blue, pale gray-blue, sky, teal, and a myriad of other hues. Blue plays well with warmer tones as well, and feels most at home when paired with a crisp white, partly to offset its richness.

Paint and plaster finishes bring out the complexities of blue. Dry layers of integrated plaster in tones of the palest blue can feel like ancient stonework, but with a crisper, fresher interpretation. For me, a stair hall or entry hall in a pale gray-blue is more stylish, welcoming, and chic than its beige counterpart. That same scheme could have a high-gloss library around the corner in a deep peacock blue, saturated until you feel immersed in the depths. Its contrast with the paleness around the corner would create revelatory absorption and reflection.

The color blue can tie the entire scheme of a house together like no other. One can liberally apply a gray-blue neutral, lean into a rich navy, punctuate with a Delft blue pattern, and add green-blue textiles and materials that overlap with ease. Saturated blue lends itself to small spaces, such as a bar or vestibule, or a cozy statement room, such as a library. Once these rooms have been selected, that same tone can be used to outline elements of nearby spaces, creating a thread that pulls it all together.

A kitchen, for example, can have pale-gray-painted cabinetry with a tonal band of green-blue and a dark slate-blue stove—far more interesting than black. Stone-colored textiles with darker blue welts, peacock pillows, and sky-blue leather all work together artfully, and naturally. Warm cantaloupe, salmon, and oyster tones can be added into primarily blue schemes to warm the combination and keep wood and leather tones balanced.

Blue is versatile, and effortless. We wear blue jeans to be casual and chic, ice-blue dress shirts to convey professionalism. We often write in dark blue ink. Blue has universal appeal, like a solid citizen, spirited and strong, familiar yet endlessly versatile, always willing to be adapted, adjusted, and combined.

Opposite: One side of the living room in the designer's Manhattan townhouse is anchored by a custom chimneypiece crafted from Italian marble in blue and purple tones. It is complemented by a distinctive armchair by the twentieth-century French designer Jacques Quinet. A chandelier by Archimede Seguso is reflected in the mirror. Following pages: A rich, smoky blue flows through the room, coating the opulent original cornices, the curtains, and the furniture while providing a stunning backdrop for 1950s Belgian and Danish abstract art.

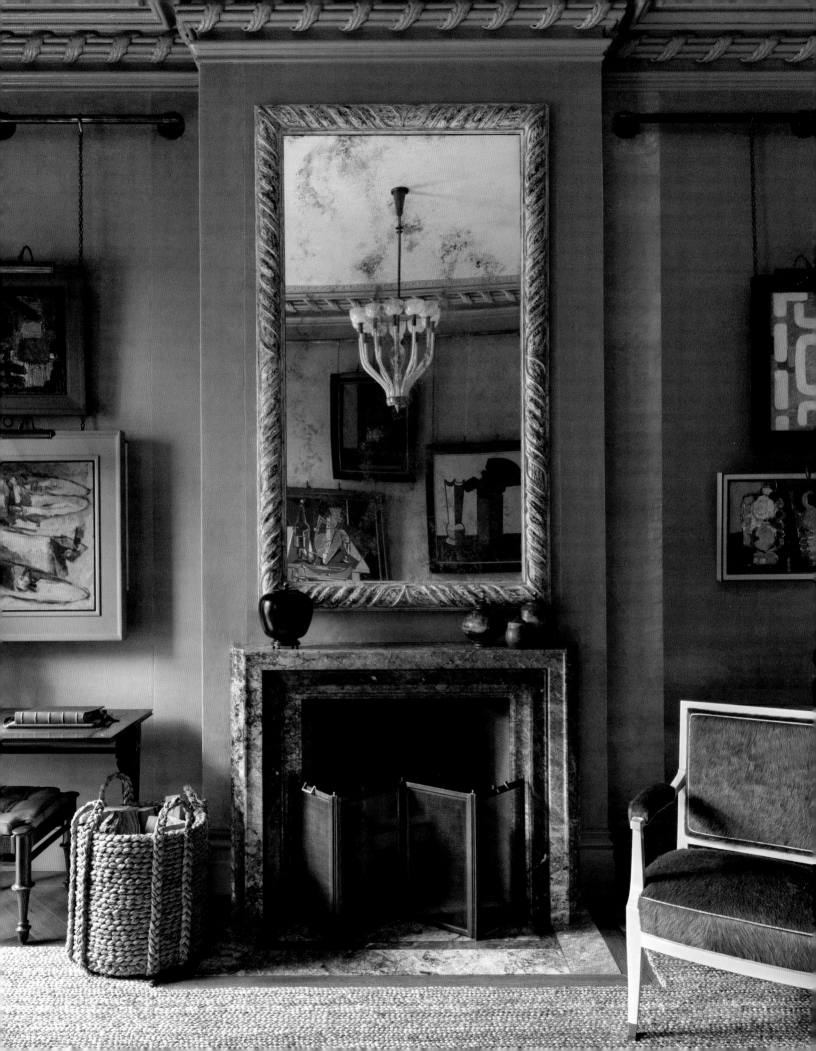

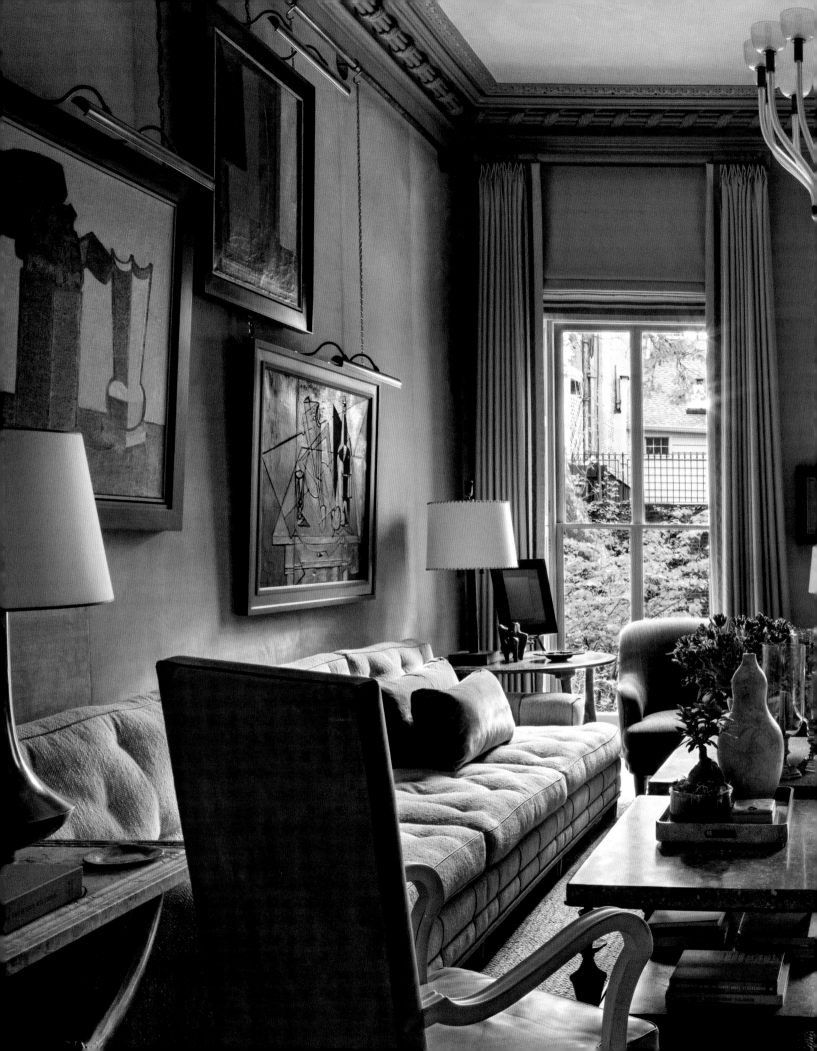

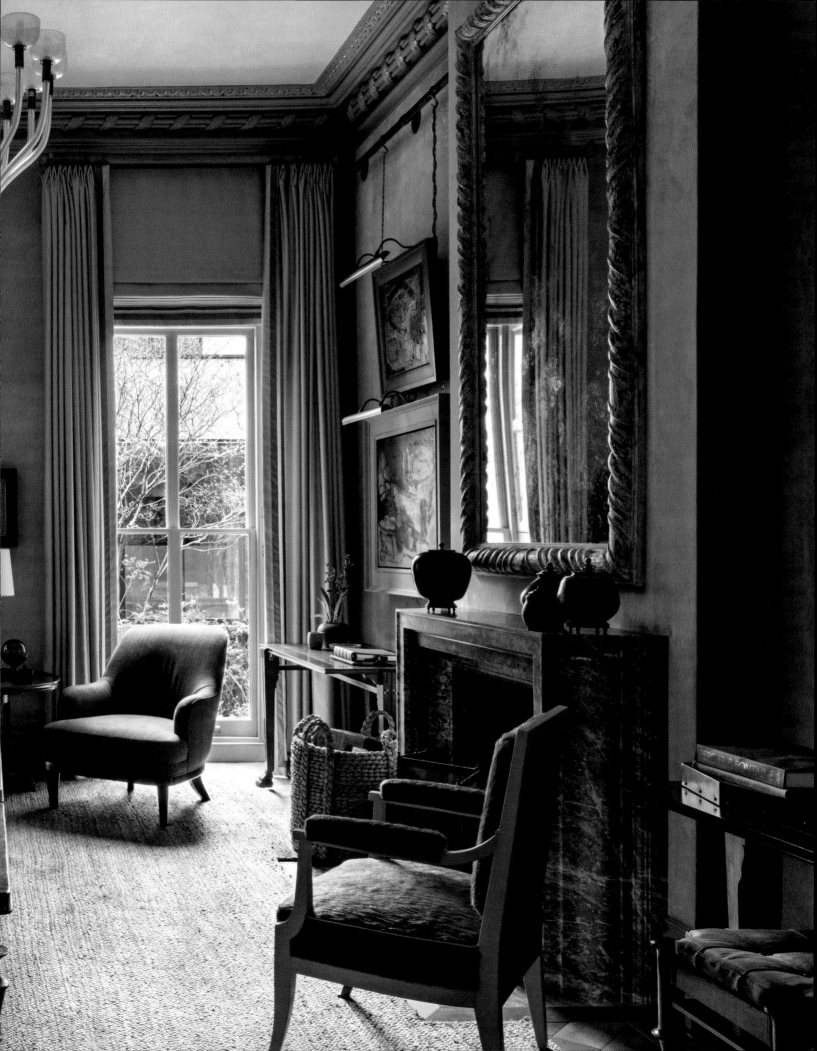

64

HISTORIC RENOVATION

MELISSA LEE

[Bespoke Only]

To me, the most important thing about renovating a historic home is to approach it with a sense of humility and responsibility. At my firm, we tread carefully, seeking a balance between staying true to the history of a dwelling and bringing the space up to date with a sensible flow that suits the present. I find this process particularly gratifying—the limitations that come with timeworn rooms are not restricting but rather exhilarating, as we search for ways to push the design forward while staying mindful of our duty as custodians. We're here to observe, study, and interpret what's been written during the time before us and our job is to shine new light on these stories while adding the next chapter. There is usually lots to uncover.

Through studying the original layout, we're granted an intimate peek into other people's lives in a different era. We trace back how people used to live and move through their home, their physical bodies, their lifestyle, and the makeup of the household—it's all endlessly fascinating. We come to a new understanding of how these homes were built, along with the concerns and priorities behind seemingly superficial design choices. I find this type of sleuthing helps us to understand better the canvas we're given before applying

our own strokes and prepares us to approach with appropriate consideration and respect.

Altering a home from the roots often brings about a bad case of impostor syndrome—a historic house changed drastically always ends up feeling artificial and contrived. I think a home is at its most charming when it remains its true self but is allowed to evolve with age. At the same time, I don't like to be restricted by architectural rules. People change over time, and a real home should reflect the dweller's lifestyle honestly. Preserving the historic characteristics of a home does not mean acting as an archivist who is restoring the space to a museum-like state. We're informed and inspired by architectural detailing, but not handcuffed to a minuscule bathroom when its proportions no longer suit the modern-day lifestyle.

In the end, historic renovation represents thinking and creating with an eye to forward motion. To undertake this work is to be part of something larger than ourselves in the hope that a new narrative will not only resonate with the dwellers today but will also connect with others in the past and future via a shared vernacular viewed through our individual lens.

In this Central Park West library, a custom cerulean velvet banquette and curved sofa blend
old-world grandeur with Scandinavian simplicity. A sleek quartzite table adds contemporary polish and is
juxtaposed against the home's original light fixtures, bookshelves, and ceiling.

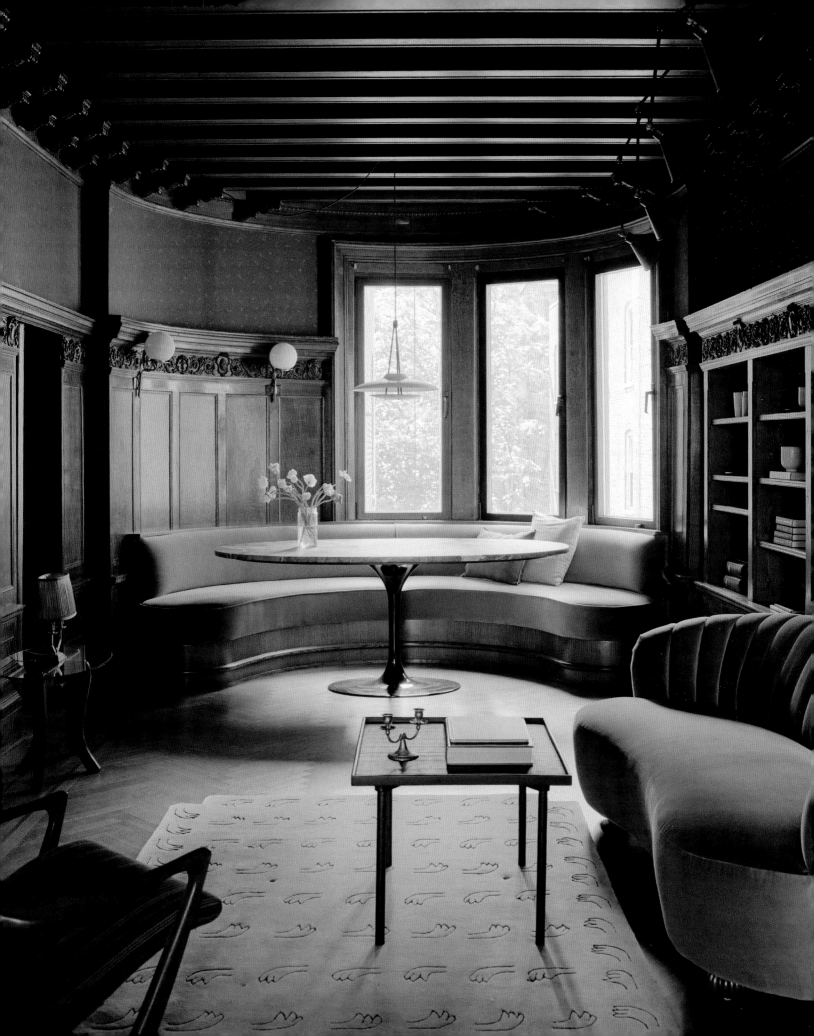

Often overlooked, transitional spaces are the vital connective tissue of a home. They unobtrusively orchestrate our daily movements. A well-designed entryway doesn't just welcome—it gracefully manages arrivals and departures. When an entryway is properly outfitted, the transition between public and private life is seamless. Likewise, staircases and hallways are more than mere thoroughfares; they're opportunities to build anticipation for dramatic reveals and galleries for personal expression. Such in-between spaces can tell stories through family photos or art collections. Flexible spaces that adapt to our changing needs— a home office used as a game room in off hours and as a guest space when needed—are also important. The versatility of these multifunctional areas makes them indispensable in our modern lives.

TRANSITIONAL

65

ENTRYWAYS

NICOLE HOLLIS

An entrance to a home is a first impression. It sets the tone for the entire house; like a novel's opening chapter, the design of an entryway sets the pace for the story ahead. A well-orchestrated entryway invites pause, reflection, and, sometimes, anticipation.

Transitioning from exterior to interior can be made seamless, for example, by using a glass front door to bring the outside landscape in. Materials can also be a powerful tool; use the same stone outside and inside, but change the finish to textured stone on the exterior for a rugged, weathered look and a smoother finish on the interior for a polished, refined look.

When approaching the design of an entryway, consider the scale and proportions of the space to set a mood. If the home has high ceilings and large rooms, compressing the space at the entry by lowering the ceiling makes the transition to the larger rooms more grand. In contrast, a large two-story entry can dramatically affect the mood upon arrival, especially when it is complemented by a sculpture, significant artwork, or over-scaled decorative light fixture.

Keeping the entryway simple from a design standpoint, and hanging an important artwork that nicely introduces the rest of the collection, is a beautiful way both to greet guests and to usher residents into their home.

When a home has incredible views, it's important not to give away those vistas at first glance but to allow them to unfold in a few separate layers before a big reveal. Adding a decorative screen or art wall can block the view or allow a glimmer of what is to come.

A calming entry sets the mood for the home and creates an inviting feel. Live plants, a large floral arrangement, or a fragrant candle can also add to the sensory experience upon arrival.

With a few dramatic interventions, the entryway sets the stage for the first act of arrival and the final act of farewell.

Hollis reimagined the entryway in this 1897 San Francisco Colonial Revival home,
originally designed by Edward John Vogel, by boldly pairing a prismatic Venini chandelier with ornate
Moroccan carved-teak lattice doors, reflecting her clients' adventurous spirit.

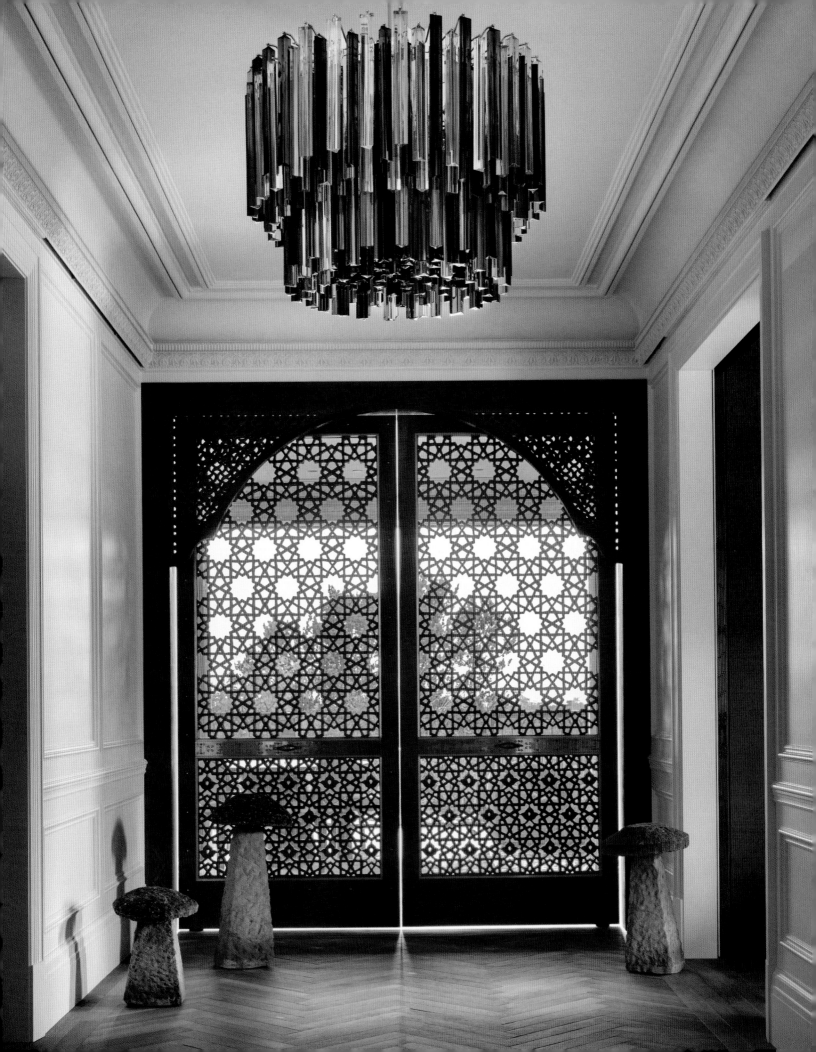

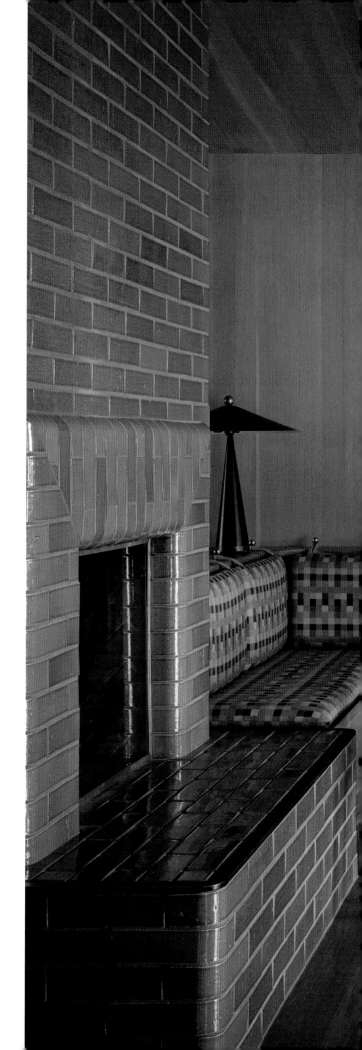

66

OPEN FLOOR PLANS

JESSICA HELGERSON

I've spent a significant part of my professional life considering the open plan—either loving or hating it, embracing or resisting it, feeling grateful for it or fighting to remedy it.

The mid-century era brought about architectural (and societal) shifts away from kitchens (and cooks) needing to be hidden, towards the kitchen as entertainment center, a vital part of the family living space. Hence the open plan or great room was born, which in many ways created a better, more democratic way to live.

The problem, from a design standpoint, was that removing walls required cooking, dining, and relaxing spaces to be treated as one design-wise. But with their very different needs, coupled with the inevitable trends revolving around moldings, wallpaper, and paint colors (all things that work well in older houses with rooms and not so well in modern open plans), we wound up with enormous amorphous spaces, lacking in architectural definition and covered in an unfortunate pastiche of the latest retro-leaning trends.

My advice? In older homes, keep the rooms and just stick to widening openings to create a happier and more modern flow. In houses that were purposely designed with the great room in mind, enjoy the openness, but then stick to a single design language, and don't try to paint the kitchen area white, add moldings to the dining space, or wallpaper the section that functions as the living room.

Let the older house be itself and work with, rather than fight, the architecture of that era. And let the modern house be itself too, rather than trying to layer on traditional design moves that feel out of place. Let your house guide you.

Right and following pages: This open-concept home just outside Portland features a dual-sided fireplace clad in artisanal glazed tiles from Bison Brick. The fireplace elegantly separates the living room and kitchen while maintaining spatial flow.

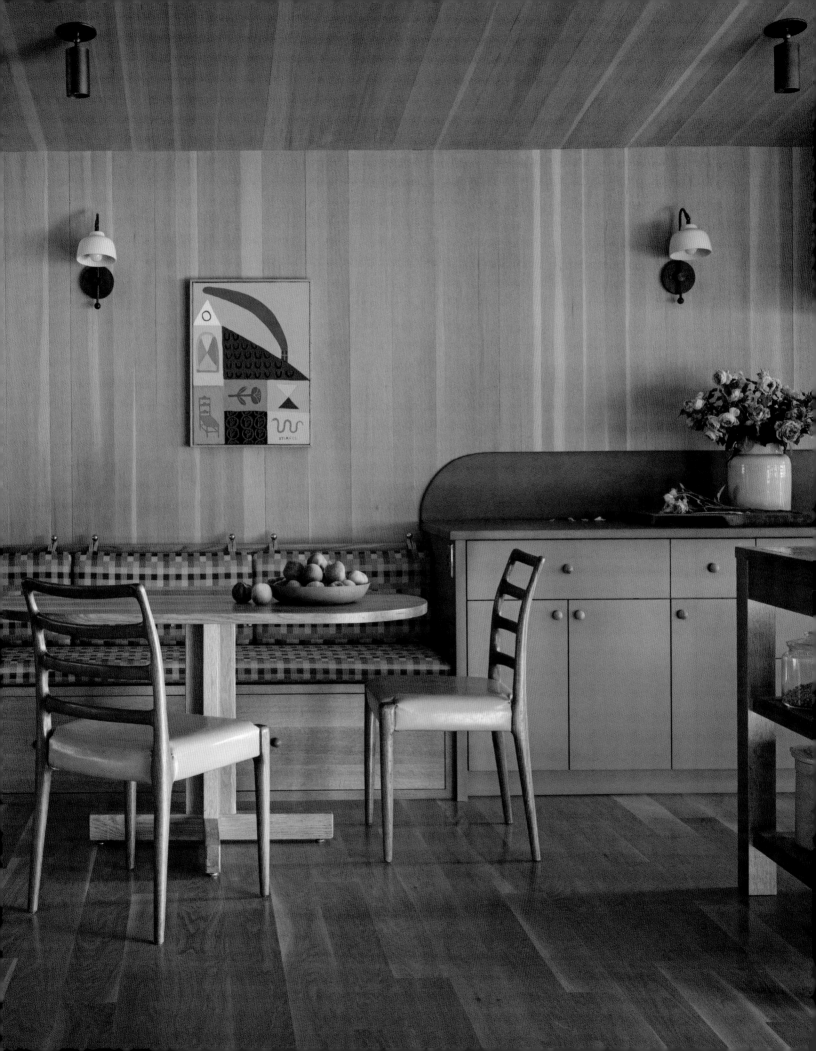

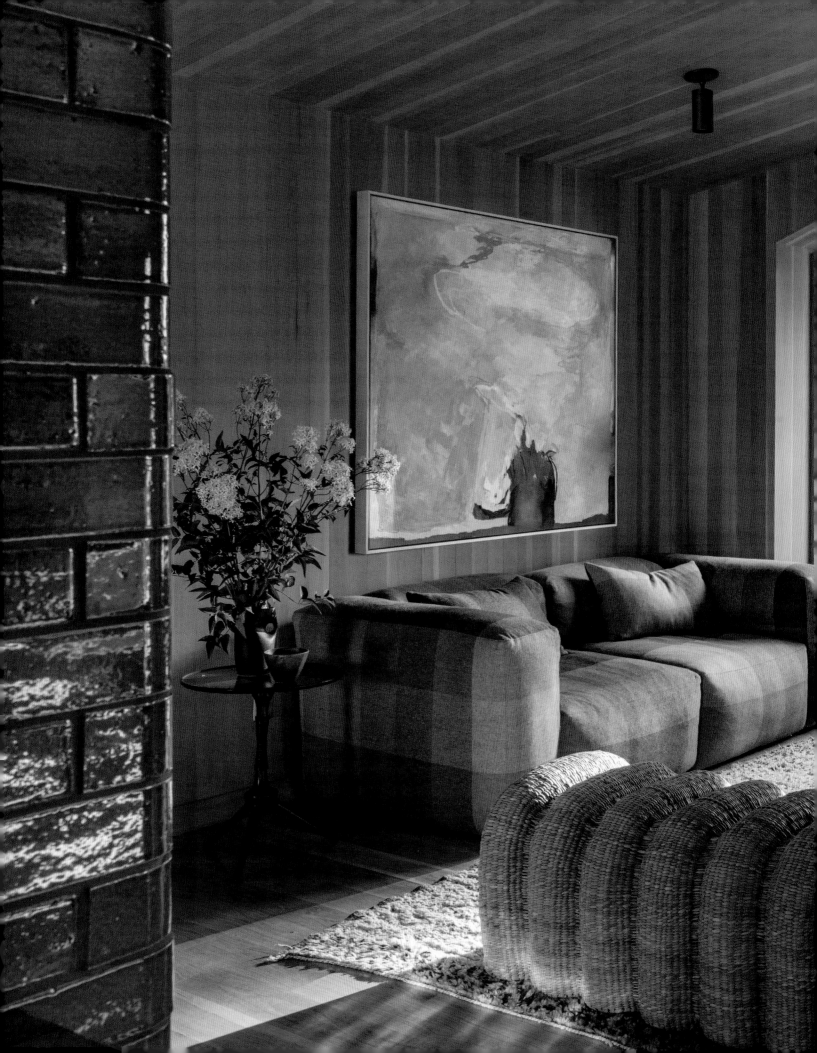

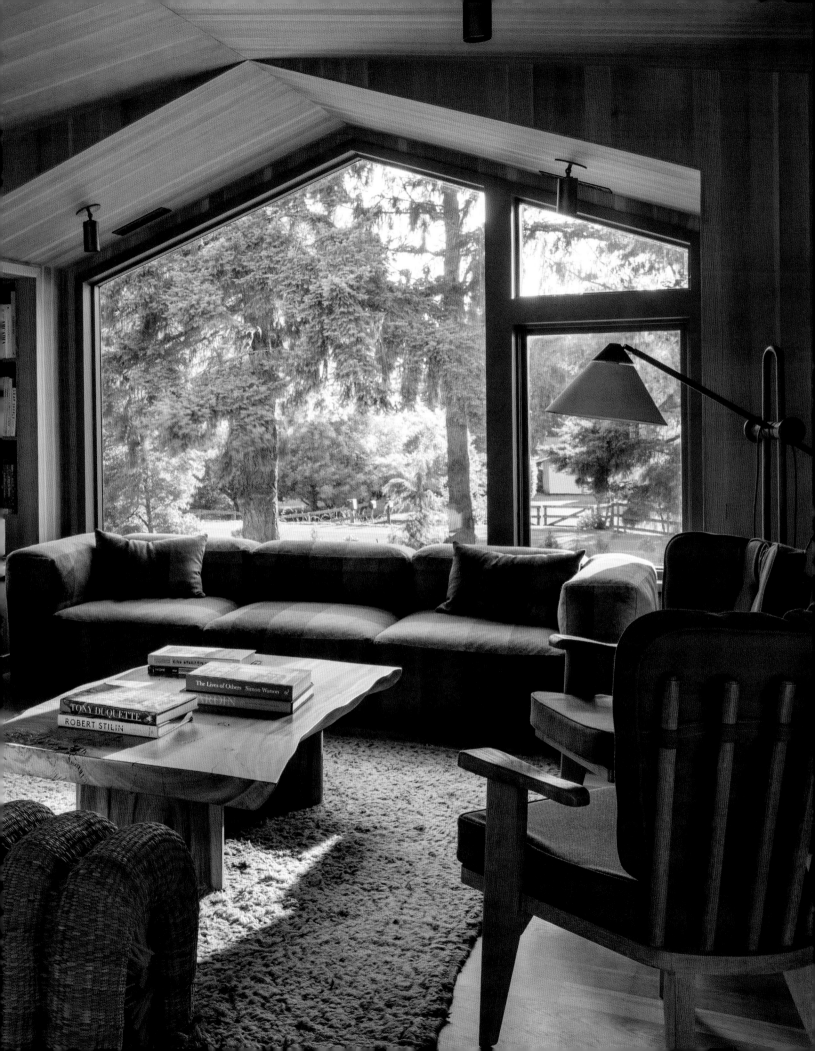

67

UNCONVENTIONAL CHOICES

MILES REDD

[Redd Kaihoi]

I fit the definition of "conventional" to a tee. My business partner, David Kaihoi, less so, but one must have a degree of convention to exist in society; it is a survival skill. The problem with convention is that it can make one restless. It is natural for us to grow bored with norms and predictability. Let's face it—we all loathe ennui.

It is here that revolution starts to fester. Fortunately, revolutionary decorating is fairly harmless, but as Oscar Wilde said on his deathbed, "My wallpaper and I are fighting a duel to the death. One or the other of us has to go."

Unconventional decorating boils down to taking something we have seen before and rendering it fresh. Trust me, there is a reference point for everything, and very little under the sun is entirely new. After all, we have been creating spaces for literally thousands of years. How could a historical antecedent be lacking? What is interesting are the way familiar elements can be combined to funnel toward the avant-garde.

Recently, I saw the movie *Poor Things*, directed by Yorgos Lanthimos, and I was struck by the director's sci-fi version of a London townhouse. The historical touchstones of the Edwardian era are on display: crotch-mahogany-paneled doors, sumptuous curtains, and broken pediment overdoors. But they are all turned on their heads: the floor is button-tufted, and an immense plaster ear is set in the middle of the coffered ceiling. We have all seen button tufts on furniture, but this is the first time I have seen them on a floor. The plaster ear feels Soane-meets-phrenology. This fusion is unconventional in the best sense.

In the practical world, we tend to see hallmarks of unconventional decorating with less hyperbole. But mankind is always pushing. In a recent project, we put a large red-leather canopy bed in the corner of a very grand living room. Many asked what made us do something so bold, and we answered them simply: we fell in love. We found the bed at an auction, and this living room was the only place where it felt at home (let alone where it would fit physically). Sometimes necessity is the mother of invention. Still, England's Stanway House shows that it's not the first time a canopy bed has held pride of place in a living room. Unprecedented? No. But unconventional? Well, you got me there.

Opposite: An audacious red-leather bed, once owned by decorator Thomas Britt, is an unexpected addition to this vibrant living room. It boldly mixes with treasured pieces from legendary American estates.
Following pages: Theatrical flair meets Gilded Age opulence. Bold patterns, rich textures, and dramatic proportions create a layered, cinematic atmosphere reminiscent of classic Hollywood film sets.

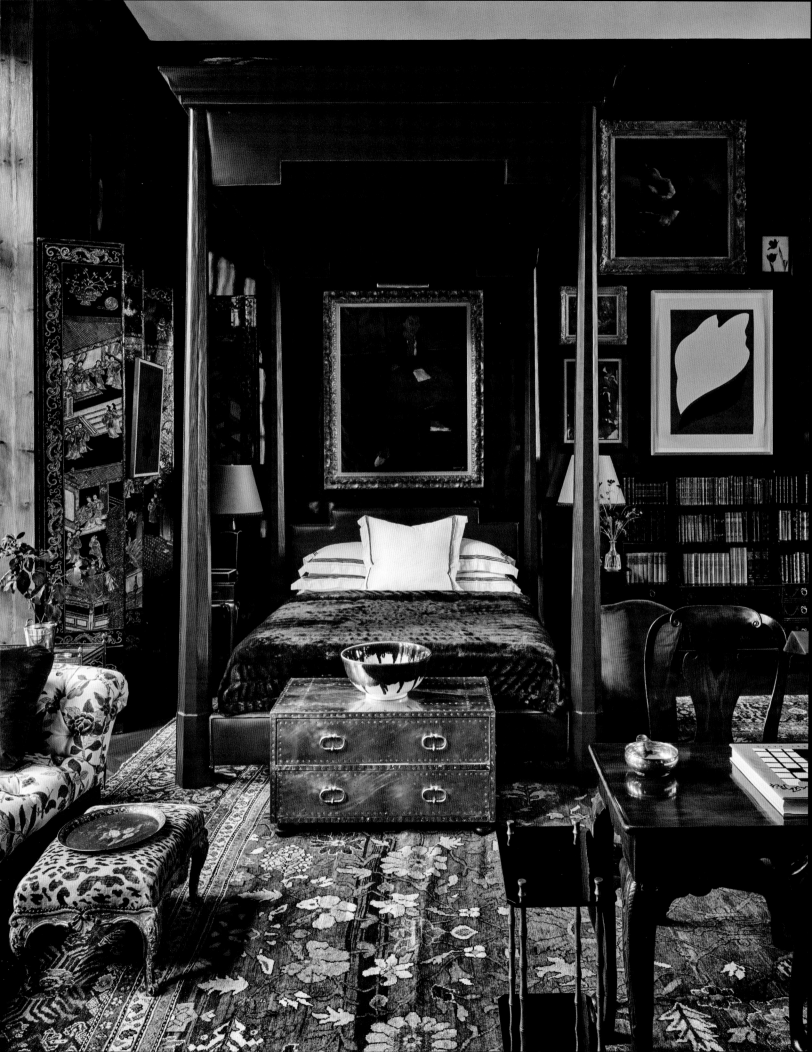

68

SMALL SPACES

JEAN LIU

Interior design in small apartments or homes presents unique challenges and opportunities, and requires creative solutions to maximize space without compromising aesthetics or functionality. Efficient use of space and thoughtful selection of furnishings and decor are essential to creating a comfortable, stylish living environment.

One of the primary considerations in designing small spaces is the choice of furniture. Multifunctional pieces are invaluable; for example, a sofa that converts into a bed or a dining table with built-in storage both save space and add utility. Furniture that can be folded or stacked away when not in use also helps to keep the area uncluttered. Opting for furniture with exposed legs can create a sense of openness, making the room feel less crowded.

Storage solutions play a crucial role in small-space living. Utilizing vertical space by installing shelves or tall cabinets can help keep floors clear and make the room appear larger. Hidden storage options, such as ottomans with compartments or beds with drawers underneath, are excellent for maintaining a tidy appearance while providing ample storage. Built-in storage solutions, like wall-mounted desks or custom cabinetry, can be tailored to fit specific needs and architectural constraints, optimizing every available space.

Lighting is another critical aspect of small apartment design. Natural light should be maximized wherever possible, as it makes a small area feel more expansive and airy. Sheer curtains or blinds that can be fully opened allow light to flood in. Additionally, using mirrors strategically can reflect light and give the illusion of a larger space. Layered lighting—incorporating ambient, task, and accent lighting—creates depth and versatility in a compact area.

Color also significantly impacts the perception of space. Light, neutral colors make rooms feel larger and more open, while dark hues can make them more enclosed. However, incorporating pops of color through accessories or accent walls adds personality without overwhelming the space.

Lastly, maintaining a cohesive design theme helps to unify the space and avoid a cluttered look. Minimalist and Scandinavian design styles, known for their clean lines and functional aesthetics, are particularly well-suited to small apartments. By carefully considering these elements, it is possible to create a small living space that is both stylish and highly functional.

Opposite: In the dining area of her sophisticated New York City studio apartment, the designer paired a Patricia Urquiola marble and wood dining table with vintage Børge Mogensen chairs sourced from Lawson-Fenning. Following pages: In this broad view, a curved sofa and cork cocktail table define the living area, while an antique daybed provides a restful spot. The decorative plasterwork is original to the home; hand-embroidered panels from de Gournay cover the walls.

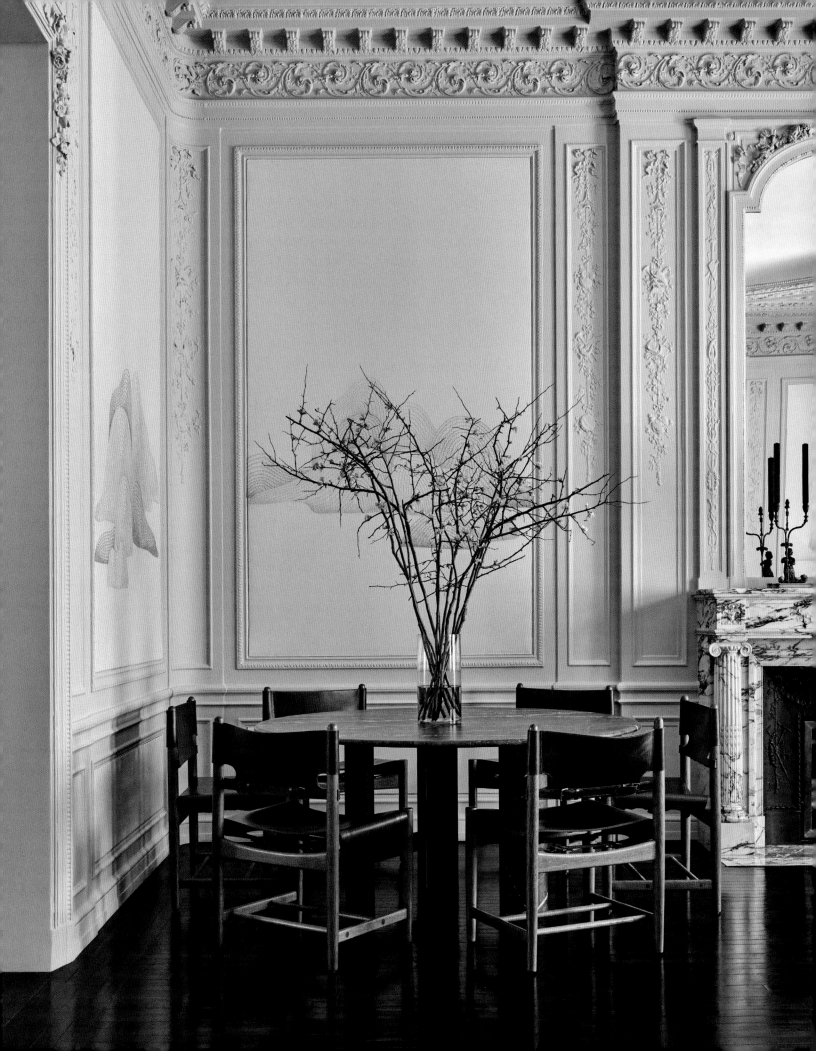

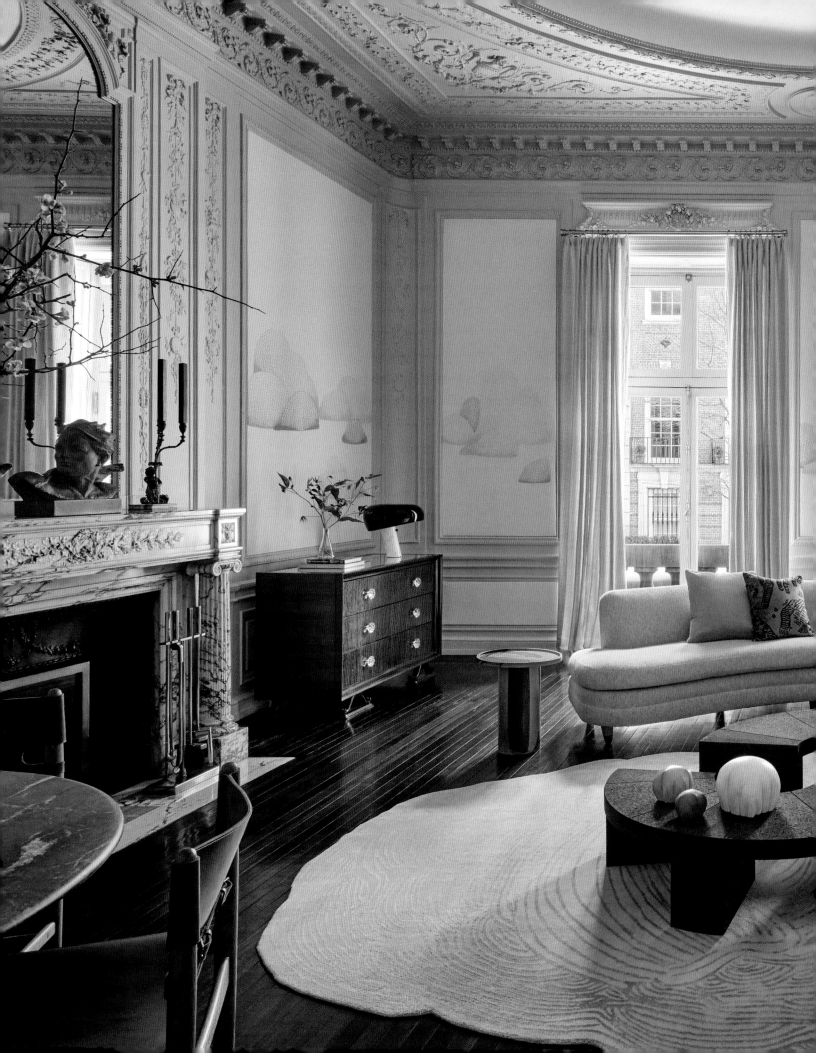

69

OPEN-AIR SPACES

MARSHALL WATSON

When I was growing up in Kansas City, my family's outdoor porch, nestled beneath huge oaks and maples, with a grand view of our gardens, was our favorite spot. The space was protected, so we often gathered there to experience huge Midwestern thunderstorms that were frightening but also exhilarating.

We lived on our porch, enjoying the cool of late summer nights, humming with the pulsations of cicadas, as well as early morning Swedish pancake breakfasts. Later on in life, I realized it was the best spot for gin martinis! Basically, we invented every opportunity we could to live this indoor-outdoor existence—an essential extension of our family's home life.

Our four dogs would lumber up to the porch, lie down, and nap. Neighbors would casually drop by, knowing that if we were on the porch, everyone was welcome. Laughter and music resounded and enduring memories were formed.

I try to recreate the joy I experienced on my family's porch in the homes I design today. A purposeful mixture of indoor and outdoor furnishings helps. Rattan, iron, bamboo, and teak are used for worry-free comfort. Drip-through foam cushions, wrapped in thick Dacron, dispel mold yet offer comfort.

With so many spectacular endurance fabrics available, not to mention today's all-weather carpeting, the sky is the limit for designing fully furnished rooms in the open air. Cabana-style curtains, or romantic sheers in all-weather fibers, can be as supple and sensual as the most luxurious indoor fabrics.

To enhance the mood, I rewire attractive lamps with all-weather voltage and fashion pleated lampshades in performance textiles. A host of outdoor sconces and pendants have hit the market, but I often prefer to outdoor-wire interesting vintage lanterns for a dramatic and exotic evening ambiance.

Rather than hanging weather-vulnerable artwork, I choose artistic mirrors, which have the added benefit of expanding the space. Frequently I also seek out architectural fragments to enhance the area and use houseplants, the perfect inhabitants for these spaces, to create warmth and interest.

To extend the seasons, I install discreet ceiling heaters. In tropical environments, vintage fans cool the still air. An outdoor fireplace crackling with burning logs, another season extender, not only sets the mood and offers an invitation to toast marshmallows, but draws guests—like moths—to circle around its cozy flickering flames.

This outdoor living room, transformed from an enclosed space, was inspired by the homeowner's cherished memories of his aunt's Palm Beach home. The vintage bamboo furnishings offer both practicality and timeless elegance.

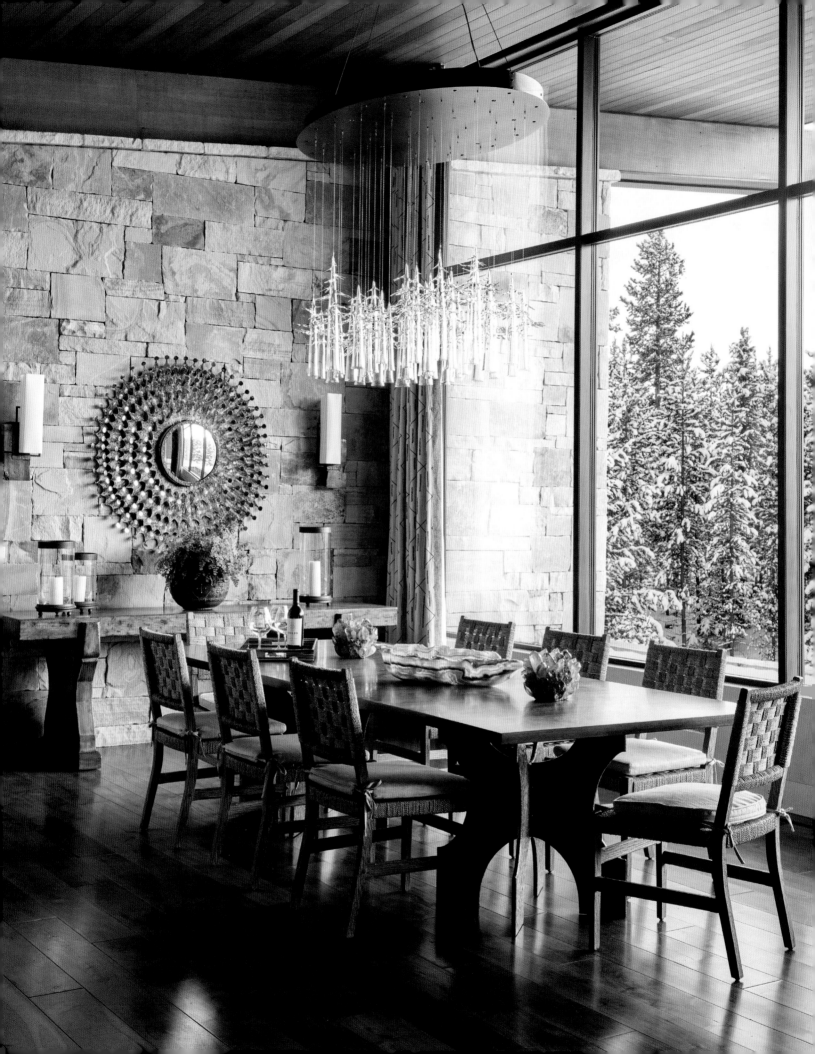

70

STONE

SUZANNE TUCKER

Perhaps due to a childhood spent collecting pebbles in creeks and on beaches, I find stone endlessly fascinating. Stone speaks to our history, our origins, and our civilizations. One only needs to walk the streets of Rome to see the effect of centuries of wear on stone, how footsteps hone stairs until they are soft underfoot and smooth to the touch. Stone outlives all of us, bearing silent witness to the past.

In decoration, stone can require intimidating commitment. After all, it's heavy and expensive both to purchase and to move, and it often reads as cold at first glance. Yet when stone is embraced and used in unexpected ways, it can be seductive, romantic, soft, and warm.

From flooring and walls to plinths and lintels, from countertops and backsplashes to hearths and mantels, from benches and table bases to urns and columns, there is a stone for every application. For example, limestone, a sedimentary rock, can be easily cut and carved, allowing for intricate architectural details; its neutral tones provide a timeless and quietly elegant look. Vivid veining or the many subtle hues found in marble and onyx lend themselves to dramatic book-matching and intricate intarsia floor patterns and borders—favorite custom design elements of mine. Even stone remnants can be repurposed into confetti-like terrazzo flooring. The result: durable, chic, and resilient!

I can't consider stone without addressing texture. Smooth or rough, honed or polished, leathered or flamed, waxed or left dry—the options are endless. An entire wall of stone can speak to place and become a dramatic textural backdrop.

Best of all, stone is grounding and meaningful in a profound way. As sculptor Andy Goldsworthy once told a journalist, "There is life in a stone. Any stone that sits in a field or lies on a beach takes on the memory of that place. You can feel that stones have witnessed so many things."

Opposite: A dramatic Italian glass chandelier by Simone Crestani echoes Montana's natural landscape, while a French convex mirror with a brass frame refracts the ample natural light. Streamlined dining furniture allows the snow-swept vista to take center stage. Following pages: A petrified sequoia slab table anchors the living room, where plush upholstery is arranged so everyone can view the fireplace. Massive stone walls throughout the home contrast with wooden beams and ceiling boards.

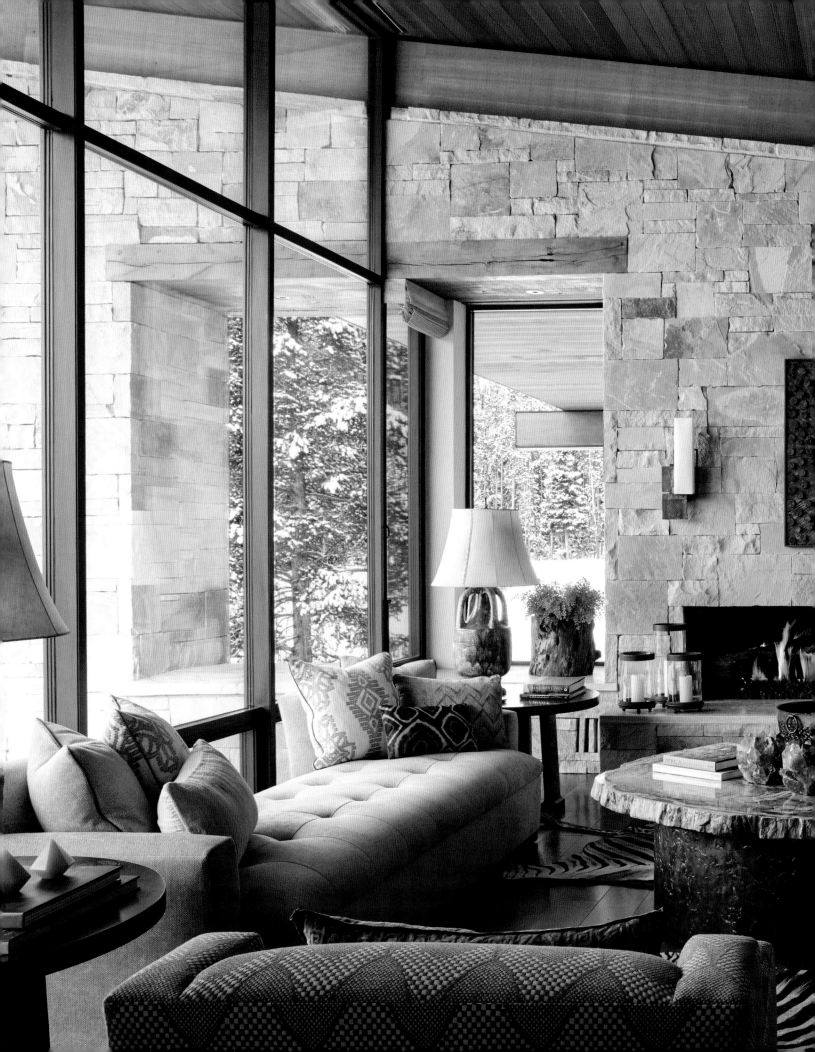

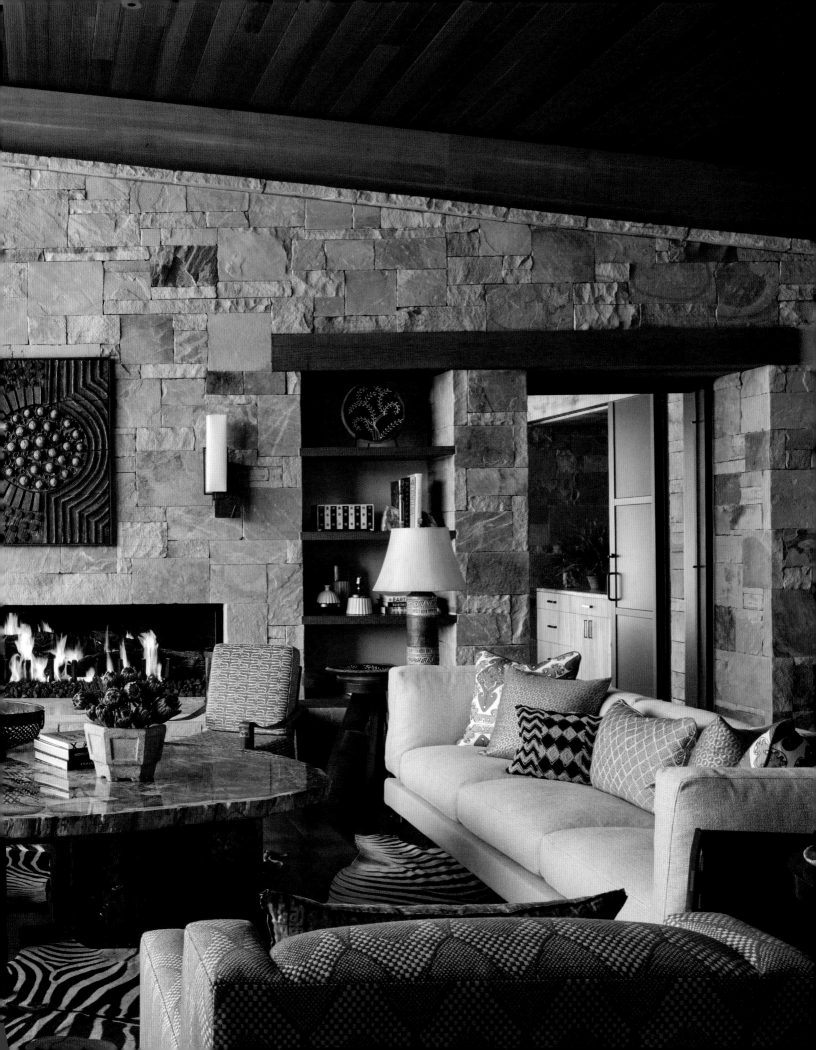

71

STAIRCASES

BRIAN J. MCCARTHY

A staircase is pivotal to a home's overall aesthetic and character. A well-designed staircase serves a functional purpose and enhances and complements the space's architectural integrity. The stairs must integrate seamlessly with the interior design, reflecting the home's style and atmosphere.

Staircases serve as transitional architectural elements, bridging the gap between the public spaces below and the private areas above in a house. They guide movement from communal living areas, like the living room or kitchen, to more secluded ones, like bedrooms and bathrooms. This transition facilitates physical movement and subtly shifts the atmosphere from social to intimate, marking a change in function and privacy.

The materials and finishes of a staircase are crucial to aligning it with the house's overall style. Typically, stairs feature wood treads and painted risers, providing a classic and versatile look that fits various interior designs. However, alternative materials like marble, stone, glass, and metal can create striking and unique looks. Marble or stone stairs add a touch of luxury and grandeur, while glass stairs offer a contemporary, airy feel. Metal stairs can introduce an industrial edge or a sleek modern aesthetic. The choice of materials should be developed in concert with the home's overall color scheme and decoration, ensuring a harmonious and cohesive appearance. By thoughtfully selecting and coordinating these elements, the staircase enhances the home's architectural character and is a beautiful and integral interior feature.

Adequate lighting is essential to avoid dangerous conditions. If the stairs are continuous, you might choose a chandelier overhead, or you might rely on intermittently placed sconces. If not, a combination of downlights or lighting incorporated into the stringer or treads might be used.

One final thought: stairs can be an exciting opportunity for art placement, offering the chance to be bold in selection. It's essential to consider how one walks up and down and views the art from various vantage points. The width of the stairs also dictates the type, medium, and placement of art—there can be no possibility that those ascending or descending the stairs will knock into the art and cause damage.

Stairs are by definition places of movement. They offer exciting opportunities for drama and impact.

McCarthy designed this breathtaking staircase to replace the original iteration in a Park Avenue duplex.
An El Anatsui tapestry overlooks the space, while an iconic Wendell Castle chair provides high-style seating.

72

TRANSITIONAL SPACES

GARY MCBOURNIE + BILL RICHARDS

Transitional spaces such as hallways, stairwells, and landings are often overlooked. With a little bit of thought, however, they provide a unique opportunity both to unify the design aesthetic woven through the home and to create a special moment or resting spot.

When designing transitional spaces, we like to consider the decor of the adjacent rooms, as we believe the rooms should speak to each other—and the transitional spaces should facilitate that conversation. That said, we do like to add contrast by making a transitional space lighter or darker while keeping it within the overall color palette of the home. Pattern and texture via a woven wallcovering, a decorative paint finish, or even a mural can add visual interest.

The walls of transitional spaces provide a great opportunity to be creative and have fun. Make guests want to linger and look by incorporating a variety of things. We like to juxtapose etchings with paintings, framed objects, sculptural items, and even decorative plates.

Furniture can add character and purpose to a transitional space. What is more welcoming than a bench or a settee in an entranceway or hallway? A great old chest can be decorative and also serve as storage for scarves, gloves, and other items that need an accessible home. The top of the chest is also a great spot for a small bar. Take out that unused silver tray and layer it with interesting glassware, a favorite beverage, and napkins, and you will have created another magic moment.

One last thought: transitional spaces do have a primary function, so remember to leave enough space for safe passage.

In this historic Stanford White residence, once Brooke Astor's home, a plain hallway was transformed into an intimate gathering space with a cocktail bar and a deep-seated, down-filled sofa perfect for intimate conversations.

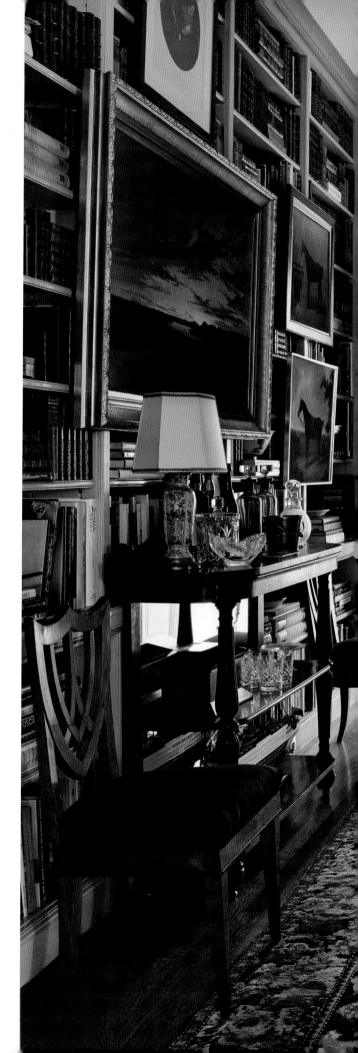

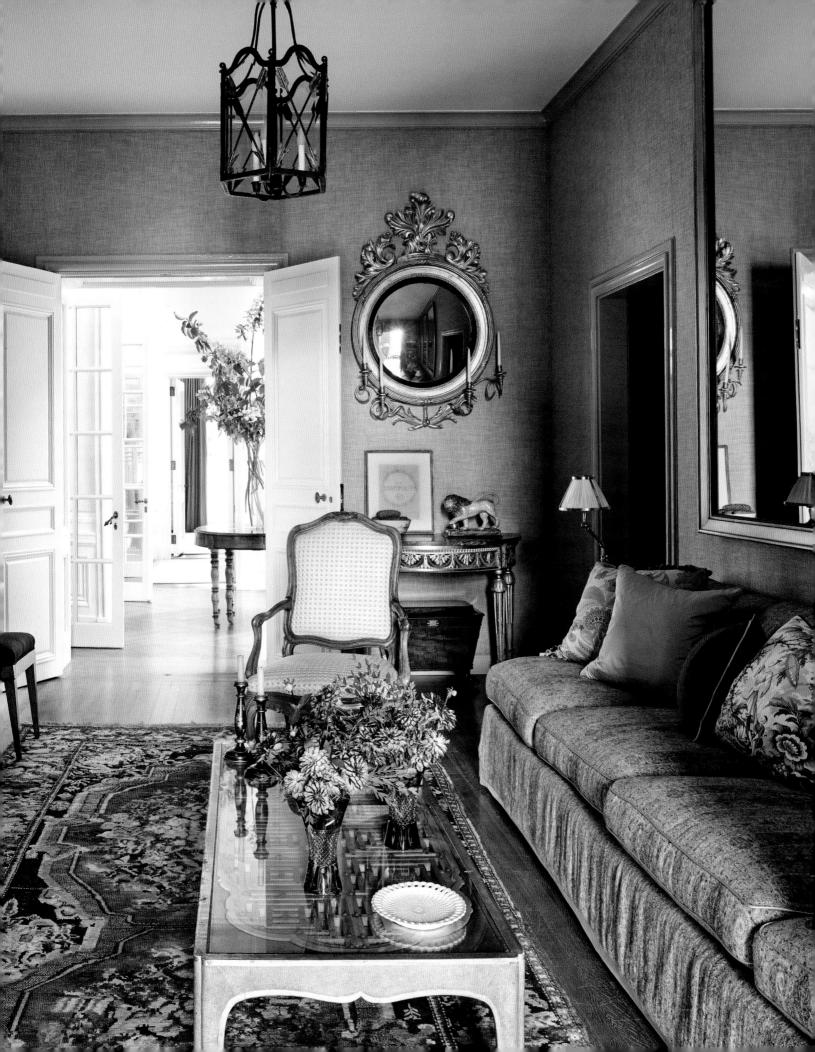

73

AL FRESCO DINING

MINDY GAYER

An al fresco garden party is the perfect way to welcome spring. Warm summer nights also call for outdoor dining. Whatever the season, an al fresco meal makes for magical moments with friends.

When I'm organizing an outdoor gathering, I rely on a series of nuanced elements: vases filled with romantic florals, tapered candles in neutral hues to create a dreamy glow, woven chargers for textural interest, both formal and informal dinnerware pieces that I've collected, and etched floral tumblers to dress up freshly brewed iced tea or house-made cocktails. I like to think of every element on the table as a special love letter to guests with a story to tell.

I always encourage collecting table linens and flatware as a starting point for hosting. When I travel, I almost always find myself bringing something home, whether it's a storied tablecloth, a set of embroidered napkins, a woven scalloped tray from a new-to-me artisan, a local ceramicist's gorgeous platter and serving bowl, or hand-poured candlesticks for our glass hurricanes. My personal favorites include linen tablecloths in whimsical florals and ginghams from a girls' trip to Paris, and tailored napkins to mix and match that I picked up at a local beloved home store. Keep an eye out for French tortoise flatware and vintage silverware—both elevate an otherwise perfectly imperfect tablescape. Maintaining these collections makes hosting effortless.

Florals, whether cut by hand from your garden or selected at the farmers market, spark creativity. I try to opt for blooms I haven't used before, for a fresh-from-the-garden look. Never too formal, and always colorful. I'm forever in awe of the intricacies, hues, varieties, and sheer happiness florals bring.

There are a few things that make al fresco dining more pleasant for everyone: An overhead covering ensures the meal can go on regardless of the weather. Glass domes protect food. Citronella candles and bug spray help deter bugs. Pillows for chairs soften outdoor furniture and individual blankets provide warmth in case the evening gets chilly.

It's all about curating a beautiful series of moments for friends—moments that evoke a true sense of home. Perfection is not the goal. Create a comfortable setting and incorporate items that bring joy and when guests sit down they will feel the love and intention. Everything else is magic from there.

Opposite: A constellation of woven rattan lights hung from the pergola ceiling illuminate this dining table when friends and family gather for a meal. The weatherproof, classic bistro chairs add to the casual vibe.
Following pages: A lush canopy of climbing vines envelops the pergola-covered dining space, transforming it into a natural outdoor room. The stone fireplace serves as both an architectural anchor and a gathering point.

74

MILLWORK

GLENN GISSLER

One way to make a room memorable is by installing millwork, which refers to anything made of wood that is applied to surfaces other than the floors of a home. As a rule, millwork is architectural and permanent. It includes moldings, paneling, stair banisters, cabinetry, and window- and doorframes. Functionally, millwork addresses specific construction issues. It can smooth transitions from plaster walls to wood floors and from walls to ceilings. It also helps to integrate openings in walls, such as doorways and windows. Kitchen, dressing room, and bath cabinetry are also considered millwork when either fashioned from wood on-site or crafted in workshops and then transported to a home.

Millwork can employ shadows and material contrast to add interest to an interior or, in the case of more minimalistic approaches, limit shadows to make interior surfaces appear more planar.

In Edith Wharton's seminal volume on decoration, *The Decoration of Houses,* she speaks broadly about the importance of simplicity and restraint in millwork. She advocates for appropriately scaled designs that enhance architectural harmony with elegant proportions and reinforce hierarchies of rooms.

Millwork comes in a wide range of styles, from classical and ornate to modern and minimalist. Traditional styles often feature intricate carvings, moldings, and detailed paneling. (Looking for more on traditional designs? Check out the essential references *Traditional American Rooms: Celebrating Style, Craftsmanship, and Historic Woodwork* and *Roberts' Illustrated Millwork Catalog: A Sourcebook of Turn-of-the-Century Architectural Woodwork*.)

In contrast, contemporary millwork favors clean lines, smooth surfaces, and subtle geometric patterns. It focuses on functionality and simplicity. Modern interior architecture can be distinguished from other styles by its lack of millwork or an attempt to have the millwork visually disappear.

Transitional millwork combines strategies from traditional design with cleaner, more modern sensibilities to create the types of spaces that suit many people today.

Millwork surfaces may be sealed or stained to take advantage of wood's natural characteristics, or they may be painted. The choice largely is based on the type of wood used and the intended decorative effect and function. Invest in high-quality materials and skilled craftsmanship, as millwork is a long-term feature that adds value and aesthetic appeal to a home.

This double-height entryway features custom millwork painted glossy aubergine, the owner's favorite color. A streamlined redesign replaced a coat closet with an Empire console adorned in antique calligraphy paper and a painted Swedish antique chair.

75

BLUE AND WHITE

GEORGIA TAPERT HOWE

I have always loved experimenting with new color combinations, but I inevitably return to one classic pairing: blue and white.

I grew up on the East Coast, so blue and white were an inescapable part of my visual world, and they naturally became a key component in my decorating DNA. My original reference points were the prints of the 1980s—blue-and-white chintz and classic masculine stripes—and those have earned their rightful place in the pantheon of traditional design. But as my tastes have evolved, I have tried to employ blue and white in fresh ways. I find I return to blue and white time and again in kids' rooms, family rooms, and primary bedrooms. There is something comforting about the combination. However, I always try to add a twist. I particularly love throwing in a pop of another color like a rust or mustard yellow.

While blue and white is a quintessentially American combination, it is also a mainstay in many other cultures worldwide. Think of France's wonderful toile de Jouy, the cobalt-and-cream combination in Chinese ironstone, Japanese shibori prints, Moroccan blue-and-white kilim rugs, the stucco of Greek houses set against the Aegean Sea, or my personal favorite, the dusty-blue and white combinations seen throughout Scandinavia, just to name a few. I'm endlessly inspired by how other countries use this combination in textiles, porcelain, tiles, and paints, and I love to incorporate new color ideas that I discover on my travels.

I think of blue and white as a neutral combination, so I also use it as a glorious backdrop for all sorts of different materials, especially dark wood, beachy oak, and wicker—another personal favorite. That's the beauty of this pairing: there are a million ways to put your stamp on it.

Opposite: Wicker furniture and blue-and-white prints frame the garden views from this screened porch in Greenwich, Connecticut. Following pages: The porch, anchored by a pair of Serena and Lily Anacapa coffee tables, features a 14-foot Wicker Works sofa in Penny Morrison's Zanzibar fabric. Ceiling fans and heat lamps offer year-round comfort. Howe enhanced the pool-facing space with Benjamin Moore's Yarmouth Blue on the ceiling and Coventry Gray on the floors.

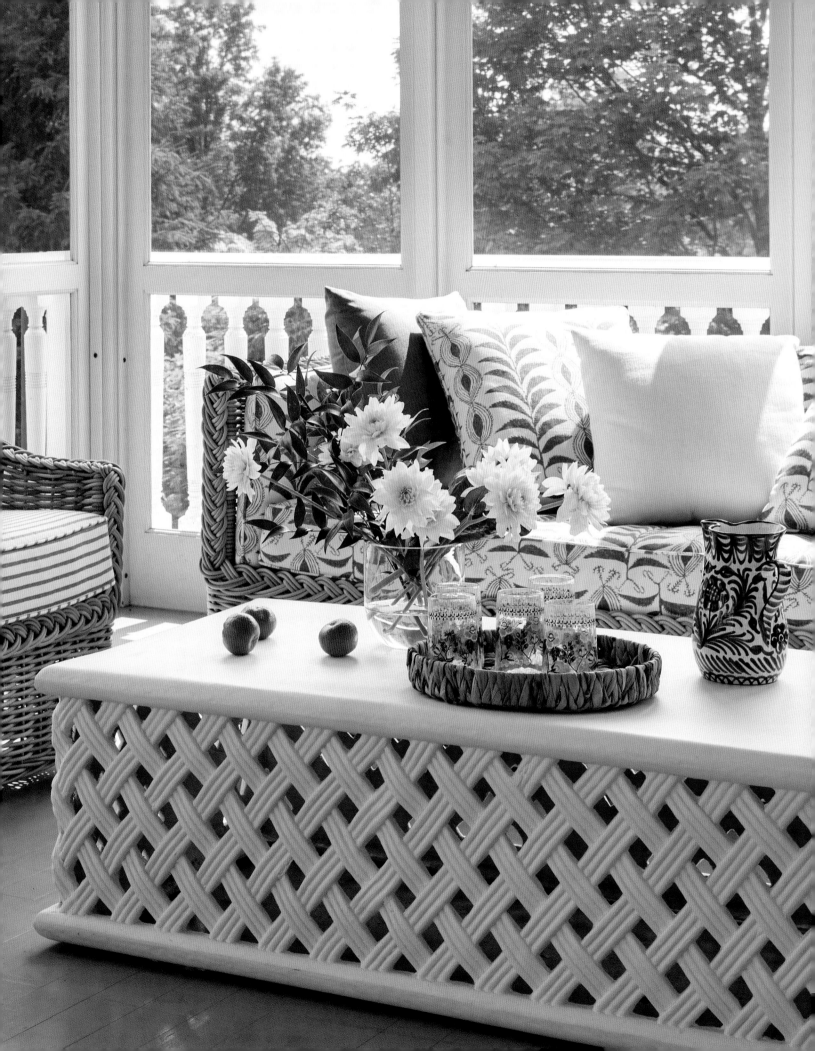

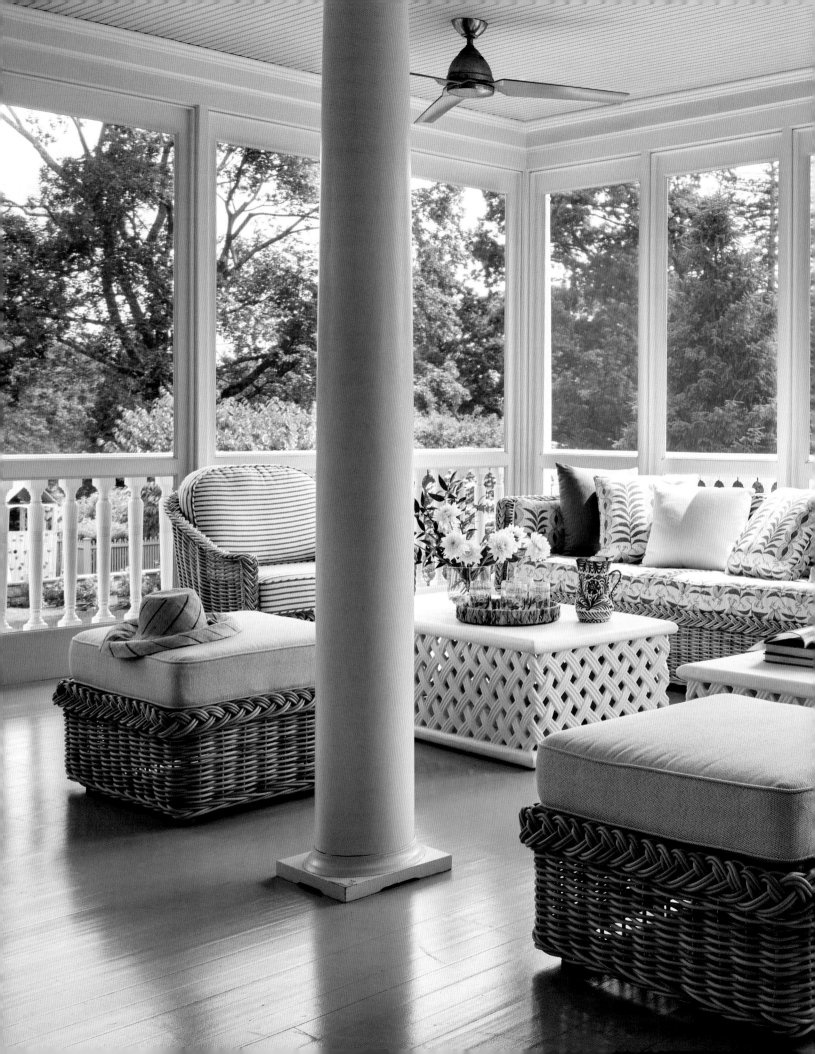

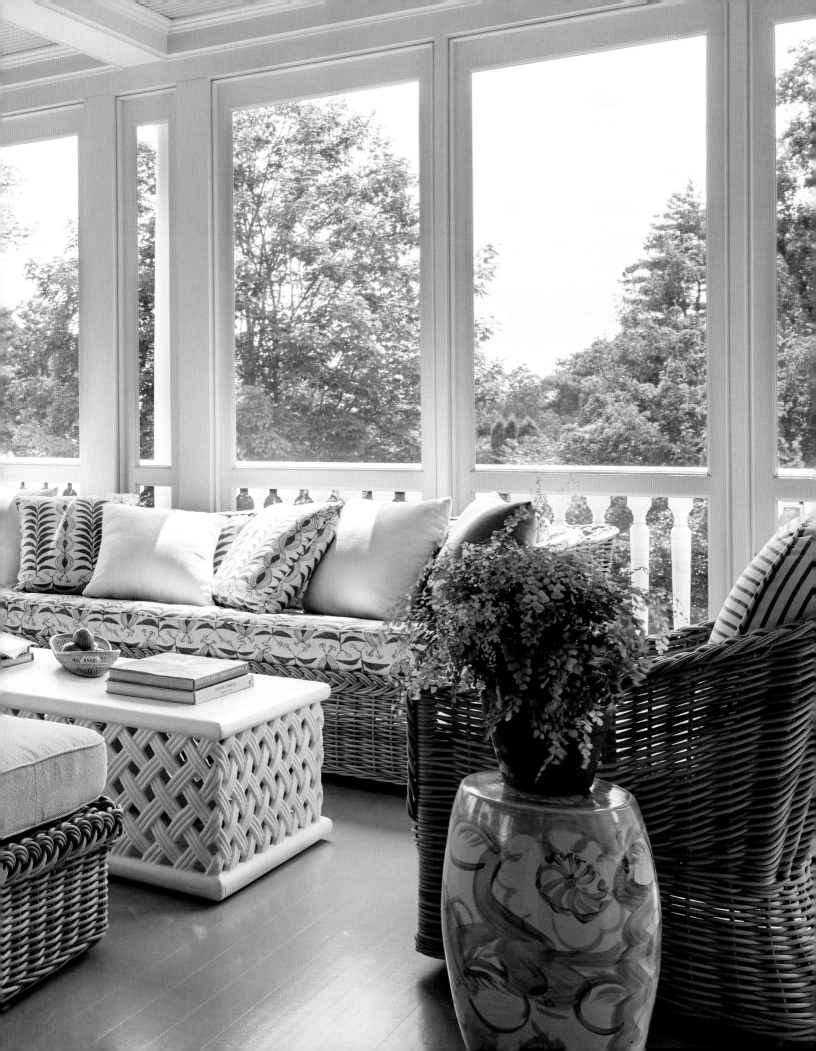

76

HALL TABLES

BRUCE FOX

Upon entering a foyer or entrance hall, one is often greeted by the ubiquitous center table. Historically, a home's entry has been designated as a very public space, a place where transactions between a landowner and their tenants happen. The entry tables we enjoy today were inspired by pedestal tables that were often referred to as rent tables. Such a pedestal table had multiple drawers around the perimeter, one drawer for each day of the week and another designated for cash. Today, the entry table has transformed into an elegant focal point, a welcoming addition to the foyer.

An entry table can be fashioned of nearly any material, from stone to bronze to glass, and in any style, from antique circular mahogany tables to ultra-modern steel and glass creations. With items arranged on top, an entry table forms a vignette that informs the decoration of the entire home.

We've all seen entry tables in the pages of design magazines styled with abundant floral arrangements or huge tree branches in bloom. As lovely as these look, practicality is of equal importance. An entry table often serves as a landing strip for a busy family's comings and goings, so adding a tray or bowl as a place to collect items such as keys, phones, and wallets can be significantly useful. Such a piece, combined with other decorative objects, such as sculptures and books, can make a striking arrangement that is beautiful and functional and can be enjoyed every day.

Any decoration added to a foyer enhances the decoration throughout the rest of the home. For example, decorating an entry table for the holidays or a special occasion is a lovely way to add a festive spirit that will greet guests as they arrive. It is also important to remember that these tables are generally in the centers of foyers or entry spaces and thus are often viewed from multiple angles. Any arrangement, including flowers, should be considered in the round to ensure that it is beautiful from various angles. Ultimately, a table vignette should be a personal statement—an apparatus to project the homeowner's personal style.

Chevron-patterned curtains on wrought-iron rods frame a welcoming
hall table with fresh flowers in the entryway of a Boy-Scout-camp-turned-private-retreat.
A brick-red door contrasts perfectly with the original paneled walls.

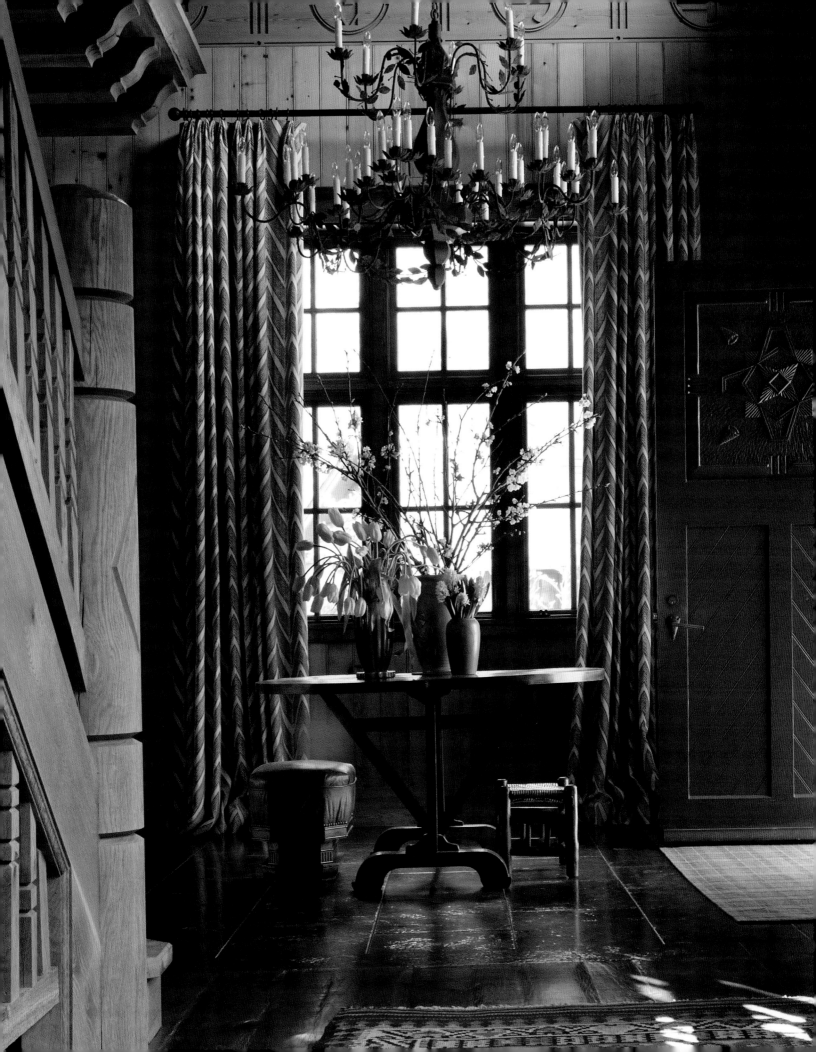

77

GREEN

TIMOTHY WHEALON

When I think of green, I think of energy and life force. I think of spring, of hope, and of new beginnings. I think of the lilies of the valley, their leaves a vibrant green, that would emerge from the earth to the side of our screened porch after a long Wisconsin winter. I think of seeds germinating, of boxwood and English ivy, of chlorophyll circulating and soaking up the sun's rays. I think of the vegetable garden I had as a child, and the joy I felt when the green sprouts from my beans, snow peas, and lettuces popped up through the dark soil. I think of the smell of freshly cut grass and memories of summer days gone by, the sharp chartreuse leaves of birch trees juxtaposed against their white and gray limbs, and the mighty oak with its leaves glistening in the sun and moving with the wind, letting us know that all is well in the world.

Green is my favorite color, as it always makes me lighter, brighter, and more optimistic—whether it's the green of nature outside my window, the green of an Ellsworth Kelly print, a vintage bottle green, or pillows fabricated in lush cotton velvets in a range of greens.

In decorating, the color green plays well with many other hues. I love green against crisp whites, blacks, grays, and natural fibers. I also love green with browns and soft pinks. Green enters the party and brings life and vibrancy to other colors. It's akin to a breath of fresh air—exactly the feeling I strive to evoke when you walk into one of my interiors.

A vaulted observatory in North Carolina, detailed with random-width boards and board-and-batten trim sheathed in coordinating shades of green paint, was inspired by Yves Saint Laurent's Moroccan menzeh room. The sofa and chairs are covered in a Robert Kime fabric.

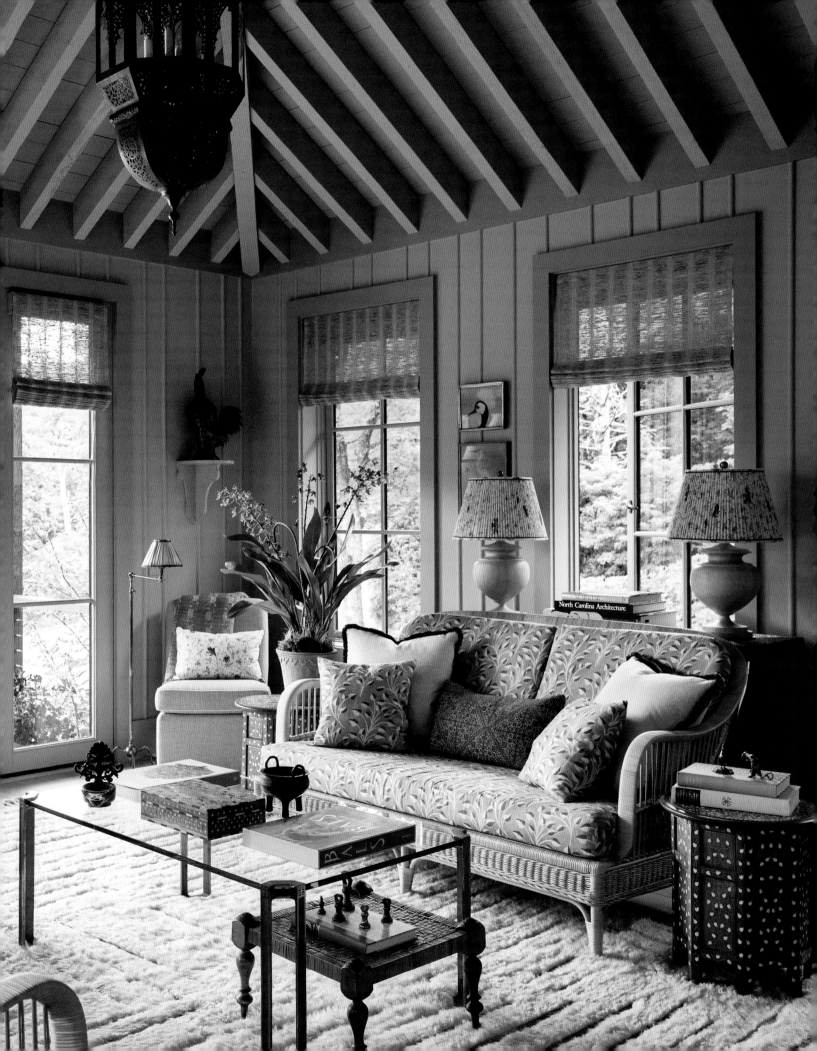

78

MIRRORS

TIMOTHY BROWN

On more than one occasion when I have suggested mirroring the walls to a client, in return I have received a raised eyebrow and been asked, "It's not going to look like my grandmother's house from the 1970s, is it?" Nothing could be farther from the truth. With all the contemporary colors and textures available, mirrors are an excellent resource for brightening narrow spaces, dark entryways, and areas far from natural light sources.

First, consider a brief history of mirrors in design. Throughout the centuries, mirrors have played a significant role in enhancing the aesthetics and functionality of interior spaces, as well as for personal vanity. In ancient civilizations such as Egypt, Greece, and Rome, mirrors were made of polished metal. These early mirrors served both practical and decorative purposes and were highly valued. Mirrors evolved during the Medieval and Renaissance periods, when more refined glass and silver backing were introduced. As time went on, mirrors became more elaborate and were often framed with intricate designs. Mirrors began to be used to create illusions of space and light in interiors. The Baroque and rococo styles of the seventeenth and eighteenth centuries embraced mirrors as a design element. Large, ornately framed mirrors were strategically positioned to play up the extravagance of the time and serve as statement pieces in grand estates and palaces. The Victorians placed mirrors over fireplaces and along hallways to create drama. The Art Deco movement embraced geometric shapes with bold designs, while the modern era favored sleek, minimalistic mirrors.

Mirrors can be used in contemporary interiors in many places, though I still favor a mirror over a fireplace or in a foyer. Today mirrors are available in various textures and colors that can bring depth to a space that paints or wallpaper can't achieve. These mirrors don't need to provide a full and accurate reflection the way a regular mirror does (for example, in a bathroom); the abstract quality of a textured mirror allows for the mere notion of a reflection and a soft glow from ambient light.

When mirror is used as a wall covering, the shape of the space fades and becomes larger by default. Textured mirrors, colored glass, and frosted glass wield different effects. When using a textured mirror, one can achieve a light-reflective, elegant space free of the funhouse moments that may occur with a clear-glass mirror. Colored-glass mirrors can be substituted for traditional mirrors when the goal is expanding the space while adding color and warmth. Frosted glass allows for a more solid surface yet one that still has a reflective quality with light.

In short, have fun with mirrors; they are certainly not just for your grandmother's house!

Mottled architectural mirrored walls with smoky purple undertones enhance
this New York City foyer by amplifying ambient light throughout the space. The cabinet is
lacquered in a complementary shade of dusty ballet-slipper pink.

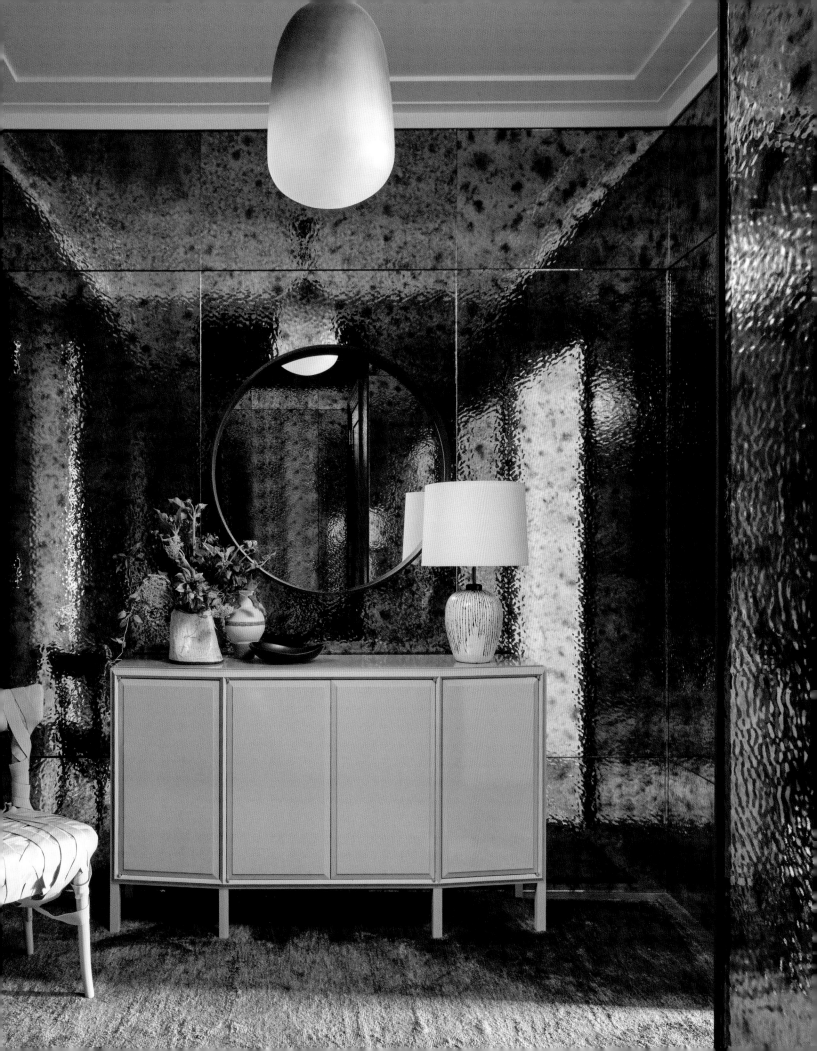

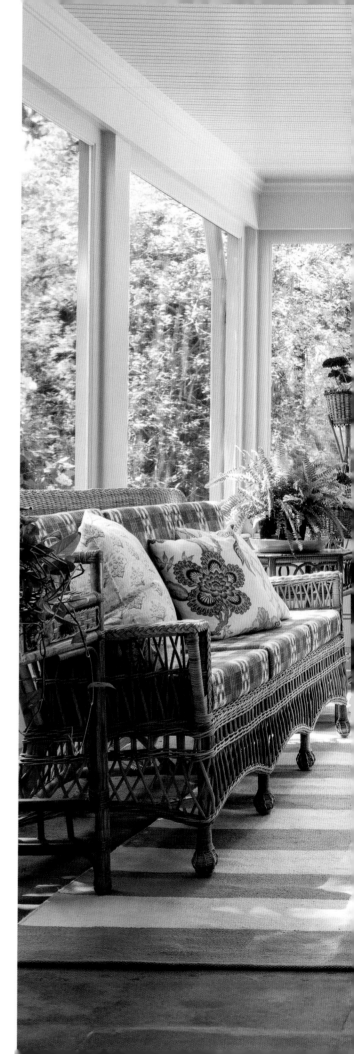

79

SUNROOMS

ARIEL OKIN

When I think of the calmest room in a home, I immediately envision a sunroom, or sunporch, glinting with late afternoon or early morning light. Collected and patinated furniture sits comfortably, potted plants soak in a drink of water, and a slight breeze comes in through screened windows. If you're looking for peace, you can find it in a sunroom.

There are three important tenets of a beautiful sunroom. The first: let nature be the star. Don't obscure beautiful views with fanciful drapery or otherwise obstruct the line of sight to the outdoors.

The second tenet: comfort is key. No matter the size, a sunroom should be kitted out for comfort, and that usually includes the areas for entertaining, as sunrooms are natural gathering spaces. It's important to have a lounging area with a sofa or settee and chairs and usually a dining component as well. In a small sunroom, a chair for reading next to an occasional table plus a bistro table for dining for two are all you need. Conversely, delineating a large sunroom into easily identifiable zones for eating, drinking, and lounging, with a pathway between, makes hosting a breeze.

Third: incorporate natural elements. Create layers with plants and flowers and natural fiber materials like jute, sisal, bamboo, and rattan. Include a table to showcase potted plants and a mirror (or two) to reflect the beautiful views outside.

I prefer to use warm white paint for sunrooms and let nature provide the color. If the aim is to be more bold, choose hues that mimic the outdoors—pale sky blues or a sage or deep hunter green. Natural wood can also add character and charm.

In Okin's Westchester County home, a once-empty screened porch became a coastal-inspired retreat featuring a sofa in Sister Parish fabric, Mainly Baskets Home wicker furniture, and a Cailini Coastal striped rug. The space maximizes outdoor living despite the property's limited yard area.

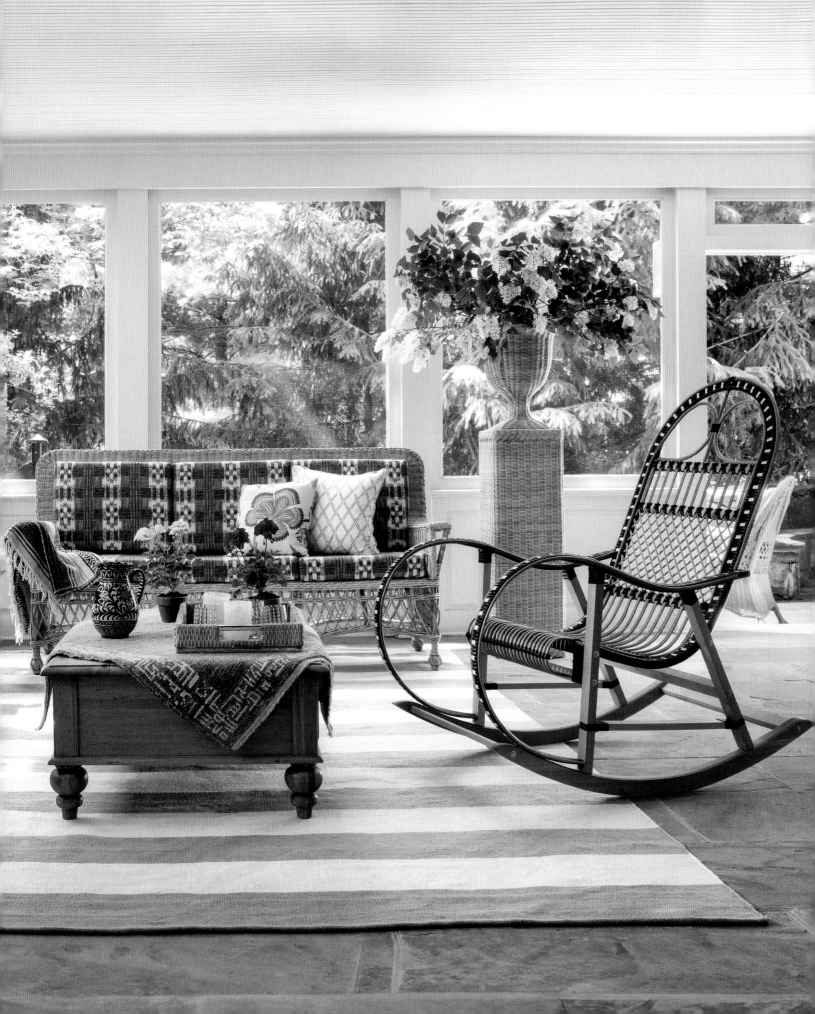

80

MULTIPURPOSE ROOMS

THOMAS HICKEY + EDWARD YEDID

[GRADE New York]

Multipurpose rooms may arise out of necessity—as in a prewar apartment for city-dwellers—or they may be the product of sheer imagination, for example: the open-concept loft where entertaining, art gallery, and the everyday overlap within a single space. In either scenario, a multipurpose room is a custom space that synthesizes the pragmatic and the aspirational.

Designing a multipurpose room begins with a wide view: zoom out to envision and take stock of what the end result might look like. Good design calls for an intentional plan, understanding the multiple ways the space will be used, and a cohesive strategy for selecting furnishings, finishes, and decorative elements that agree with the overall concept.

Who will occupy the room? When? How will its occupants converse? What should be visible or concealed? What's missing? And perhaps most notably: How should the space feel? Identifying the desired feeling for the room provides a North Star, a compass, for evaluating whether decisions at any stage feed into the intent. This inquiry process provides a roadmap for successful execution, leading us through the blue sky of possibilities to land on a focused outline of requirements, goals, and a singular aesthetic identity.

A room with multiple programs or functions requires hierarchy, establishing zones that account for the priority of each function within the greater context and flow of the space. Combine a library, lounge, bar, and reading nook—a few options that play well together—and all must work in concert toward the overall composition, providing areas for the individual as well as social interaction.

Connections between the underlying architecture and the interior of the room begin to take shape with a framework of structural elements and features built into the perimeter. Millwork is a key component to a well-organized space, and cabinetry and built-in shelves alleviate visual clutter. A calming palette of finishes and stonework on walls, floors, millwork, and even the ceiling pulls the room together to form a unified backdrop for furnishings.

Function and aesthetics always overlap, but that is particularly true in a multipurpose room. Elements needn't be identical, but they do need to be coordinated. Texture, color, pattern, materials, furnishings, art, lighting, and accessories must be meaningful and tie into each other and the room in the aggregate. Review, edit, and reiterate with intention, and the end result will keep the vision and desired feeling intact.

Opposite: In this SoHo library/office, a custom channel-tufted niche houses a built-in daybed, while a curved Jan Ekselius club chair features a Pierre Frey silk textile. Following pages: In this view, a custom waterfall-edge desk by GRADE provides workspace framed by built-in bookshelves. Hidden bar doors and artisan lighting complete the sophisticated tableau. The ceiling is articulated in cerused oak with dark stained strapwork, while a sumptuous Fortuny velvet sofa provides seating.

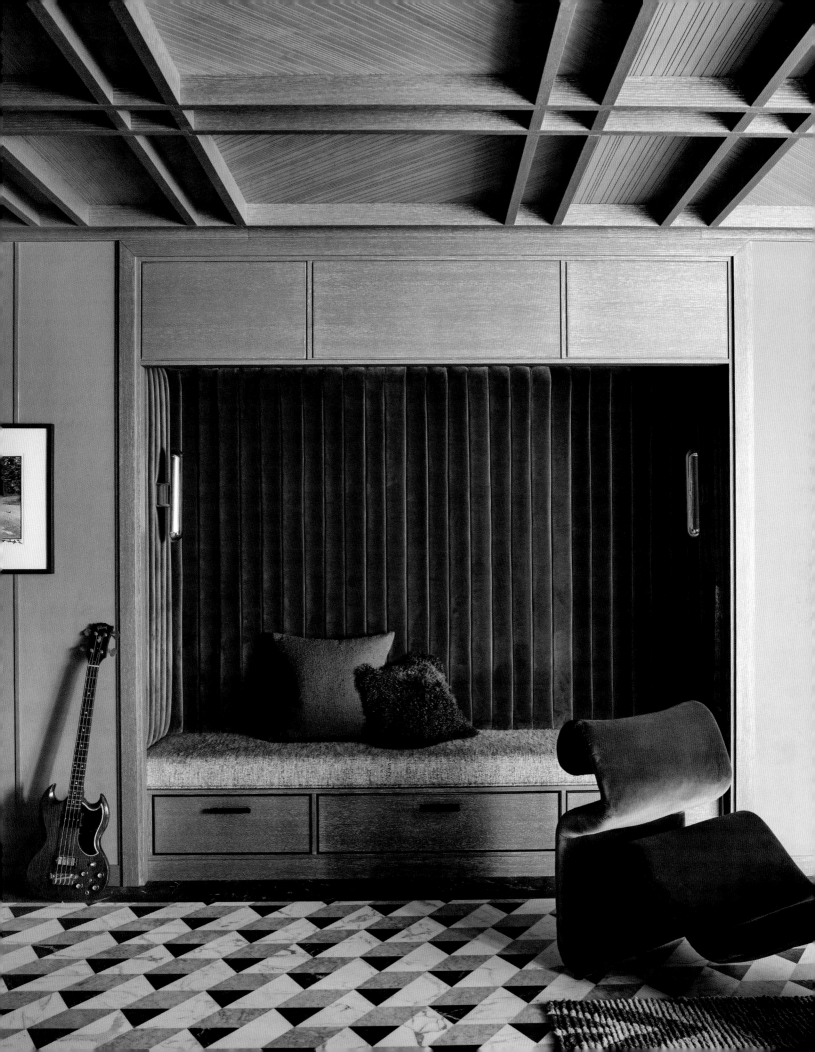

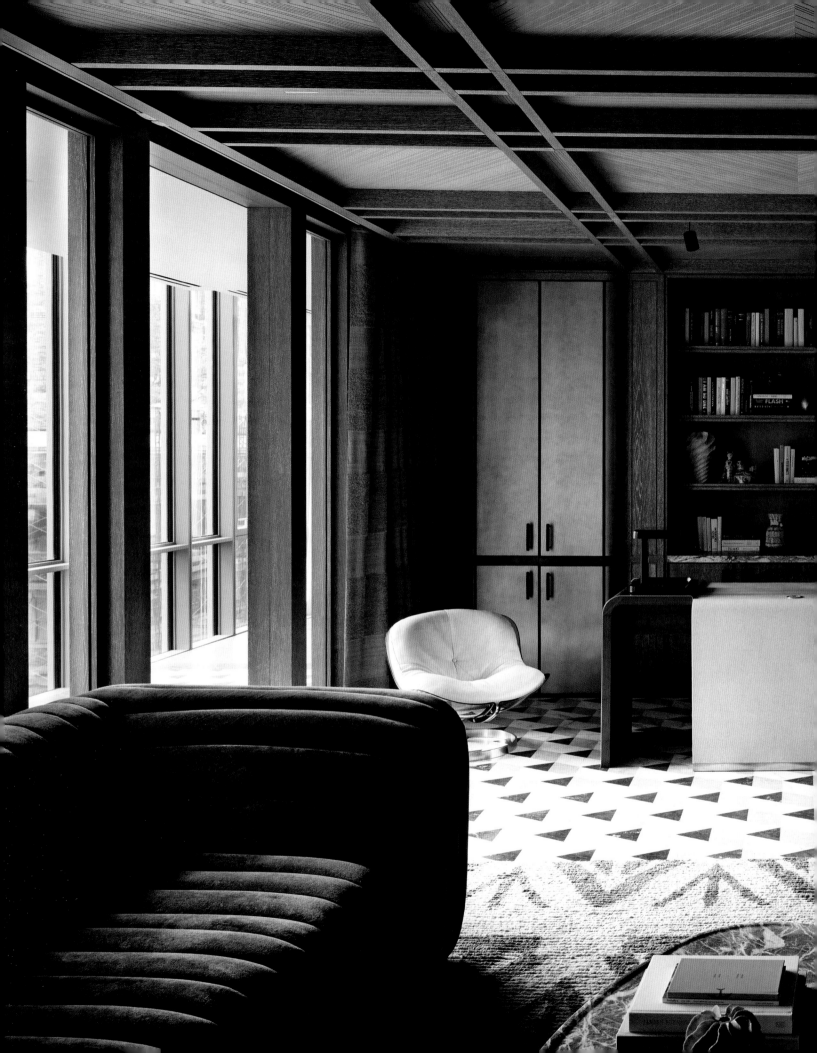

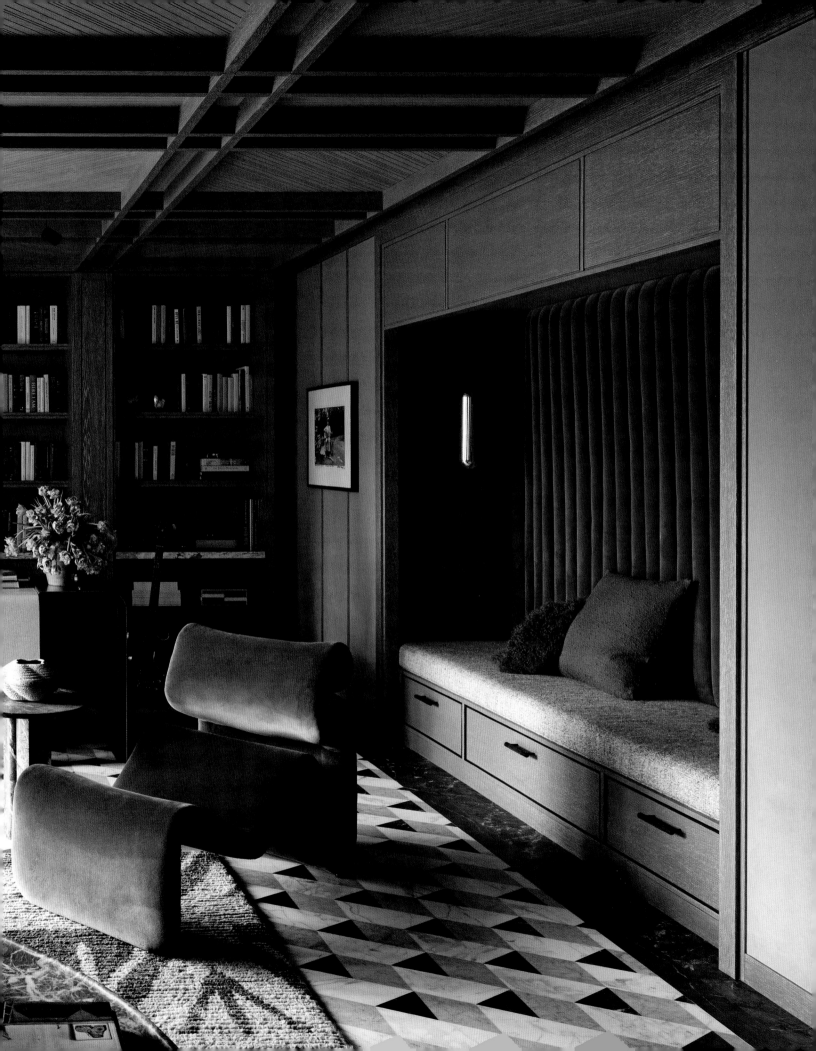

81

MASCULINE SPACES

ALFREDO PAREDES

The interior design of masculine rooms is characterized by grounded energy, an inviting atmosphere, and elevated style. As a designer known for a masculine style, the first step I usually take is to envision the story a room should tell and from there extrapolate to how it should feel. To bring the narrative to life and create unforgettable experiences, it is crucial to pay attention to every small detail, from the textures, colors, materials, lighting, and accessories to the scent and sound.

Any room in a home can be designed to be masculine—living room, bedroom, den, or kitchen. With polished decor and high-quality furnishings, designers can achieve a masculine space that is functional, welcoming, and sophisticated. The aesthetic can also contrast with the rest of the home for an unexpected moment of playfulness and modern style. For example, a study or a bar area in an otherwise modern home might stand out with dark wood paneling and muscular leather seating.

The selection of color palette and materials plays an important role in creating the backdrop for a masculine room. Natural materials such as wood, rustic leather, and weathered brick complement neutral tones of tans and browns for a heightened dramatic and moody feel. Contrast these traditional masculine materials with lighter fabrics and upholstery, such as linen and wool, for a visually striking effect.

A mix of eclectic furniture establishes a dramatic yet welcoming environment and offers an opportunity to get creative with the selection of varying shapes and textures. Curved and arched pieces, especially pieces in warmer hues, soften the space while maintaining a strong presence. Incorporate layers of different textures through wallpaper and fabrics, art pieces, and accessories.

Maximalist fixtures, pendants, and table lamps are the finishing touches for a masculine room that is an engaging and functional space.

The original wood-beamed and vaulted ceiling in the designer's Locust Valley, New York, great room
inspired a warm, neutral palette. Leather chairs and a generous sofa create a relaxed seating area,
while a monumental arched window ushers natural light into the adjoining kitchen.

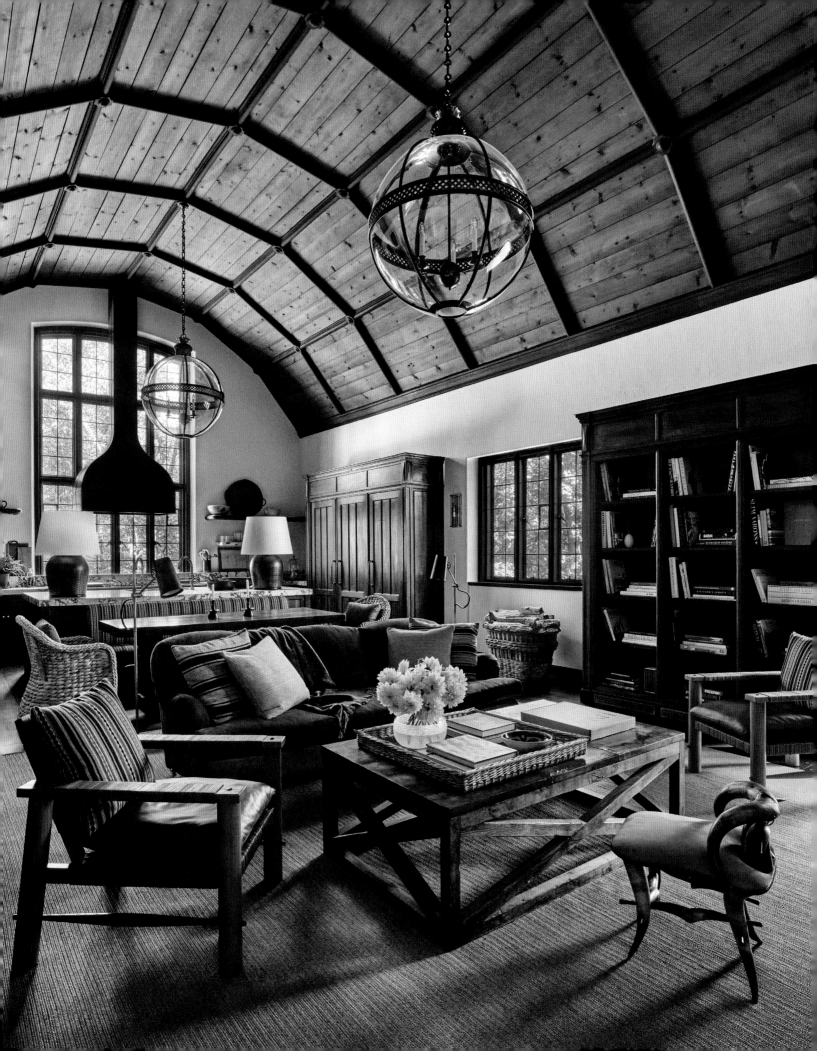

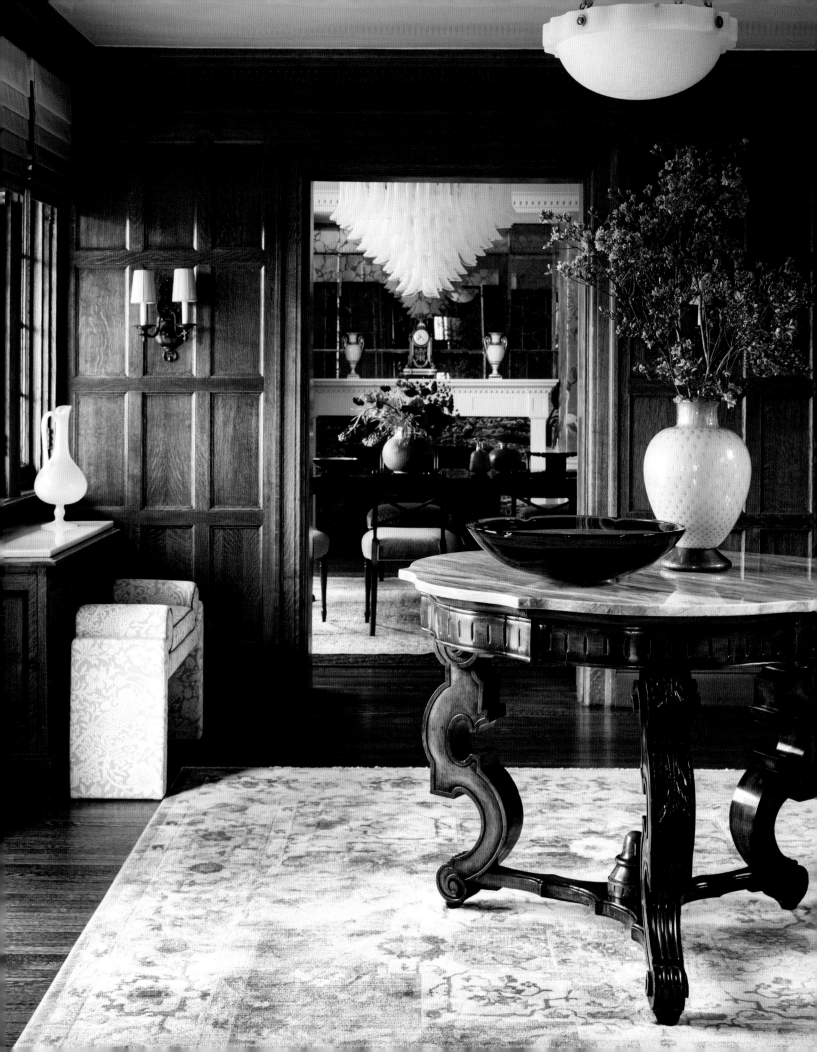

82

NATURAL LIGHT

ANDREW SUVALSKY

When I'm designing a home—whether an apartment or a multi-roomed house—I want every space to have a unique personality that transcends style. No single feature contributes to this more than the quality of natural light. The light then influences nearly all of my choices of color, fabrics, and finishes. Just as the right lighting flatters facial features, great natural light brightens and enhances an interior.

When first thinking about natural light in a space, I consider the number of windows, their size, and the direction they face. A dark paneled room with windows on both sides can feel more sun-kissed than a bright white apartment that never gets direct sunlight. And since natural lighting is ever-changing with the time of day, weather, and seasons, a room is best served when a few rules are followed.

Use window treatments to delineate, not cover, windows. Like a beautiful frame around a work of fine art, a window treatment should carry the eye to the source of natural light without limiting it.

Balance the areas of a room where natural light doesn't quite reach using beautiful non-natural lighting sources like lamps and ceiling fixtures. If a large window at one end floods half the room with natural light, an intimate lamp on the opposite side will even out the lighting.

Regardless of palette, liberally add bright tones that reflect well in natural light. Blues, creams, and yellows are a mainstay for me, but other colors that spring to life when washed in natural light work, too. Think sun, water, and other colors of nature.

Avoid dark finishes on ceilings, which absorb and limit the reflective quality of natural light. I frequently rely on color-depth (not darkness) and sheen as light-enhancing features.

Natural light is a gift, and it's often fleeting. Rooms that are used at night or generally lack natural light still need good and well-balanced lighting, which can be achieved by following the suggestions above. To those I would add, always include dimmers as part of your lighting scheme. Dimmers can be used to create different and nearly limitless variations in lighting, perfectly tuned to one's mood, the time of day, and other features that affect experience of a space.

Opposite: A nineteenth-century walnut table with its original marble top greets visitors in this foyer.
It is topped with a purple Murano glass bowl and an urn brimming with flowering branches. A Venetian wedding-cake
chandelier illuminates the dining room beyond. Following pages: This foyer features restored French
oak paneling and a dramatic high-gloss Wedgewood blue lacquer ceiling that amplifies the streaming sunlight.
Custom blue-upholstered benches, ombré shades, and an Oriental rug add a vibrantly youthful counterpoint.

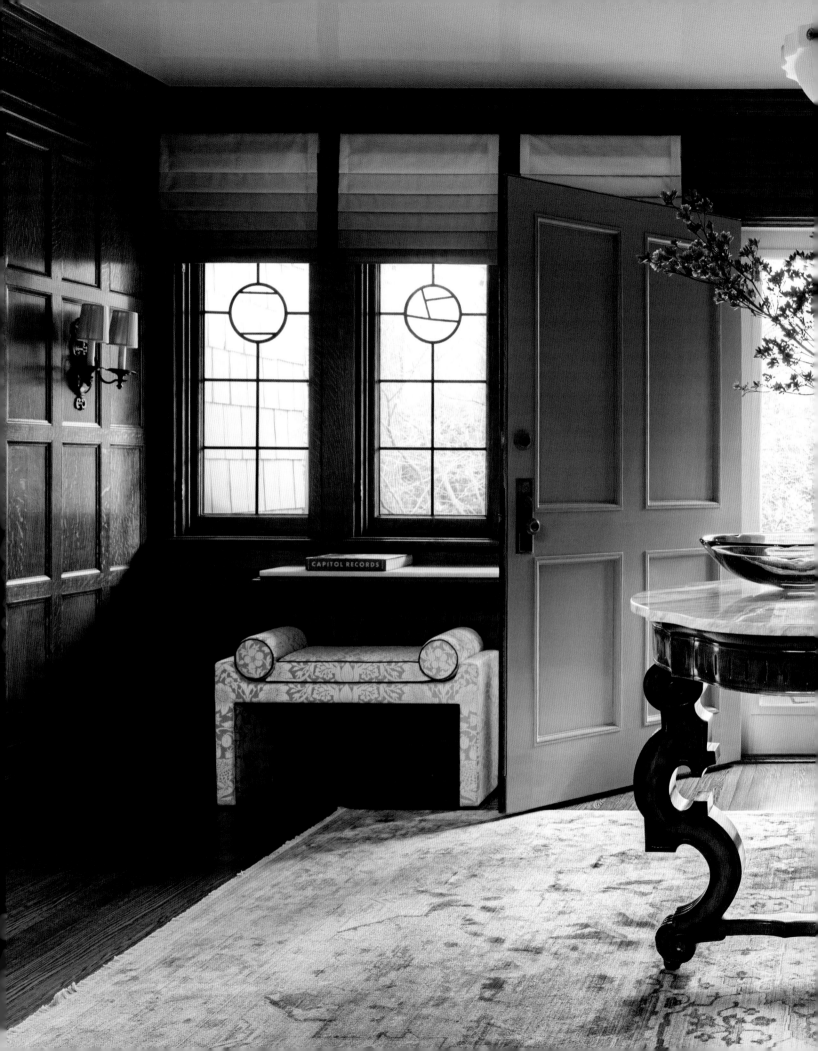

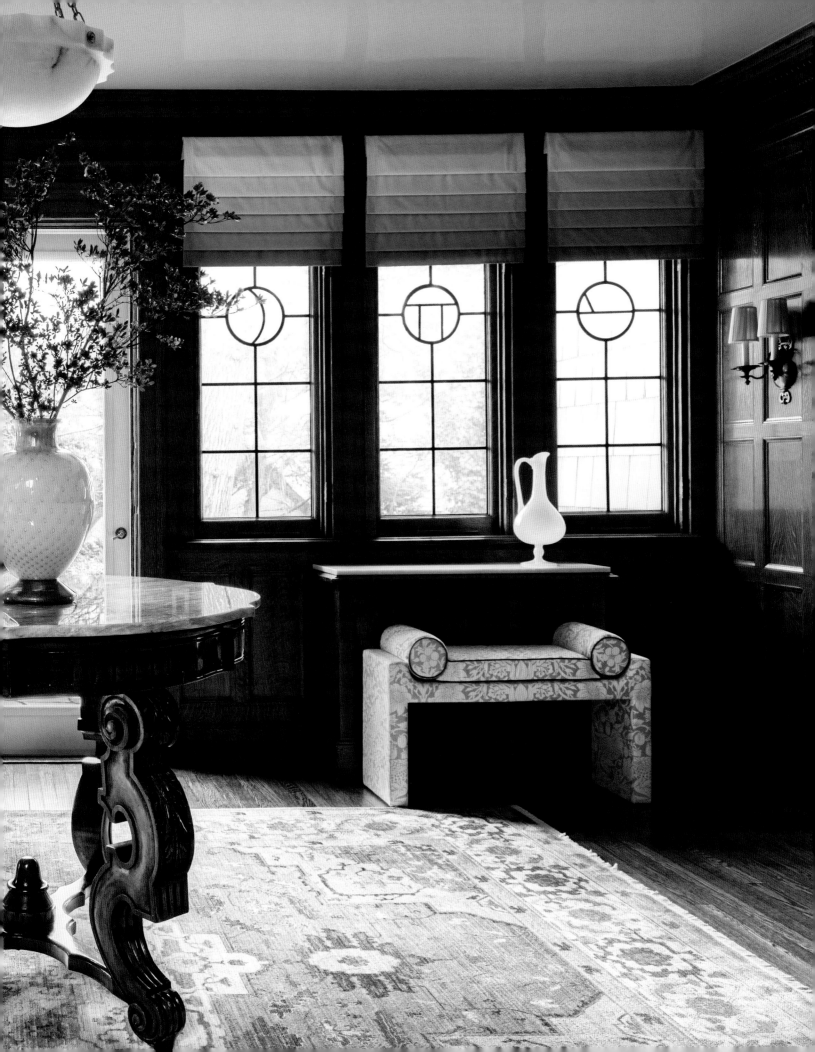

83

POOLSIDE ROOMS

MARIE FLANIGAN

Designing a poolside space is all about creating a balance between beauty, functionality, and safety. Here are some of my considerations for crafting a poolside oasis that feels both inviting and serene.

I envision a pool and its surrounding area as a natural extension of the home—one that feels cohesive with the surrounding landscape but also offers a unique atmosphere. I love to start with the larger elements like the pool's shape, any surrounding structures such as pergolas, and the way the space flows from indoors to outdoors. It's about creating an experience that's both relaxing and visually harmonious.

Organization is key, and I often separate the space into zones: a lounging area, a dining area, and perhaps space for sunbathing or even an outdoor kitchen. It's helpful to think in layers, with cozy seating clusters around tables to encourage conversation and chaise lounges near the pool for sunbathing. Modular or sectional seating can provide flexibility and accommodate different numbers of guests. Low tables near seating work well for drinks or snacks, while taller tables are perfect for casual outdoor dining.

Shade is essential! Not only does it provide relief from the sun, but it also creates pockets of cool, inviting space. Always pay attention to how the sun moves across the space throughout the day. Incorporate options for sun protection so that the area is enjoyable all day long, from sunny mornings to hot afternoons. A pergola, umbrellas, or shade trees can be your best friends here. For plant material, I lean toward hardy, low-maintenance plants that thrive in the local climate and add a lush backdrop without much fuss. Consider potted plants or shrubs that bring in texture and color without overcomplicating the area.

Safety is always a priority, especially around the pool. Slip-resistant materials for decking, like natural stone or treated wood, are ideal. Look for outdoor-rated fabrics that are both UV-resistant and quick-drying, as they'll stand up well to the sun and splashes. Avoid materials that can become too hot underfoot, like certain metals or darker stones, and prioritize surfaces that are durable and easy to maintain.

When arranging furniture poolside, first think through the flow and functionality. Ensure that movement through the space feels natural, with clear paths to and from the pool, lounging areas, and any exits. As in interior rooms, vignettes are essential. Carve out spaces that invite relaxation and conversation, with comfortable seating, side tables, and maybe an outdoor rug to anchor the area.

Creating a beautiful poolside space is about embracing the elements while creating a personal haven. With careful attention to layout, materials, and flow, it's easy to build a sanctuary that's both inviting and enduring.

Opposite: This sheltered poolside pavilion has comfortable furnishings arranged for relaxing afternoons in the filtered sun. Underfoot, limestone pavers add a note of gravitas. Following pages: A pergola fashioned from knotty Western cedar establishes the perimeter of this outdoor room, with lush plantings as a backdrop. Three hanging lanterns cast an amber glow from dusk into the evening hours. The jacuzzi and plunge pool are lined with glass tiles.

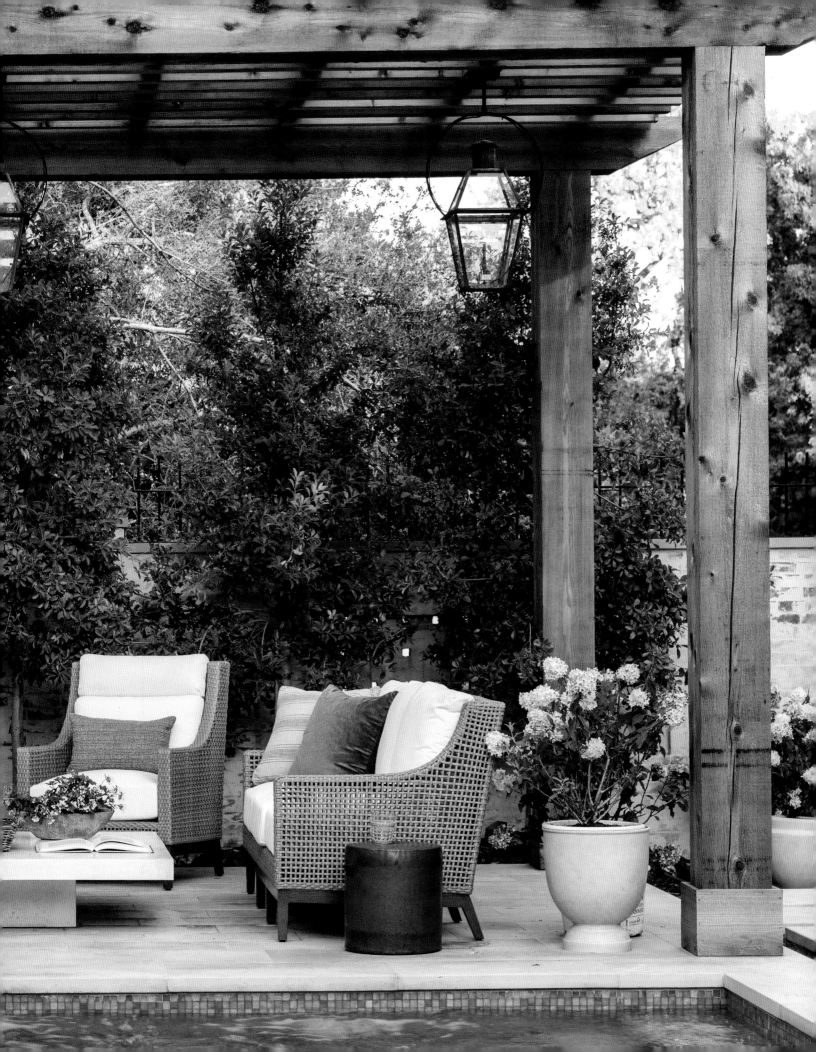

The days of functional rooms being treated as an afterthought are long over; utility areas are designed as purposefully as other areas of the home. The kitchen is the magnetic center of family life, where homework mingles with dinner prep, and Sunday pancakes become a ritual. The breakfast room straddles the line between kitchen functionality and dining room formality. Here, coffee is enjoyed, a quiet lunch is eaten, and conversation flows. Mudrooms are sophisticated tamers of chaos with clever storage and indestructible finishes. Laundry rooms, no longer basement dungeons, are organized command centers where built-in systems institute a pragmatic choreography. Playrooms serve as laboratories of imagination, containing creative chaos while growing alongside their users. All of these spaces share one thing in common—they make the tasks of daily life manageable, and even joyful.

UTILITY

84

KITCHENS

FRANCES MERRILL

[Reath Design]

Kitchens are so much more than spaces for cooking; they can be beautiful, they can be charming, they can be monstrous showpieces built to impress the neighbors. The best ones fulfill their practical function and then are very specific to, and expressive of, their inhabitants. While one person might want a comfortable chair in a sunny spot for morning coffee and reading the paper, another might prefer to use the space for more counters to grow herbs. Somebody hates marble because they are afraid of etching it with lemon juice, while someone else must have marble for rolling out pastry dough.

There is a clear starting place when designing a kitchen: function. More than any other room in a house, a kitchen must be functional—for storing, preparing, and cooking food, as well as providing a cozy place to gather for family meals.

I love parameters because they provide a jumping off point. Start with the appliances. Refrigerators are typically the bulkiest and tallest items and finding spots for them can be tricky. If possible, we like to tuck the fridge into a wall of full-height and full-depth cabinets. These cabinets will take care of the storage of the many unattractive things that accumulate in a kitchen: microwave, Instant Pot, air fryer, bread maker, margarita machine. The list goes on and on.

The dishwasher needs to be near the sink and the trash. It should also be close to the everyday dish storage to make unloading less of a chore. The stove should never abut the refrigerator, as the heat of the former will compete needlessly with the cooling of the latter.

Next, consider the existing architecture. Is there a window with a nice view for washing dishes? How does the flow of the kitchen work with the rest of the house? In one kitchen we dropped the height of the counter section closest to the back door by six inches to stop the inevitable creep of mail and keys taking over the working kitchen space.

The key to designing a successful kitchen, more than any other room in the house, is to ask questions—so many questions!

Opposite: Original beadboard walls anchor this reimagined Massachusetts cottage kitchen, preserving its coastal heritage. A vintage American hooked rug underscores the sensibility. Following pages: Fearless colors lend a youthful air to the space. A red 1953 Chambers stove is paired with lilac Pyrolave countertops, yellow Bruno Rey chairs, and Farrow & Ball's Cook's Blue on the trim. The antique wingback chair is covered in a jaunty plaid.

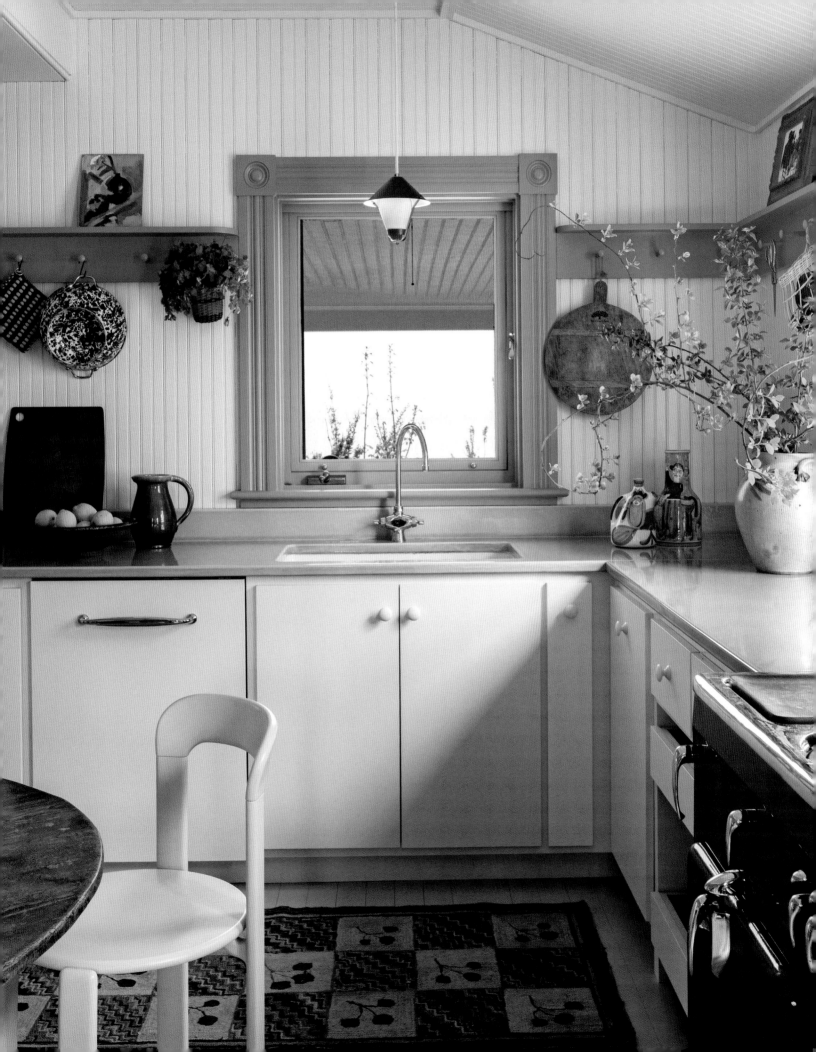

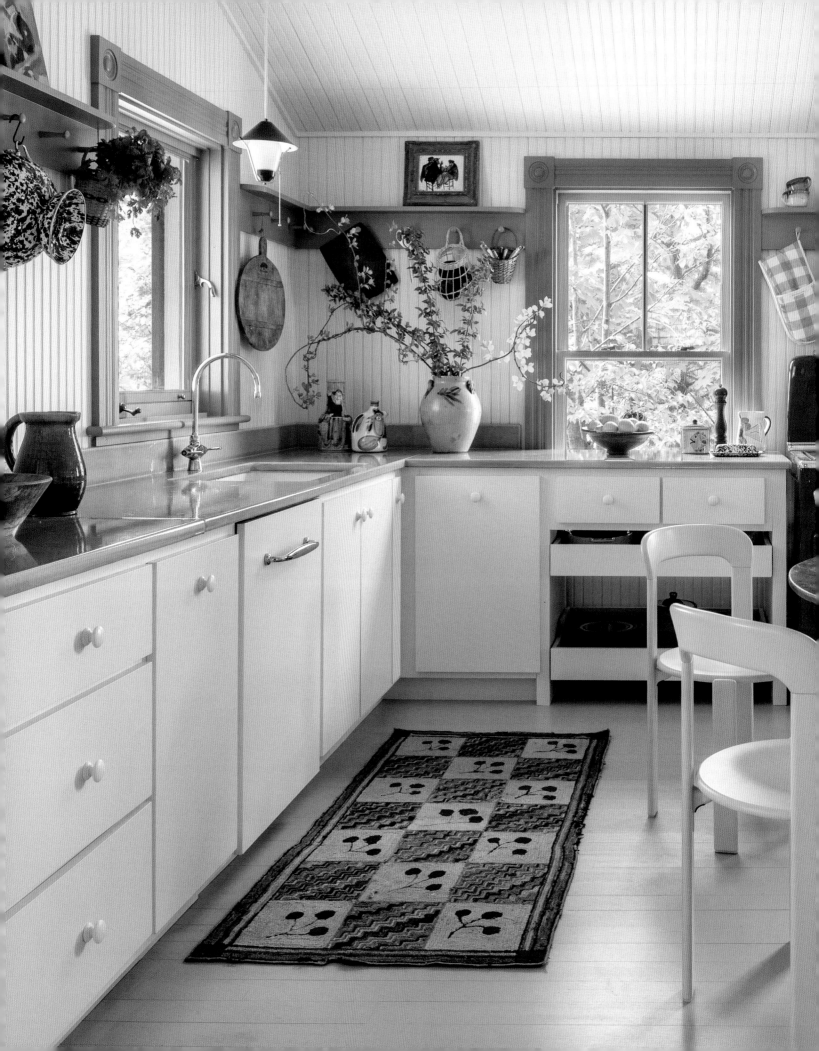

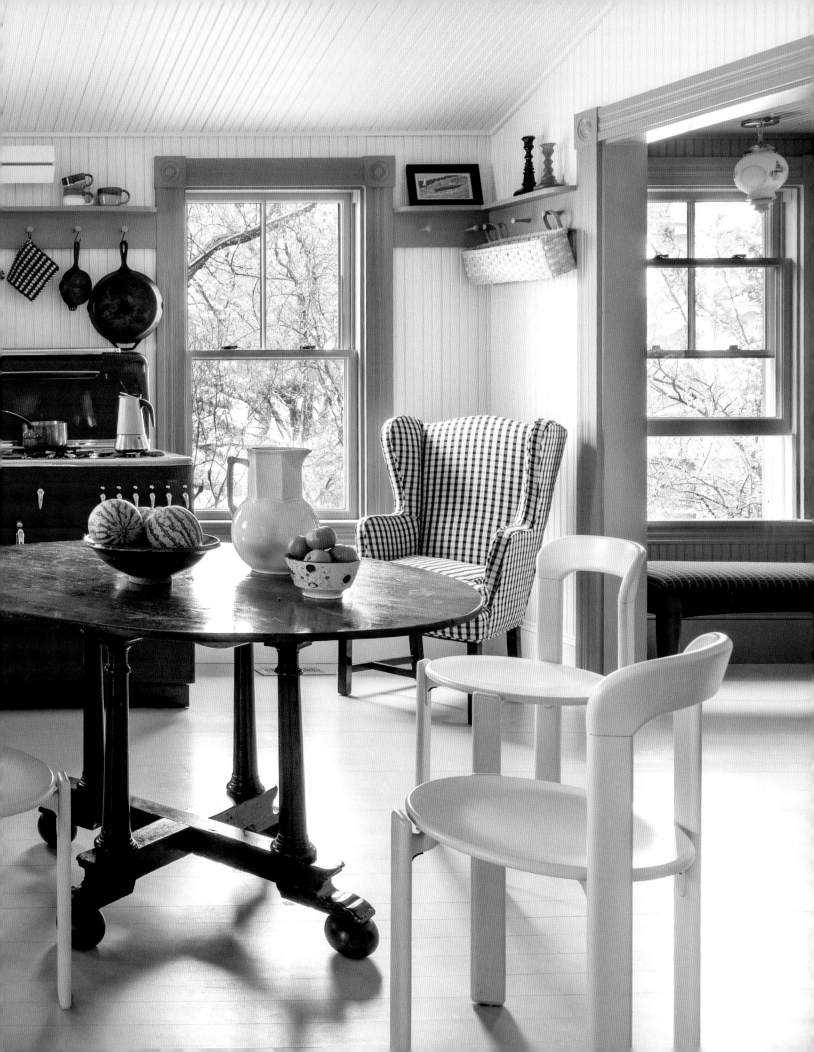

85

OFFICES

FERN SANTINI

The best home offices are extensions of the living space. They reflect personal inspiration and aesthetics. The same rules that apply to other spaces in the home apply to the home office as well. The space should be thoughtfully styled, but also practical. Home offices that feel cozy and inviting can also be organized, efficient, and well-lit. Indeed, if a home office is disorganized and chaotic it will likely go unused—people are more likely to sit at the kitchen island or some other place in the home that is clean and calm.

Here are my essentials for a beautiful and functional home office:

Layer the lighting. Overhead lights, pendants, lights on cabinets or bookcases, floor lamps, and task lights are all good—include as many types as you can fit. If possible, they should all be on dimmers so each source can be adjusted to the right level.

Create space to work and space to organize. If there is room for bookcases and cabinetry, those are great. If not, try a writing desk or table (which appears lighter visually) with another storage piece, such as a buffet or credenza, to keep everything organized and out of sight. I love mixing antiques with contemporary pieces in an office. An antique writing desk may be the perfect style, but for the sake of function you may want the piece with drawers that open and close all day to be a newer piece.

Make it personal. Surround yourself with things that tell your story—some things make you think, some things make you smile. Color, art, rugs, photographs, and furniture all play into this intensely personal mix and make the office a place of comfort, not to mention an oh-so-interesting backdrop for Zoom calls!

Opposite: A brass spiral staircase leads to a sitting room balcony in this Lake Austin home office, where soaring ceilings and natural light create an airy workspace. Following pages: High-gloss teal walls illuminated by an expansive window wall create a dramatic backdrop for business meetings, while brass sculptures and color-coded books draw the eye around the space. The faceted wood doors add a natural note.

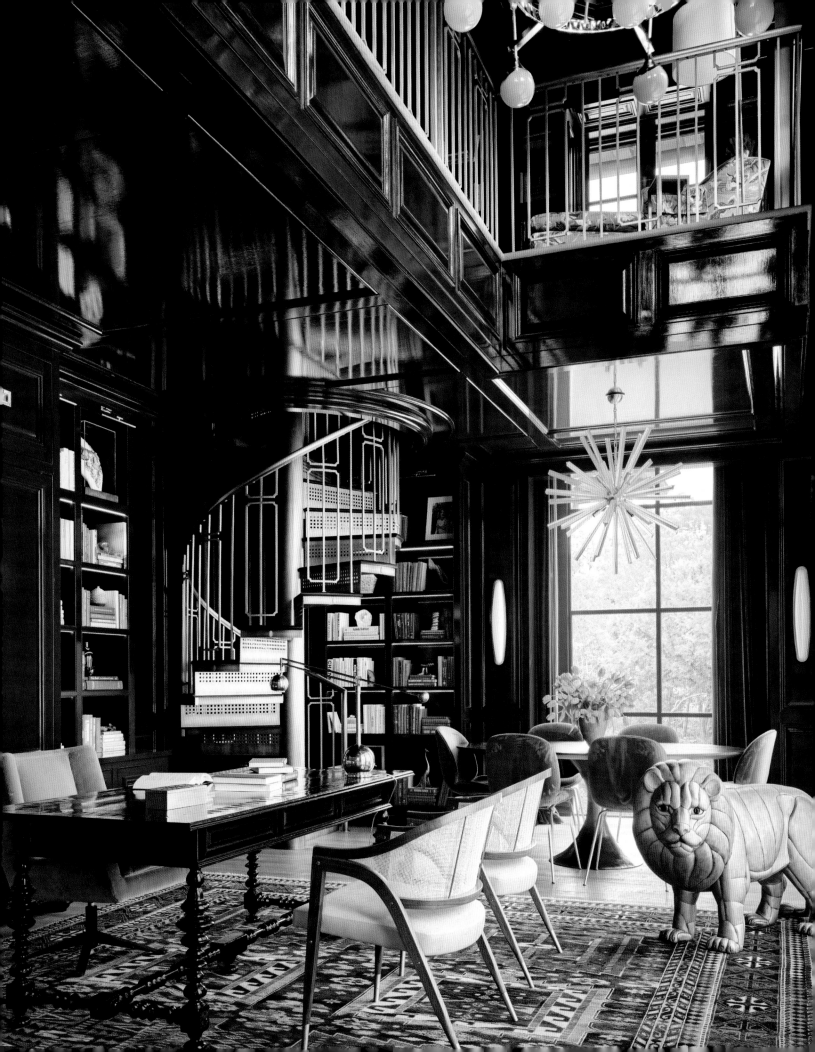

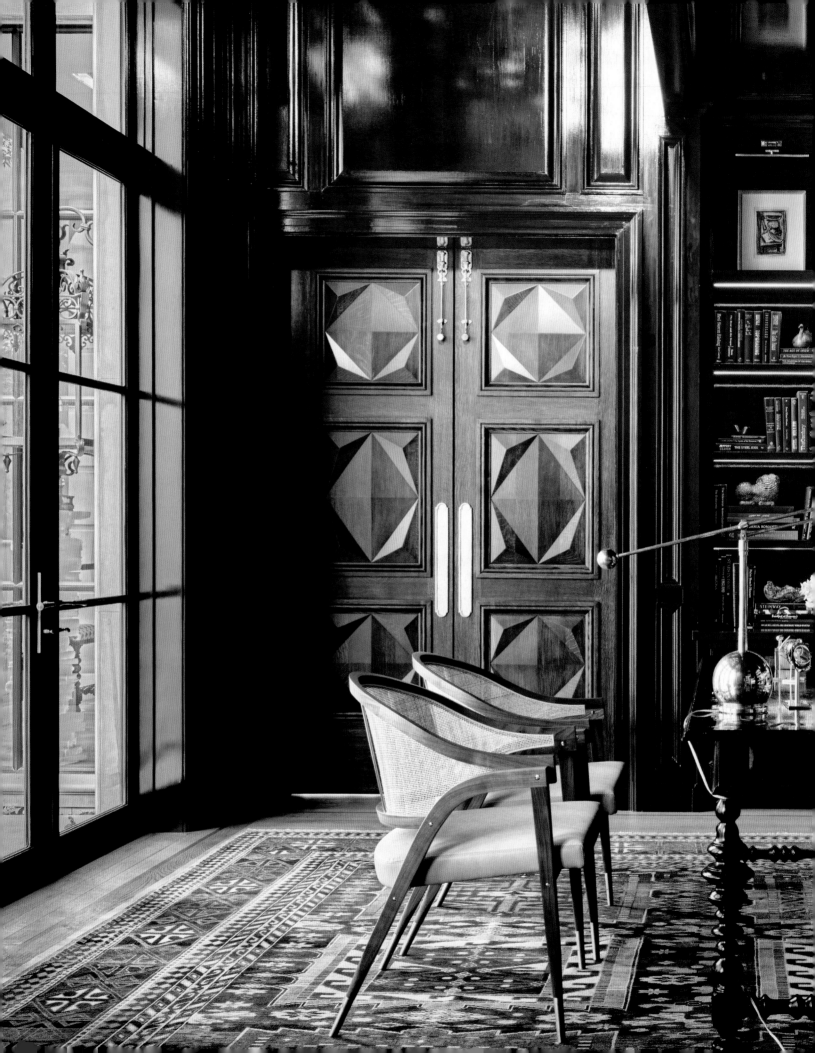

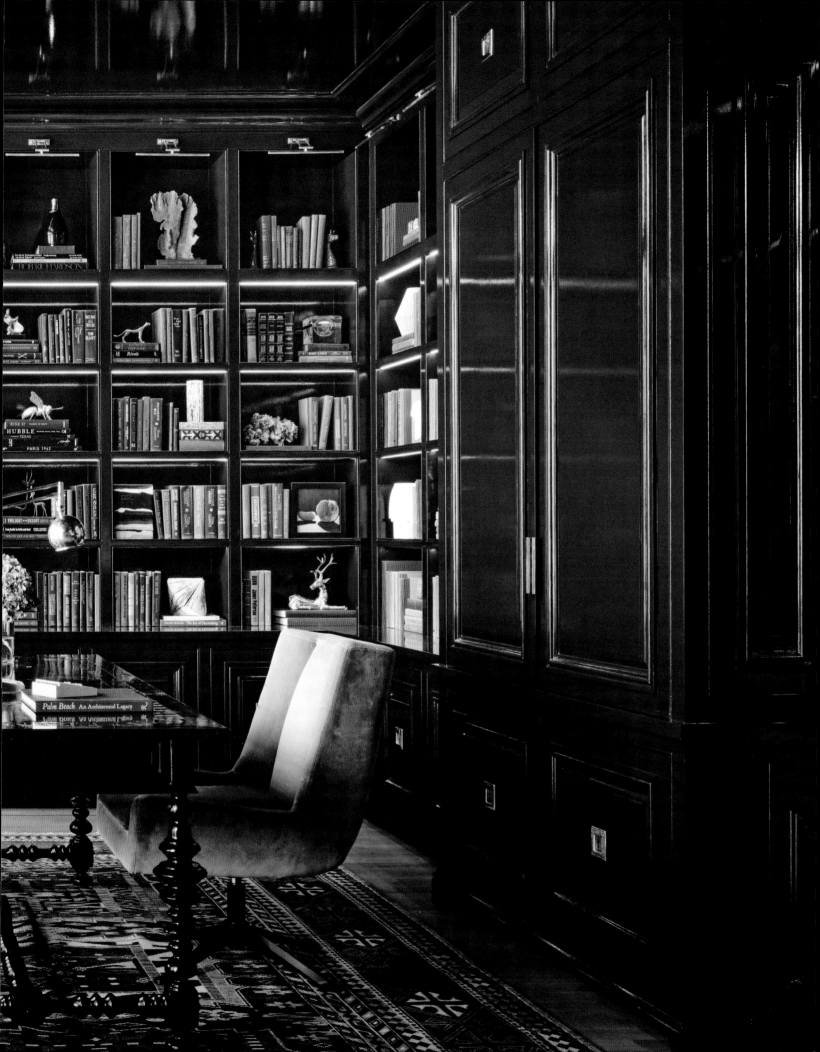

86

UTILITY

WESLEY MOON

In design, the word utility conjures up visions of unadorned workaday spaces, often with—God forbid—florescent lighting. These are generally tucked away in back-of-house areas, never to be admired by guests unless the owner is showing off their impeccable organizational skills. Au contraire! Utility, which simply means usefulness, especially through the ability to perform several functions, must be incorporated into every single aspect of a home's design. All spaces can, and should, be able to perform multiple duties, and it's the job of any good designer to integrate the tools needed to accomplish these tasks in a seamless, thoughtful, and visually pleasing way.

Good design happens when you consider the big picture while also studying every aspect on a micro level. Like a jigsaw puzzle, a great home is the sum of its parts. As Ludwig Mies van der Rohe said, "God is in the details." The essentials to consider are the purpose of the home, the support needed to achieve that purpose, and the aesthetic vision. On a macro level, a home must have a sense of place and of itself. Is this a primary residence, or a beach home, or a ski villa? How will the inhabitants live and entertain here? Will it be on a grand scale, or is there a longing for coziness and intimacy?

Once you know the purpose, you can start to focus on how to reinforce the objective. What types of rooms are needed and what kind of storage is desired? How can these spaces be multifunctional? How will people utilize different areas of each room? What types of collections and objets d'art do the occupants want to display, and what serviceable items, tools, and appliances do they want to conceal? How can you make the shift between these tasks effortless? Every square inch should be assigned a role, and all of the residents' possessions should be given a spot.

Finally, these considerations must be wrapped in the desired aesthetic. Classic spaces may conceal functional aspects of the home using traditional built-ins, concealed doors, or divided rooms, while modern homes may celebrate various functions with free-flowing spaces, incorporating open shelving and moving walls or furnishings to cue different areas. The most successful designs marry all of these elements together to create a truly custom space.

Crafting a design that achieves beauty and function while remaining convenient and sophisticated is a juggling act. It requires a strong sense of purpose and a vision that spans the entire scale of the project. To attain the ultimate master plan, you have to sweat the small stuff!

Opposite: In this corner of a fully renovated kitchen for the 2023 Kips Bay Decorator Show House, Moon orchestrated a sunlit seating area overlooked by a Robert Polidori photograph taken at the Villa dei Misteri in Pompeii.
Following pages: This kitchen is a multipurpose gathering space with built-in bookshelves, a china cabinet, and a breakfast area. The 1987 Friedel Dzubas painting *Many Voices* above the fireplace adds artistic presence.

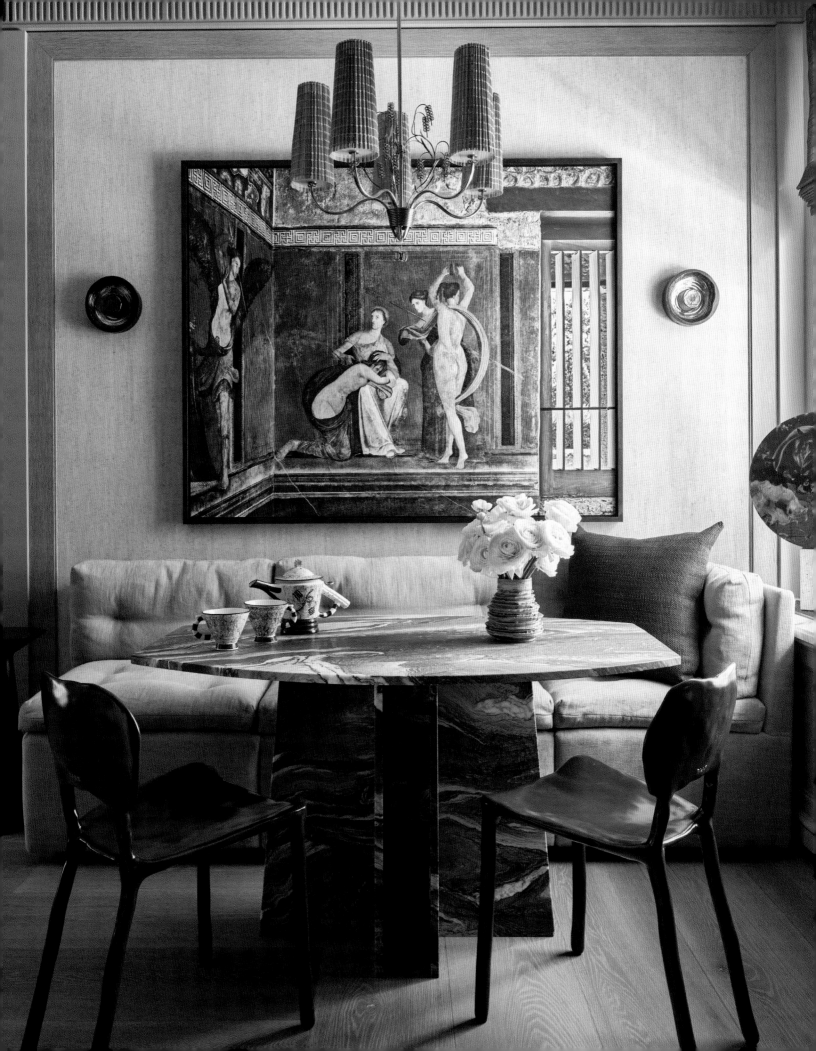

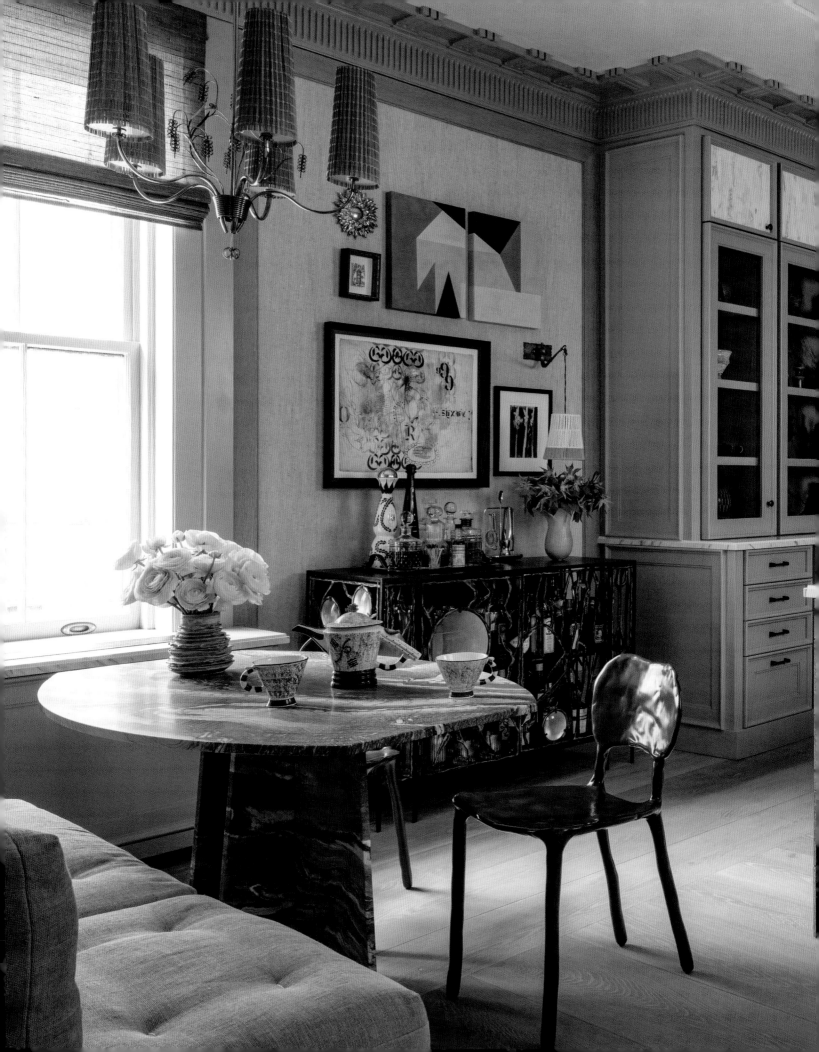

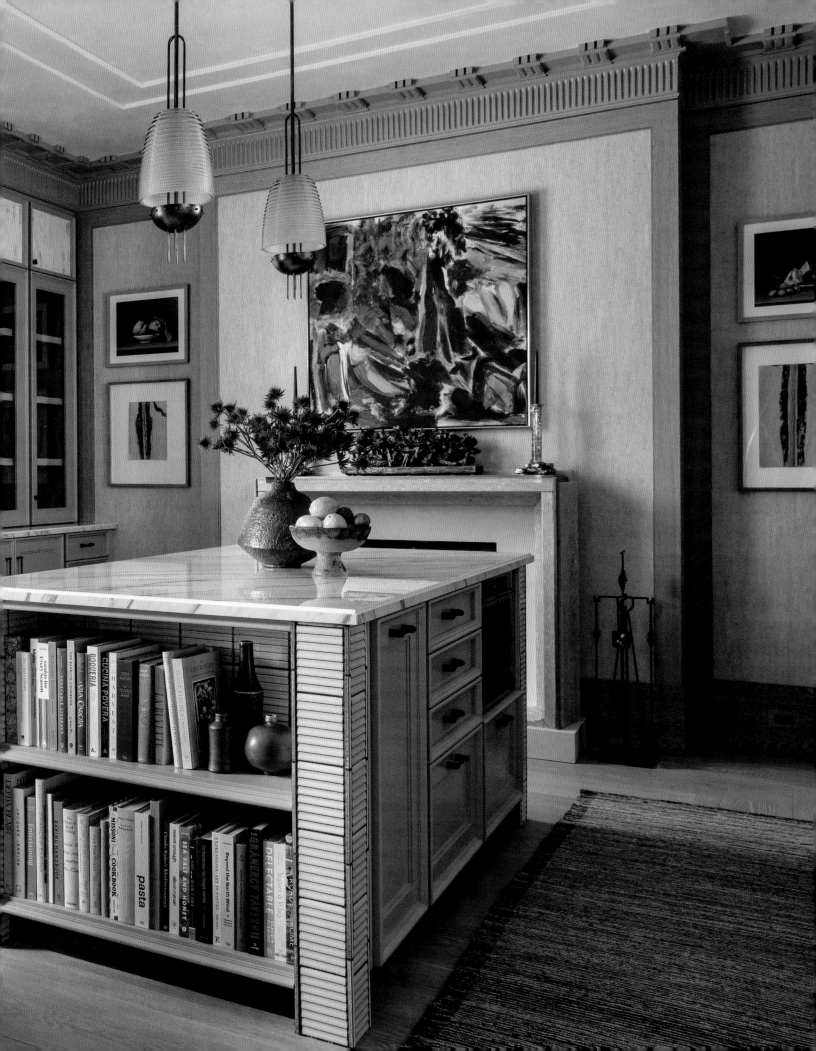

87

BREAKFAST ROOMS

ALISA BLOOM

In recent years, breakfast rooms have sashayed their way from simple dining spots to the fabulous heartbeats of homes, places where family and friends gather, connect, and even get a bit of work done—if they must.

Comfort is the name of the game. Plush seating, bathed in natural morning light, creates a sanctuary that beckons to sit, sip, and stay a while. Think cushy banquettes, chic chairs, and cozy nooks perfect for a morning gossip session or an afternoon siesta.

But the breakfast room isn't just about lounging—functionality is essential. Breakfast rooms are pulling double duty as workspaces. Integrate chic charging stations, fabulous lighting, and adaptable furniture to make a breakfast room a multitasking marvel. Whether enjoying a lazy brunch or tackling a Zoom call, it's the space where everyone wants to be.

Let's talk aesthetics. A breakfast room should be as fabulous as the people who use it, reflecting their unique style while blending seamlessly with the rest of their abode. Play with colors, textures, and decor to create an ambiance that's as inviting as it is stylish. Imagine a blend of contemporary elements, such as a new custom-fitted banquette that feels like a cozy sofa, paired with stunning vintage chairs. And naturally, don't forget amazing light fixtures hunted down at flea markets!

At the end of the day, the modern breakfast room is more than just a place to eat. It's a dynamic, multifunctional space that caters to a range of needs. When comfort and functionality are prioritized and paired with a dash of style, a breakfast room can become the ultimate hangout spot. So, raise a coffee mug and toast to the new hub of the home!

A fantastical blue-hued mural featuring flora and fauna—note the flamingos—wraps the walls of this breakfast room in the Kalorama neighborhood of Washington, D.C. The back-painted glass-topped table from Jonathan Adler punctuates an otherwise muted palette.

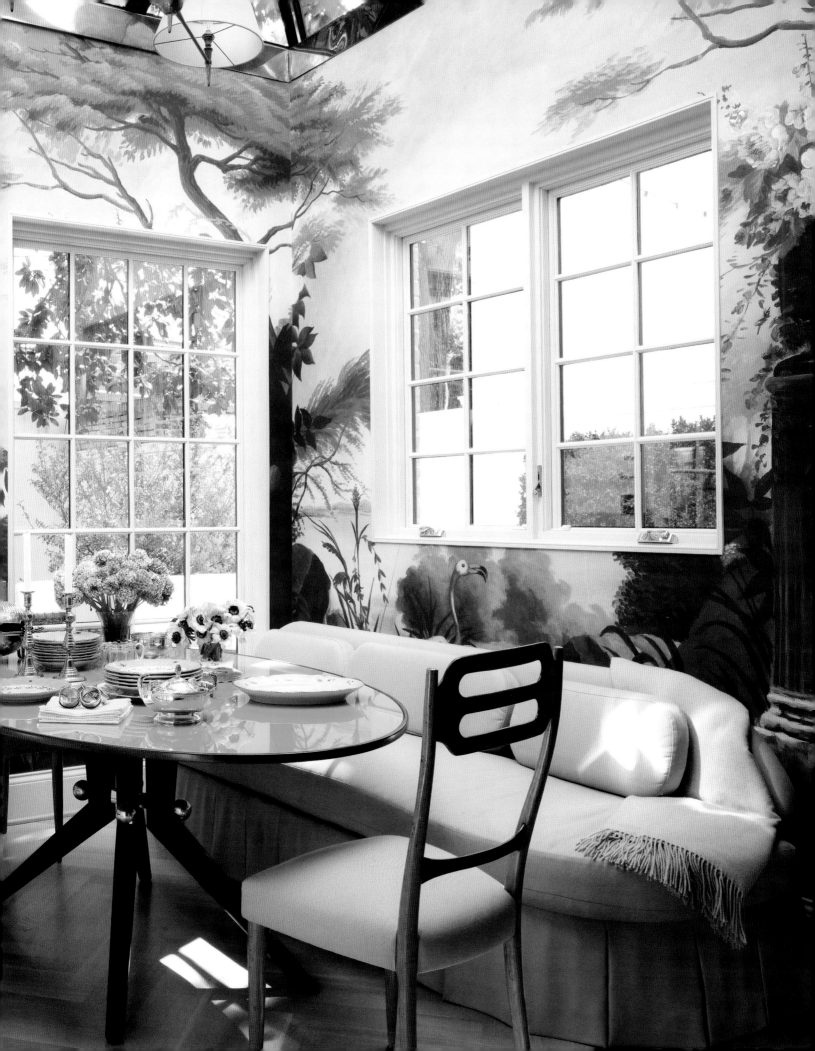

88

BATHROOMS

JOSH GREENE

Designing a bathroom is akin to orchestrating a grand theatrical production. The tiles set the stage, the tub plays the leading role, and the plumbing fixtures are the supporting cast.

A bathroom is more than just a place to brush your teeth; it's a sanctuary, where you can escape the world's chaos and indulge in self-care. When laying out a bathroom, I'm thinking about optimizing it for maximum relaxation: a walk-in shower spacious enough to fit a small village, a luxurious soaking tub that practically begs you to sink into its depths, and not one but two vanity sinks because, well, who wants to share?

Then there's the matter of materials. I'm talking stone, my friends. Giant slabs or, if you're on a budget, the largest stone tiles you can get. We're not just slapping any old ceramic squares on the walls; we're doing marble or travertine.

And let's remember the plumbing fixtures. Faucets, showerheads, handheld showers, you name it—I scour the earth for the crème de la crème of plumbing paraphernalia. Sleek, minimalist designs that look like they were plucked straight from the pages of a design magazine? Check. Detailed statement pieces that scream, Look at me! Double check.

Now, on to lighting. What's the point of having a luxurious bathroom if you can't see yourself with flawless skin? There should be no overhead lighting above the sink to cast shadows on your face. You want warm but bright lighting on either side of the mirror and ample natural light: anything and everything to make you look and feel like a million bucks. And every switch on a dimmer.

Let's not forget the extras—heated floors, unique hardware, bespoke cabinetry—the bells and whistles that take your bathroom from ordinary to extraordinary. Every detail counts when designing a bathroom fit for a king (or queen).

So there you have it, folks. Designing a bathroom isn't just about picking out tiles and fixtures; it's about creating a space that's as indulgent as it is practical, as luxurious as it is functional. And with imagination and flair, you, too, can have the bathroom of your dreams.

Opposite: A falling-block-patterned tile set the color palette for this expansive bathroom, designed for the 2021 inaugural Galerie House of Art and Design showcase. Following pages: A cool-toned grisaille wallpaper from Fromental extends the grayscale throughout the space, which features twin 9-foot custom vanities accented with Hoffman Hardware pulls and fittings by Sherle Wagner International. Native Trails handcrafted the sumptuously deep bathtub.

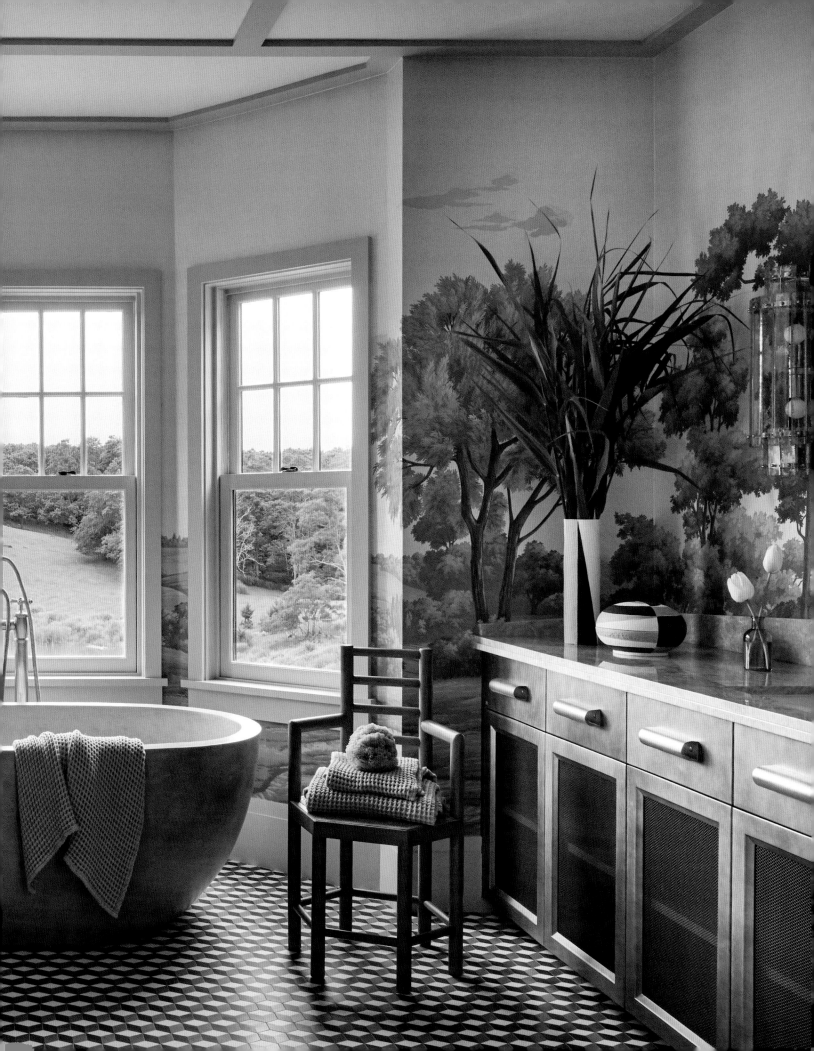

89

MUDROOMS

BRITTANY BROMLEY

More often than not, a mudroom is the first room a guest sees when they arrive, so it should set the tone. Think of the mudroom as the amuse-bouche of the home—a delicious taste of what's to come in succeeding rooms.

Considering how the space will be used is paramount. Determine whether the mudroom will primarily store jackets, coats, and wellies, or whether it will house larger sports equipment and household odds and ends. Some clients hang their coats the moment they arrive home and others do not hang them from December till May, so make sure the storage fits their lifestyle. For young families, I often incorporate baskets, which can hold mittens and hats and allow for self-sufficient tidying, and I opt for easy-to-use hooks instead of interior closet space with hangers.

Mudrooms by nature necessitate cabinetry, which is most often painted a solid color. Due to the volume of this color, I often pair it with a patterned wallcovering that provides visual interest. Consider utilizing clean, wipeable surfaces that will not show wear and tear. And because wall space is limited, for this wallcovering select a bold graphic print that carries much of the design weight.

Whenever possible, use natural materials for the floor in a mudroom. Not only are materials like Pennsylvania blue-stone visually interesting because of their color and texture, but they are also durable and forgiving. I often have traditional rectangular blocks hand-cut into a pattern such as herringbone. And I always suggest that mudroom floors be radiantly heated—there's no greater luxury than slipping off boots to stand on a warm floor in the dead of winter.

Because storage requirements dictate that large walls be used for cabinetry, furniture in a mudroom is often sparse. A small demilune or case piece works as an accent and a spot to drop keys, store a charger, and place a table lamp.

Overhead lighting feels utilitarian by nature, so I combine recessed lighting with decorative fixtures, preferably on two different switches. Having a source of natural light is strongly encouraged.

Cabinetry and closet hardware dresses up woodwork and provides the shine of a metal finish against the solid paint color. I gravitate toward the living patina of unlacquered brass, but for some clients the upkeep required is a barrier to entry.

Finally, make every effort to incorporate a bench or a built-in seat in the millwork. It's handy for lacing one's boots and allows introduction of a textile in the form of cushions or pillows that soften lines and angles—just one more expression of the way a mudroom melds form and function.

In this 1865 Locust Valley, New York, farmhouse, hand-painted striped walls and waxed ceramic tiles create a durable mudroom for a family with three boys. An antique Anatolian runner enhances the room. The built-in bench is perfect for slipping out of soiled footwear.

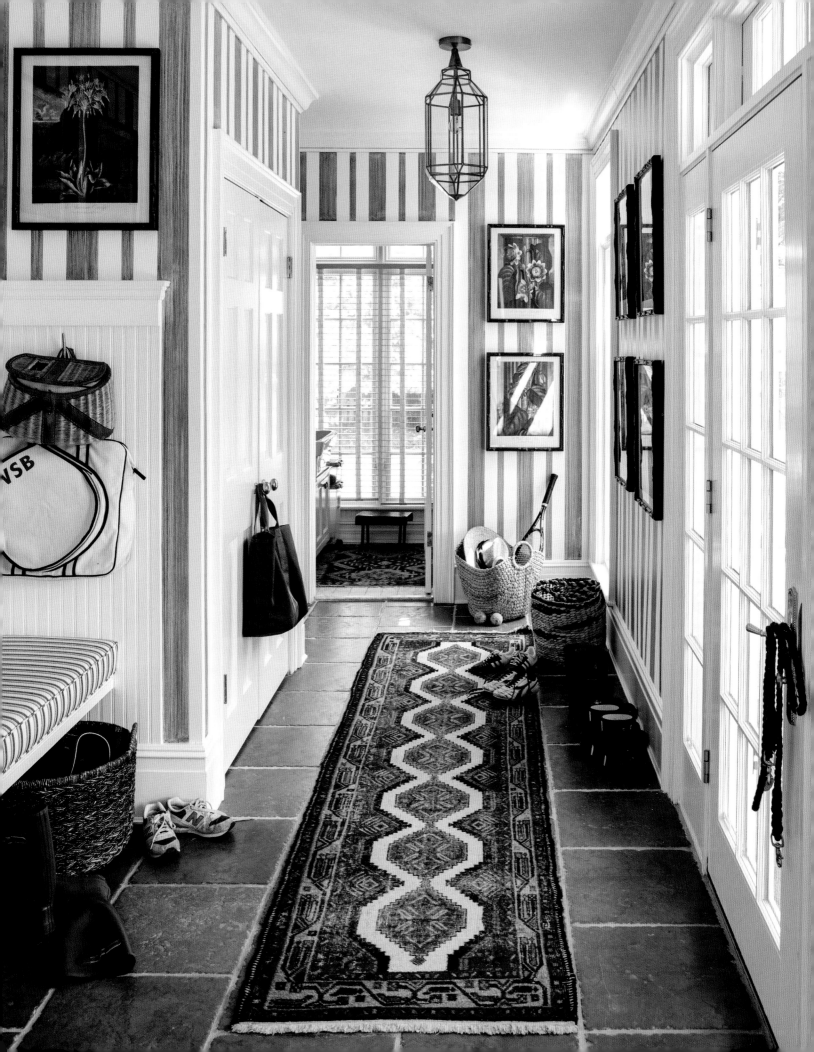

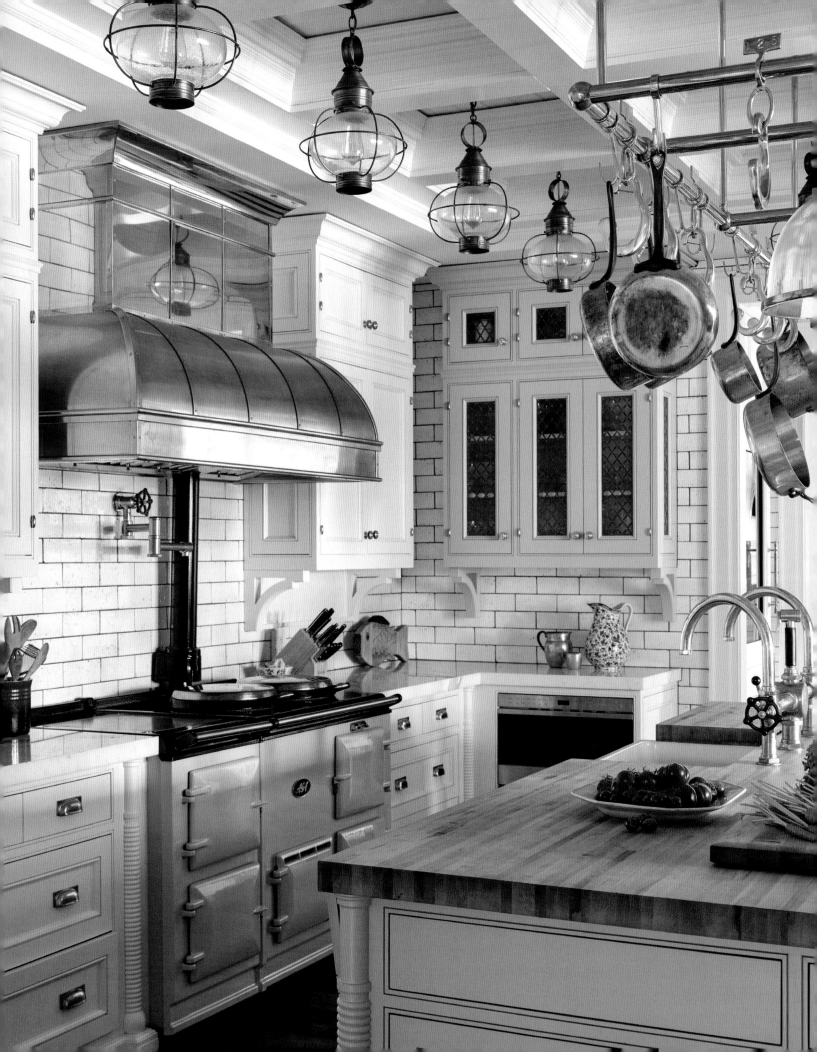

90

HARDWARE

PHILIP MITCHELL

Choosing hardware for your home is more than a matter of selecting embellishments; hardware is a crucial element—both its appearance and its functionality. From the smallest detail like hooks to the functional essentials like door handles and hinges, every component offers a chance to leave a memorable mark and tell a story.

Selecting the ideal hardware is an art, one that balances both aesthetics and practicality. Elaborate patterns, unique forms, and striking finishes have the power to capture attention and serve as focal elements within the room. Each selection offers a prime opportunity to mirror the individual style and taste of the inhabitant.

Take cabinet hardware, for instance. Akin to the jewelry that completes an outfit, these finishing touches tie the whole look of a room together. Whether it's a sleek, contemporary kitchen adorned with leather-wrapped bar pulls or a traditional room embellished with antique brass knobs, the choice of hardware significantly influences the visual story of the space.

Considerations of size and material further refine hardware choices. From ergonomically designed handles facilitating easy access to durable materials promising longevity, each aspect contributes to both the visual appeal and practicality of cabinets. Moreover, hardware doesn't necessarily have to match other fixtures, but it should either align with or complement them. An unlacquered brass faucet can pair well with bronze hardware, creating a cohesive yet interesting combination. This cohesion plays a vital role in crafting a well-considered and refined design. But practicality is also important. Hardware must not only enhance the visual appeal but also provide the functionality that appliances, doors, and cabinets require and deserve.

Ultimately, I have always believed in the importance of designing homes that are reflective of the personalities and style of their residents, and hardware offers a unique opportunity for personal expression. Every detail in a home, hardware included, should bring joy to those who live there. Whether hardware acts as a conversation starter, evokes meaningful memories, or simply completes a space so that it feels collected and calm, it should be carefully considered on its own and in the aggregate.

This new Nova Scotia kitchen was designed to look historic, with custom-colored cabinets that complement the AGA range, an Ann-Morris pot rack, Waterworks fixtures, and an unlacquered brass stove hood that will develop patina and character.

91

WOOD

SEAN ANDERSON

Wood is the most versatile organic material the earth has to offer. There is tremendous depth of personality and individualization that can be derived from natural wood. The various grain patterns are art in and of themselves and contribute to a home's authenticity and character. There are boundless possibilities with the material—hence its popularity in homes around the world.

When introducing wood into an interior space, I first consider how its texture, tone, and finish will contribute to the richness and depth of the space. The grain pattern and natural imperfections of the wood bring an organic, tactile quality to a space, balancing sophistication with warmth. Additionally, I think about how wood complements other materials, like leather or metal, for an elevated, cohesive effect.

Considering your lifestyle is paramount when selecting wood finishes. Assess how and where it will be used (floor, walls, ceiling), how much time you're willing to dedicate to maintaining it, and how you'll feel about it as it begins to develop patina and change character over time. Base your decisions on how you live first, rather than how you want it to look.

For living spaces and kitchens, I gravitate most often toward oak or walnut, often in raw or matte finishes to imbue a sense of approachability and informality, as well as durability, in these high-traffic spaces. Consider the visual effect and hand feel of each application. The texture of unfinished wood provides visual and tactile irregularity that enhances an organic or rustic space. Glossy finishes have a home in spaces that are more formal and less high-touch. I also love a teak moment in a bathroom.

Think about how the wood's color communicates with the things around it. How does it relate to the home's natural environment? If you're opting to stain the wood, how will the stain interact with the natural color, both immediately and over time?

Wood is a natural—and it's naturally versatile. Don't hesitate to think outside of the box when incorporating it into any number of interior styles.

Opposite and following pages: Custom-stained white oak boards wrap this rustic kitchen in Lake Martin, Alabama. Honed soapstone countertops add a decidedly masculine note. Designed for entertaining, the kitchen is part of an open floor plan that balances rustic and refined elements. Patinated brass hardware and a stainless steel range add metallic notes.

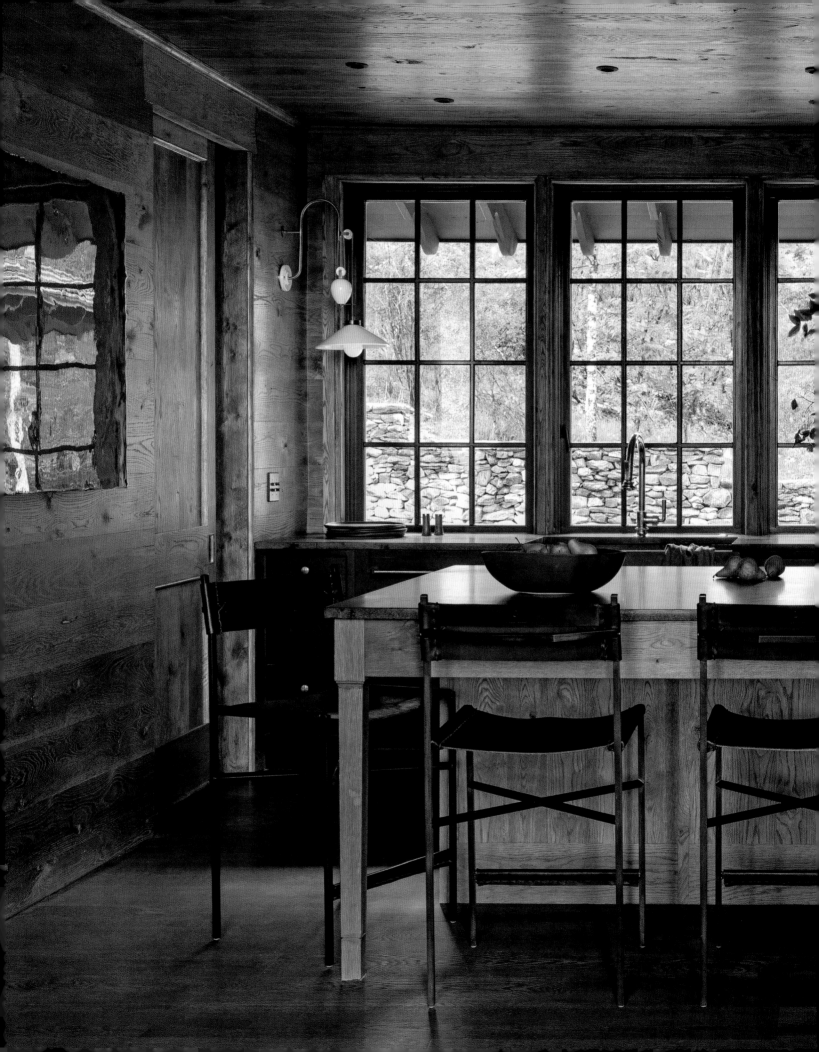

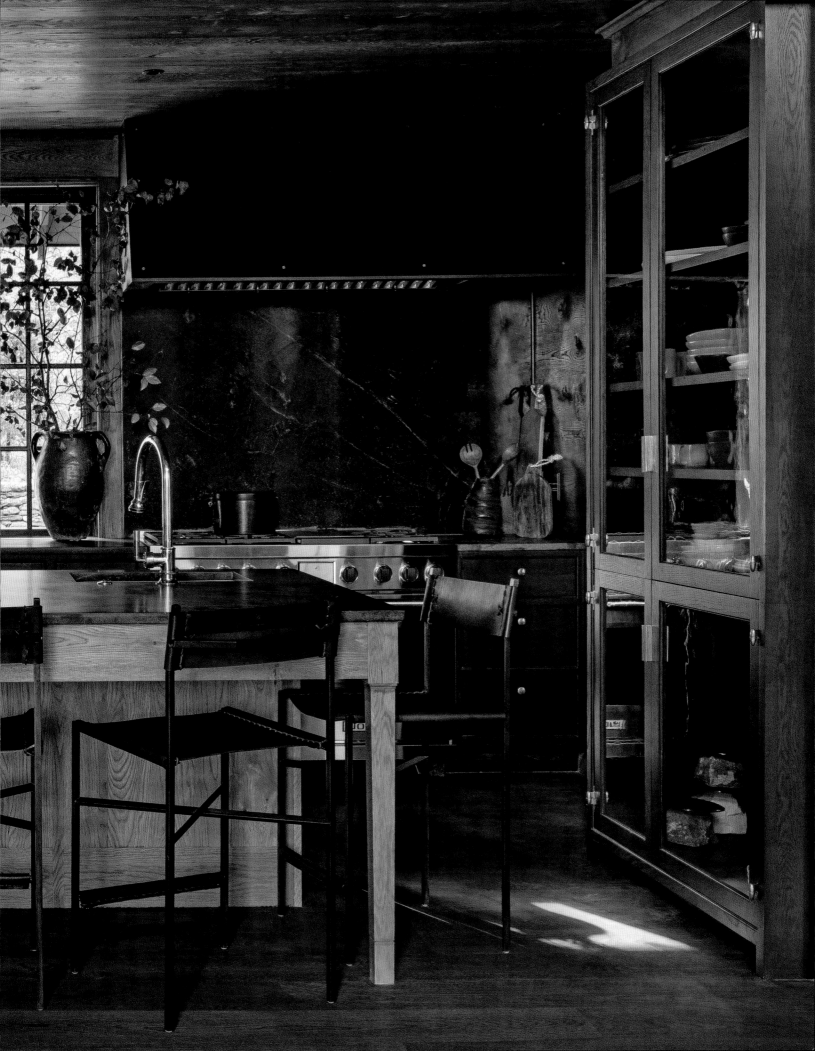

92

MARBLE

CLIVE LONSTEIN

Marble is special because of its permanence. It always sets the tone of a room; it's one of the first things I select when considering a space. Marble is a strong, bold material that brings color and pattern into an interior. With its wide range of hues and unique veining, marble is a wonderfully varied element, and it can be used in surprising and creative ways.

Being intentional about the directional nature of marble's veining structure also offers a subtle way to usher visitors through a space, perhaps leading their eyes upward to suggest added height or using the direction of the veining to emphasize a certain design element. Book-matching—placing two mirror-image marble slabs next to each other as though they were pages of a book—is a powerful tool for further emphasizing vein structure. If the rest of the design elements in a room are left more minimal and quieter, the marble can do much of the heavy lifting in cultivating an atmosphere.

I love using natural materials in my design, in no small part because their variety and nuance is so beautiful. Marble sourced from different places in the world can look wildly different. At the same time, marble provides a natural, earthy quality and brings the outdoors into the interior. When we think of incorporating natural materials, we might first think of something like wood, but a stone like marble is a natural element that still feels clean and modern. Entering a room with a marble element is like stepping into nature, but in a controlled, concentrated way. And when marble is used throughout an entire room, it envelops the space and its inhabitants with its inherent quality—whether that be tranquility or excitement.

Selecting a marble with a client can tell you so much about their sensibility; their preference for a quiet stone versus a bold one can inform the overall direction of the design. Bright, busy marble with intricate, colorful veining provides tremendous energy, while a subtle, patterned stone offers serenity. Marble can play so many different roles, but it always lays a foundation for both style and function.

In this Central Park West kitchen, the backsplash, island, and floor are fashioned from Calacatta Viola marble, quarried in the Carrara area of the Apuan Alps. New York firm VMAD did the architectural work.

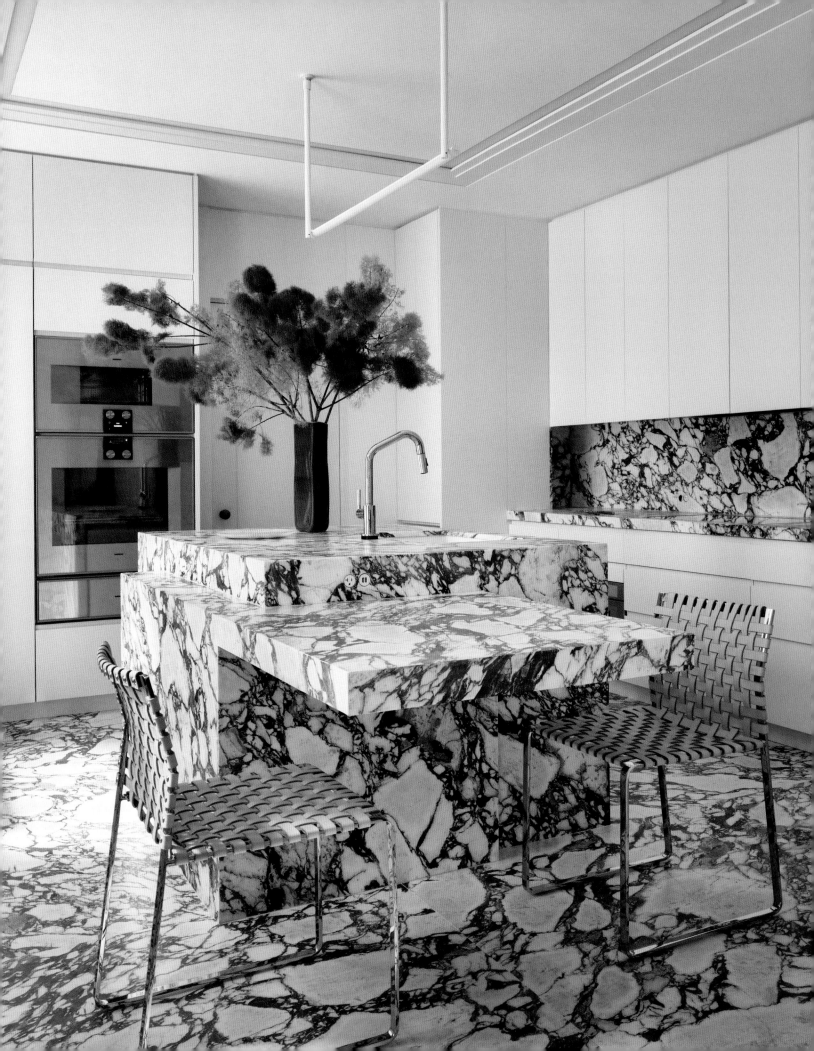

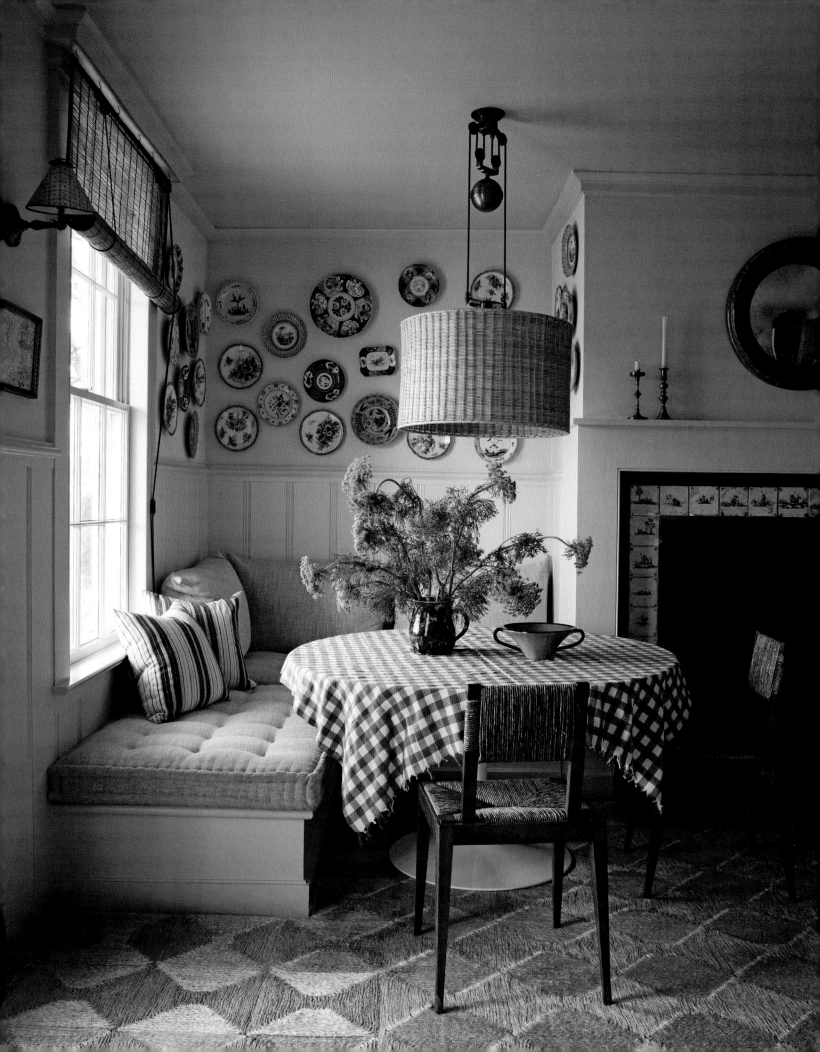

93

NATURAL FIBERS

BILLY COTTON

Natural materials offer a quiet allure that goes beyond aesthetics. Their presence infuses spaces with tactile charm and a sense of craftsmanship, creating a balance between the built environment and the natural world. They have consistently played a significant role in my own work.

When considering which natural materials to use, it is essential to understand how they will shape a space's ambiance. They must blend seamlessly with the design narrative, whether a cozy retreat in the countryside or a modern haven in the city's heart. One must also consider how they will hold up and look with patina over time. From the practicality of hardwoods to the enduring charm of natural stone and the sophistication of leather, these durable materials are ideal for high-traffic areas of a home because they last for years and can handle a lot of use.

When it comes to furniture, natural materials bring warmth and personality to a room. Wooden pieces, whether new, made from reclaimed wood, or antique and given a second life, make a space feel cozy. Natural stones introduce texture and visual interest, lending a sense of luxury and sophis-tication to kitchens and bathrooms. Fabrics are also a vital component of natural materials. Cotton, linen, wool, and silk—these materials are all about softness and durability. Whether you're covering furniture, windows, or floors, they pull a space together and each can be the centerpiece of a room.

Weaving is a cornerstone of many natural materials, and I firmly believe in its power—not just the rhythmic interlacing of threads but the profound connections it creates. Through the manipulation of fibers, weaving embodies a timeless tradition that transcends mere craftsmanship, becoming a vessel for cultural heritage and storytelling. Woven fabrics, furniture, and objects should be worked into a room whenever possible and can be juxtaposed with a more modern aesthetic.

Sustainability has become an increasingly important consideration in interior design, driving a preference for natural materials sourced responsibly and produced with minimal environmental impact. Materials like bamboo, cork, reclaimed wood, and recycled glass offer sustainable alternatives to traditional options and can look just as elevated when used correctly.

Natural textures define a Southport, Connecticut, breakfast room that features a Soane rattan pendant, sisal rope chairs from Quindry, and rush matting. A window-side bench with a mattress-edged cushion and blue-and-white ticking pillows completes the setting, primed for morning coffee.

94

FARMHOUSE KITCHENS

FRAN KEENAN

The farmhouse aesthetic calls for simplicity with a nod to the past. Rooms that have a strong relationship with land and the outdoors are called upon to be functional, but they can also glow with charm. Farmhouse-inspired kitchens evoke wonderful nostalgia that is often expressed through design details like antique hardware, wood walls, aged tile, and hard-working tools. Many such kitchens incorporate antique bread boards, mixing bowls, and other accessories that are not just for display but are used on a regular basis and have purpose. This sense of utility lends authenticity and warmth.

Ideally, a garden is situated outside the kitchen windows for lovely framed views. With a quick glance, the cook can see what tasks need doing. Perhaps the herbs need trimming or the tomatoes are ripe for picking. The kitchen or scullery is the location for work such as prepping the produce harvested from the garden. This natural flow elevates the sense of place and makes the kitchen fit for purpose—and not just pretty.

The kitchen hardware should also be hardworking—utilitarian and not too dressy. I particularly like turned knobs inspired by those on English chests of drawers; they are easy to grip and add warmth.

The lighting should be charming, with turn-of-the-century shapes and materials. Natural light is important to maintaining a historic feel. Minimize harsh artificial lighting, which would make the space feel too modern. For example, eschew recessed lights in favor of more period-appropriate surface-mounted fixtures. Of course, authentic antique light fixtures are a nod to the farmhouse aesthetic.

Rugs and fabrics should be inspired by old loomed textiles. A needlepoint rug that pulls together the colors used throughout the house is a cook's best friend when it comes to camouflaging drips from the tasting spoon. Often, the farmhouse look celebrates natural, neutral tones, leading more with texture layered over shades of white and warm wood. However, color can be a wonderful vehicle for whimsy when applied to cabinets or textiles. It renders the design approachable and fun. Ultimately, that warm feeling is the great joy of the farmhouse kitchen.

Opposite: A colorful needlepoint runner sounds a vivacious note underfoot in the kitchen's entryway while softening the expanse between the cooktop counter and the contrasting sink island in rich teal blue. Following pages: The room features tall, glossy wall panels that draw the eye upward. Above the curved doorway, a wooden beam serves as a decorative header. Warm, nostalgic colors create an inviting dining space centered around a large farmhouse table with ample seating for ten.

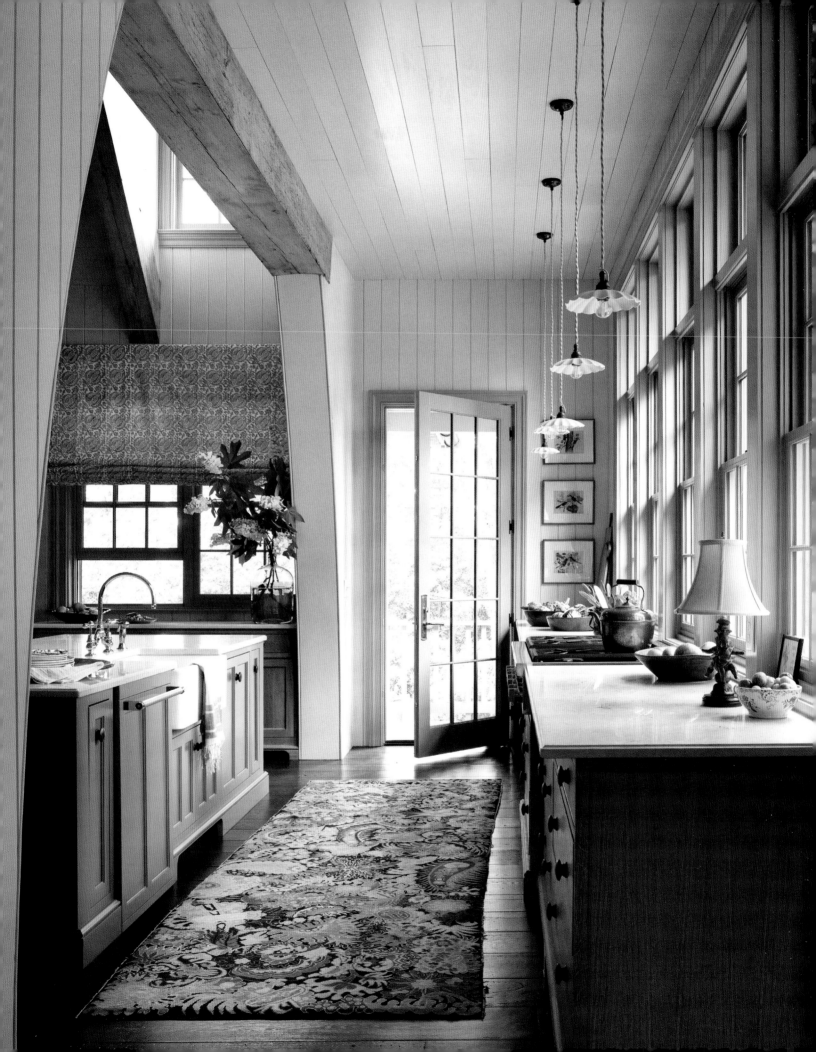

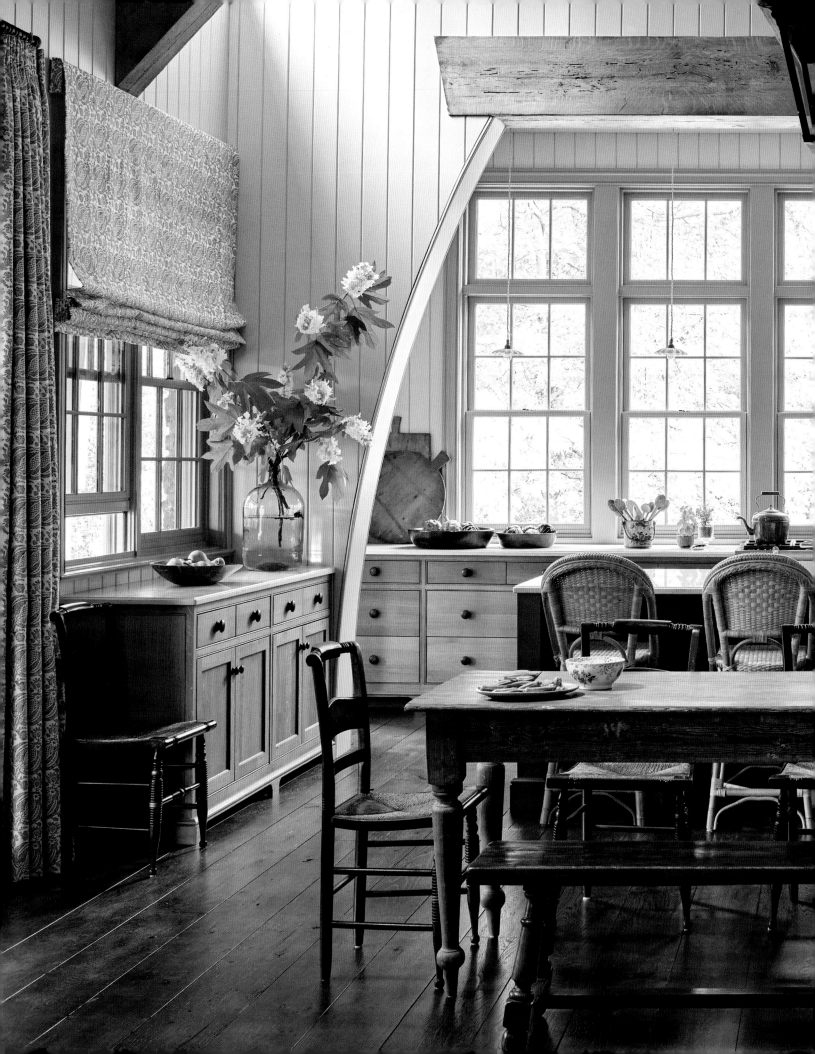

95

LAUNDRY ROOMS

CASEY HILL

A well-designed laundry room blends beauty with efficiency, ensuring that an often-overlooked space becomes a seamless extension of a home's aesthetic. The first step in designing a laundry room is to consider its function: Is it purely for washing and drying, or does it need to accommodate storage, folding, ironing, and perhaps even pet care? Identifying these needs from the outset allows for a floor plan that optimizes both space and workflow.

What was once considered a back-of-house space is now a place where we find ourselves spending more and more time, making it essential to give it as much attention during the design process as any other room in the home. The laundry room should not be skipped over or treated as an afterthought but rather designed with intention and care.

When laying out the floor plan, functionality reigns supreme. The classic work triangle concept—often used in kitchens—can be applied to laundry rooms, ensuring smooth movement between washer, dryer, and folding areas. Positioning appliances near plumbing sources and keeping frequently used items within arm's reach enhances usability. If space allows, incorporate a countertop above front-loading machines as a practical folding surface. A deep sink can be employed for multiple purposes, from handwashing delicate garments to cleaning up after craft projects.

Ergonomics play a crucial role in reducing strain during repetitive tasks. Placing appliances at a comfortable height minimizes bending, and pull-out hampers or baskets streamline the sorting process. Good lighting is also essential; natural light is ideal, but layered artificial lighting can brighten workspaces effectively. Ventilation is another key factor, as proper airflow prevents moisture buildup and maintains a fresh environment.

Storage is the cornerstone of an efficient laundry room. Custom cabinetry, floating shelves, and pull-out drawers keep essentials organized and accessible. Labeling bins for different fabric types or family members simplifies sorting, while drying racks preserve delicate items. Thoughtfully planned storage ensures that everything has its place, reducing clutter and enhancing efficiency.

For those embarking on a laundry room renovation, three guiding principles should be followed: first, prioritize functionality—ensure that layout and storage solutions cater to everyday needs. Second, consider durability—opt for materials that can withstand moisture and wear. Lastly, incorporate style—use finishes and hardware that align with the home's design.

Avoid overcomplicating the space with unnecessary elements, and steer clear of poor lighting or inadequate ventilation. A well-designed laundry room is one that balances aesthetics with utility, making an everyday chore feel almost effortless.

This laundry room is decorated with Arts and Crafts–inspired floral wallpaper. The cabinet hardware features matching petaled designs. A deep utility sink fills both laundry and flower-arranging needs. The window treatments are basic woven shades finished with grosgrain ribbon trim.

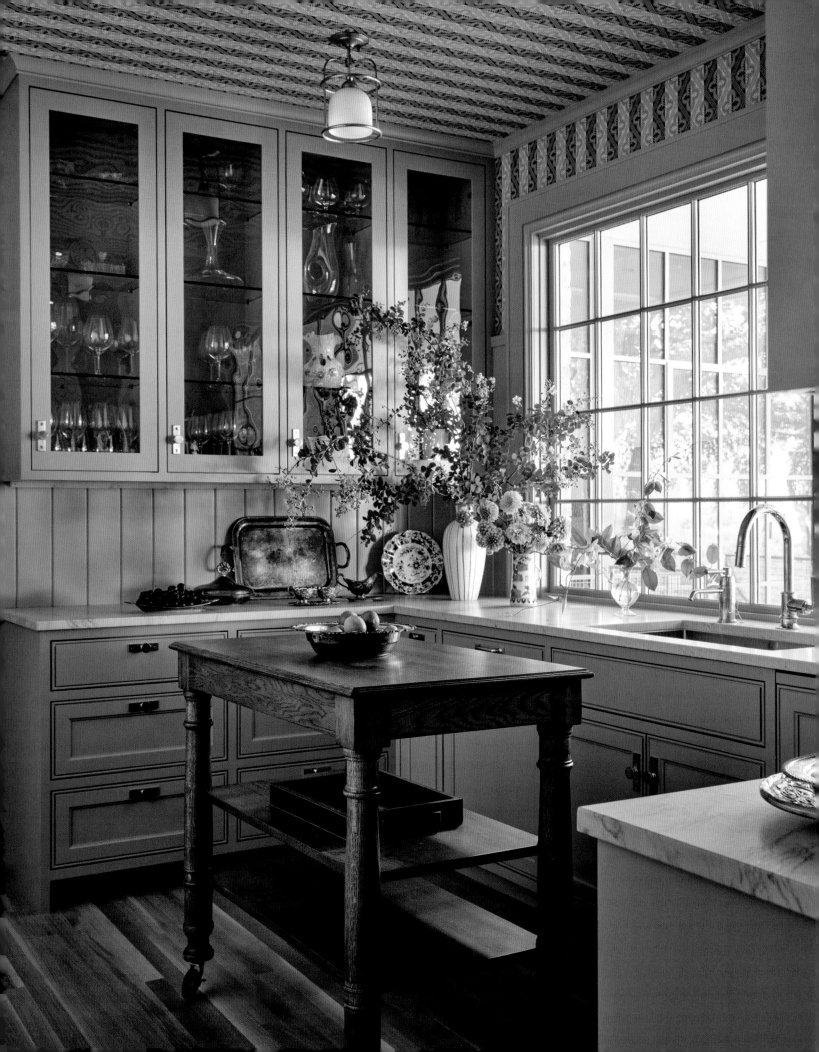

96

PANTRIES

ANDREW HOWARD

A pantry means different things to different people. To some homeowners—and especially their children—it's strictly food storage space, basically a closet for snacks and canned goods and rarely used countertop appliances. To others, it's a hard-working, high-style extension of the kitchen—a place for caterers to work and for kids to indulge their biggest mess-making baking fantasies beyond the gaze of judgmental houseguests.

This sort of spot, often called a back kitchen or scullery, keeps things neat and tidy in the show kitchen up front, letting dinner and cocktail party guests ooh and aah over gleaming stainless-steel gadgets, sparkling stone countertops, lacquered cabinets, and witty repartee.

If you asked the kids in my neighborhood, they would say my family's got the best pantry in town, and not because of how it looks—though it looks pretty great, if I do say so myself—but because of what's in it. We keep it stocked with snacks and drinks, all tucked away but also easy to access. It's just as important for a kid getting home from school to be able to grab a pack of goldfish crackers and a Gatorade from the pantry as it is for a caterer to orchestrate the magic behind

a well-planned event there. The best pantries offer space for both scenarios—and with style, too.

The most successful way I know to combine form and function, substance and style, is to build off the main kitchen without repeating or replacing it. The pantry needs to have its own moment. To me, that means using the same or a similar aesthetic for cabinet profiles and hardware, but amping up color and pattern. Pantries tend to be small, so they can handle going big and bold, even when paired with a stark white kitchen. (Color and pattern can also hide messes.)

Make things easy to find and get to in the pantry. Glass-doored cabinets and open shelving are two possible solutions. I love drawers in the lower cabinetry to hold kid-friendly snacks, and I always design room for glassware and special-occasion tabletop items above. This is the place to keep beloved wedding-registry pieces that don't get used often.

The overarching thing to keep in mind is this: In the best pantries, everyone feels at home. Even someone visiting for the first time—the friend-of-a-friend dinner guest—is eager to hang out and help with prep and have a great time. In a good pantry, too many cooks don't spoil anything.

A removable rolling island allows this multifunctional pantry to serve as a staging area
for catered parties. Beyond offering essential storage, the room showcases a stylish papered ceiling
and protective wainscoting, making it as fashionable as it is practical.

97

TILE

JESSICA DAVIS

[Atelier Davis]

Tile is an exceptional material for a variety of spaces, including kitchens, bathrooms, mudrooms, outdoor patios and pools, and even unexpected areas like bedrooms. With an ever-expanding array of options, tile can range from large-format rectangles to small mosaic sheets, from modern porcelain to imperfect hand-glazed zellige. So, where should you begin when selecting a tile? What factors should you consider to achieve the greatest impact, beauty, and functionality?

First, think about the overall design of your home. Is there a unifying theme or aesthetic throughout the space? Consider how the tiled room will connect to adjacent areas. I love using tile to weave a narrative through colors, textures, and spatial design, all of which then harmonize with the home's overarching scheme. For instance, if you're designing a powder room and want it to feel moody and dramatic, consider selecting deeper, more saturated versions of the colors and textures found in surrounding spaces to create a room that stands out while still fitting in.

Next, assess the intended use of the room. Is it a hard-working mudroom, a seldom-used powder room, or something in between, like a primary bath? While tile is generally a durable choice, various factors can influence its performance. For example, some large tiles are more slippery and may not be suitable for a shower floor, whereas smaller tiles can provide additional slip resistance due to the numerous grout lines.

Finally, consider the sizes and shapes of the surfaces the tiles will cover. For smaller surfaces, you may want to avoid large tiles that will require extensive cutting. Conversely, for a curved wall, smaller kit-kat tiles, so called for their similarity to the rectangles making up the popular candy, may be ideal as they can better conform to the curve. Additionally, if your tile installation has visible edges, consider using finished-edge tiles or brass Schluter strips for a refined look. I love combining a large-format tile on the floor with something smaller, like a penny round, or something with a pattern on the walls for contrast. Don't be afraid to combine different colors and textures in tile!

Tile is truly versatile and can be the star or play a supporting role, adding depth, texture, and vibrancy to any space.

For the powder room she created for the 2022 Kips Bay Decorator Show House in Dallas, Davis chose a color palette inspired by the Texas landscape. To that end, she wrapped the walls in a sophisticated tile from Artistic Tile. The cabinet hardware was sourced from Nest Studio, while the sconce is from Rosie Li Studio.

98

PLAYROOMS

TINA RAMCHANDANI

Children's playrooms are one of my favorite areas of a home to design, because when I'm creating for children I'm allowed to truly think outside of the box. I love to create spaces that spark creativity, foster playfulness, and nurture unrestricted thinking. I want the spaces I design for my young clients to feel free of boundaries. I use combinations of color, pattern, and texture that we don't allow ourselves to be surrounded by as adults. These bright, bold hues and often whimsical patterns encourage kids to follow their imaginations. I aim for children to feel genuine excitement when they enter their designated areas, to sense a warm welcome, and to enjoy their time in these rooms.

Of course, you do need to address practical matters. In every playroom, regardless of its size, prioritize efficient storage solutions. Given that kids tend to accumulate many items, the aim is to ensure that everything is easily accessible and discoverable. This can be done by implementing a combination of open cubbies with baskets or bins, pull-out trays, and doors to conceal clutter. When laying out the room, focus on designing distinct zones for various types of play, allowing children the freedom to engage in messy activities in one area while providing a serene space for quiet moments—such as a reading nook—in another. It is also important to personalize these rooms, so each child in the family feels seen and heard. If one young client loves to play dress-up, incorporate a wardrobe rack and possibly a stage to show off their different looks. If another is interested in arts and crafts, be sure to create a space for them to draw and paint.

There are many things to consider when creating children's playrooms, but the most important to me is that my young clients feel loved and cared for, and enjoy the spaces that were created specifically for them.

Opposite: Brightly colored chairs from Design Within Reach surround a low table in this playroom.
The clothing rack showcases a selection of favorite party dresses. Following pages: Rainbow-cloud wallpaper
draws the eye upward to create the illusion of a taller ceiling. The built-in storage unit serves dual purposes:
it cleverly conceals heating and cooling ducts while providing abundant space to organize toys and books.

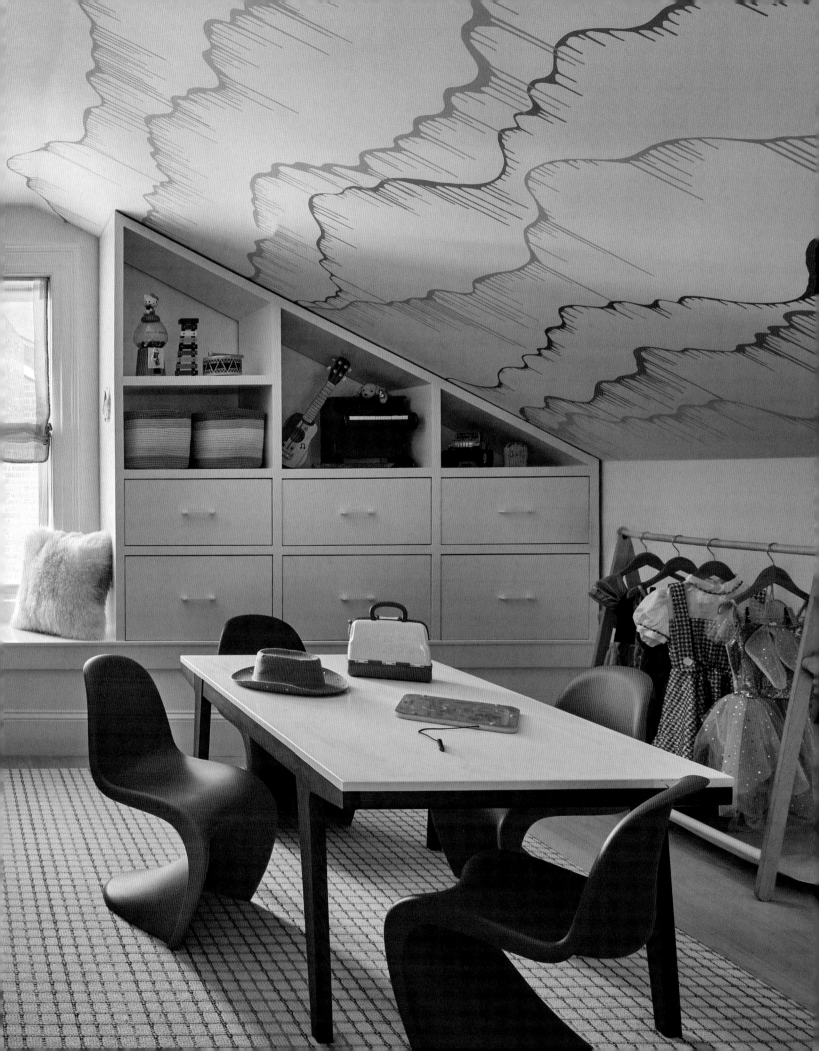

99

CABINETRY

MATT MCKAY

When approaching custom cabinetry for the home, it is crucial to understand your needs clearly. The most successful designs balance practicality and aesthetic appeal.

Begin by taking stock. What will occupy the cabinetry? This inventory will guide decisions on size, configuration, and style. Proper scaling is essential; cabinetry should be appropriate to the room's proportions, neither overwhelming the space nor appearing insignificant.

As a professional designer, I am always focused on the narrative of the home. Cabinetry should contribute to this, and resonate with the architectural style while enhancing the overall character of the space. This thoughtful integration creates cohesive and purposeful design.

Hardware selection is a critical detail that can significantly impact the final aesthetic. It is the finishing touch that can complement or contrast with the cabinetry. For a more minimalist approach, consider concealed hardware to maintain clean lines.

To take cabinetry to the next level, explore textural elements or strategic use of color. An inset panel in a contrasting material or a chosen hue can transform standard cabinetry into a focal point. Consider varying the opacity of storage solutions; a mix of open shelving and closed cabinets offers both display opportunities and discreet storage.

I always advise clients to extend their design considerations to the cabinet interiors. Custom organizers and thoughtful internal configurations can dramatically enhance functionality and user experience. If you're feeling daring, consider painting the interiors of the cabinetry for a pop of color.

Incorporating hidden features, such as a concealed bar or a specialized storage area, adds an element of surprise. These touches often become the most cherished and functional aspects of a design.

Above all, custom cabinetry offers an opportunity for deep personalization. Every choice, from materials to finishes, should reflect the overall style and the specific requirements. This level of customization ensures that cabinetry is not merely a storage solution but an integral part of the home's design language. Remember, in the world of interior design, it's the thoughtful details that elevate a space from ordinary to extraordinary.

Opposite: The kitchen in this Greenwich Village home features floor-to-ceiling custom cabinets with clean lines, maximizing storage space. Following pages: This kitchen features oak upper cabinets, grasscloth panels, and lower drawers with craftsman-style box joints. Teal quartzite countertops add color, and barstools welcome guests.

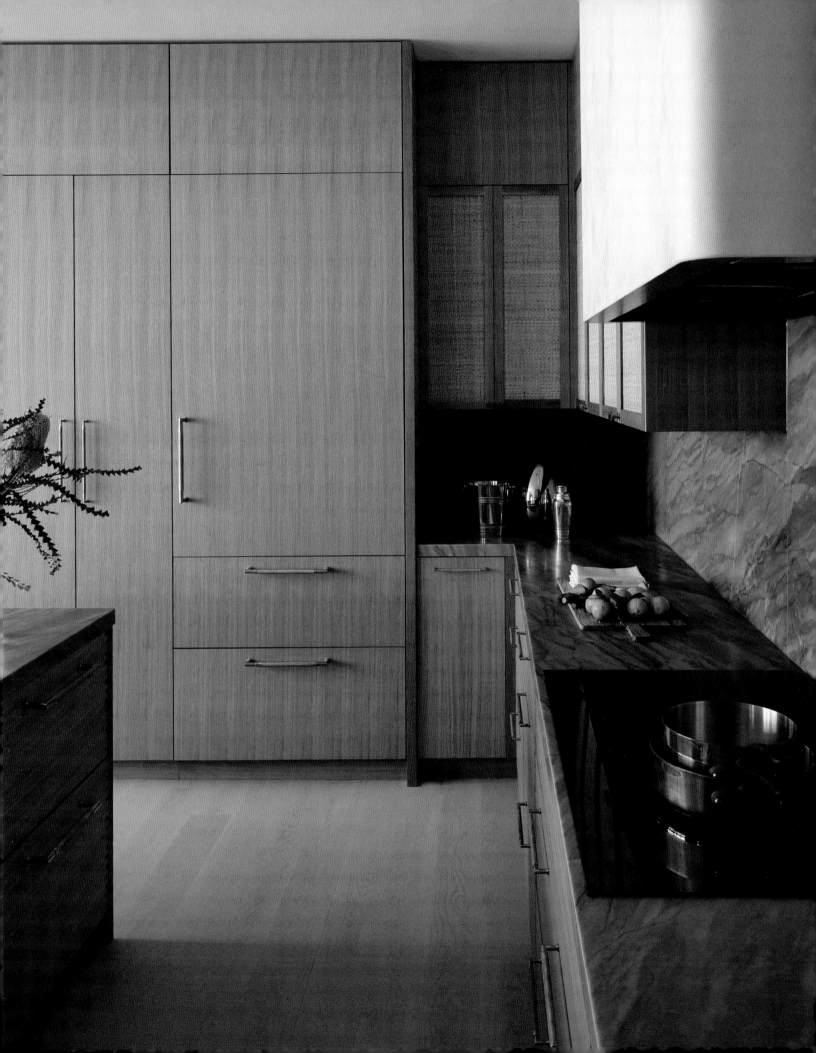

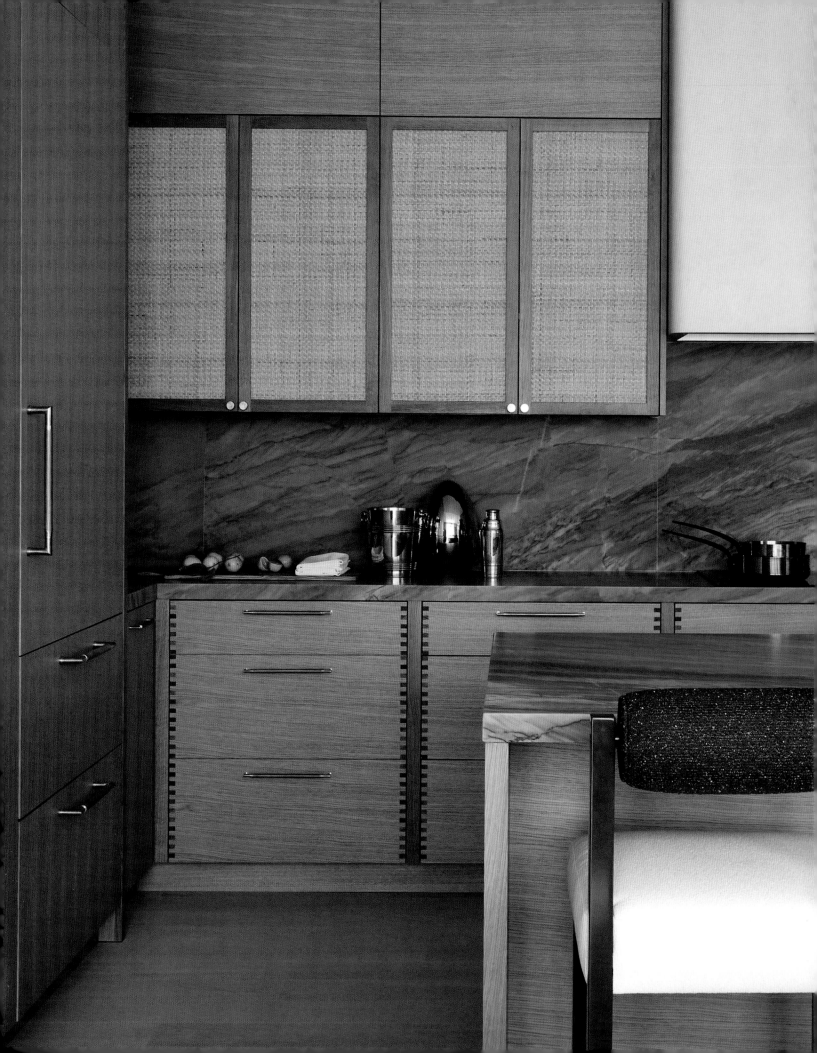

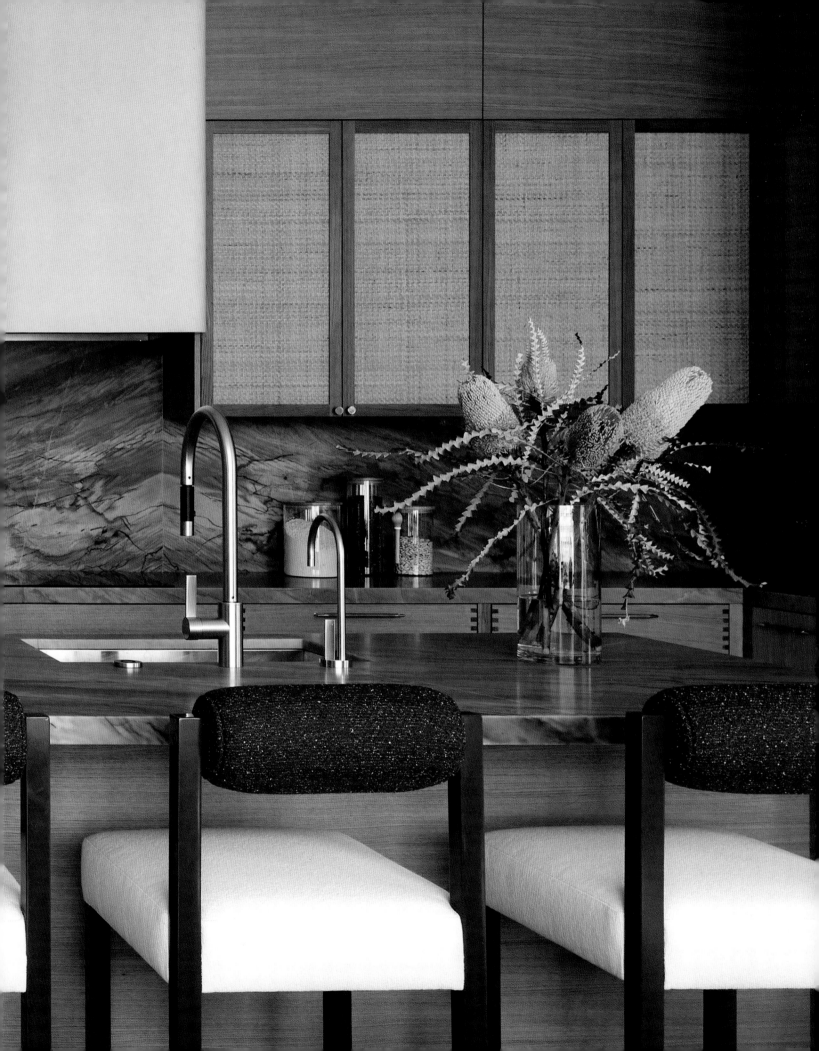

100

WINDOWS

BETH WEBB

Mediums of light, windows are also powerful creators of atmosphere. As designers, we paint with light and shadow, creating moments of chiaroscuro or capturing the glow of the golden hour. Architecture is our partner in this work: placement, form, dimension, and material all impact window design and selection, as do considerations of privacy, energy efficiency, craftsmanship, and sheer beauty.

There are many styles and periods from which to draw aesthetic inspiration. Window shapes range from enchanting oeils-de-boeuf, or ox-eyes, to monumental grids of blackened steel. One can add visual interest with a historic shape, dramatically illuminating a great room with Gothic arched windows, as did one architect I collaborated with on a modern beach home, or installing charming wood shutters to represent the Southern vernacular.

Light needn't stream only from the four walls. One can direct illumination with alternate light sources like an oculus, skylight, or even a floor portal that enables sun to flow from upper to lower levels. Unexpected scale can be played with as well, and on the practical side, helps control the brightness of a space: the petite windows in stone homes in the Italian countryside reduce intense sunlight, while a retractable window wall can frame expansive views of mountain or meadow. Even color can be a factor—artisanal glass is enjoying a renaissance, with craftspeople creating sublime stained-glass windows for both exterior and interior walls.

Interior design, of course, shapes the life of windows. For one recent project, the architect framed a series of massive arched windows in polished wood, creating a refined backdrop for an antique elm table set with a still life of objects. In a study for an art collector, I chose a deep charcoal gray in a high gloss for the walls that reflects the luminous grid of the panes. And for a villa bedroom, I designed a handsome, upholstered window seat where the client can rest and gaze out on the lake and landscape.

Windows define our view of the world. On Brays Island, South Carolina, my husband and I live in a house of glass. The heart of the space is the long room, a space 50 feet in length with a 22-foot ceiling and full-height windows. Offering views of the surrounding landscape, the windows are a defining feature of how we live. These portals of glass enable us to bask in natural light in every season.

Soaring windows in this Brays Island galley kitchen frame the leafy South Carolina countryside just beyond the glass, while custom rift-cut oak cabinetry and Belgian bluestone floors complement the natural setting inside.

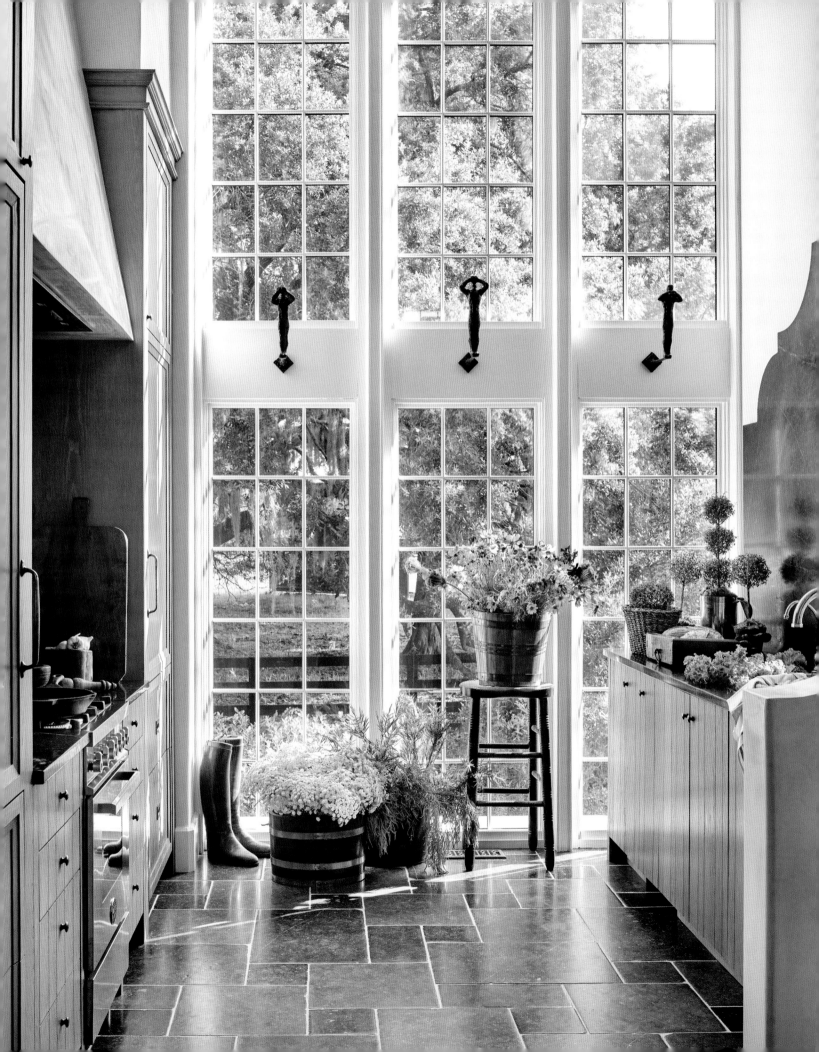

PHOTOGRAPHY CREDITS

A pair of sconces from Urban Electric provide reading light on each side of the designer's Gramercy Park bedroom, and under each is a lacquered table populated with books, pottery, and other objets. "I like symmetry," designer Bennett Leifer explains.

ACKNOWLEDGMENTS

Immense thanks to my literary agent, William Clark, for his kind
representation and steadfast friendship.

A wealth of gratitude to everyone at Rizzoli, New York, including publisher
Charles Miers; my editor Kathleen Jayes; my copyeditor Natalie Danford; the
book designer Susi Oberhelman; and publicist Jessica Napp.

Heartfelt appreciation to everyone in the design community for joining me
in this project, including the late Amy Lau.

Thank you to my family and friends for your love and support.

And, finally, a special word of thanks to my partner Stephen Link, who holds
infinite space for my creativity. I'm grateful for you.

First published in the United States of America in 2025 by Rizzoli International Publications, Inc.
49 West 27th Street | New York, NY 10001 | www.rizzoliusa.com

© 2025 Carl Dellatore

ART CREDITS
Page 77: Maurice Utrillo, "La Cathédrale de Rheims" © 2025 Artists Rights Society (ARS), New York / ADAGP, Paris
Pages 79 and 81: Larry Poons, "Log Train," 1985 © 2025 Larry Poons / Licensed by VAGA at Artists Rights Society (ARS), NY
Page 80: Jules Olitski, "Phantom Touch," 1961 © 2025 Jules Olitski Art Foundation / Licensed by VAGA at Artists Rights Society (ARS), NY
Page 103: Franz Kline, "Crosstown," 1955 © 2025 The Franz Kline Estate / Artists Rights Society (ARS), New York
Page 279: Friedel Dzubas, "Many Voices," 1987 © 2025 Estate of Friedel Dzubas / Artists Rights Society (ARS), New York

Special thanks to Fortuny Textiles for the use of their iconic Canestrelli pattern in French blue and white
for the chapter openers on pages 8-9, 92-93, 150-151, 208-209, and 266-267.

Publisher: Charles Miers | Senior Editor: Kathleen Jayes | Copyeditor: Natalie Danford
Design: Susi Oberhelman | Production Manager: Colin Hough-Trapp | Managing Editor: Lynn Scrabis

ISBN-13: 978-0-8478-7445-3 | Library of Congress Catalog Control Number: 2025934189 | Printed in China

2025 2026 2027 2028 / 10 9 8 7 6 5 4 3 2 1

The authorized representative in the EU for product safety and compliance is Mondadori Libri S.p.A.,
via Gian Battista Vico 42, Milan, Italy, 20123, www.mondadori.it

Visit us online:
Instagram.com/RizzoliBooks | Facebook.com/RizzoliNewYork | Youtube.com/user/RizzoliNY